THE WOUND AND THE STITCH

RSA·STR

THE **RSA** SERIES IN TRANSDISCIPLINARY **RHETORIC**

Edited by

Michael Bernard-Donals *(University of Wisconsin)* and
Leah Ceccarelli *(University of Washington)*

Editorial Board:

Diane Davis, The University of Texas at Austin

Cara Finnegan, University of Illinois at Urbana-Champaign

Debra Hawhee, The Pennsylvania State University

John Lynch, University of Cincinnati

Steven Mailloux, Loyola Marymount University

Kendall Phillips, Syracuse University

Thomas Rickert, Purdue University

The RSA Series in Transdisciplinary Rhetoric is a collaboration with the Rhetoric Society of America to publish innovative and rigorously argued scholarship on the tremendous disciplinary breadth of rhetoric. Books in the series take a variety of approaches, including theoretical, historical, interpretive, critical, or ethnographic, and examine rhetorical action in a way that appeals, first, to scholars in communication studies and English or writing, and, second, to at least one other discipline or subject area.

A complete list of books in this series is located at the back of this volume.

Loretta Victoria Ramirez

THE WOUND AND THE STITCH

A Genealogy of the Female Body
from Medieval Iberia to SoCal Chicanx Art

THE PENNSYLVANIA STATE UNIVERSITY PRESS
UNIVERSITY PARK, PENNSYLVANIA

Library of Congress Cataloging-in-Publication Data

Names: Ramirez, Loretta Victoria, author.
Title: The wound and the stitch : a genealogy of the female
 body from medieval Iberia to SoCal Chicanx art / Loretta
 Victoria Ramirez.
Other titles: RSA series in transdisciplinary rhetoric.
Description: University Park, Pennsylvania : The Pennsylvania
 State University Press, [2024] | Series: The RSA series
 in transdisciplinary rhetoric | Includes bibliographical
 references and index.
Summary: "Traces a historical genealogy of imagery and
 language centered on the concept of woundedness
 and the stitching together of fragmented selves in
 Chicanx self-representation"— Provided by publisher.
Identifiers: LCCN 2023055332 | ISBN 9780271097275
 (hardback) | ISBN 9780271097282 (paperback)
Subjects: LCSH: Mexican American arts. | Wounds and
 injuries in art. | Wounds and injuries in literature. |
 Women in art. | Women in literature. | Rhetoric.
Classification: LCC NX512.3.M4 R36 2024 |
 DDC 700.89/6872073—dc23/eng/20240108
LC record available at https://lccn.loc.gov/2023055332

Copyright © 2024 Loretta Victoria Ramirez
All rights reserved
Printed in the United States of America
Published by The Pennsylvania State University Press,
University Park, PA 16802–1003

© The Rhetoric Society of America, 2024

The Pennsylvania State University Press is a member of the
Association of University Presses.

It is the policy of The Pennsylvania State University Press to
use acid-free paper. Publications on uncoated stock satisfy the
minimum requirements of American National Standard for
Information Sciences—Permanence of Paper for Printed
Library Material, ANSI z39.48–1992.

To

those who diagnose the wounds

those who resist being "fixed"

those who bare their wounds, so others might mend.

We are not the only ones to walk this road.

Contents

List of Illustrations | ix

Preface | xi

Acknowledgments | xvii

Introduction: The Wound and the Stitch | 1

PART 1: THE RHETORICAL WOUND | 27

1 Cherríe Moraga's Rhetoric of Fragmentation and Semi-ness | 33

2 Woundedness as Decolonial Rhetoric | 48

PART 2: THE INFLICTED WOUND | 69

3 Biopolitics and "Crying Wounds" in *No Más Bebés* | 77

4 Border-Patrolling Chicana Bodies and Wound Theory as Resistance | 95

PART 3: THE GENERATIVE WOUND | 111

5 Reading Wounds (from Right to Left) to Reclaim Mexica Cosmologies | 119

6 The Art of the Generative Wound (from Container to Co-Redemptrix) | 146

Conclusion: The Linguistic Wound and Stitch Pedagogy | 173

viii CONTENTS

Notes | 195

Bibliography | 209

Index | 225

Illustrations

1. Virgen abridera of San Juan Chapultepec, seventeenth century 2
2. Virgen abridera of San Juan Chapultepec (detail), seventeenth century 3
3. Coyolxauhqui Stone 28
4. Ignacio María Barreda, *Las Castas Mexicanas*, 1777 54
5. Still of Maria Hurtado, *No Más Bebés*, 2015 83
6. Still of Consuelo Hermosillo, *No Más Bebés*, 2015 87
7. Andrea di Bartolo Cini, *St. Lucy*, fourteenth century 112
8. Guillermo Gómez-Peña, Felicia Rice, Gustavo Vazquez, Felicia Rice, and Zachary James Watkins, *Doc/Undoc* 126
9. Guillermo Gómez-Peña, Enrique Chagoya, and Felicia Rice, *Codex Espangliensis*, Superman and Skull and Mickey Mouse on Plate, 2000 131
10. *Codex Magliabechiano* (detail), ca. 1566 132
11. Guillermo Gómez-Peña, Enrique Chagoya, and Felicia Rice, *Codex Espangliensis*, Man of Sorrows and Massacre, 2000 134
12. Guillermo Gómez-Peña, Enrique Chagoya, and Felicia Rice, *Codex Espangliensis*, Anima Sole and the Bisected Woman, 2000 141
13. Christina Fernandez, *Untitled Multiple Exposure #4 (Bravo)*, 1999 149
14. Christina Fernandez, *Untitled Multiple Exposure #6 (López)*, 1999 152
15. Maya Gonzalez, *The Love that Stains*, 2000 153
16. Amalia Mesa-Bains, *The Twins: Guadalupe*, 1997 156
17. Virgen abridera, ca. 1576–1625 159
18. Virgen abridera, opened, with the Passion of Christ, ca. 1576–1625 159
19. Shrine of the Virgin, opened, with the Trinity, ca. 1300 162
20. Virgen abridera, 1520 167

Preface

The Wound and the Stitch is my own generative wound.

This exploration bleeds from decades of life in academia as a student with one BA, three MAs, and one PhD and as an educator at a community college, then a private Catholic university, and finally at a public state university. As a first-generation Chicana and Apache academic I have suffered constant institutional inflictions, usually as subtle microaggressions that graze my ever-thickening skin but also sometimes as heart-piercing stabs that incapacitate me for months (even years) at a time.

From every front of academia, I have been slashed—dismissal of my past achievements, doubt in my current abilities, and rejection of my future potential. Concurrently, I witness these wounds occurring for the first time in my students, largely Chicanx first-generation students as I teach at a Los Angeles university in a Chicano and Latino Studies department. It is in the first-time of suffering each academic wound that we most ache and that we are most fragile in the recovery process. Sometimes recovery never happens, and then we leave, battle-scarred yet with no medals of service, no shiny degree. We are dishonorably discharged.

Fortunately, I survived my deployments, and I have medals to pin over the scars. At least, that is how I used to wear my degrees—to hide hurt. I believed this was the best way to help my students—to present shiny victories that conceal pain. Then, I realized otherwise.

The biggest source of woundedness is in not representing one's truths.

My truth is one of survival, but I am not healed, and I no longer wear victories in such a way as to hide the reality that my wounds are merely delicately stitched—ever aching and threatening to burst. I often receive shocked congratulations for my abundance of degrees, but I must say that while I am proud of those degrees, I am also resentful.

My truth is that my excessive war badges testify to an academic path that was not straight and level. Like most Chicana and Apache bodies, be it in war or academia or frontline service during a pandemic, I was appointed to risky combat zones with minimal rations and equipment to navigate, advance, and

survive. And this is precisely where wounds begin for us, when we are marked expendable—as someone whose well-being does not matter. In academia, my well-being concerned no more than a dozen individuals.

Still, this is my army and my chosen war. I was not drafted. And, while I continue to be marked expendable—from start to present—I do not believe that academia necessarily *wants* to lose me. Indeed, I have found invaluable allies and many more who cannot hear my truths but want to listen. Some even want to learn and act—not just listen. The problem is, even with these prospects to gain alliances and cultivate safe zones for first-generation, multi-marginalized academics, there is often a break in communication.

It is my first quarter in the PhD program. I am in an enormously intimidating post-human theory seminar with one of our campus's leading thinkers. Before each session, I feel sick. I just cannot understand any of the readings that we are set to discuss. During the session, I am silent, incapable of following the discussion. I do not even understand the vocabulary. Afterward, I cry. What is posthuman? Is it a removal of the body? Can it be studied as a spiritual framework?

Maybe that's really it!

I feel better. I have a plan. I will write my seminar paper on the posthuman as aligning with notions of spiritualism, perhaps tapping my background in Iberian late medieval / early modern spiritualists. I share my ideas at the next session.

I am met with silence for an agonizing minute. Maybe two minutes.

I am then asked, why would we return to religious structures that have led us to the problems we face today?

I am confused. Afterward, I cry again. I am wounded. I bleed. I am failing in my first few weeks as a PhD student.

I seek my advisor. He tells me that if I was met with silence and then confusion, I need to investigate further. He hands me his copy of Cherríe Moraga's Loving in the War Years.

I realize that I am not the first to walk this road.

Others can understand me. Others speak like me—others who are wounded but locate generative awakenings in those wounds. Those Others are me. We are beyond the limits of our bodies yet concurrently defined by our bodies. I write of our body rhetorics and ways that these rhetorics engage with notions of human and posthuman within decolonial frameworks. I write.

I write.

Each new seminar session, I haul a printout of my growing draft to show my posthuman professor my ideas during our break time. He listens closely. He wants to learn. I ask if he feels that this would be a good seminar paper. He tells me to write seventy pages—or a book. The stack of writing is higher each visit. I take class notes on my manuscript's margins. My classmates begin to watch my pen oozing with connections as they all speak, and my stack grows—a stack built from non-receptive audiences who now desire to know what I am writing; indeed, they help me to write.

I take my first step in developing The Wound and the Stitch.

It is my last quarter of my first year as a PhD student. I have adjusted. I have survived. I am looking forward to summer though I am so very engaged with my current seminar. I am taking a course on multilingualism. This is my type of class—multilingualism is all about me, the one who can be heard everywhere and nowhere. I want to study this. I really dig into one of our readings. It speaks of semilingualism.

And I confirm that I am not the first to walk this road.

Others can understand me. Others speak like me—others who have a tongue that works in so many ways yet never in a complete way. Those Others are me. We can speak everywhere and nowhere.

I am semi.

At home, I can sound like my family but never quite express my ideas and positions—though my family listens; at school, I can express my ideas and positions—to those who listen—but never sound like an academic. These are a few ways that I am semi. I declare in my multilingual seminar, I am semilingual!

"You know, Loretta," a voice responds, "the identifier of semilingual is derogatory. It implies incompleteness: semi-ness."

I am surprised. I am embarrassed. I am wounded, even.

Yet, I maintain, I am semilingual in my semi-ness. And, what is so derogatory, what is so shameful about semi-ness?

I take the question to my advisor. What is so shameful about semi-ness?

He tells me that if I was met with resistance, I need to investigate further.

So, I investigate: What is the source of this shame? Is the shame that which is possessed by the Chicanx rhetor who elects a vocabulary of partialness? Or is the shame a reminder to audiences that the rhetor has lost pieces of her cultural, historical, and linguistic self? And, why do I feel no shame?

I take my second step in developing The Wound and the Stitch.

Rhetoric is the lens through which I address woundedness because engagement is in the now. What I mean is that in development of some of my most meaningful thoughts, I have found generation through encountering non-receptive audiences. My rhetorical persona was unable to meet the expectations of specific audiences, and in this disconnect, my truths were lost. While early in my academic journey I felt only the woundedness of these rejections, silences, and confusion, I have found a way to see beyond pain. The wound is surely an upset, often spiteful but sometimes simply mistaken and even well-meaning. Yet it is still an upset, one that snaps me into immediate attention and now leads me towards investigation. The disconnect between rhetor and audience is not my shame. It is not even the audience's shame. There are no villains in my story, not really, even though I feel ill-equipped at the frontlines, expendable. There is merely a rhetorical gap, a gap in our knowledge of cultural rhetorics, a gap in our history of rhetorics—and all gaps can be stitched.

It is the penultimate quarter of my PhD program. I sit in my advisor's office on the same day that our campus is being shut down due to rampant spread of Covid-19. Will this be the last time I sit in his office? The world is about to change. Yet in that well-worn chair of mine in my little corner of his corner office, I am at peace. I have finished my dissertation. I have completed a historical genealogy of Chicanx rhetorics that examines feelings of incompleteness as locations where emotions of semi-ness might stimulate transformation of self. I am finished, and I already begin to miss my chair, which fits my body's depth so well. I begin to miss my view of the coffee-brown visual studies building beyond my advisor's desk and these moments when the skinny trees outside our window bend to the crazy and scary world. Yet all is calm inside our discussion space, with punctuated moments of sparkling inventions. Remarkably, there are no inventions that I seek that day. I am finished. And then, he tells me that I am not.

I am wounded.
Even in my safe space.
Even by my greatest ally.
I want to cry. I am so tired.
He says that being tired is no excuse.
I want to cry. I say that I am overworked.
He says that I chose this work.
I want to cry. I say that there is a pandemic outside.

He will take no excuses. I must investigate why the historical genealogy of rhetorics of woundedness matters. I must write another chapter that extends history into the classroom.

So, I step into the pandemic. I do not know where I am going beyond my advisor's office. I just know that it is time to live my scholarship. It is time to ground woundedness in the present, where it has been all along.

I take the next step in developing The Wound and the Stitch, *realizing that with this next step I also begin a new life.*

My advisor was really telling me that I am finished because I have begun.

I am not the first to walk this road.

Only by knowing my rhetorical history do I realize this. History explains our ownership of our rhetoric—be it complete or in semi- or fragmented states. We own a rhetorical history. We can claim it back from colonization, obliteration, ignorance, time. Our path has always been there; we travel this path through our own rhetorical strategies, navigation informed by rhetorical ancestors and those we encounter along the way. We narrate our truths during roadside pauses, knowing that these truths will grow deeper and more complex at each new rest stop. And these truths have a greater likelihood of reaching our audiences the more we claim and share our histories.

The history of Chicanx rhetorics of woundedness is one lineage, one rhetorical thread that I investigate, practice, and share. *The Wound and the Stitch* is my contribution to validating and owning this cultural rhetoric, rejecting notions that it is expendable. There are many other lineages or threads in Chicanx rhetorics. They are all distinct, but most interweave. Many we have yet to regain, and others continue to be tangled, waiting for decolonization. Still, the Chicanx rhetorical tapestry will continue to be stitched together—threads from the past and threads that are entirely brand-new, that move in dynamic creativity toward our future. These stitches close the gap of our colonial ruptures but must always remain visible so that we can discern each of our specific rhetorical genealogies—born sometimes from pain but always persevering as the way we can tell our varied and unique truths.

Acknowledgments

The Wound and the Stitch would not exist without Daniel M. Gross. He handed me his copy of Cherríe Moraga's *Loving in the War Years*, and I realized that I was not alone. I was not alone since Moraga's rhetoric became my constant companion, and I was not alone because by pairing me with this companion, Daniel proved that he could see me—the history I craved, the obstacles I faced, and the future triumphs I could secure. Daniel has been the first and most durable stitch to bind my wounds.

I am grateful to further stitching at the University of California, Irvine: Jerry Won Lee for sponsoring my efforts in linguistic justice as a personal endeavor to confront semi-ness, and Jonathan Alexander for convincing me that I could bind wounds, myself, if only I share my voice. I accordingly thank everyone at Irvine who exercised, expanded, and magnified my voice: Roland Betancourt, Rodrigo Lazo, Fatimah Tobing Rony, Rajagopalan Radhakrishnan, Ngũgĩ wa Thiong'o, Rachel O'Toole, Emily Thuma, Braxton Soderman, Cécile Whiting, Carol Burke, Irene Tucker, Elizabeth Allen, Becky Davis, Andrea Henderson, Victoria Silver, and the magnificent Susan Jarratt.

Beyond Irvine, I am indebted to Charlene Villaseñor-Black, a pathblazer whose transdisciplinary contributions demonstrated for me how to productively work in the in-between spaces. I am also grateful for the support and inspiration from Santa Barraza for modeling in her art and life all the ways that we can grow from *nepantla*.

Enriched by my guides in the in-between spaces, I now teach in the transdisciplinary department of Chicano and Latino Studies at California State University, Long Beach. Here, I am grateful for the inspiration, support, guidance, and friendship that I have received from the entire department—past and present. I want to especially thank Gladys Garcia for finding me and escorting me into CHLS and the wider CSULB community, where I have benefitted from constant support. I send special thanks to Michelle Seales for all the laughter, honest talk, and dreams we shared over the years. We will walk The Way soon.

I have been walking for so long already. I am grateful for my friends and mentors at the J. Paul Getty Center who inspired me to walk the art historical

pathways: Elliott Kai-Kee and Christina Rachal for their guidance and encouragement, and especially Katrina Klaasmeyer for her forever friendship. My time at the Getty changed my world, prompting me to redirect my passions in art and culture toward an academic life that had long become stagnant for me.

For reinvigorating my academic pursuits, I thank Mariah Proctor-Tiffany, Catha Pacquette, Matthew Simms, and Elizabeth Aguilera. With their mentorship, I found my way to a PhD program that finally consolidated my scholarship of rhetoric, literature, cultural studies, and art history.

I appreciate Penn State University Press and the Rhetoric Society of America for finding value in this transdisciplinary scholarship. In particular, I am indebted to Archna Patel for helping me through every step of the publishing process and Josie DiNovo for keeping me on track. I am grateful to the editors of the Rhetoric Society of America series in Transdisciplinary Rhetoric, Leah Ceccarelli and Michael Bernard-Donals. I am awed by the vigilance with which Catherine Osborne, Alex Ramos, and Emily Paige Lovett elevated my manuscript into tip-top shape. Catherine, while I shy from other hands touching my manuscripts, you have the magic touch, and I am so happy we could collaborate! Alex, thank you for your responsiveness and care. And, I must say that I have benefited enormously from all my readers, both internal and external to Penn State, most notably Aimee Carrillo Rowe.

Only through rigorous academic review could I progress from dissertation to book. Part of this process included journal reviewers and editors who challenged my writing to a new level. Accordingly, I thank Elise Hurley, Ersula Ore, Christina Cedillo, Kim Wieser, Jaime Armin Mejia, Stacy I. Macias, Liliana C. Gonzalez, Malea Powell, Matt Davis, and Kara Taczak for engaging with my various journal submissions and publications. I am also grateful to my keen-eyed developmental editor, Meghan Drury, for more directly working with me on *The Wound and the Stitch*.

My scholarship would be empty without the rhetors and artists who have motivated me throughout the construction of this book. Thank you for your inspiration to begin this project and your assistance as I finalized my manuscript: Cherríe Moraga, Renee Tajima-Peña, Virginia Espino, Felicia Rice, Christina Fernandez, Maya Gonzalez, Amalia Mesa-Bains, Gabriela Sánchez Reyes, Irene González Hernando, and Ana Berrelleza for her cover art.

To those who have traveled this journey with me through many campuses, I thank you all for your companionship—my students, my colleagues, and my friends. Barbara Love, thank you for decades of friendship, adventure, and

acceptance. You welcomed me into your family, and I am honored to be part of your life. As a tribute to your beautiful mother, on May 15, 2023, when we sat together to say goodbye to her, I hit the "send" button on the email that contained the final manuscript of *The Wound and the Stitch*. At that moment, my friends at Penn State University Press received the book, but I also hope that your mom grabbed a free copy as the email transitioned through the air space— and shared it with your dad.

To Allison Dziuba, although our years together were few, they were intense! Thank you for your positive energy and coffee chats. I know that many more years are ahead for us as our visions intertwine, even if we are currently positioned in faraway institutes.

My family have never been far away; distance is impossible for us. Because of that, we can survive the wounds, and we can stitch together. Always.

Introduction | The Wound and the Stitch

Opening the Wound

In 1803 Marcelo de la Cruz, an Indigenous Mixtec man from Nochistlán, defied the bishop of Oaxaca, Mexico, by disregarding the condemnation of the dilapidated parish church of San Juan Chapultepec. The town had been founded in 1523 to acknowledge Indigenous inhabitants who battled alongside Hernán Cortés's Spanish forces in capturing Tenochtitlán, the Mexica/Aztecan empire's royal capital, but by 1803 the Spanish Catholic Church had abandoned San Juan Chapultepec because of the supposedly idolatrous traditions that the community practiced in its syncretized form of Indigenous Catholicism.[1] With Church doctrine denied, funds were cut and the parish church fell to ruin and shame. Yet according to legend, in an act of rebellious devotion Marcelo eventually prevailed in his mission to secure a revived sanctuary in San Juan Chapultepec.

This accomplishment transpired because Marcelo carried with him a seventeenth-century *virgen abridera* or Shrine Madonna, a small polychromed wooden sculpture of the Virgin Mary in the Immaculate Conception motif that had been entrusted to him by his aunt, Maria Manuel Aguilar (fig. 1). Maria had inherited the virgen abridera from a maid at the Franciscan convent of Santa Catarina de Sena in Oaxaca, Manuela Ramirez, who had received the sculpture from Juana Maria Olivera Chavez, another maid at the convent, who was bequeathed the sculpture by one of the convent's nuns, the first known owner—although her name has been lost.[2] Measuring 6.3 inches tall and 2.4 inches wide, this sculpture was designed with movable joints, allowing for the Virgin's arms to extend from a folded prayer position to reveal her chest cavity. When unadorned and opened, the Virgin's inner cabinet features carved bas-relief narrative scenes of Christ's Passion and Mary's Sorrows (fig. 2). Marcelo de la Cruz

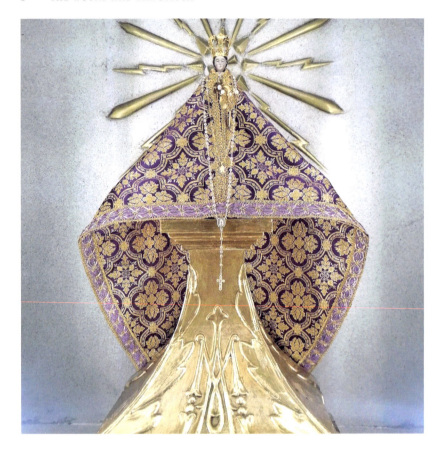

Fig. 1 | Virgen abridera of San Juan Chapultepec, seventeenth century. Wood, pigment, gold, polychromed, 6.3 × 2.4 inches. Oaxaca, Mexico. Photo: Author.

established this virgen abridera as a local devotional object, thus raising the profile of and support for the previously doomed San Juan Chapultepec church.

The San Juan Chapultepec virgen abridera and a second Mexican sculpture in Gama de la Paz were only recently located by Gabriela Sánchez Reyes and Irene González Hernando. In 2009, Sánchez Reyes and González Hernando reported an initial art historical analysis of the pieces for the *Boletín de Monumentos Históricos*, a publication sponsored by the Mexican Council on National Monuments. In 2022, Ana Laura Vázquez Martínez published an essay focusing on archival documents that contextualize church politics around Marcelo de la Cruz's donation of the sculpture. Vázquez Martínez places the sculpture's

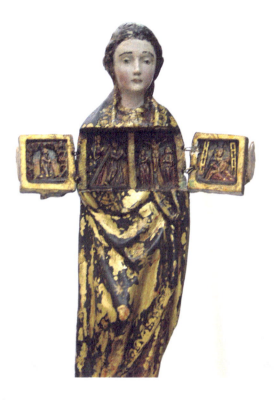

Fig. 2 | Virgen abridera of San Juan Chapultepec (detail), seventeenth century. Wood, pigment, gold, polychromed, 6.3 × 2.4 inches. Oaxaca, Mexico. Passion of Christ narrative scenes: (from left) Agony in the Garden, Encounter with Mary on the Way to Calvary, Crucifixion surrounded by Mary and John, and Descent from the Cross as a pietà with Mary holding the body of Christ. Image courtesy of Gabriela Sanchez Reyes. Photo: Mario Carlos Zúñiga Sarmiento.

establishment at San Juan Chapultepec parish church into conversation with histories of colonial conversion propaganda that situate Indigenous devotees as bolstering Marian dedications within communities that had otherwise been abandoned by traditional institutional indoctrination.[3] Although the sculpture has yet to be examined outside these two Mexican publications, it is vital to note that the virgen abridera also extends a medieval European tradition of Marian devotional sculptures that open to expose an inner body cavity.

Traditionally determined by distinctive visual rhetorics of female Iberian Christian patrons and custodians, this type of sculpture proliferated throughout Western Europe and later in the Americas during colonization. While art historians have conducted significant inquiries into these sculptures in Europe, there has yet to be a study of the specific thread of female Iberian rhetorical tradition that crossed the Atlantic or of their uses and meanings within colonial contexts.[4] In "Behind Closed Doors," Melissa Katz lists seventy-two virgenes abrideras from 1250 to 1700, spanning Europe and the Americas, but she does not examine the American pieces.[5] She does not list the San Juan Chapultepec piece, which was identified by Sánchez Reyes and González Hernando the year of Katz's publication. However, she does list an ivory-carved virgen abridera from a workshop in Dieppe, France, whose travels can be traced as far as its sale in Mexico City, where it vanishes from historical records. I suggest that the Gama de la Paz virgen abridera, which fits the features and styling of French sculptures of this genre, might be that lost ivory sculpture. Meanwhile, the San Juan Chapultepec sculpture, a polychromed wood piece, aligns with Iberian models in exterior styling and inner narrative. This virgen abridera serves my study of female Iberian visual and devotional rhetorics and their impacts on—and adjustments for—audiences in the Americas, with special attention to Poor Clare and Franciscan visual programs, particularly those that support Mary as the Immaculate Conception.

While most scholarship on virgenes abrideras investigates the European sculptures in the milieu of material and visual cultures of medieval Christendom, I localize the Iberian and Ibero-American sculptures in conversion-oriented contexts. Vázquez Martínez, similarly, uncovers vital historical documents in her scholarship, yet her focus is not on the sculpture but on Oaxacan religious politics. My interest centers the visual rhetorics that inform the San Juan Chapultepec sculpture as it represents devotional iconographies from Iberia but also shifts to suit new Mexican audiences—not just in the sculpture's placement in its Indigenous parish church but in its visual vocabulary that also suited previous female patrons and guardians in the convent of Santa Catarina de Sena. I study the sculpture's rhetorical genealogy as shaped by European tradition, informed by Mesoamerican audiences through various historical engagements, and inherited by distinct forms of Chicanx rhetoric. By concentrating on the sculptures' site-specific rhetorical encounters and colonial power dynamics, I begin to understand a particular Iberian female devotional rhetoric of the body that enters Mexican regions. While these opening sculptures of the Virgin Mary

were not cultivated exclusively by female patrons for female devotional practices, there is a tremendous pattern of such provenance for Iberian and Ibero-American pieces, even if male custodians enter the virgenes abrideras chronicles.[6] Just as Marcelo de la Cruz inherited the San Juan Chapultepec virgen abridera after a series of female owners, the majority of Iberian virgenes abrideras are identified with female sponsorship and/or guardians, beginning with the first known piece that Queen Violante of Castile commissioned circa 1270 for a Franciscan Poor Clare convent in Allariz, Spain.

It is this Iberian female contribution, or at the very least extensive female participation, in promoting a particular rhetoric of fragmented bodies that is the chief aim of my exploration in *The Wound and the Stitch: A Genealogy of the Female Body from Medieval Iberia to SoCal Chicanx Art*. This brief consideration of the virgenes abrideras initiates a historical genealogy from late medieval to contemporary Chicanx self-representation strategies that rhetorically engage female woundedness.[7] While devotion to and meditation on Christ's generative wounds were common throughout medieval and early modern Christendom, my scholarship traces impacts of the Virgin Mary's fragmented and abstracted body on potential Ibero-American female perceptions of body and identity, particularly in the context of fissures in selfhood made by the historical shockwaves radiating from colonial violences.

Specifically, *The Wound and the Stitch* examines Chicanx textual and visual rhetorics that focus on the phenomenon of wounds and a stitching together of fragmented selves as stemming from female Catholic devotional rhetorics, yet also interweaving ancient Mesoamerican philosophy. I consider how rhetorics of the Virgin's emotional woundedness engage with Nahua metaphysical understandings of securing stability during lived turmoil through the application of *nepantla*. Accordingly, *The Wound and the Stitch* offers a historical rhetorical genealogy that develops insights from my work in Chicanx literary and visual studies, decolonial feminist theory, medical humanities, and medieval art history; the end goal is to confirm my claim that a ubiquitous form of Chicanx self-representation strategies, notably manifested in late twentieth-century Californian print media and art, positions woundedness to generatively express Chicanx realities and transform the self.

While I claim that Chicanx self-representation of fragmentation through rhetorics of woundedness can be generative and healing, they can also be exploited by an outside gaze due to perceived vulnerability. A response to exploitation is both essential unintelligibility and deliberate illegibility—denying full

disclosure to exterior spectators. Sourced in private pain, rhetorics of woundedness reserve sections of narrative as exclusive to the rhetor as her own audience, since the exact experience of anguish can never be fully intelligible beyond the sufferer's body and feelings at a specific ephemeral moment. Illegibility is also deliberately retained for self or community when Chicanx rhetors situate performativity of woundedness as distinctive from normative affective performances, recalling José Esteban Muñoz's study of "feeling brown, feeling down."[8] Inaccessibility here highlights nonreceptive audiences as extending institutional silencing of grievances experienced and performed by underrepresented or subaltern voices. I examine the strategies of sharing and not sharing woundedness as they impact the personal and the public, rendered by Chicanx rhetors who conceive a spectrum of wounds—metaphorical, physical, historical, and linguistic—and strategies to repurpose woundedness to advocate redress.

The redress I seek in *The Wound and the Stitch* is twofold: to understand rhetorics of woundedness in connection with current decolonial scholarship and to validate my own experiences of linguistic and identity woundedness within academic spaces. Rhetoric is part of a decolonial process as we locate distinct ways to articulate community and self beyond multitudes of imposed frameworks. When I write that rhetoric is a decolonial process, I envision rhetors who do not prioritize a response to exterior imaginary Europeanness but who prioritize an internal audience of self.[9] Indeed, this rhetorical study is less about examining external audiences than shaping rhetorical personae to prioritize an inner audience. While a goal of rhetorics of woundedness is to seek exterior redress of infliction, the aforementioned unintelligibility and illegibility of wound narratives dissolve the edges of rhetorical frameworks.[10] Such a dissipation reserves legibility to the self as rhetor-audience and maintains aspects of inarticulate pain as a private source of motivation that must, as is the nature of pain, be incomprehensible beyond the body and emotional experience of agony.

Woundedness shuts out the world as one is consumed by the extremity of pain. The immediacy and urgency of articulating identity in moments of pain provide our lenses for studying rhetoric as an action in the *now*. *The Wound and the Stitch* accordingly delves into wounding experiences that make more discernible the audience within—an initial audience that one pleads with and later strategizes with to manage torment. Woundedness is the stinging initiator of this rhetorical reshaping as pain necessarily reorients one's attention inward, where one might seek directions from oneself on how to pivot from infliction.

In this navigation discoveries, inventions, and strategies must satisfy the self as both the expressor of pain and the sole audience that seeks pathways away from pain. Such reshaping and reorienting facilitate a delinking from privileged forms of semiotic and epistemological systems, thereby raising potential—even if only in the momentary surge of pain—to know self and devise pathways particular only to that moment and need. Yet it is in these moments that one might harness a decolonizing delinking to reimagine rhetorical participations within the exterior world.[11]

The Wound as Narrative Fount

My motivation to study rhetorics of woundedness surges from linguistic and identity woundedness within academic spaces that I have yet to fully unpack and make legible to myself. My efforts in *The Wound and the Stitch* permit me to personally begin to delink my ideas of self from normative views of what defines a first-generation Chicana-Apache academic. This process is lengthy, yet I attempt to repurpose woundedness so I may learn from trauma. I have benefited from the results already, even if the process is necessarily painful. To be clear, I do not condone my woundedness. Although I articulate generative strategies that emerge from pain, I will always resent and contest the wounds that individuals and institutions have inflicted on me. I also recognize that the damages I have suffered are not physical assaults. I am grateful for that. Yet my standing as an academic was founded on enormous physical, emotional, and social woundedness within my family.

I pay tribute to that now and to an uncle who, like many Chicanos in the 1960s, did not participate in the rhetorics of the Chicano Movement or walk in our local Los Angeles Chicano Moratorium. Indeed, he could not walk or speak in protest, as he was killed in the early stages of the Vietnam-American War. Sgt. Jesus Ernesto Chavez was nineteen when he stepped on a landmine in Hau Nghia Province. While my family sought solace by recalling my uncle's youthful bravery and patriotism, a broader community protested the disproportionate casualties of Chicano enlistees and draftees, arguing military action as unethical and sacrifice as wasteful. Unable to endure the rhetoric of unjust war while mourning a child whose death could not possibly be worthless, my grandparents relocated outside these discourses and the Los Angeles inner city, opting to consolidate family income and my uncle's death gratuity payment to

situate themselves in our new home base. This base would become my birth environment.

I was privileged by a white-dominant school system in Southern Californian suburban beach cities, and my access to various academic pathways therefore opened because my uncle's single pathway as a young Chicano of the 1960s was toward the army. My pathway also opened because my grandparents sought generation from woundedness. Though they would later identify unjustness in the Vietnam-American War and racist biopolitical frameworks that led to tragedy, their initial need in processing pain was to shut out exterior exchanges and prioritize an inner voice from the wound.

My wounds are mere scratches compared to those suffered by my uncle, grandparents, and mother. Yet the privileged pathway that opened new worlds for me also isolated me as a rare Chicana (and the only Apache) in the spheres of my social and educational upbringing, marking me vulnerable in my dislocation. The wounds I have suffered in this seclusion are not physical but metaphorical, historical, and linguistic. They impact my feelings of self-worth and my consequential uncertainty to give voice to a self that has already been predetermined as worthless simply because of my surname and racialized body. To be clear, I consider myself of extremely high worth, but I do recognize that I am always in a state of semi-ness while I navigate multiple spaces and engage with audiences who predominately share none of my cultural experiences or racial identity. I have always lacked the fluidity to perform these navigations entirely and seamlessly.

While semi-ness can be a derogatory term, I am not ashamed that I feel always partially belonging. Rather, I am ashamed of exterior forces that stretch me beyond reasonable capacities. My sense of semi-ness or partialness is largely based on my experiences as a first-generation Chicana academic. (I neglect my Apache identity here, principally because the invisibility of that inheritance has been so absolute that I cannot honestly claim social experiences as an Apache). As an identifiable Chicana, I do not need to explain my encounters with unreceptive academic audiences. Narratives abound of subtle yet significant microaggressions in classrooms, particularly against female students and faculty of color.[12] In my reaction to microaggressions, I tend to withhold full disclosure of myself and my thoughts, opting for silence and illegibility instead of trusting audiences I encounter in academic spaces. In this way semi-ness becomes a form of control and self-empowerment as I elect and perform rhetoric that maintains my distance, enacts my lack of comfort, and conveys my deficiency in total

integration. This semi-ness is, accordingly, dually maintained as nonreceptive audiences do not possess frameworks to understand my positionality, and as I resist melding into a system that denies hospitality for my body and voice.

Still, semi-ness is concurrently a source of woundedness for me even if I have defiantly embraced illegibility. This is because there are parts of my semi-ness that I cannot control. I remain isolated from a family that cannot envision my intellectual life, from an academy that will not upset hierarchies to accommodate those like me, and from a Chicanx community that questions my authenticity because my family broke from normative Chicano networks, which shows in my nonnative Spanish, the foods I eat, the beach I love, and the history my family disowned. In essence, my uncle's death and my family's strategies to survive mourning have also closed doors to my culture, marking me a traitor even as I devote my scholarship and teaching to reentering my cultural inheritances. Simply, I belong nowhere.

Yet when I am in pain from this inflicted/maintained wound, I find clarity. I know an urgent truth: I do not deserve this pain. However, my escape from pain cannot be through giving myself to the institute or quitting my attempts to claim my culture. Such a surrendering of self may heal me but replace me in the process. Melding is not the way out of pain. I accept my semi-ness and fragmented self, and I continue to listen to pain. In this rhetorical reorientation toward myself as the sole speaker and listener, I have learned that I cannot leave pain until I satisfy myself as audience. I have also discovered that when we listen to the voice from the wound, initial unintelligible pain purges us of imposed rhetorical performances so that we can eventually locate our own articulation of personal testimony. We locate rhetorics of woundedness amid a rhetorical system that confronts hierarchical frameworks that otherwise control the articulation of self. *The Wound and the Stitch* is, in this way, a personal journey along a historical pathway, one that I hope will strengthen my voice and concurrently illuminate a strategy of self-representation that participates in ongoing traditions and values.

This rhetoric of generative woundedness that I own, centralize, and contextualize is one that I practice, protect, and share with so many Chicanx rhetors. Yet it is only one thread of Chicanx rhetoric and only one specific genealogy within a vast tapestry of Latinx historical rhetorics that continue to represent traditions while transforming to suit current agendas and needs. Each rhetorical thread in this wider tapestry is distinct, deriving from specific moments in and through time and space. Many of our threads have been irrevocably snipped

from our rhetorical histories, leaving gaps in our understanding and making us vulnerable to linguistic assault. Other rhetorical threads are partial but may be mended, and still others are tangled and difficult to discern. However, through creative and attentive decolonization, a Chicanx rhetorical tapestry may be stitched to close gaps of our colonial ruptures.

In this way, *The Wound and the Stitch* focuses on disrupted historical lineages and how such disruption disempowers contemporary Latinx rhetors. While this disruption is undoubtedly part of a broader colonial discussion, and I invite *The Wound and the Stitch* to involve rhetorics beyond Chicanx contexts, I view rhetorics of woundedness as functioning beyond decolonial considerations. Indeed, sexuality and gender identities are parts of our analysis of rhetorical strategies that empower the wounded by repurposing hurtful labels and actions as counter-confrontations.[13] In this intersection of ethnicity, sexuality, and gender, many demographics and many rhetorical lineages may populate our discursive space. I elect to center a specific Chicanx rhetoric that situates woundedness as a conceptual lens through which to analyze self-representational strategies that urgently confront violations against body and challenge normalized categories placed on Chicanx identities. Accordingly, *The Wound and the Stitch* models a methodology to retrieve rhetorical antecedents that may help shed light on pathways for contemporary Chicanx rhetors to advance our voices and ambitions yet also contributes to methodologies in decolonial, feminist, and sexuality studies for the retrieval of histories that today's rhetors may claim and own for self-empowerment.

A Critical Examination of the Application of Nepantla

While legacies of Indigenous rhetorics have been fundamentally torn from the tapestry of Chicanx rhetorics by colonization and dominant European epistemological frameworks, I must include in my genealogy threads of Indigenous rhetorical traditions of the wound.[14] In this endeavor, I hope to avoid interpretations of Indigenous philosophical and linguistic traditions as colonial constructs. Rather, I acknowledge Indigenous etymologies and usages, leading me to now define my understanding of nepantla since the term informs the development of my historical genealogy of Chicanx rhetorics of generative woundedness.

I begin with a prominent Mexica understanding of nepantla, so I might examine a potential Indigenous rhetoric that negotiates with European *topos* to inform

developments in the rhetorics of woundedness. My intention in this historical genealogy is not to represent passive Indigenous rhetorics that are conquered and therefore positioned as irrelevant to modern Chicanx rhetorical legacies. Instead, I argue that the syncretic nature of a specific Iberian and Mexica metaphysical and spiritual understanding complements an incorporated rhetorics of woundedness, a joint inheritance that the Chicanx writers and artists whom I study utilize in their rhetorical strategies.[15] It is therefore vital that I begin my studies by examining nepantla in its Indigenous usage, since it develops a corresponding foundation with Iberian female devotional rhetorics. My understanding of nepantla often deviates from prevalent applications in Chicanx studies that position the term as colonial negotiation. To illustrate my point, I offer a brief examination of the use of nepantla in the context of its colonial and postcolonial understanding as opposed to Náhuatl application of the word—Náhuatl being the language of the Nahua peoples of Mesoamerica that includes the Aztec/Mexica. I also note here that while *Aztec* is the dominant scholarly name for the peoples inhabiting Mesoamerica during conquest, I employ the name *Mexica*. This is how the peoples of the Tenochtitlán region (modern Mexico City) and their territories named themselves. The term *Aztec* was popularized in the early nineteenth century by Alexander Von Humboldt and derives from European misunderstanding of the Mexica who identified themselves as peoples of Aztlán, the mythical home of the Mexica.

The first known Castilian definition of nepantla is in Franciscan Friar Andrés de Olmos's 1547 dictionary, *Arte de la lengua Mexicana*. De Olmos defines nepantla as "en medio" or "entre." Franciscan Friar Alonso de Molina's 1571 *Vocabulario en lengua Castellana y Mexicana y Mexicana y Castellana* defines the word similarly as "en el medio," "en medio," or "por el medio."[16] These sixteenth-century Castilian definitions of nepantla—"in the middle," "through the middle," "in-between," or "inside"—continue to resonate in modern applications of the word. In her visual rhetoric and Chicanx art history scholarship, Laura E. Pérez defines nepantla as an in-between state, "the postconquest condition of cultural fragmentation and social indeterminacy."[17] This understanding of nepantla traces to what is believed to be its first published appearance, in a sixteenth-century narrative that details a Castilian-Náhuatl exchange and thereby privileges (above the aforementioned Castilian dictionaries) the spoken context of the Indigenous word by an Indigenous speaker. Still, the report of the interchange is made by a Spanish Dominican friar, Diego Durán, in his *Historia de las Indias de Nueva España* (ca. 1581). Durán describes an encounter between himself and an Indigenous

man during which Durán reprimanded the man for practicing Indigenous customs. The man responded, "Father, don't be afraid, for we are still 'nepantla.'"[18] In accord with an earlier interpretation by Miguel León-Portilla in *Endangered Cultures* (1976), Pérez explains nepantla as a neutral in-between state, signaling that the Indigenous man is still in the process of being converted in both faith and customs.

Following a similar interpretation, Anzaldúan theories on nepantla emphasize the neutral in-between state as one weighs among various options. In "Putting Coyolxauhqui Together" (1999), Gloria Anzaldúa envisions nepantla as analogous with writing processes wherein writers are in between inspiration and invention, thereby struggling among possibilities.[19] Anzaldúa fine-tunes her initial borderlands theory in her 2000 *Interviews/Entrevistas* by applying concepts of nepantla as a more advanced descriptor of cultural collisions. Anzaldúa writes, "I found that people were using 'Borderlands' in a more limited sense than I had meant it. So to elaborate on the psychic and emotional borderlands I'm now using 'nepantla.' . . . With the nepantla paradigm I try to theorize unarticulated dimensions of the experience of *mestizas* living in between overlapping and layered spaces of different cultures and social and geographic locations, of events and realities."[20] In 2002, Anzaldúa continues to define nepantla as "the overlapping space between different perceptions and belief systems."[21]

Acknowledging that she builds on Anzaldúan nepantla theory, Chicanx scholar-activist Maylei Blackwell writes that nepantla is a word "used by Náhuatl speakers during the colonization of Mexico to name a place or space between two colliding cultures."[22] She argues that female farmworker activists in California might discover in this space strategies of resistance and negotiation. This understanding and utilization of nepantla is of a location that forms a site of marginalization and violation but then transforms into a space in which to discover advantage—an in-between space where Chicanas might understand cross-cultural existence and formulate strategies in pursuit of social justice.[23] This idea of finding a space for interrupting dominant narratives has pervaded Chicanx studies, even when the word nepantla is not applied. Juan Guerra does not reference nepantla in his discussion of critical pedagogies, but he extends the concept of in-betweenness as a state of empowered "nomadic consciousness."[24] He asks that classroom composition pedagogy foster spaces of in-betweenness where students might compose reflections on their travels between languages, modalities, and social identities. In these student reflections, Guerra believes writers

might connect critically with their immediate world. This aligns closely with theories of nepantla, particularly Anzaldúa's narrative theories. Even if Guerra distances his work from a border concept to identify a transient, nomadic experience, his key claim is that reflection of the transition, the in-betweenness, when one navigates spaces will cultivate in student writers critical awareness of the shifting dynamics of their lives.

The dominant and extended understanding of nepantla in Chicanx academic discourse, theory, rhetoric, methodology, and pedagogy is, then, an in-between space where a Chicanx person might coexist with various social, language, cultural, and identity intersections in a transcultural United States geography. This ironically eclipses Nahua usage of the word and its metaphysical concepts to privilege social and political associations within colonial and postcolonial realities. As previously noted, Pérez builds on León-Portilla's study of the first known published usage of nepantla by Friar Durán. In Durán's account, nepantla is specifically applied to a context of conversion and understood as a response to transcultural negotiations.[25] It is later applied in Anzaldúan theories, methodologies, and pedagogies as decolonial resistance during postcolonial negotiations. However, the word preexisted colonization and still exists for Náhuatl speakers. To apply the word in its limited manifestation between the friar and the target of his conversion efforts is to lose its fuller Nahua framework.[26] This is a tangled rhetorical thread, interwoven so tightly with colonial discourses that it is difficult to examine how the etymological transformation and engagement of nepantla can inform rhetorical lineages that do not partake in concepts of colonial in-betweenness.

My project undertakes to detangle nepantla. In this way, I join efforts in decolonial rhetorical scholarship to delink language usage from one privileged form of semiotic and epistemological system to allow examination of the Americas' rhetorical traditions that do not entirely derive from colonial impositions.[27] My understanding and application of nepantla reach for Nahua construction of the term as a metaphysical concept of securing balance within a fluctuating liminal space. The chief emphasis of nepantla is not on sites of in-betweenness but on the action of finding balance when life forces push an individual in various directions. I prioritize nepantla as a verb rather than a noun. The importance of nepantla is in the emergence of the individual from the liminal space—not the inhabitation of that liminal space, not the state within the metaphorical "borderland." Finding stability allows one to emerge from liminal spaces and generatively

transform. Linked to the metaphysical concept of *ollin*, a Náhuatl term for movement or earthquake, nepantla signifies entrance to a new state of being once balance is secured in the "earthquake" or upsets of lived experience.

The liminality of the space in nepantla is nearly ritualistic in concept. This is not liminality as defined by cultural anthropologist Victor Turner.[28] For Turner, liminality is temporary and exceptional. Instead, nepantla is a permanent condition of the cosmos, human existence, and reality—not limited to solely cultural and colonial contacts in which the metaphorical earthquake erases Indigenous paradigms. In actuality, nepantla cannot represent paradigm-erasing contacts, as there can be no erasure in the Nahua metaphysical concept because all change is possible and allowed for. In a permanent condition of renewal after the constancy of upset and at the moment of balance, nepantla is performed. My argument benefits from philosopher James Maffie's visualization of nepantla as a "grand weaving in progress" where each thread of being transforms into a stable stitch for just a moment before moving back into motion for the next stitch to be secured as an ongoing eternal cycle of renewal and rebirth.[29] This process is ordinary, not extraordinary.[30] The upsets or wounds of life are generative and necessary for renewal of each and all. They are, in actuality, the purpose of life.

In my study of rhetorics of woundedness, I apply concepts of nepantla in its generative, balancing action. I emphasize that moment of knotting the stitch, yet this is a delicate ephemeral stitch that makes woundedness visible in order to rhetorically repurpose upsets as concurrently testaments of survival and accusations of assault. This attention to nepantla as a stabilizing activity, rather than a state of being in between, is my contribution to reassert a wider spectrum of etymological interpretation of nepantla and *ollin* that considers beyond colonial frameworks. While my research will focus on an Iberian genealogy, the Mexica concept of securing stability in a quake serves as an interweaving Mesoamerican genealogy in the construction of later Chicanx rhetorics of woundedness. These joint concepts of survival after assault and continued confrontation of turmoil form a rhetorical partnership.

To illustrate this notion, I return to our consideration of the virgenes abrideras. In these sculptures, the Virgin Mary presents steadiness and tranquility for a worshipper audience who approaches. Mary appears in peaceful meditation at this approach. However, by design, the worshipper interrupts this peace as Mary's praying hands must be parted to reveal the inner triptych. Such action reveals the sculpture's carved narrative of pain and sacrifice. This is the upset-state that activates the worshipper's own prayer. Once the upset-state is reconciled through

ritualistic meditation, the worshipper achieves temporary spiritual balance. Thus, the worshipper's prayer ends, the triptych closes, and Mary's prayer begins again with her hands returned to the clasped state. At this stage, the sculpture may physically regain its original positioning as before the upset, yet it may never again appear the same to the viewer who has witnessed the wound within. Mary can never again be viewed as whole and steady. Her being is fragmented between a constant state of prayer and pain, between motherhood and mourning, between warding against sin and welcoming salvation. Mary is altered based on the worshipper's new state of perception. Once her hands return to clasped prayer, Mary is no longer unaffected but rather recovering after the upset of her son's death. Furthermore, her prayer is no longer undefined but instead focused on the reverberations of her son's reality-shaking sacrifice. These reverberations are renewed with each moment of sin or temptation that returns the worshipper for new visits to the virgen abridera, a constant quake around the sculpture that reinforces the link between upsets of life and renewal from woundedness.

In Mexica thought there is generative transformation in life's constant earthquakes. Nepantla signals a disruptive event in life's journey, a continuance of existence as ever-transforming. However, the application of nepantla as a borderland noun-realm that exists between colonizer and colonized—and that a colonized figure might inhabit for negotiations—blurs the genealogical rhetoric that I examine. To be clear, there is a vital element of in-betweenness in nepantla, and my analysis of the rhetorics of woundedness will include speakers who inhabit the wound. The wound is a third space that will absolutely rely on the scholarship and theory of Chicanx writers who discuss nepantla as a generative space between cultures, between languages, and between colonizer and colonized. However, I distance myself from borderland theories and Chicanx studies that link nepantla more directly with this borderland as reflecting predominately colonized and capitalized tensions.

My distance is mindful of four critical cautions. First, to make the borderland metaphor universal to Chicanx experience obscures specific political violence committed at the geographic border. Second, it metaphorically relocates specific issues of Chicanx populations that are far removed geographically and generationally from the border. Third, borderland theories all too often essentialize Chicanx experiences while simultaneously erasing Mexican heritage in the Southwest and Western United States prior to the fabrication of any modern border. Finally, to equate postcolonial borderland theories with nepantla is to make natural the forces of colonial legacies. In other words, nepantla denotes

finding balance while turbulent life forces naturally rise to destabilize individuals; by equating natural life forces to colonial forces and coloniality, colonization becomes the true way of the world. I am not interested in this framing of nepantla or of colonial borderlands so much as I am in the crossroads that split Chicanx loyalties and identities—the intersections that violently crash and the wounds that occur from such crashes, the quakes that activate generative forces toward new self-awareness.

The Stitch as Methodology

So, what exactly is this Chicanx rhetoric of generative wound, and why is it stitched, not healed? A short answer is that the *wound* serves as an insistent marker to examine rhetorical inheritance impacted by historical conditions wherein assault is continuous and systematized; the *stitch* signifies delicate, ephemeral acts of healing amid an otherwise still-extant woundedness that insists on further redress. In terms of the colonial wound, the *postcolonial* is not yet achieved if we understand it as a political signal of a post–World War II Western atmosphere that cultivates sovereignty.[31] *Postcolonial* does not mean "after colonialism" or "the time after colonizers leave." It is a historiographical concept referring to the terms and conditions of power that remain even after colonial managers depart. However, the use of *post* might signal otherwise. *Post* implies that violences committed in the *colonial* have concluded. Coloniality, however, persists even if the historical governing systems have been dismantled. In my project, I advocate a *decolonial* process that continues to address still-extant wounds from past colonial violences and present coloniality—*coloniality* being a term that focuses on the continuity of dominating strategies formulated during and extended beyond colonial governing systems.[32] These still-extant wounds are most exactly physical in the displacement of land and bodies but also metaphorical in the displacement of identities, languages, cultures, religions, and epistemologies.[33] The colonial is still an open wound that must be tended and compensated. As Jinah Kim concisely states, "The wound tells how conditions for healing have not been met."[34] *The Wound and the Stitch* accordingly studies Chicanx rhetorics that make apparent one's fragmented state to repurpose woundedness as a testament of assault and to activate activism.

To focus tighter on the woundedness at the core of this rhetoric, I select from among interweaving Chicanx rhetorical inheritances. I define *rhetorical inheritance*

as a claim to voice that derives from and fortifies one's sense of belonging. This belonging is situated in a rhetor's election of one or multiple intersecting cultural associations within various heritage options, contextualized in local and temporal identification. *Rhetorical inheritance* is not a birthright but a dynamic sense of voice, impacted by one's living relationship with communication experiences and mitigated by historical (dis)connection.[35] As previously noted, I am interested in (dis)connections with Nahua philosophy as it understands the wound metaphorically in conceiving existence as a series of upsets (moments of *ollin*) from which new ways of being may be temporarily secured (reaching nepantla) until the next moment of *ollin* again alters existence. Yet this wound may also manifest as a physical wound, and it concurrently signifies a lived historical wound that extends along the series of upsets. In Catholic philosophy, the wound is similarly metaphorical, conceiving humanity as traversing a series of temptations leading to sin from which atonement and reconfirmed faith may be temporarily secured until the next moment of temptation necessitates penance. Furthermore, this wound may manifest as a physical wound in the actualization of sin, and it concurrently signifies a lived historical wound that extends from Adam and Eve's original sin to Christ's sacrifice and ongoing practices within the Catholic Church. *The Wound and the Stitch*, therefore, addresses metaphorical, physical, and historical wounds in my development of a rhetorical strategy that reharnesses woundedness for generative purposes. I am interested in how the formation of this rhetorical strategy brings into conflict, compromise, and entanglement the two primary influences that concern my historical genealogy: the Mesoamerican and the Catholic Iberian female discourses on generative woundedness.

However, this rhetorical genealogy is also a living one, the practice of which may be a wound itself, derived from moments when Chicanx rhetors elect to make visible their inflictions but confronts a society untrained to esteem the language of fragmentation or woundedness. After all, to apply such rhetorics is to admit one's incompleteness. This is a dangerous strategy, since declarations of incompleteness or semi-ness are often misinterpreted as self-contempt or disclosures of inability or defect. A common response may be to act on a perceived need to heal or fix the Chicanx rhetor, which may result in accusing such rhetors of irresponsibly maintaining the wound. Such actions prevent ownership of this rhetorical inheritance and further alienate rhetors from expressing themselves.[36] Accordingly, the concluding thoughts of *The Wound and the Stitch* also briefly address a linguistic wound that concerns critical race pedagogy. While books on

rhetorical studies typically do not involve writing pedagogy, I insist that explorations of cultural rhetorics enhance ways we teach writing and contest suppositions that particular forms of self-expressions—such as representing self as *semi*—are signs of deficiency rather than elected rhetorical enactments.

While this project's scope is vast, I concentrate my rhetors in a Californian context, focusing on writers and artists currently in their fifties and sixties and sharing urban, cultural, and social commonalities. I focus on Californian life, text, and art for three reasons. First, the geographical range provides more definition to the lineage I draw than an abstracted essentializing would; generative wounds can be examined as a more targeted site-specific rhetorical performance to confront past and present forces that impart violence against a Chicanx sense of physical and emotional self. Second, the ongoing violence I examine is contextualized within the kinds of Californian classrooms where I have studied and now teach; I respond to linguistic violence committed against Chicanx university voices and identities. Third, as a native Californian, I ground my scholarship in the immediate spaces and generations that inform my positionality. I follow a Chicana feminist tradition of theorizing through the flesh as I write through my living body as it navigates spaces—both physical and imagined—shaped by Californian histories, politics, communities, cultures, and arts.[37]

A project covering these spans of eras, spaces, and topics necessitates the application of various methodologies to stitch together the often disjointed and complex historical genealogy in assorted textual and visual rhetorical manifestations. I accordingly employ transdisciplinary scholarship and a variety of methodologies in the study of relevant historical, cultural, and social contexts.[38] This transdisciplinary framework is one that I practice daily in the ethnic studies department to which I contribute as a professor at California State University, Long Beach, teaching textual, body, material, and visual rhetorics and the application of such rhetorics in composition. I have learned to reject additive models, preferring the transdisciplinarian considerations that inseparably inform my understanding of Chicanx identities.

After all, additive models wherein we collect representative voices from a global population simulate a colonizing logic of laying claim and essentializing voices to advance the power of our presentation of self.[39] I rebuff any extension of the university as a colonial cabinet of curiosity. Rather, I aim to disrupt rhetorical methodologies. Building on my background in Californian graduate programs in creative writing, art history, and rhetoric, my service in Californian museum spaces, and over two decades of teaching composition in a range

of Californian community college, private university, and public university spaces, *The Wound and the Stitch* bridges cultural rhetorics, decolonial studies, critical race and biopolitical theory, trauma studies, feminist studies, visual rhetorics, and critical pedagogy to explore the legacies of female medieval Iberian rhetorics of the wound in modern Chicanx textual and visual self-representation strategies. I hope to illustrate that interweaving numerous modes is crucial to recovering fragments of cultural inheritances that have been scattered by colonial disruptions and ongoing coloniality hierarchies.

In this way, I align with methodologies used by Walter Mignolo, particularly his concept of *pluriversality* as a renouncement of the "conviction that the world must be conceived as a unified totality ... in order for it to make sense." Instead, Mignolo calls for a worldview that interconnects diversity, thereby setting "us free to inhabit the pluriverse rather than the universe."[40] As I have already shown in my brief examination of nepantla, this delinking of writing from one form of semiotic and epistemological system allows for greater understanding of the Americas' rhetorical traditions that do not entirely derive from colonial impositions.[41] The delinking concurrently values the fragments that we may then discern without the facade of a stable, core unity. My research utilizes a pluralistic methodology as I envision the *stitch* as maintaining the visibility of colonial woundedness and deterring hierarchical scholarship.

Indeed, a multimodal and multimethodological approach to understanding Chicanx rhetorics is essential. This is particularly the case when we consider that in the Mexican regions that concern my project, cultures were first approached through visual and corporal gestures to overcome verbal and textual obstacles. This first approach launched the colonization of cultures. Thus, for my project to recover Iberian crossover of the rhetorics of the generative wound, I employ overlapping studies of visual, corporal, and cultural rhetorics. In other words, when modes of communication become jumbled into a colonizing system that attempts to obliterate or transform those modes, it is problematic to recover a rhetorical genealogy without considering a methodological framework that allows for multimodal analysis. While I hope to trace a European historical genealogy, I do so with an awareness of various modes of early transmission and the complicated and often incomplete reception of such European traditions by Indigenous interpretations and enactments based on Indigenous understandings of the world.

In this way, I find a helpful model in the transdisciplinary collaborations performed by anthropologist Joanne Rappaport and art historian Tom Cummins, whose *Beyond the Lettered City: Indigenous Literacies in the Andes* (2012) recovers

historical Andean rhetorics by applying multiple methodologies and multi-modal analysis to the culture's literacy traditions. The authors broaden notions of literacy, arguing that "the literate world is constituted by intersecting literacies that individually cannot stand alone. The literate world is thus multifaceted and often recursive."[42] I find Rappaport and Cummins's multimodal methodology and its expansion of literacy instructive, in that my historical genealogy for-sakes linear narratives to intermingle with differing ontological and rhetorical systems, much like a tapestry wherein threads of knowing, being, and creating spread from and into multiple directions.

Instead of conceptualizing coloniality as a binary of conqueror and conquered, we might consider ways that various threads or rhetorical genealogies inter-mingle, transforming the entire Ibero-American plane with diverse colors that serve one function, deliberate or otherwise—the formation of later Chicanx self-representation rhetorical strategies. What I find particularly useful in this tapestry metaphor is its avoidance of hybridity. The tapestry does not recover indigeneity to the exclusion of colonial realities and does not impose European structures on Indigenous subjects. This model complements my attempt to avoid isolating Chicanx inheritors into solely Indigenous or Iberian narratives, instead considering Iberian rhetorical traditions alongside yet distinct from Indigenous traditions—and yet still historically contextualized in settler-colonial realities. Again, the stitching must be made apparent. I intend to study fragments or wounds as part of Chicanx rhetorical inheritances but not to position those frag-ments as binaries of a hybrid mestiza state.

Indeed, concepts of hybridity conflict with rhetorics of fragmentation, par-ticularly in the idea of mestiza as a blended, cohesive state of mixed Indige-nous and Spanish heritage. In chapter 2, I am particularly critical of the uses of mestizaje as participating in or complicit in both Mexican and United States settler-colonial projects of Indigenous dispossession. Accordingly, when I speak of fragmented Chicanx inheritances, I do not assert a framework of cohesiveness, as Anzaldúa famously offered in her "mestiza consciousness" the-ory.[43] My focus is on rhetorics that make apparent a lack of cohesive wholeness in order to highlight woundedness as part of many Chicanx rhetors' daily expe-riences, confronting a spectrum of split loyalties and fractured identities at the metaphorical crossroads of mundane life. The query I raise thereby initiates examination of a dominant United States privileging of rhetorics of wholeness that impairs audience reception of cultural rhetorics of fragmentation. *The Wound and the Stitch* cautions that what may be lost in melding our disparate

parts into oneness are threads of Chicanx rhetorics in their ubiquitous forms—particularly the rhetorics at the core of my historical genealogy.[44]

Entering the Wound: Narrative Overview

Although I conduct a historical genealogy, I do not map a linear chronology. Instead, I launch this examination by prioritizing and centralizing—first and foremost—modern Chicanx rhetorics of woundedness before I contextualize the rhetorical tradition within historical inheritances from Mesoamerican concepts of sacrifice and Iberian female devotional arts of Marian generative woundedness. This trajectory delinks my historical genealogy from temporal linearity and delinks Chicanx rhetorics from a "starting point" in Iberian and Mesoamerican histories, privileging modern Chicanx rhetors as our new "starting point" from which to radiate outward toward consideration of exterior publics and relevant histories.

In part 1, I define my interpretation of the generative wound in contemporary writings by investigating applications of metaphorical fragmentations and emotions of semi-ness. This study employs a cultural rhetorics methodology to examine strategies for Chicanx self-expression. In chapter 1, "Cherríe Moraga's Rhetoric of Fragmentation and Semi-ness," writings by a Los Angeles native provide the vehicles for my project. Moraga raises issues that often seem disconnected, but not if we consider her discourse through cultural rhetorics of fragmentations, semi-ness, or wounds. In the span of her publications from "La Güera" (1979) to *Native Country of the Heart* (2019), Moraga struggles with disjointed existence and split loyalties. These splits are so extensive that she often writes of startling moments in which she discovers that she is her own oppressor. Such moments occur as she prioritizes certain pieces of her identity at the expense of others. For Moraga, her fragmentation impacts not only inner but physical identity. Her father's whiteness, now the color of her skin, conceals that which Moraga claims as her mother's Indigenous blood that flows beneath. The outer does not match the inner. This is a source of Moraga's wound.

Her solution is to undo her desire for wholeness, to tear apart her white exterior to make public the many aspects of her inner self.[45] Like a virgen abridera, Moraga breaks open to reveal that which cannot be imagined from the white shell. Within, Moraga contains the persecution, pain, and sacrifice of a brown

lesbian identity—but also salvation through sharing her hidden truths. Ultimately Moraga finds her wounds to be constructive. By entering them Moraga learns to embrace her fragmented identity, never finished and never complete but continuously transforming. Such a concept of self recalls Anzaldúa's conceptualization of the borderland experience as a *herida abierta*, an open wound inflicted by a coloniality that maintains fractured identities. While Anzaldúa examines destructive forces that emerge from this *herida abierta*, she privileges the fluidity of linguistically navigating this borderland third space. Anzaldúa conceives a *translingual* forked tongue, a single unit with fragmented endpoints, that Chicanxs may utilize to gainfully negotiate among various cultural heritages and socioeconomic realities.[46] Yet Moraga's tongue is not forked as a tri-tipped oneness. Her tongue is metaphorically severed as she protests a "neogringo theft of the tongue and tierra" and her consequential shame about linguistic inadequacies.[47] This focus on shame evokes Anzaldúa's adaption of Gershen Kaufman's *Shame: The Power of Caring* as she connects concepts of physical borders, sociocultural woundedness, and emotional shame. But while Anzaldúa perceives dissociation among disparate selves as stimulating action, she seeks to heal fragmentation to purge shame. Anzaldúa participates in rhetorics of woundedness but contradicts Moraga's insistence on maintaining fragmentation.

Moraga's writings are my selected lens to understand nuanced strategies within rhetorics of woundedness precisely because she allows a visible wound state and because her career trajectory unlearns colonial fictions of wholeness to embrace fragmentation. This unlearning of colonial fiction is the focus of chapter 2, "Woundedness as Decolonial Rhetoric." Here I explore how Moraga discovers in woundedness keen insights into the tensions and splits that inform decolonial identities and realities. The wound also reminds Chicanxs that we are not obligated to fit a narrative of "correct" seamlessness of language, identity, or culture. Indeed, such narratives of wholeness are suspect, a point of examination that invites discussion of Alexander Weheliye and Sylvia Wynter's application of (non)humanness to refute raceless views of biopolitics, Trinh T. Minh-ha's decolonial theory of the "not-I," and Anibal Quijano and Enrique Dussel's rejection of *myths of modernity*. For Moraga and these theorists, splintered oneness becomes essential to decolonize scholarly epistemologies, systematic biopolitics, and personal identities.

After defining the generative wound through analysis of Moraga, in part 2 I contrast the generative wound with the inflicted wound, precisely a type of physical wound that impairs lives through biopolitical frameworks in the United

States. Part 2 applies decolonial methodologies and critical race theory to make apparent the nongenerative wound. Here the wound is produced and controlled by forces that regard Chicanx bodies as sites of violence and border patrol, thus necessitating my attention to modern biopolitics as a systematic extension of historical colonial governance wherein hierarchical forms of racism determine which living beings might be deemed a "political problem" as depriving resources from privileged vectors of the State.[48] In chapter 3, "Biopolitics and 'Crying Wounds' in *No Más Bebés*," I explore the border patrolling of Chicana wombs in *No Más Bebés*, a documentary directed by Renee Tajima-Peña on the sterilization of Chicanas during the 1960s and 1970s at Los Angeles County-USC Medical Center and the subsequent *Madrigal v. Quilligan* case initiated by the Madrigal Ten (the Chicana plaintiffs). *No Más Bebés*, released in 2015, has yet to be extensively examined by the scholarly community, yet the film serves two essential purposes for my studies: first, to demonstrate the inflicted wound as a form of institutionalized border patrol, and second, to critically engage with (il)legibility of Chicanx woundedness. The illegibility of Chicanx rhetorics of woundedness here highlights both the existence of nonreceptive audiences who are unaccustomed to detecting specific Chicanx rhetorical traditions and the domination of narratives that deliberately or unintentionally extend institutional silencing of grievances experienced and performed by female Chicanx rhetors. *No Más Bebés* gives voice to members of the Madrigal Ten to pursue ongoing protections of female reproductive rights, including but not precisely the rights of Chicanas. I study how audiences might not detect rhetorics of woundedness when Chicana articulation of grievances are absorbed by more prominent advocacy discourses. My concern here is that the Chicana wound is not opened solely for the generative benefit of Chicanxs but for intersecting aspects focused on motherhood and womanhood that include yet concurrently decentralize Chicana-specific lived realities.

Indeed, in chapter 4, "Border-Patrolling Chicana Bodies and Wound Theory as Resistance," I illustrate how Chicana woundedness is often repurposed to serve others beyond the Chicanx community and often positioned to obscure biopolitical systems of coloniality. The voice from the wound is recontextualized to heal another rather than address one's woundedness and associated institutionalized state violences. I end chapter 4 by considering Cathy Caruth's trauma theories. Caruth posits generative potentials within "the crying wound" when the aggrieved maintain possession of and attention to one's woundedness as an alternative epistemological method to sustain remembrance of violence until an

otherwise unavailable reality becomes perceptible.[49] Caruth discovers potential in the wound when one examines history's ripple effects. I connect trauma theory to my discernment of rhetorics of woundedness. By observing yesterday's wound in today's reality, we might advocate compensation to distinct communities while celebrating perseverance and resistance even in a state of woundedness.

Parts 1 and 2, by contrasting the generative and the inflicted wound, set foundations for part 3, which at last focuses on the medieval-to-modern rhetorical genealogy and the historical wound that erases threads of this inheritance. In part 3, I return to the generative wound to claim that a dominant form of Chicanx visual and textual rhetoric inherits a distinctive Iberian female strategy that positions wounds and fragments in ways that confront and transform the self. In this analysis, I focus on two prevailing threads in Chicanx art that make productive the wounds of coloniality: the reverse-colonization via reclamation of genres and imagery of Aztecan/Mexica visual arts, and the appropriation of imagery of the Virgin Mary into the lived realities of Chicanx artists. I accordingly bring into my genealogy a consideration of Indigenous heritages that shape Chicanx art together, in parallel, and in discord with medieval Iberian influences. However, it is crucial to consider this history in conversation with contemporary studies and strategies of autopathography, a genre of autobiography that centers on first-person accounts of one's disease or wounded experiences. In this way, I link my historical studies of woundedness to modern visual rhetorics.

Chapter 5, "Reading Wounds (from Right to Left) to Reclaim Mexica Cosmologies," focuses on visual counter-stories that dismantle colonial fictions of wholeness to address historical woundedness. This type of wound develops from geographical relocation and disrupted histories based on coloniality systems. In response to displacement and narrative erasures, the artworks I feature in chapter 5 make central a lack of resolution. While my attention is drawn to the female Californian strand of this rhetoric, the generative wound is deeply rooted in broader Chicanx visual rhetoric. Therefore, works outside female demographics, such as by the collaborative art group Asco (Los Angeles–based) and Enrique Chagoya (born in Mexico but a Californian resident since the 1980s), also help me bridge the medieval and modern.

Much of chapter 5 applies museum or collection theory as we consider how Chicanx artists reclaim visual narratives of self and culture. The Chicanx cabinets of curiosities by Amalia Mesa-Bains and the collaborative *Doc/Undoc* project mirror attempts to seize control of pieces of lost narratives, wherein the collected

becomes the collector of her own story and archetypes. I also query how rhetorics of woundedness contend with permanently erased histories—fissures in history and land-based knowledge that cannot be stitched together. Indeed, this inability to recover cultural inheritances and knowledges that have been entirely erased by coloniality returns our discussion to strategies core to rhetorics of woundedness that advance challenges against dominant narratives of wholeness. Accordingly, chapter 5 concludes by examining the collaborative multimodal *Codex Espangliensis* to consider further challenges to normative storytelling of wholeness and authority. Cast in the medium of a simulated Mesoamerican codex, the accordion-styled folds of the *Codex* can be pulled out into one single, long page. In the Mesoamerican tradition, one reads this page from right to left, but one may elect to unfold this codex from left to right, as in the European reading direction. I offer a reading of the *Codex* from right to left that applies rhetorical strategies of woundedness that are obscured in the European left-to-right mainstream narrative. Here, I consider how rhetorics of woundedness appoint audience responsibility in redressing coloniality wounds while concurrently inviting readers to assert agency in electing alternative reading approaches.

Indeed, the *Codex Espangliensis* returns our discussion to the virgenes abrideras in chapter 6, "The Art of the Generative Wound (from Container to Co-Redemptrix)." These mutable devotional sculptures of the Virgin Mary necessarily challenge worshippers to elect an approach to interpreting the contained narrative to redress woundedness. In chapter 6, I examine traces of the multimodal rhetorical inheritances of these sculptures most prominently in my studies of Chicanx artists who work in various mediums: Christina Fernandez, Amalia Mesa-Bains, and Maya Gonzalez.[50] I have selected these three artists because not only are they Chicanxs who utilize generative rhetorics of woundedness, but they are all female Californians currently in their fifties and sixties, sharing urban, cultural, and social commonalities with both Cherríe Moraga and the Madrigal Ten, thereby providing more definition to the lineage that I draw. In short, part 3 explores visual depictions of Chicanx fractures in modern Californian Chicanx art—a motif repurposed from female Iberian devotional rhetorics, informed by Mesoamerican visual cultures, and now deployed to advance current campaigns.

In my conclusion, "The Linguistic Wound and Stitch Pedagogy," I examine linguistic wounds in classroom spaces. After twenty years of teaching college composition in Southern California, I can fill a void in composition research

and critical pedagogy. The reality of my current Californian classroom space is that I am a professor of Latinx rhetoric and composition in an ethnic studies department. In that context, I define *cultural rhetorics* as expressions of a convergence of both hemispherical studies of Latinx rhetorical histories and practices grounded in specific spaces in time and place, encounters, and individuals. This recalls Malea Powell's descriptions of cultural rhetorics as spaces "practiced into being through the acts of storied making, where the past is brought into conscious conversations with the present and where—through those practices of making—a future can be imagined."[51] For my Latinx students, I propose conscious conversations between present learners and textual spaces informed by specific Iberian and Mesoamerican rhetorics that impact Southwestern United States communicative modes, as expressed today in many of our communities but shaped by individuals who navigate an assortment of life experiences and rhetorical spaces.

I also propose an exploration of how applying rhetorics of woundedness in classrooms may challenge teaching methods that normalize rhetorics of wholeness and their enforcement of language competencies and "correctness" in writing and genre conventions. My goal is to investigate ways that prescribed classroom performances of wholeness may continue to inflict shame on student rhetors, particularly when they practice Chicanx rhetorics that offer generative woundedness and elect forms of semi-ness.

I emphasize, however, that the specificity of my teaching environment and student demographic should not limit this pedagogy to Chicanx students but serve as a consideration for how we might expand historical rhetorics in more diverse writing inheritances. By contextualizing writing strategies within various rhetorical inheritances, *The Wound and the Stitch* guides scholars, educators, students, and communities as we enter historical rhetorics as part of a decolonial process to stitch the wound of marginalized rhetorical identities.

Part 1

The Rhetorical Wound

In the 2000 foreword to the second edition of *Loving in the War Years*, Cherríe Moraga describes her new awareness of the image of Coyolxauhqui, the Mexica or Aztecan moon goddess who was torn to pieces by her brother, Huitzilopochtli, chief war god of the Mexica empire, after she opposed his emergence to power. The colossal Coyolxauhqui Stone from the Late Postclassic Mexica period (1200–1519 CE), the only remaining depiction of Coyolxauhqui in her full-bodied dismembered state, was rediscovered in 1978 at the base of the Templo Mayor in Mexico City, formerly Mexica capital city of Tenochtitlán (fig. 3).[1] When Moraga first began to write *Loving in the War Years* in 1983, she had not yet incorporated this newfound Coyolxauhqui image into her work. By 2000 Moraga claims that the spirit of Coyolxauhqui has been her guide all along. She relates to this fallen warrior-sister who defies heteronormativity. Moraga writes, "Without knowing, I looked for Coyolxauhqui in these dark wartime writings of twenty years ago, the dim reflection of my own pale moonface lighting my way. *I am not the first*, I kept telling myself, *I am not the only one to walk this road*."[2] Here, Moraga evokes Coyolxauhqui as a symbol of ever-present violence committed against female bodies that strive for change.

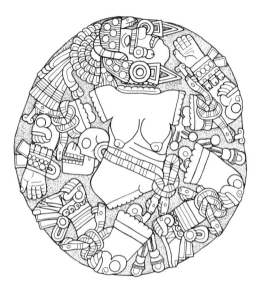

Fig. 3 | Drawing by Emily Umberger of the Coyolxauhqui Stone, Late Postclassic (1200–1519 CE), Museo del Templo Mayor, Mexico City. Volcanic stone, approximately 11-foot diameter. Image courtesy of Emily Umberger.

The powerful revolution that Moraga perceives in the Coyolxauhqui Stone may seem at odds with the actual visuality of the object, which presents a deceased woman who has been disrobed, her nudity indicating a humiliating defeat in Mexica iconography. This defeat is specific to Coyolxauhqui's femaleness, as her exposed breasts figure prominently in her disgrace.[3] She maintains sandals, arm braces, and headdress, but significantly these clothing items are specific to the Mexica iconography of male warriors. Although ancient and medieval Mesoamerican iconography often contains male-female dynamics or dualities within single entities to represent balance and dynamism, the centrality of Coyolxauhqui's breasts in death, surrounded by the male attire that she wore in life, conspicuously highlights the figure's gender transgressions.[4] Her outer male accoutrements do not match her shielded female body. This parallels Moraga's narratives of her own discordant inner and outer selves, while Moraga concurrently positions the female body as a painful conduit to insight and solidarity.

Interestingly, Moraga's handling of the Coyolxauhqui Stone shares rhetorical *topoi* with the virgenes abrideras. These two cultural artifacts are not commonly joined in Chicanx studies. Art by native Kingsville, Texas, contemporary Chicana artist Santa Barraza offers rare examples of pairing iconography and icons from Iberian and Mesoamerican traditions to express modern Chicana identities and culture, as seen in Barraza's *Cihuateteo con Coyolxauhqui y Guadalupe* (1996).[5]

Yet it is unusual to encounter Coyolxauhqui and the Virgin Mary in shared discourses since the figures are both perceived as highly iconic on their own sides of a binary spectrum, which often precludes conversations of syncretic Catholic and Mexica cultural objects. As discussed in my introduction, I intend to avoid binary systems that discourage the analysis of intertwined trajectories in a complex tapestry of cultural inheritances. This makes my current project novel in its pairing of Coyolxauhqui and the virgenes abrideras. This is a link that Moraga does not make but is nonetheless understandable through the cultural rhetorics that inform Moraga's analysis of Coyolxauhqui.

Certainly, this pairing extends beyond Moraga's writings, since Moraga is only one of many Chicanx writers who evokes Coyolxauhqui as a symbol of embodied female experiences of ever-present violence. Other prominent writers who connect Chicanx female identity to Coyolxauhqui include Gloria Anzaldúa, Ana Castillo, Emma Pérez, and Alicia Gaspar de Alba. These writers, like Moraga, also apply rhetorics of woundedness. Moraga is not isolated in her rhetorical strategies; this, indeed, is impetus for attention to a more extensive Chicanx rhetoric. Coyolxauhqui is positioned by these writers as both victim and heroine, repurposing woundedness from the traditional legend; yet, in Moraga's emphasis on Coyolxauhqui's woundedness as generative and in her insistence that fragmentation be maintained, we discern a tighter resonance with Catholic cultural rhetorics and a nuanced definition of rhetorics of woundedness.

In an analogous application of visual rhetorics of woundedness, both the Coyolxauhqui Stone and the virgenes abrideras use concealing breasts to expose narratives of pain and sacrifice beneath an otherwise steady resolve. Unlike the female ideal Mary, however, Coyolxauhqui's disparate engendered parts are exhibited as abominations. Coyolxauhqui must be punished and her incongruous selves exhibited as justly destroyed in graphic detail, with bones jutting from her torn body, her severed tongue falling from a gaping mouth. She is stripped, silenced, and shattered. Only the serpent belt wound around her waist with a skull at its rear divulges any former power, the snake being a predator and a symbol of regeneration in Nahua iconography, as the movement of blood renews life via both its course through the body and its spilling into generative sacrifice. In this lingering hint of regeneration amid bodily and vocal destruction, Moraga's writings participate in Chicanx rhetorics of woundedness.

I begin part 1 of *The Wound and the Stitch* with consideration of the Coyolxauhqui Stone because I see the generative wound as expressed in Moraga's discourses as related to her identification with Mesoamerican rhetorical traditions

of woundedness. Moraga's strategy is to examine violent fragmentations both to analyze a multitude of constraints placed on female selves and to delink the self from normative wholeness. Historically, I associate this tearing apart with Mexica perception of bodily sacrifice as a gateway to spiritual victory. In the earthquakes of life, there is generative transformation. I also recognize prominent Christian parallels, as in Christian contexts woundedness motivates renewal. These joint Iberian Catholic and Mesoamerican concepts of survival after turmoil form an association inherited by Chicanx rhetors. While Moraga tends to distance her discourse from the Virgin Mary, this partnership continues to echo in cultural rhetorics that Moraga extends, particularly in her focus on tormented motherhood-daughterhood.

In chapter 1, "Cherríe Moraga's Rhetoric of Fragmentation and Semi-ness," I identify rhetorical traditions of generative woundedness in contemporary writings by examining fragmentations and emotions of semi-ness as expressed in the span of Moraga's publications from "La Güera" (1979) to *Native Country of the Heart* (2019). My primary focus is Moraga's nonfiction autoethnographic writings. Particularly helpful to these examinations is the second edition of *Loving in the War Years* (2000), where Moraga expresses pain as companion to discovery and construction, a theme initiated in her 2000 foreword on Coyolxauhqui and in her autoethnographic essay "The Dying Road to a Nation" (1998). Here, the visibility of Chicanas' battleground wounds inspires Moraga to retrieve Coyolxauhqui's fallen-warrior accoutrements and enter the still-raging "war years." Moraga engages fragmentation to illustrate both agony and power. She maintains the wound as a generative source for negotiating decolonial identities and realities, which recalls Walter Mignolo's observation that it is in "the colonial wound [that] decolonial thinking is weaved."[6] Moraga locates potential for reinvention from woundedness. At the same time, fragmentations and emotions of semi-ness become testimony to confront violators with past and ongoing wrongs.

In chapter 2, "Woundedness as Decolonial Rhetoric," I consider how Moraga's adoption of fragmentation illustrates her participation in a rhetorical tradition of generative wounds to confront and transform self-perception and social constructs of female selves. The wounds also serve to remind Chicanxs that we should not feel obligated to fit a narrative of "correct" seamlessness of language, identity, or culture. In fact, such fictions of wholeness are suspect, which aligns with Moraga's concepts of fragmentation to biopolitical and decoloniality theories on (non)humanness and Otherness within. I end chapter 2 with a final exploration of Moraga's autoethnographic writings in the context of advocacy as

Moraga extends her personal experience of generative wounds to a wider Chicana and lesbian community that she perceives as being under assault. Here, studies on precariousness and mourning add to the conversation since Moraga's focus on fragmentation aims to fortify her specific Chicana community by mourning a colonial wound too large to ever close, while concurrently celebrating perseverance and resistance amid woundedness.[7]

1

Cherríe Moraga's Rhetoric of Fragmentation and Semi-ness

It gets messed up. So, anyway it's all good. It really is all good. Because every single time it's humbling, you know? You just get really humble. You just realize how much you messed up. See, you wouldn't know that I messed up, but I think it's important to say, you know? Like, we're not *all that!*

—Cherríe Moraga, *Helena María Viramontes Lecture Series*

In April 2019, as I began drafting material that would become *The Wound and the Stitch*, Cherríe Moraga serendipitously visited California State University, Long Beach, hosted by the Chicano and Latino Studies Department where I had been an adjunct faculty member since 2007 and where I am now an assistant professor. When Moraga ascended the stage to read from her latest publication, *Native Country of the Heart* (2019), she realized that from where she stood with a microphone and stool at center stage, the controls for her Power-Point presentation were not within reach. There was a large room full of faculty, many of whom (including myself) had in our belongings cordless clickers, but no one offered assistance. Yet we were rewarded despite our shameful stillness. We were all given an authentic and live Moraga demonstration of generative woundedness. In front of three hundred and fifty people in the at-capacity university theater, and after all her planning had been stalled, Moraga became grateful for her logistical mistake—for dispelling the audience's reverence, even before her presentation officially began. She was suddenly no longer "all that," but simply a flawed human.

Moraga's embrace of flaws, a consistent theme throughout her writing career, will be the focus of this chapter and the vehicle through which I define and illustrate a rhetoric of generative wounds. For Moraga, the body is both location and source of woundedness and resurgence. Moraga's body is a very specific one: of a feminist woman in a male-driven society, of a Chicana with white skin, and

of a lesbian in a heteronormative Catholic family culture. These binaries lead Moraga to examine how her fragmentary selves are not cohesive and cannot find peaceful intersectionality. Semi-white, semi-Chicana, semi-of-the-family, semi-exiled for her sexual orientation, the life Moraga portrays is of constant tension and flux. Because of these tensions, she expresses that her body, in both construction and performance, is externally perceived to be flawed in its semi- or partially formed fragmented state, with such perceptions inflicting internalized wounds. In examinations of her fragments, Moraga realizes that to choose one side of the conflict or binary would suppress the greater, albeit messy, truth of herself—a woman who will always be at odds with her incompatible parts yet is nonetheless grateful for her daily complications of identity, no matter the perceived flaws of it all. Moraga models a form of self-acceptance that participates in a historical rhetoric of generative woundedness.

Retrofitting History and Unmaking Colonial Fictions

Since this project places Moraga's writing in the historical genealogy of Mesoamerican-Iberian rhetorics of woundedness, I briefly consider her approach to history, which I liken to Maylei Blackwell's strategies. In ¡Chicana Power! (2011), Blackwell discusses a historical methodology that she terms "retrofitted history," or counter-memories that function as destabilizing forces against entrenched hierarchical histories and as expansions of our understanding of events. Specifically, Blackwell writes of contemporary narratives on the history of activism in the 1960s Chicano Movement and 1970s feminism. She examines representations of these particular activist histories and concludes that Chicana participants in these movements are consistently yet inaccurately positioned as add-on players who functioned as neither major catalysts nor game-changers.[1] To interrogate such dominant narratives, Blackwell suggests an approach that stitches together fragments of histories through a "shared authority" that recalls, reinterprets, and even misremembers.[2] She posits that *how* people remember is as pertinent as *what* transpired—the *what* being a product of empowered authorities, and the *how* being a sharing of often-emotional and obscured informal recall via oral interviews.

If we relocate Blackwell's framework in colonial contexts, the *what* is history that prioritizes the colonizer's version of contact. Only rarely is the *how* shared; when it is, it is predominantly restricted to sanctioned emotions. This

marginalization of emotional recall diminishes the unsanctioned feelings of the broken and the shamed, a point of contention for Moraga. Perhaps most relevant to my interpretation of Moraga's strategy is Blackwell's focus on "how trauma shapes memory" with the purpose of ending silences associated with such trauma.[3] Moraga's application of this retrofitted memory to the Coyolxauhqui Stone argues that by remembering Coyolxauhqui's trauma, we remember her life's purpose. Per Moraga, figures such as Coyolxauhqui are ultimately not overpowered and are not abominations of femaleness. They are heroes whose fragmentations signal their own election and agency for renewal amid external assault. In this way, Moraga challenges dominant narratives that Coyolxauhqui's historical significance is of an unequivocally vanquished figure.

The traditional telling of Coyolxauhqui's legend begins with the immaculate impregnation of her mother, Coatlicue, by the appearance of a ball of feathers. Coatlicue's adult children are suspicious of this mysterious pregnancy. One daughter, Coyolxauhqui, gathers her brothers, the Centzonhuitznahua, and leads an attack to the top of Coatepec Mountain to kill her mother and the unborn child. During the attack Huitzilopochtli emerges from Coatlicue as a full adult to defend his mother. He decapitates and dismembers Coyolxauhqui, whose body he then tosses from the heights of Coatepec. Huitzilopochtli proceeds to kill his brothers. Amid the action, Coatlicue dies, torn apart by the birth of her divine child. This origin narrative of the Mexica's primary deity, Huitzilopochtli, later assumed iconographic significance. While Coyolxauhqui was not originally a moon deity, the Mexica signified her by the moon and Huitzilopochtli by the sun, paralleling the dominance of the greater heavenly body over the lesser.[4] This iconography possibly informed rituals enacted in the Mexica Templo Mayor, as human sacrifices are thought to have been performed on top of the temple pyramid, symbolizing Coatepec Mountain. Fallen sacrifices were possibly removed to the bottom of the pyramid, where the Coyolxauhqui Stone was later found in 1978.

It is this later Mexica celestial application of the myth that Moraga references when she calls Coyolxauhqui a moon goddess, suppressed by the patriarchal Huitzilopochtli through the violent sacrifice of femaleness. Although Coatlicue remains part of this legend, she is removed from Mexica ritualistic remembrance in terms of celestial iconography. In the removal of Coatlicue as interpreted by the celestial map and later by Moraga, the legend focuses on Coyolxauhqui's victimization. In other words, the origin of this myth is relocated to strategize a later retrofitting. The concept of retrofitting is important to the historical lineage

I trace because this rhetorical tradition repurposes memories of trauma to gain new understanding of both the past and present. In this retrofitted memory of Coyolxauhqui, sacrificial moments now deny defeat. Indeed, the sacrificed becomes victorious in her perseverance and emotional conviction—and in her faith that her convictions will become generatively contagious to those future female inheritors who maintain vigilance against violent patriarchal acts. Although Coyolxauhqui is the aggressor against her pregnant mother and unborn brother, many Chicanx feminist writers reposition her as both heroine and victim, particularly Moraga and Ana Castillo, though this is less true of Gloria Anzaldúa, who focuses on healing the heroine rather than maintaining attention to ongoing woundedness.

Again, to note nuances in rhetorics of woundedness, while Anzaldúa employs Coyolxauhqui to symbolize Chicanx female empowerment, she recollects Coyolxauhqui's fragments to reform wholeness. In "Putting Coyolxauhqui Together" from her posthumous *Light in the Dark*, Anzaldúa evokes Coyolxauhqui as analogous with writing processes, wherein dreams in the calm of night usher invention; the writer's daytime toil organizes fragments of these inspirations "into a unified whole," "a full version," that puts "Coyolxauhqui back together again."[5] While writing deadlines impose increasing pressure, Anzaldúa commits to meticulously reforming Coyolxauhqui and shuns moments where the stitching together of her pieces remain apparent, a "Frankenstein-like monster" with "grotesque" misplaced body parts.[6] She seeks "coordination among parts, balanced proportions."[7] Interestingly, Anzaldúa is no longer identifying with the Shadow-Beasts and notions of monstrosities from her earlier seminal *Borderlands*.[8] Though Anzaldúa's essay ends as the author accepts that she must prematurely submit her manuscript to editors, she continues her endeavor to heal Coyolxauhqui and thereby express her own seamless compositions. In contrast, Moraga commends Coyolxauhqui's woundedness and embraces her own Frankenstein state—an assortment of incongruent pieces that, in discord, demand consideration. Moraga aims not to re-*member* Coyolxauhqui's torn body but to *remember* the emotions that hold her fragments together, the spirit of regeneration that lingers in Coyolxauhqui's story, and the perseverance that grows from pain.

Moraga's writings are my selected lens to understand nuanced strategies within rhetorics of woundedness exactly because she allows a visible fragment state and because her career trajectory unlearns colonial fictions of wholeness to embrace fragmentation via a retrofitted retelling of her cultural inheritances. In

Moraga's writings, I perceive a defining element of rhetorics of woundedness as insisting that the colonized body be metaphorically destroyed, piece by piece, to free a new identity. Indeed, we can observe in Moraga's career a systematic unmaking of self—a delinking from exterior notions of body, home, language, and even love—to find clarity in the fragments within.

The Dying Road of Body, Home, Language, Love

Fragmenting the Body

In "La Güera" (1979), published in *This Bridge Called My Back*, and later in *Loving in the War Years*, Moraga addresses her shame at realizing that the solidarity she seeks with her mother's Chicanx culture is problematized by her own white skin, inherited from her father's white race. Whiteness prevents Moraga from sharing significant commonalities with her dark-skinned mother, diminishing her perceived power to identify with and advocate for her Chicanx sisterhood. Moraga's body and her ability to perform whiteness alienate her from those she most cherishes while allying her with those of privileged skin. Through performativity of white body norms, she views herself as having become the oppressor of the women she values and, ultimately, herself.[9] Realizing that an enemy resides within through internalized whiteness, Moraga resolves to "assess the damage" of her self-oppression and observe ripples of this damage in other areas of life, namely the feminist movement to which *This Bridge Called My Back* largely responds.[10]

Moraga was vocal about her disappointment in the 1970s feminist movement. Her collaboration with Gloria Anzaldúa in coediting *This Bridge Called My Back* reacts to fissures in the feminist movement. In their foreword, Moraga and Anzaldúa assert that white middle-class women continue to resist expanding the definition of what "feminist" means to women of color in the United States, as well as to Third World women.[11] In the essay "A Long Line of Vendidas" in the first edition of *Loving in the War Years*, Moraga further differentiates her ideologies from those of white middle-class feminists, aligning herself with principles stated in the 1977 Black feminist Combahee River Collective.[12] Throughout these engagements, Moraga insists that a refusal to examine the wounds in the identities of women of color and within their various coalitions is based on a "polite timidity [that] is killing us."[13]

Moraga continues to assess this woundedness in her 1981 "theory in the flesh," which she discusses in the preface for *This Bridge Called My Back*, asserting that it is through voicing the often-violent lived experiences in one's skin color, sexuality, and locality that "contradictions in our experience" can be understood. She clarifies: "Daily, we feel the pull and tug of having to choose between which parts of our mothers' heritages we want to claim and wear and which parts have served to cloak us from the knowledge of ourselves."[14] In assessing the damage of self-concealment through her performativity of whiteness, Moraga realizes productive potentials of exposing her disparate parts. In this way, she joins discourses advanced by decolonial feminists such as María Lugones, who argues that perceiving and reflecting on one's many selves is an arduous yet necessary liberatory task.[15] In alignment with such pathways toward self-liberation, Moraga launches a campaign to rhetorically break apart her white body and its contextual social licenses to release a brown identity-inheritance, no matter the risk to her white-skin privileges. This abandonment of "la güera" or "the light-skinned" as the dominant vehicle for social performativity propels Moraga's rejection of colonial epistemologies and value systems that she had previously unwittingly enacted and internalized.

Moraga pairs this rejection with an insistence on exposing historical appropriation of the female physique so women might reclaim each of their parts.[16] We can observe this in Moraga's 1994 play *Heroes and Saints* in the character of Cerezita, whose body consists solely of a head and whose mobility is driven exclusively by chin and tongue movement. Moraga emphasizes the tongue's power as the primary organ to move lives by expressing both thought and sexuality.[17] Yet even so, Cerezita is still a metaphorical wound to be addressed, with a tragic backstory in the play as a product of congenital disabilities caused by exposure of pregnant Chicanas to pesticides. Moraga turns the memory of violated body pieces into formidable accusations—the pieces no longer the shame of dismantled victims but instead shaming the system that inflicted violence.

This tactic continues in Moraga's 1995 play *The Hungry Woman*, which uses wounds to advance Chicana political ideologies. The character Luna states, "My private parts are a battleground. I see struggle there before I see beauty."[18] Moraga associates violated Chicana bodies with the robbing of social, cultural, geographical, and political spaces in which a Chicana might freely rejoice in and give of her body. Yet until such political wrongs are compensated, Moraga insists that the Chicana will continue to see struggle in her own body rather than its beauty.[19] Later, when Moraga revisited *Loving in the War Years* in a second edition,

we see heightened resolve on the above point. Indeed, while much scholarship has focused on Moraga's emphasis on the body in her plays and poetry, my project analyzes primarily the nonfiction development of Moraga's rhetorics of woundedness, mainly as conveyed in her second edition of *Loving in the War Years*. In its autoethnographic writings, Moraga expresses Chicana realities as informed by and strategically repurposing woundedness.

Fragmenting Home

Rhetoric is central to repurposing woundedness since Moraga's writings tend to equate the body with language. In her early "La Güera," the whiteness of her Chicana body signals betrayal of her mother's race. Similarly, Moraga reflects in her later writings that whiteness also serves as a betrayal of her mother's Spanish language. This sentiment is expressed in the 1982 essay "A Long Line of Vendidas," published in *Loving in the War Years*: "I have not spoken much of lengua [language] here, possibly because my muteness in Spanish still shames me. In returning to the love of my raza, I must confront the fact that not only has the mother been taken from me, but her tongue, my mother tongue. I yearn for the language, feel my own tongue rise to the occasion of feeling at home, in common with other Latinas . . . and then suddenly it escapes me. The traitor-voice within me chastises, '¡Quítate de aqui! You don't belong!'"[20] Again, we see conveyed the oppressor-within from "La Güera," this time as the "traitor-voice" within, reminding Moraga not of the privilege of whiteness but that she lacks the privilege of Spanish, that she does not belong in her mother's home language but in a colonized linguistic landscape. We might consider this lack of inherited maternal home base as cultivating in Moraga a sense of rhetorical homelessness that stunts her confidence to advocate on her own behalf and construct coalitions with other Latinas.[21] This perhaps leads to Sidonie Smith's observation that Moraga's essays detail a sense of "homelessness in and out of the body."[22]

Moraga continues to write of these limits in "A Long Line of Vendidas." She recalls that during the 1960s and 70s, she did not participate in the Chicano Movement and never marched in protests or attended on-campus MECHA meetings because, "No soy tonta. I would have been murdered in El Movimiento at the time—light-skinned, unable to speak Spanish well enough to hang; miserably attracted to women and fighting it; and constantly questioning all authority, including men's. I felt I did not belong there."[23] Moraga narrates life in a wounded state, rejected by all her aspects: white and brown, English and Spanish,

heteronormative and lesbian. Simply, she belongs nowhere. However, while in this earlier writing Moraga rages against her wounded state, sixteen years later, in the 1998 "The Dying Road to a Nation," she reaches a stage in which she can embrace wounds of rejection and strategically employ her rhetoric of generative wounds, precisely because of an initial fragmentation from her community, this homelessness or exile.

I invite considerations of this generative wound in connection with Edward Said's theories on exile as fostering a dynamic and assorted understanding of contextual realities that encourages the mutability of self. Said argues that "Most people are principally aware of one culture, one setting, one home; exiles are aware of at least two, and this plurality of vision gives rise to an awareness of simultaneous dimensions."[24] I note Said's argument as aligned with my reading of Moraga. Throughout her later writings, Moraga locates productive vantage points when she elects to select among her various overlapping pieces of selves, achieving that which Said calls a "nomadic, decentred, contrapuntal" life that is "led outside habitual order." Such an awareness encourages "originality of vision."[25] In part 2, we will return to concepts of the exile as fostering originality of vision in a more in-depth exploration of trauma theory, particularly as expressed in Cathy Caruth's research. It is important to note here that Moraga cultivates her positionality from the vantage of insider-outsider, both wounded by her exile and empowered by her polycentric experiences. This recalls Gloria Anzaldúa's "mestiza consciousness" that slips fluidly through multiple worlds that the mestiza navigates. However, while Anzaldúa places the mestiza into a grounded state of borderland realms, with one foot in the United States/English and the other in Mexican heritage/Spanish, Moraga inhabits a no-place and a destabilization where her feet find no purchase.

In "The Dying Road to a Nation," Moraga begins to embrace this destabilization, this earthquake or Náhuatl *ollin* that offers opportunities to achieve momentary nepantla or balance with her disparate parts before the next quake hits. As previously noted, I apply nepantla not as a colonial encounter of in-between borderland space but as a Náhuatl metaphysical concept of reaching balance in a permanent condition of renewal throughout the constancy of upsets. Significantly, Mexica rhetorics of crossroads are linked to concepts of nepantla, the term sharing etymological associations and applications that correlate with *onepanco* and *onepanolco*, commonly translated as "crossroads."[26] In Mexica calendar symbology systems crossroads are typically a portent of "danger, destruction, or conflict."[27] Furthermore, as Cecelia Klein suggests, the danger of

crossroads arises from an excessive number of paths, leading to disorder and lack of direction.[28]

These excessive pathways feature prominently in Moraga's narrations of the earthquaking encounters with split loyalties that exile her from spaces of home and into spaces of conflict. Unlike prominent applications of nepantla as an in-between space wherein collision creates invention that empowers self with a sense of managed wholeness, Moraga's encounters with the in-between space do not secure wholeness or lasting stability. Her encounter with nepantla motivates activity to identify and then claim her fragmentation as valuable. The danger at the crossroad derives from excessive loyalties that Moraga encounters daily within herself, yet Moraga realizes that this danger is an external aspect, an external pressure to narrow the roads taken rather than a danger that originates from within her fragmented variations. Moraga's nepantla is thereby a shake-up to reject external pressures that prioritize one aspect of self over others, to unlearn exterior languages of selfhood, and to maintain her excessive selves as necessary tensions that provide a constancy of renewal and growth.

I accordingly analyze Moraga's writings as they pivot from an early desire to avoid excessive paths so that she may streamline her journey along a single continuous road to her later realization that excessive choices are the purpose of life. Again, I emphasize that Moraga unlearns *rhetorics of wholeness* to embrace *rhetorics of fragmentation* or woundedness—and the impact of such rhetorical transformations on her sense of self. While Moraga is a constant insider/outsider, daily exiled from one or all her pieces as they meet at these crossroads, there is no danger in such complex earthquakes within self. The threat exists only with exterior forces that regulate and limit selves into confined gridwork systems. In this way, I argue that through Moraga's focus on metaphorical woundedness and severed selves (the excessive choices of paths), we might discern a specific thread of Chicanx rhetoric that undermines colonial fictions that the self is whole and unified (single path). I invite readings of Moraga's rhetoric as making visible fissures that inform Chicanx decolonial understandings. Ultimately, Moraga's writings demonstrate a process of recognizing and embracing fragmentation to celebrate one's polycentric selves and purge coloniality and heteronormative internalizations. We can observe this particularly in Moraga's 1998 "The Dying Road to a Nation." This unlearning of colonial fictions is the "dying road" that Moraga navigates in the hope that disparate selves may coexist in fragmented togetherness rather than be shamed into a sense of homelessness.

Fragmenting Language

Still, this way of knowing the self as fragmented is not an easy journey. Moraga notes the extent to which the external language of US English and the teachings of the Catholic Church encroach on her sense of herself, which is inseparable from both. Moraga seeks that which is akin to philosopher Jean-Luc Nancy's concept of the thinking body: "To think without knowing anything, without articulating anything, without intuiting anything. It is thinking withdrawn from thinking."[29] Moraga's writings link the thinking body with decolonial processes also akin to Sabelo J. Ndlovu-Gatsheni's call for rethinking thinking: "Fundamentally a decolonial move that requires the cultivation of a decolonial attitude in knowledge production" and a "painstaking decolonial process of 'learning to unlearn in order to re-learn.'"[30] In other words, Moraga envisions a Mignolo-like delinking from exteriority—including a delinking through and from the body—to consider new ways of understanding and experiencing the world. Moraga's method is a composite of these concepts as she must unlearn her body as a performative physicality to tap into a form of thinking removed from external social and epistemological power systems. In this way, Moraga's rhetoric develops a generative woundedness that confronts pain to purge imposed rhetorical performances and the methods of coloniality that control the articulation of self.

Yet Moraga is disturbed by her inability to think of herself in new ways that release normative identity constructions. This is most evident in one of the essay's earliest sections, entitled "*Susto*" or "The Fear."[31] Here Moraga details her anxieties about the death of her daughter-mother self, first as she experiences her mother's illness and then as she struggles with her son's premature birth. These loved ones are, respectively, Moraga's Spanish Catholic past and her undefined raw future; they are also, respectively, the one that is meant to protect her and the one *she* is to protect. In both cases, the protectress falters. As the daughter-mother struggles with the vulnerabilities of her not-protected/non-protector identities, Moraga realizes the Catholic God's control of "body-life," a regime she resents yet concedes. Moraga states, "I call God by the name of death because nothing other than death wields such undying power in my life. I am afraid of death, the loss of body-life. I recognize this fear as I sit in mediation, rigidly holding onto the body of what I imagine to be myself."[32] Moraga's body exists at God's whim, as do her mother and son.

However, it is her conception of body-self that allows God's power. Moraga realizes that she chooses to be "rigidly holding" the physical body as her definition, though she is made powerless by the choice. Furthermore, this imagining of the helpless self correlates with language. Moraga writes: "I am so afraid, my mind conjures many images in the vain attempt to secure the parameters of 'self'—delusions of my importance and conversely my own pitifulness. And language, which codifies raw being. But all this is oh so preferable to the promise-threat of the experience of any real 'goodness,' and the radical re-vision of meaning it requires in our lives."[33] In this passage Moraga assigns language, not God, as codifier of the self. However, if the language that dominates Moraga's understanding of the self is constructed by a force that Moraga rejects, then her sense of self is indeed invaded. Yet, even aware of this invasion, she writes that she is afraid to lose "my preciously guarded 'me' . . . a world I have known intimately since my earliest remembrance of an internal reflective life."[34] Her inner life remains linked to external definitions based on bodily interactions, by which God—through the power of heteronormative language—condemns Moraga for being a lesbian who responds to Catholic shame, a daughter who needs a Spanish Catholic mother, and a mother who pleads that a Catholic God secure her son's future. Conceived by normative language, her definitions foster submission even as she battles that same source of shame, dependence, and humility. While she knows that a "radical re-vision" could release her from the narrow parameters of language, she is too fearful in this early section of "The Dying Road to a Nation." Still, this section verifies the need to dismantle self and subsequent knowledge of self, a realization that preoccupies Moraga for the rest of the essay.

Accordingly, Moraga rebels against language. Her writing becomes choppy, fragmentary statements of the fragmented self, a purposefully semilingual navigation that frequently halts in frustration as Moraga seeks a truer voice. Unlike Anzaldúa, who writes of her metaphorical "forked tongue," a single unit with multiple endpoints or modes of languages to navigate different locations of discourse, Moraga's tongue is not forked. Not only does she demonstrate her lack of code-switching proficiency, but also, as in her earlier "A Long Line of Vendidas," she lacks the language to even talk about and with herself. Moraga's tongue is metaphorically severed. Similar to her initial fears of loss of body and loss of loved ones, Moraga attempts to cling to the familiar; she attempts to re-member that which she perceives as the mother tongue. However, she eventually finds the wounded tongue most constructive in forming her voice.

Such a move parallels Thomas Paul Bonfiglio's 2013 "Inventing the Native Speaker," in which he argues that the biological metaphors linked to the conceptualization of language are steeped in early modern European Christian nation-building strategies: "The present study critiques the folklore surrounding motherese because it contributes to the surplus and surreptitious biologizing of language and the mystification of the native language and its native speaker. It can be seen as contributing to the notion of the native speaker's private ownership of the national language: when the authority of the native speaker becomes retraced to the milieu of the crib and cradle, then to contest the authority of that speaker becomes at once an affront to nation, ethnicity, and motherhood."[35] Bonfiglio argues that strategies of building national identities led to the notion of "native speakers" and "mother tongues," thereby producing hierarchies of legitimacies and purities linked to ancestral birthright. The more "pure" and more "legitimate" the ancestral right, the greater claim to land one might assert, and thereby the greater claim to nationality. This illustrates the sense of illegitimacy and homelessness that Moraga, in her early writings, feels for losing her mother tongue and therefore losing her connections to fellow Chicanas in exchange for English dominance, feelings that Bonfiglio might consider as exemplifying the harm of associating language to body—in other words, a non-generative wound. In the conclusion to *The Wound and the Stitch*, I will link this discussion of legitimacy to university composition classrooms. For now, to understand Moraga's wounds of identity, it is crucial to consider the correlations she makes between her concepts of language and body, and how her emotions of semi-ness in both trigger shame yet resistance. While Moraga continues to mourn her severed tongue, she concurrently uses it to mobilize against English domination.

In the 2000 foreword of *Loving in the War Years*, Moraga writes of a "neogringo theft of the tongue and tierra"[36] as impeding the telling of a history of ongoing female oppression. While Moraga longs to reclaim the mother tongue and attempts to recapture words and rhythms that, as a child, she enjoyed in the storytelling of her mother and aunts, she realizes that she must find a new language that "can more closely describe women's fear of, and resistance to, one another, words that will not always come out sounding like dogma."[37] She realizes that she does not need to re-*member* or make complete her language—only *remember* emotions around female antecedents who, like Coyolxauhqui, asserted power, defiance, and self-love, even at the risk of dismemberment. "The Dying Road to a Nation," therefore, continues to be English-dominated, despite brief

lapses into Spanish, but Moraga uses that domination to reveal her resistance to and eventual dismantling of language's impact on her identity. In fact, as difficult as it may be, she eventually begins to dismantle the impact of her mother tongue.

In her later writings, Moraga increasingly separates her identity from her European Spanish and Anglo heritage, a self-inflicted wound of the tongue that she endures to access a non-language of Indigenous identity as a process of decolonization. We can see this shift in the 1995 "Looking for the Insatiable Woman," the 1998 "The Dying Road to a Nation," and the 2019 *Native Country of the Heart*. In these writings, Moraga begins to indicate that while she may recover fragments of her mother's Spanish, the severed state of her Indigenous tongue is so annihilated that she can imagine indigeneity only through the aforementioned thinking body that rethinks thinking. To express this unlearning process in one of the later sections of "The Dying Road to a Nation," entitled "The Return," Moraga uses italicized journal entries to demarcate that which she views as the expression of her imaginary Indigenous self and to interrupt straight-prose dominant European narrative.

The journal entry reflects on a "return" to an inner "Beloved" who represents the imagined Indigenous self. The "Beloved" is imagined since colonial ruptures of histories obscure discernible claims of Moraga's indigeneity.[38] Accordingly, there is awe in what could have been and may be invented in this "Beloved," but also insecurity as Moraga can fill gaps of Indigenous history only through fragments of stories and imagination. Unlike the insecurity she suffers in "A Long Line of Vendidas," which manifests a sense of homelessness, here Moraga relates a sense of acceptance and instruction from her Beloved. She writes: "*I have to ask my Beloved daily many things. I have to ask her what the pain in this desert means, why do the women cry so awkwardly. I have to ask her how to enter the arbor, how to tie a prayer tie, wrap a sage stick, roll a cigarette of prayer tobacco. And I wonder how can she want me, baby that I am.*"[39] The "*baby that I am*" is the fragile unlearning-self that Moraga feared in "*Susto*" when she recoiled from a "radical re-vision of meaning" and clung to that which she already understood. In "The Return" we see the moment that Moraga decides to claim this re-vision and unmake colonial fictions.

Fragmenting Love

Moraga's arrival at this moment is preceded by a final wound in the section "A Change of Heart," which details her romantic break-up. During a final altercation

between two lovers, Moraga's white partner mocks Moraga's claim of indigene-ity. Moraga reflects, "Standing speechless and ready to bolt out her front door, the worst accusations regarding my own 'authenticity,' ironically, were hurled by the hand of my own self-doubt."[40] Moraga continues, "The whiteness of my skin and my habitual identification with it continues to seduce and betray me with its shifting disguises."[41] The guises shift from her father's, as we may recall in "La Güera," now to her lover's white skin, both serving as seduction by external alter egos whose desired companionship betrays the mother's brown culture. Even with twenty years elapsing between the writing of "La Güera" and "The Dying Road to a Nation," Moraga continues to conceal herself, most recently as her lover's partner and equivalent in whiteness. She writes, "Some place in me remained convinced I didn't have the right to *feel* so different from this white-woman I loved because I didn't *look* so different" (emphasis original).[42] The result of a life of "passing" as white is now painfully evident to Moraga. She continues to rage against and place shame on herself. Her fragments of identity cannot coexist as a binary white exterior and brown interior. She must expose her interior as fragmented oneness with the exterior.

Moraga's strategy is to destabilize her performance of whiteness and all its social and linguistic links, to unlearn her love for a longtime partner, and to decline her privileges of "passing" as a white body. This break-up is more about splitting from the self than from her partner; yet in disruption of that exterior relationship, Moraga begins to balance her physicality with the interior "Beloved." In entering the pain of the break-up with her white lover, Moraga writes, "I have to choose. There is no place for ambivalence, no place for immi-grant ethnic meanderings, no place for bi-racialized maybes. We part ways, choose different paths."[43] Moraga elects a wound that reduces her to the "*baby that I am.*" Yet that reduction allows a form of redemption in that she unlearns not only her European skin and teachings but also pain: "*I have to ask her what the pain in this desert means.*"[44] Through this re-vision of self, she has actualized the momentary lapse of knowing even the wound.

Ultimately this is the goal of the generative wound in its Iberian and Ibero-American applications. As we will study extensively in part 3, the Virgin Mary's rejection of the joys of motherhood for the acceptance of sacrifice leads her to the joys of redemption; Mary's pain is a gateway to greater non-bodily joy. For Coyolxauhqui, rejecting a socially sanctioned female identity for a socially abhorrent female warrior role leads to her ascendency as moon goddess; Coyol-xauhqui's pain is a gateway to greater non-bodily power. Although Coyolxauhqui

is forever overcome by her brother, the sun, as he rises, her persistence as the moon in all her fragmented states to be both combative *and* feminine demands and obligates that the sun daily face a new battle. In other words, the rhetoric of the generative wound does not linger in agony or celebrate that which harms women but employs pain to become the active agent of the injured party. This is the strategy that Moraga uses.

In "The Return," which is the culmination of "The Dying Road to a Nation," Moraga's sense of homelessness and speechlessness achieves the redefinition she seeks. Infantilized by the lack of a performative body as informed by European epistemologies, languages, and conceptions of self in relation to others, she can perform a new vision of self, even if only in clumsy pieces. Moraga's unraveling of performativity is a form of (un)doing race.[45] In this way, "The Dying Road to a Nation" narrates metaphorical death or amputation of body parts that have been infected by negative social, racial, and cultural linkages. The colonized body must be destroyed, piece by piece, to free a new identity.

2

Woundedness as Decolonial Rhetoric

While I have demonstrated my understanding of Moraga's writings as participating in a Chicanx rhetoric of generative wounds, she concurrently extends this rhetorical tradition into contemporary fields of decolonial theory. Moraga repurposes woundedness to formulate decolonial discourses in the direction of advocacy. When she writes of the body as a conduit for European teachings and control, she positions it as a harmful determiner of identity. This is the source of her wound. Only when the process of knowing the self is painfully confronted and delinked from the colonized body—when *identity* determines a new concept of the body—can one begin to embrace the body. In short, by concurrently expressing self through embodied experiences and metaphorical woundedness, Moraga rejects the prioritization of phenomenological formations of the self via interaction with an exterior world informed by coloniality, patriarchal, and heteronormative systems.

When I speak of phenomenology, I recall Maurice Merleau-Ponty's *Phenomenology of Perception*. Here, Merleau-Ponty states that "the world is not what I think, but what I live."[1] Merleau-Ponty conceives phenomenology as bound in an embodied perception of the physical world. He states that "truth does not merely 'dwell' in the 'inner man'; or rather, there is no 'inner man,' man is in and toward the world, and it is in the world that he knows himself."[2] Merleau-Ponty references Immanuel Kant, who "showed that inner perception is impossible without external perception."[3] Yet what happens when experience *in and toward the world* is curtailed? Are theories of phenomenological construction of identity destructive to marginalized bodies that have traditionally been confined socially, culturally, linguistically, economically, and physically to not be *in and toward the world?*

When the world is inaccessible, there is a particular violence committed against individuals who internalize semi-ness as they are limited in engagements with privileged spaces—the same spaces that practice and provide social

legitimization. There is an additional violence committed when access to the world *is* permitted; the cost accrued is an encounter with a world that teaches that one's outer life is incompatible with one's inner self. When I speak of phenomenology specifically regarding Chicana identities, I recall Jacqueline M. Martinez's *Phenomenology of Chicana Experience and Identity*. Martinez narrates a "spiraling" inner journey toward forming her Chicana consciousness. This journey initiates the realization of a *knowing-unknown*, a comprehension that Martinez describes as knowing "precisely that there is a field of unknowingness that is directly relevant to oneself."[4] Exploring the unknowingness, a Chicana might confront gaps in her histories and those gaps' impacts on her possibilities, contextualized within racist-assimilationist constructs. That is to say, with historical dislocations, a Chicana might not know herself *in and toward a world* that represents her culture and history. Her possibilities are accordingly curtailed by experiences of a world that privileges identity formations that acclimate to Eurocentrism.[5] In the conclusion of *The Wound and the Stitch*, I return to notions of assimilation in the classroom as Chicanx college students might be led to dismantle inner rhetorical identity to construct an exterior new academic-sanctioned language identity. Here, however, I first focus on how Moraga's rhetorics of woundedness complicate theories of phenomenological identity construction.

Moraga writes specifically from the positionality of a white-skinned body that encounters a world that orients her identity away from aspects of her sense of selfhood, such as her Chicana heritage and lesbian sexuality. Sara Ahmed details such disorientation concerning what she envisions as a "queer phenomenology," highlighting ways that objects prominently and continuously placed in heteronormative society fortify "straightness." Similar to Martinez's argument that lack of Chicana history impacts her sense of possibilities, Ahmed observes objects as informing the subject of what things are reachable and what might be doable with those things.[6] In other words, objects shape not only identity but a body's awareness of pathways of possibilities.[7] Objects that are not reachable and thereby not so possible to act upon are those that deviate a body from its orientation on a straight line. Ahmed summarizes that "the queer object, the one out of line, on a slant, the odd and strange one, is hence encountered as slipped away, as threatening to become out of reach."[8] It is in the concept of the slipping away, or that which may become out of reach, that I connect Ahmed and Martinez's critical contributions in the study of phenomenology to Moraga's rhetorics of woundedness.

Moraga pursues the knowing-unknown when she disorients from that which she has been taught through contact with privileged and immediate objects. Rather, she taps into the *baby that I am*, reorienting so she may begin to retrieve that which she *knows* she must contain—an unknown narrative of indigeneity that informs her Chicana heritage. Moraga endeavors to reclaim cultural, racial, linguistic, sexual, and gendered fragments that are continuously slipping away, the "queer" objects if we apply Ahmed's framework of queerness to perceive that which is made unreachable in normative phenomenological experiences, including queerness in sexuality but also various intersecting fragment identities that Moraga expresses. Yet distinct from the Chicana and queer phenomenological theories that I have considered, I view Moraga as not only disorienting her relationship with normative objects but distancing herself from objects altogether once she recognizes the restrictions of socially prescribed Eurocentric and straight lines. After all, the *baby that I am* is accessed through the *Beloved* contained within the self. Moraga's decolonial methodologies insist that the exterior be dismantled to prioritize interior exploration, knowledge, and identity. As previously noted, this alternate way of knowing the self touches on Mignolo's "epistemic disobedience" and insistence on delinking, in addition to the aforementioned disorienting.

Moraga's methods of knowing the self also align with Sidonie Smith's descriptions of the pursuit of selfhood in the genre of autobiography. Smith writes that there are typically two methods to locate selfhood. First is the horizontal method, with the self traveling "consecutively through stages of growth, expanding the horizons of self and boundaries of experience through accretion," but always carrying a "unified core" that responds to growth.[9] I suggest that we might apply the second method in our reading of Moraga's later-career autoethnographies. Here Moraga elects a vertical movement, a movement that Smith defines as "delving downward into itself to find the irreducible core, stripping away mask after mask of false selves in search of that hard core at the center, that pure, unique or true self."[10] Smith refers to this second method as a "romantic journey" that seeks "quiet water, pure being of essence."[11] For Moraga, this is far from a romantic journey; it is filled with painful confrontations with internalized coloniality. Indeed, while Moraga travels a vertical pathway to strip away falsehoods, she hits upon a distressing realization that under the masks no "unified core," no "irreducible core," and no "hard core" exist. Moraga locates discordant fragments rather than a core. She narrates the impossibility of integrating her various selves, an impossibility that stems from collective colonial grief. The

impossibility of a unified core recalls Jinah Kim's explorations on woundedness—that "there is no healing unless the living, the dead, the colonized, the colonizer, and the land on which they all reside are healed all at once."[12] In this way, Moraga extends rhetorics of woundedness from exploration of personal trauma to decolonial discourses on the historical shockwaves of colonial violences that continue to negatively impact Chicana bodies—those buried and those still living on contested spaces.

Moraga exposes the myth of a unified core by focusing on colonial intrusions that have fabricated a false self through external manipulation of interactivities. This decolonial examination stems from Moraga's early writings that attempt to make legible a distinct testimony of racialized lesbian bodies. Yarbro-Bejarano explains Moraga's midcareer tendency to strip away Chicana bodies: "The dismantling and recomposition of the lesbian body in Moraga's writing is part of a process of making sense out of the rifts and splits of what Anzaldúa calls 'our shifting and multiple identity.' I stress the 'process of making sense' rather than the production of a fixed meaning, for it is the multiplicity of the meanings that attach to the part and the whole of the lesbian body/text that allows for diverse de-connections and connections to be made."[13] An emphasis on (de)connections brings to the forefront that, per Yarbro-Bejarano, the "Chicana lesbian is besieged from within as well as from without" as she "struggles with the internalization of oppressive attitudes."[14] I am interested in how Moraga's later writing career applies her earlier Chicana lesbian studies to launch a form of Chicana lesbian feminist decolonial imaginaries in which decomposition of female physique becomes a strategy to recompose narratives and imaginings of Chicana bodies.[15]

Through this reimagining, Moraga unlearns colonial fictions that pressure her to privilege one socially sanctioned piece of self in denial of her fragmented existence; she begins to discern conflicting loyalties that vie for her attention and may be productively harnessed for self-empowerment rather than turmoil. As I have argued, Moraga illustrates this discernment as obtained through an undoing of body, a delinking of phenomenological knowledge, and a metaphorical death of identity impacted by coloniality. These moments of undoing are important to purge shame associated with semi-ness and to refute binary thinking, while fractures within identity and the performative self are recognized as generative. Accordingly, rhetorics of woundedness become rhetorical action that confronts that which Karan Barad explains as a "colonizing logic" that perceives the self as stabilizing itself through eliminating that which it deems to be the

"savage,""uncivilized,""non-European" in order to assert the self as wholly assimilated for socially sanctioned reward.[16] Rhetorics of woundedness instead reject wholeness and thereby assimilation as all aspects of self may be maintained.

Yet the fractured, the semi-, and the fragmented are still perceived in dominating colonial fictions as nonhuman monstrosities—repurposed as another manifestation of the uncivilized or partially civilized. We again might recall Moraga's embrace of her own Frankenstein state and her leading characters, such as Cerezita, whose body is comprised solely of a head that can function only through tongue movement and articulation. Indeed, through the visibility of the monstrous as fragmented, violated, and mutated, Moraga's rhetoric both urges audiences to validate Chicanx humanness and challenges the same audiences to examine why, in the first place, they need proof of Chicanx humanity. We see similar explorations of monstrosity in connection to everyday rhetorics of racism, sexism, classism, ableism, and homophobia in works by Bernadette Calafell. Calafell's examinations of Anzaldúa's writings on psychic trauma of colonialism and her reflections on her own performance of monstrosity as a counternormative strategy within academic contexts are both noteworthy.[17] Also destabilizing normative notions of humanity and hierarchical control over the power to define humanness, Moraga's particular rejection of healing indicates that she does not conceive humanness as equating wholeness.

With this move, Moraga's rhetorics of woundedness links with contemporary theories on biopolitics as examining notions of monstrosity and humanness to make visible governmental systems that negotiate resources based on discerning particular populations as "political problems."[18] We might detect, for example, alignment here with Alexander Weheliye's application of (non)humanness to refute raceless views of biopolitics.[19] Weheliye insists on the visibility of institutionalized racism that propels biopolitical violences against humanity, yet he concurrently intervenes on definitions of humanness. Per Weheliye, for Black lives to be recognized as "suitably human," Blackness must be killed.[20] Such notions resonate in biopolitical writings by Christina Sharpe on living in the wake, Stefania Pandolfo on living in the wound, and Abraham Acosta on remembering those who never arrive. All are writers who, like Moraga, perceive dominant definitions of (non)humanness as a core justification to (in)validate BIPOC lives to suit a variety of biopolitical agendas.

By rejecting humanness as a stable and whole construct built on the paradigm of male, heteronormative Europeanness, Moraga targets myths of humanness as a desired state. In this way, rhetorics of woundedness bring to the forefront

activities of humanness and dehumanization to make visible still-extant colonial wounds. Entering the wound maintains the active-verb state of humanness. For Moraga, exposure of wounds refutes desensitization regarding ongoing violences directed at racialized, female, and LGBTQ+ bodies.[21] Such deployment of (non) humanness as rhetorical action recalls Sylvia Wynter's reframing of humanness from noun to verb.[22] Wynter contests historically fictionalized definitions of humanness that suit Eurocentric hierarchies. This myth of humanness parallels a myth of modernity, which, as Enrique Dussel notes, is built on human hierarchies that situate Europe as an evolved global leader in its encounter with perceived natural-state indigeneity and Global South infant-societies. Fundamentally, myths of humanness and modernity rely on fabricated dualities of Europeanness and non-Europeanness, colonizing strategies that Anibal Quijano famously observes as supporting fictions of unilinear Eurocentric progression that externally control bodies and economies.[23]

As I continue to connect rhetorics of woundedness with decolonial theories that aim to unlearn normative phenomenological identity constructions, Eurocentric myths of modernity, and fictions of wholeness, a brief consideration of binary identities, especially as related to constructs of mestizaje—and more specifically mestiza—may elucidate my argumentative points. Although Moraga launches examinations of dualities (Moraga's white skin and brown interior), she ultimately rejects binary structures as inherently Eurocentric and colonizing through a linear progression toward phenomenologically-induced assimilation epitomized by the "colonizing logics" expressed in notions and depictions of mestizaje.

Cultural Identities as Fragmented but Not Binary, Wounded but Not Healed

Mestiza is the female form of mestizo, a colonial term that denotes the offspring between a pure Indigenous American mate and a pure Spanish mate. As a social and racial category, mestizo is often studied visually in *casta* paintings. As depicted in Ignacio María Barreda's *Las Castas Mexicanas*, the genre typically consists of a painting divided into twelve to sixteen panels that each depict a family: mother, father, and one or two children (fig. 4). Each panel represents a racial caste. Children shown in the panels bear the caste name. Thus, the mestiza/o panel would feature a pure Indigenous parent and a pure

54 THE RHETORICAL WOUND

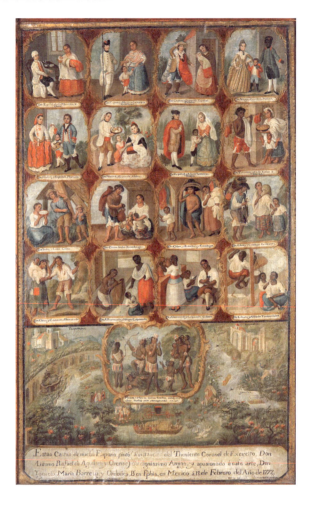

Fig. 4 | Ignacio María Barreda, *Las Castas Mexicanas*, 1777. Oil on canvas, 30.3 × 19.2 inches. Real Academia Español, Madrid. Photo © Archivo fotográfico. Real Academia Española. Photographer, Pablo Linés.

Spanish parent with their mestiza/o child(ren). Regularly placed as the top left image in the *casta* series, the mestiza/o caste was ranked highest in a mixed-race hierarchical system based on the believed ability of each race to breed out Othered features into an eventual return to a pure Spanish state.[24] Another feature of this genre is that the castes were often depicted alongside distinctive regional landscape, local fruits and vegetables, or before a landmark, such as prominent sites in and near Mexico City; for example, the Paseo de Ixtacalco, a village built

around canal systems, designated Mexico City as an American Venice and is featured prominently in *casta* paintings, as in the Barreda painting's lower register.[25] In this way, mestizos along with other castes are offered alongside products and resources of the Americas.

Daniela Bleichmar studies the *casta* genre as demonstrative of imperialistic global collecting strategies informed by European Enlightenment ideologies. Bleichmar observes that *casta* paintings ordered nature and society "into an idealized taxonomy, attempting to minimize one of the great social fears of the higher classes in viceregal societies by suggesting that ethnicity was not uncertain, fluid, and hard to pin down but rather mathematically fixed, rigid, and readily identified through visual inspection."[26] As counternarrative to Bleichmar's analysis of the imperialistic nature of *castas*, Crista Olson argues that the genre reflects a growing proto-nationalistic pride and self-representation in the Americas. Focusing on rhetorical choices that informed designs of *casta* paintings, Olson perceives agency in the actions of specifically the *criollos*—those of solely Spanish parentage but born in the Americas. Olson claims *casta* paintings represent *criollo* efforts to construct a vision of Mexico as uniquely populated and capable of exceptional offerings. She argues that *criollos* identified "simultaneously with European authority and American rebellion" and therefore presented the "racial mixture [of the Americas] as a distinctive trait" to heighten the uniqueness of their own Spanish identity outside the Iberian Peninsula.[27] While restricting this rhetorical agency to *criollos*, Olson is explicit in distancing from scholars like Bleichmar who consider *casta* paintings as purely imposed representations that were manufactured predominately for European markets, like an extravagant postcard featuring peoples, foods, and terrains of the Americas. Even so, Olson still argues that the "distinctive trait" of American miscegenation was a point of pride for *criollos* to transmit to Europeans. In this way, Olson arrives at a similar conclusion to Bleichmar: that the peoples represented in *casta* paintings are commodified to advance a privileged class's purposes—in which case, the term mestiza/o is still part of a history of packaging and selling the identities of people of Spanish and Indigenous descent, and to a lesser degree African descent.

Bringing this discussion closer to our exploration of fragmentation, Ilona Katzew and María Elena Martínez consider notions of physicality as linked to civility and purity. Katzew and Martínez additionally complicate Bleichmar and Olson's debate as they move the timeline of *casta* discussions to pre-Enlightenment considerations and extend focus beyond commodification and

collection to a broader social spectrum that includes religious identity, gender role structures, and nuanced race systems that support socioeconomic hierarchies. Katzew links *casta* structures to classical and medieval classification methods.[28] She observes that the term "mestizo," while surely indicating an introduction of Spanish racial lineage and thereby civility into Indigenous bodies, also functioned as reinforcement of Spanish hierarchies. Katzew argues that "mestizo" signaled illegitimacy and lack of stable cultural affiliation; therefore, mestizos were often banned from holding positions of power.[29] While the introduction of Spanish blood was perceived in one sense as a raising or civilizing of Indigenous peoples, the blood concurrently highlighted one's inadequacies and inabilities. Katzew summarizes that *casta* systems demarcated "*gente de razón* (people with reason) versus Indians; *gente decente* (respectable people) versus the pleb."[30] In essence, the system created a joining of peoples through potential to "breed out" the "uncivilized" while simultaneously actualizing a divide-and-conquer method to control reproductive choices based on socioeconomic arrangements.[31]

Martínez similarly offers scholarship on the caste system as a scheme to both recognize potential mobility within a single system and demarcate levels within that system. Launching her studies from medieval Castilian hierarchical concepts of Christian spiritual purity, Martínez claims that, when extended to the Americas, purity begins to be applied within an embodied racial categorizing system that correlates purity of soul with whiteness of skin. Markers of impurity based on faith, lineage, cultural practice, and eventually race led to classifications that shaped colonial *casta* systems.[32] The mestizo/a, a hybrid person of Spanish and Indigenous American descent, was classified lower than "pure" Spaniards of the Iberian Peninsula and "pure" Creoles of strictly Iberian heritage born in the Americas; yet they were placed above hybrids of African descent whose blood was deemed too potent for complete assimilation into Catholic colonial culture.[33] The idea of mestizaje is grounded not only in European religious purity systems and colonial racialized *casta* systems but on the ability to fully merge fragmented selves into an eventually assimilated oneness.

We might detect Martínez's notion of purity in Barreda's *Las Castas Mexicanas*. The painting's bottom central image depicts Indigenous Americans in their "raw" state, untouched by "civilizing" genes of European colonizers. Meanwhile, the mestizo at the top of the painting denotes a new and improved Indigenous American, yet one who, as Katzew might caution, is still marked as culturally illegitimate for power roles in society. This positioning of mestizaje

concurrently demotes Indigenous identity, marking indigeneity as incapable of addressing modern complexities of Eurocentric life or as precursor to modern mestizos.[34] The Indigenous body becomes a merely abstracted container of potentially "civilizing" European genes and ideologies in the Americas. We might recall Anibal Quijano's observations of colonizing strategies that apply historical narratives of duality and unilinear progression to control bodies and economies.[35] Here, indigeneity is relegated to a natural past. At the same time, Europeans usher mestizos into a linear progression toward a civilized future. This linearity aims to leave behind darkness and shun any blackness that might disrupt a mythical unidirectional history of civilization. The "myth of modernity," as Enrique Dussel notes, is built on these hierarchies, with Europe evolved as the global leader in its encounter with natural-state indigeneity and, hence, infant societies in the Americas.[36] The Indigenous body is relocated in the Barreda painting to the natural world and exterior to the civilizing progression in the future. Beyond the *casta* paintings, Afro-Latinidad will eventually enter an imaginary space even further dislocated from mestizos—in the United States, identified as racially African American and prominently disbelieved as culturally Latinx.

Given this historical context of the use of mestiza/o and the ever-changing rhetorical situation that scholars engage in through time and space, it is not surprising that scholarly inquiries have gathered to complicate understanding of the term. While Chicanx rhetors from the 1960s to today have applied mestiza/o to productively interrogate and commemorate identities within the crossroads of indigeneity and Europeanness—a critical application of the term to mark distinctions from colonial imposition of Spanish "whiteness"—in emerging rhetorical contexts there is expanding discontentment with the term. Such criticism centers on ways Chicanx identity both negotiates within the United States through a constructed imagined indigeneity and privileges mestizaje as a hierarchically elite cosmic consciousness that fluidly crosses geographical, social, cultural, racial, and linguistic borders. This privileged hybridity ironically recalls Olson's views of colonial-era *criollo* strategies to assert a "distinctive trait" unique to the Americas.

Critical of the idealization of this hybrid state is a spectrum of recent rhetorical scholarship that rejects the term mestiza, mestizo, *and* mestizaje. Sandra K. Soto writes that application of mestiza dangerously "glosses over the violent history of colonial miscegenation," Carmen Lugo-Lugo examines mestiza as part of a racial categorizing system that relates to the conquest of the Americas

58 THE RHETORICAL WOUND

and the virtual obliteration of Indigenous peoples, and Karma Chávez and Karrieann Soto Vega interrogate mestizaje as negating or erasing African and Indigenous races within Latinx demographics.[37] Chávez and Soto Vega, in particular, question mestiza/o as a unifying cultural identifier by their emphasis on the colonizing term as reinforcing exclusions and hierarchies. Echoing this sentiment, José Cortez investigates the use of mestiza/o as damaging Latinx scholarship by reproducing colonial hybridity structures, and asks Latinx scholars to reconsider the function of the term in order to truly decolonize Latinx rhetorical strategies of self-representation.[38] Finally, recalling our discussion on Martínez's scholarship of the medieval "purity" system that supports later American caste structures, Abraham Acosta expresses concern over hybridity studies that separate the Indigenous and European into categories that imagine original purity for each binary source.[39]

Yet the appeal of mestiza/o in Chicanx rhetoric is deeply rooted, particularly in early ideologies of the Chicano Movement, which pulled heavily from the nation-building textual and visual rhetorics of early twentieth-century post-Revolution Mexico.[40] Indeed, the rhetorics that connect mestizos to a privileged race and rightful ownership of Indigenous lands dates from the sixteenth century, as detailed in María Josefina Saldaña-Portillo's *Indian Given* (2016). Yet early twentieth-century Mexican rhetorics provide a more direct impact for Chicano identity rhetorics. The post-Revolution Mexican government–sponsored rhetorics celebrated indigeneity as the starting point for modern Mexicans while marginalizing existing Indigenous populations and physically relocating them to reservations—all for advancing Mexico's new face of mixed heritage. Pivotal in these rhetorics were José Vasconcelos's *raza cosmica* and Manuel Gamio's integrationist politics that not only asserted the superior racial structure of mestizaje but justified forced Indigenous removal while simultaneously declaring the mestizo claim to their vacated land based on ancestry and also the racial superiority of the "mixed."[41] In other words, uses of mestizaje participated in and were complicit in Mexican settler state projects of Indigenous dispossession.

To propagate the claim to Indigenous land and heritage within the body of Europeanized superiority, government-sponsored civic arts of the early twentieth century urged artists to reassess tradition, reclaim native landscapes in art, cast Indigenous subjects in these settings, and use allegory to mark distinct national and racial life in Mexico.[42] Emphasis on indigeneity was also inspired by Mexico's Archaeological Inspection Department's excavations of Teotihuacán,

a city revered by and predating the Mexica or Aztec. Fifty years later, 1960s United States Chicano protest art and textual rhetoric were informed by these Mexican nationalistic strategies to emphasize Indigenous purity and Aztec heritage as securing modern mixed-heritage descendants their rights to land. Discourses that propagated Aztlán as a third-space utopia due to its historical understanding as spiritual homeland of the Mexica was rampant in Chicano Movement activist groups such as the Brown Berets, United Mexican American Students (UMAS), El Movimiento Estudiantil Chicano de Aztlán (MEChA), and La Raza Unida Party. In Chicano Movement discourse, Aztlán is often described as a conceptual space that reclaims the Mexica mythical home, untouched by European imperialism and thereby pure and utopian.[43] Chicanx feminists of the 1980s and 1990s, like Anzaldúa and initially Moraga, adopted and adapted similar strategies in their use of mestiza theory and Aztlán utopian visions. Yet, in the case of Moraga, we can discern a gradual distancing from visions of utopian oneness of mixed fragments. As previously noted, Moraga's peeling of false constructs of selfhood reveals no unified oneness, which essentially rejects notions of mestiza as a joining of selves.

In my conceptualization of rhetorics of woundedness, notions of hybridity conflict with fragmentation, particularly in the idea of mestizaje as a blended, cohesive state of mixed Indigenous and Spanish heritage. While my recap of scholarly dialogues on histories and ramifications of the term mestizo/a and its depiction in *casta* paintings is brief, it helps to articulate my topmost concern that colonial and biopolitical forces have designated the Chicanx female body as both an exemplar in breeding out brownness and controllable as a site of reproductive conflict.[44] These ideas will be central in the following chapters. For now, I examine the rejection of dualities and unidirectional narratives as a way to deter historical breeding-out of brownness in relation to Moraga's metaphorical woundedness and fragmentation.

Trinh T. Minh-ha's theories of the "not-I" may be helpful here. The "not-I" or uncivilized non-European is detected within self in contrast to a socially sanctioned, constructed "I." Obliteration of the "not-I" to perform more fully the "I" and gain socioeconomic rewards reinforces colonizing values of hegemony to support fictions of the "civilized" or assimilated.[45] These rewards recall the phenomenological objects that Ahmed notes as determining orientation along a "straight" road of prescribed possibilities. We observe this process in "La Güera" as Moraga testifies to conflicts between claiming the privileges associated with her whiteness and claiming the woundedness of her Chicana sisterhood. In

pursuit of the desired European (civilized) whole "I," Moraga's early writings narrate pressures to choose one of her binaries while obliterating the other. The unchosen, historically marked as the non-Europeanized or the "not-I," is banished from active identity and consequently may be diminished as a motivator for the external performance of the self. Such a binary fosters a "breeding out" of difference within, reminiscent of *casta* paintings.

Before we completely leave the colonial history of *casta* paintings, I invite consideration of Rebecca Earle's examination of one root of this colonizing logic as cultivated by early modern Spanish colonizers who feared becoming "othered" through contact with the Americas. Earle considers concepts of *becoming colonial* in the body-identities of these conquerors. Drawing on cultural theorist Stuart Hall, Earle argues that cultural and racial identities are of two types: identity of being, based on a sense of unity and commonality, and identity of becoming, based on a process of imaginative rediscovery.[46] This imaginative rediscovery is the shift to a colonial fiction of body and identity.[47] Earle references medieval Iberian understanding of body humors as impacted by later colonial interactions with foods, climates, and geographies of the Americas. Humoral sciences taught that each body possesses a disposition determined by the degree of balance among the body's four humors; in addition, external forces influence this balance. When the body transforms due to humoral (im)balance, temperament and the spirit are impacted. Since humors are both predetermined and in constant flux, prescribed activities might manage the flux created by external forces. In other words, externalities might be manipulated to secure the desired "I." Accordingly, the "not-I," to use Trinh's modern term, correlates to body-identity that is potentially transformed through engagement with external forces in the Americas. It follows that the lines between Spanish-ness and indigeneity are changeable and temporary.

Earle writes of colonizers' fears of these blurred lines as a "fear that living in an unfamiliar environment, and among unfamiliar peoples, might alter not only the customs but also the very bodies of settlers."[48] Circa 1570, royal cosmographer Juan López de Velasco explained that "after many years even Spaniards who have not mixed with the natives will become like them, not simply in their bodies, but also in their spirit, for the spirit is shaped by the temperament of the body."[49] Sixteenth-century Franciscan friar Bernardino de Sahagún also warned of alterations in moral conduct: "The mildness and abundance of this land and the constellations that govern it encourage vice, idleness and sensuality."[50] These

spiritual and physical anxieties are essential to consider because they establish the feared "other" as an abomination or monstrosity that can corporally enter and transform the inner self. A form of resistance to this transformation was to seize control of American soil to cultivate the land, not only for the survival of Spanish bodies but also for the "saving" of natives, who, when introduced to European humoral sciences and foods, might establish exterior and thereby interior balance.[51] Thus, colonization was and is very much a process of transplanting European crops and livestock to the Americas to maintain the colonizers' own Spanish-ness and transform natives into European bodies, temperaments, and spirits. Not only was this tactic pursued for the sake of humoral balance but also for the transplanting of wheat and grape, the only foods that permit the transmutation of Christ's body and blood—the ultimate nourishment for the balance of bodies and souls in the Christian worldview.

I suggest that this historical fear of mutability of the desired Eurocentric self and the subsequent eradication of any trace of indigeneity is exactly the colonial wound that Moraga confronts. This eradication—through colonizing fictions about a self who must be whole and unified as the elected Eurocentric human—may be so complete that total assimilation is achieved without any remaining traces of previous fragmentation from colonial or coloniality violences.[52] Yet by making apparent the generative other-within as an essential part of accumulated fragments that construct an ever-more complex and dynamic (non)humanness, colonial binaries are disrupted and fictions of wholeness made suspect, since the self is never unitary but a multiplicity.[53]

For Moraga, the "not-I" is that which she wishes to embrace to highlight multiplicity and neutralize colonial hegemony. In fact, the surprising realization that a "not-I" even exists, as discussed in "La Güera," fills her with enormous regret that she had ever inadvertently neglected this fragment, this "not-I" of her mother's heritage that is crushed beneath the privileged "I" of her father's white traditions. As a response, her 1981 poem "The Welder" seeks to fuse these disparate parts of the self so she might blend the binaries into a wholeness, a new cohesive structure that "can support us / without fear / of trembling."[54] This fusion is Moraga's vision of her reality, comprising fragmentations that only with "the intensity of heat, the realm of sparks / out of control" can "change the shape of things."[55] With this fusion, all fragmentations of the past blend, melting away discernible existence. Yet this is a moment when Moraga falls into the discursive trap of wholeness. While it might be argued that the whole depends

on the parts and that nothing, therefore, is destroyed, it is the liquification into invisibility of the complexities of the past and its parts that concerns me.

This invisibility implies that fragments are shameful, something to hide rather than to repurpose as generative. As already detailed, Moraga's post-1990s writings recognize both the value of discernible fragmentation and the creative energy of shame, thereby entering cultural rhetorics of woundedness. Even when she unlearns her coloniality to become *"the baby that I am,"* she does so only to access that inner "not-I," but not to inhabit that single identity of the baby entirely and exclusively. She seeks a new way of knowing the self, not an eradication of selves within. Later, Karen Barad would initiate a similar quest, asking, "How can we understand this coming together of opposite qualities within, not as flattening out or erasure of difference, but as a relation of difference within?"[56] Particularly helpful here is Barad's metaphor of patchworks that are made of disparate parts to create a together-apart unity.[57] It is the value of fragments and the stitching of their disparate parts that especially align Barad and Moraga's later writings.

Leaving "The Welder" persona behind, Moraga adopts a strategy of no longer seeking a melding of smooth oneness but rather a visible stitching—a piecing together of a cohesive vision of the self, yet one with ever-discernible scars, never obligated to fuse into smooth, complacent assimilation. By focusing on fragments within, Moraga confronts her together-apart state—as white-skinned, Chicana, feminist, lesbian, non-Catholic, culturally Catholic, in relationships, outside relationships, advocate, writer—pieces of self that run alongside each other at assorted intensities, velocities, and tensions while regularly colliding at various levels of injury that alternate with fleeting reconciliations. Even if the fragments are not always at the same level of development or distance along the identity road, they remain a traveling unity that shares incitement from one source of inquiry. That inquiry is the imagining of a self that passes beyond colonizing languages and epistemologies, much like Barad's helpful metaphor of light beams that travel together-apart beyond narrow cloud gaps to realize new manifestations.[58] In this way, Moraga makes apparent still-extant colonial violence and the resulting fragmentation of self, fragments that in their conflicting and painful expressions emphasize the daily struggles to resist binaries (mother's indigeneity or father's whiteness, Chicana or feminist, culturally Catholic or lesbian). Here, the generative wound reinforces daily choices to accept disparate parts despite their conflicts rather than submit to homogeneity and disappear into assimilation.

An Epilogue: Daughter-Mothers in Mournful Advocacy

At Cherríe Moraga's April 2019 book reading of *Native Country of the Heart* at California State University, Long Beach, I was repeatedly struck by Moraga's choice to read aloud moments of her most intense woundedness. At times, the intensity was so uncomfortable that even I, already drafting my study of rhetorics of woundedness, found myself sunken into my seat, enormously ill at ease with the public disclosure of such intimate recollections. One such selection from the book focused on the chapter "Body Memory," which begins with a dramatized exchange between a mother (Madre) and her daughter (Hija) about the brother of the family:

> **Hija:** "Kneel down and call me God," he'd say. And so I'd whisper, "God."
> And he'd keep pressing until I'd say it louder and louder. And then—
> **Madre:** Dígame. [Tell me.]
> **Hija:** He'd have me down to my knees, before I'd submit.
> **Madre:** You gave in.
> **Hija:** I had to . . . And then he'd let me go.
> **Madre:** I don't remember that.
> **Hija:** I know.[59]

For the mother, now elderly and struggling with dementia, recollection is no longer possible. As a result, the anger the daughter holds for her brother's unbridled violence and violation similarly dissipates regarding her mother's participation. Yet she continues to insist that someone *must* remember, even if the wounds are too large to heal. She accordingly initiates discussion of the matter with her mother, knowing full well that her mother is powerless not only to act but even to remember. They can, however, mourn together and find meaningful ways to engage in their current journey as a family.

This is essentially the purpose of *Native Country of the Heart*, as Moraga focuses on the theme of returning home to her mother to bridge differences and forgive so that the remaining time can be fruitful. Moraga applies woundedness to identify losses shared within the family; concurrently, she uses this heightened awareness of loss for community activism. Such a strategy recalls Svetlana Boym's emphasis on the sharing of common wounds as fostering community bonds and Bernadette Calafell's observations on community affect.[60] Judith Butler also joins this discussion through her studies on public mourning as enabling

foundations for community.[61] While Butler examines exclusions from public mourning or those lives not deemed grievable, Moraga harnesses private pain to agitate ill-ease in her audiences—that sinking-into-the-chair feeling—that demands our attention to the wound and demands that we share Moraga's grieving. This is not a tactic to arouse pity but to consolidate moments of individual and private Chicanx mourning into a public identity that initiates potential redress. Such a strategy raises consideration of trauma theory, to which I will return. Yet my attention is currently focused on how Moraga's rhetoric fosters consideration of how private wounds generate public discourse to redress family and community needs.

I have already discussed Moraga's texts as entering a tradition of rhetorics of woundedness in which access to personal pain and emotion permits retrofitting of male-dominant historical narratives. This retrofitting aims to realize and validate identities that are fragmented under heteronormative coloniality. However, Moraga also applies rhetorical strategies of generative woundedness to reconcile and activate Chicanx communities, the members of which also travel together-apart, though often seemingly further apart. Moraga's extensive examination of this apartness within Chicanx family dynamics tends to criticize the silences, forgetfulness, and fetishizing of inner-family violences. In an interview with Roberto Lovato about her playwriting, Moraga says, "Traditionally, Chicano theater has not dealt with the condition of our families.... It tends to romanticize 'la familia.' I feel we need to kind of touch the wounds a little bit, look at the sore spots in us."[62] These sore spots provide the potential for diagnosis not only of the private family but larger Chicanx demographics. In Moraga's dramas, such as *The Hungry Woman* (1995), we can observe this diagnosis in action as the Mexican Medea is exiled by the very family and larger community she once served; she is eventually committed to an insane asylum.

In Moraga's nonfiction, we also encounter the centralization of family abandonment as a gateway to diagnosing a lack of cohesiveness in Chicanx communities. Dating to her 1981 essay "La Jornada," which served as the preface for *This Bridge Called My Back*, Moraga has viewed private pain as a strategy for community building. Moraga's attention to self-inflicted community wounds extends to her editing projects within *This Bridge Called My Back*, which sponsored particularly agonizing narratives of family and community fragmentation found in Nellie Wong's "When I Was Growing Up," Mary Hope Whitehead Lee's "on not bein," Naomi Littlebear Morena's "Dreams of Violence," Merle Woo's "Letter to Ma," and Anzaldúa's "La Prieta." In Moraga's later essay "Queer

Aztlán: The Re-Formation of the Chicano Tribe," from *The Last Generation* (1993), the focus shifts from woundedness to treatment. This treatment does not aim to heal but highlights the generative potentials of those most aggrieved to advance family and community closer to an idealized state. Indeed, Moraga positions those she observes as most wounded—in this case, the LGBTQ+ members of Chicanx families—as ideal leaders, recalling the insider-outsider perspective of the exile whose expanded vision and positionality may usher in constructive new ways of being Latinidad. As Julie Avril Minich notes regarding Moraga's conceptualization of queer Aztlán, "Those most excluded from the family's fold (or its 'sinners') are those best positioned to imagine the cultural family in a more just and democratic way, and, also like Moraga, they depict the family as a microcosm of the larger cultural family or nation."[63]

Coyolxauhqui's entrance into the second edition of *Loving in the War Years* accordingly signals Moraga's seasoned focus on betrayal and censorship within the Chicanx community, linked with semi-ness, fragmentation, and woundedness of the female body, as a strategy to decolonize Chicanx lived experiences. The newly inserted essay "Looking for the Insatiable Woman" expands Moraga's understanding of the Coyolxauhqui legend. Moraga writes, "As we feminists have interpreted the myth, Coyolxauhqui hopes to halt, through the murder of her mother, the birth of the War God, Huitzilopochtli. She is convinced that Huitzilopochtli's birth will also mean the birth of slavery, human sacrifice and imperialism (in short, patriarchy). She fails."[64] Moraga proceeds to posit that this myth reminds Mexican and Chicanx cultures that females are excluded from determining life and its future. Moraga more specifically equates Coyolxauhqui to the exterior fragmentation of Chicanas within Chicanx culture as explicitly stemming from disloyalties among women and mother-daughter divisions. Using Coyolxauhqui as her heroine, Moraga metaphorically armors up to confront her mother's role in patriarchy and her brother's dominance over her body and self. She writes that Coyolxauhqui, "like me, was a woman betrayed by her brother. She was an ancient Xicanawarrior deported into darkness. I, a young Xicanadyke, writing in exile."[65] Still, it is in this exile and extended wound state (both physical and metaphorical) that Moraga harnesses her rhetorical strategies.

In her latest full-length book, the memoir *Native Country of the Heart* (2019), Moraga initiates the reconciliation of mother-daughter apartness to prioritize *togetherness*. Metaphorically, the battle between Coyolxauhqui and Coatlicue—sparked by the betraying brother Huitzilopochtli—has settled. Releasing rage

is a main narrative of *Native Country of the Heart* as Moraga relates the last years of Elvira, her mother, whose life vanishes through a long memory struggle with Alzheimer's. The loss of the mother that had so frightened Moraga in "The Dying Road to a Nation" is finally actualized. And still, Moraga's fear has not faltered. It amplifies and spreads. She equates the death of her mother with the death of her own narrative; the story of self as an "us," as mother and daughter, is fading. She writes, "When our storytellers go, taking their unrecorded memory with them, we their descendants go too, I fear."[66] Again, Moraga faces metaphorical death, yet with a difference.

The "war years" are over between Moraga and her family. She no longer calls on her muse, the Xicanawarrior Coyolxauhqui, to address her family's faults. There are no more errors to account for, since the memory of such errors has slipped far into a shadowy existence. Coyolxauhqui, the daughter, cannot fight Coatlicue, the mother, under these conditions. The brother becomes invalidated, as well. There are no more power struggles when all the three can now do is wait for a new phase of life and death or, rather, a not-dying that in actuality becomes worse than the dreaded death as the mother's inner self fades while her exterior shell persists. In fact, with this ultimate wound experience of the not-dying, Moraga's identity as a modern Coyolxauhqui elapses. At no point in *Native Country of the Heart* does Moraga evoke Coyolxauhqui, save for a surprisingly blithe tourism note as Moraga casually recalls that the medieval Mexica stone disk featuring Coyolxauhqui in her full-bodied dismembered state sits only a few blocks away from a meeting that Moraga attends at a women's cultural center in Mexico City.[67]

This abrupt relegation of Coyolxauhqui to merely a tourist destination, while Moraga engages in serious collaboration at the women's cultural center, signals Moraga's stabilization after the earthquakes and fractures in her private life—and her consequential reemergence to serve her community. Coyolxauhqui's demotion reflects the actuality that the legend is not just about a warrior sister in conflict with a brother. Coyolxauhqui is also the daughter of Coatlicue, the Mexica goddess who Coyolxauhqui must destroy to kill the unborn Huitzilopochtli. This legend is, thus, not only about a woman battling patriarchy but about a woman battling a woman, a daughter attacking her mother, and the present killing the past.

In *Native Country of the Heart*, nothing is more critical for Moraga than protecting her past, which is rapidly unraveling into nothingness inside her mother's diseased mind. Moraga no longer identifies with Coyolxauhqui but

now identifies as "daughter of Coyote," Coyote being the trickster figure most identified with a particular Southwestern United States native religious tradition yet whose significance is also found as far south as Oaxaca, Mexico. As a trickster, the mother steals that which she desires. For Moraga that desire is memory, taken by the mother and stashed into the edges of an unreachable mind. In her final description of her mother's passing Moraga writes of her mother's spirit as Coyote, who *"when you least expect it . . . leaps out of the snarl of blackberry bush and flashes across the roadway. You nearly hit him, but then he gets away with it, meat between his teeth."*[68] For Moraga, that meat is the memory that her mother snatches away, the stories and the past. While this visualization of Elvira as crafty Coyote empowers the mother with agency to run free into the unknown with ownership of her stories, Moraga is left behind with only the desolate realization of a new form of fragmentation.

This new fragmentation is Moraga's sense of self as only a partial story or a vulnerable and fleeting memory that will be forgotten. When Elvira departs, like Coyote, she takes stories that were never Moraga's to claim and, in the process, takes pieces of Moraga's family and cultural history. At the book reading, Moraga rejected the idea that *Native Country of the Heart* is a biography or autobiography, calling it rather a memoir that shapes a strand of her life into a "portrait of a relationship." Moraga no longer trusts (auto)biography—only the brief glimpses of interactions between those who travel together-apart, herself and her mother, one unit from the same light source who then splinter to pass narrow openings into altered and varied beam lanes. Moraga's goal, however, differs from Coyote in that Moraga insists on sharing the meat (the stories), claiming historical narratives and cultural rhetorics, mourning together the gaps in that history and culture, and building communities of storytellers that will help to preserve cultural memory from continued threats of loss. In this way, Moraga's efforts parallel my own as I endeavor to address historical gaps in Chicanx rhetorics of self.

However, it is important to note that when Coyote runs away with the meat in *Native Country of the Heart*, a story is repossessed by its storyteller. While mourning that stories and storytelling rhetorics are lost along with our elders, we might be comforted that the owner maintains custody. Still, *The Wound and the Stitch* focuses on disrupted historical lineages and how such disruption disempowers our contemporary Chicanx rhetors, whether this disruption occurs from the loss of our ancestors or suppression by ongoing structures of coloniality. Accordingly, my project continues to retrieve from obscurity a specific

Chicanx rhetorical strategy that situates woundedness as a conceptual lens through which to analyze self-representational strategies that urgently confront violations against body and challenge normalized categories placed on Chicanx identities. My hope is that by studying our rhetorical antecedents, today's Chicanx rhetors might fortify our custody over our own stories and our rhetorical sovereignty in those storytellings.

Part 2

The Inflicted Wound

Stories of violations against Chicanx female reproductive organs are among the most private and protected narratives and belong strictly under the custody and control of each storyteller. When a historical Californian grouping of these storytellers chose to share their intimate reports of woundedness in a public forum through the 1978 filing of *Madrigal v. Quilligan*, a federal class action lawsuit, it was to seek redress at a personal, community, civic, and legal level. The storytellers advanced their purpose, yet in subsequent decades, their stories have also been rhetorically resituated. Most recently in 2015, producer Virginia Espino and director Renee Tajima-Peña released *No Más Bebés*, a documentary that relates allegations made in the *Madrigal v. Quilligan* case of nonconsensual sterilization procedures performed on Chicanas during the 1960s and 1970s. While contemporary reports of nonconsensual sterilization were filed nationwide, *No Más Bebés* focuses on accusations raised against medical staff at Los Angeles County-USC Medical Center by the *Madrigal* plaintiffs.

I esteem *No Más Bebés* as a retelling of the *Madrigal v. Quilligan* case by a director-producer team who are women of color and as a narrative that connects to my scholarship of institutional body violence that is indicative of larger national biopolitics. I have accordingly shared the documentary many times with

THE INFLICTED WOUND

students. Since the film's release, I have screened the film's fifty-three-minute edition sixteen times in various rhetoric, composition, and ethnic studies classes. In these classes, totaling 773 students, I have informally conducted post-screening debriefings and/or assigned short writing reflections on the film. My students overwhelmingly perceive three fundamental purposes served by the documentary: topmost, to raise greater awareness of female rights to their own bodies; second, to advocate language and reading accessibility to fully inform patients of medical rights and options; and third, to emphasize socioeconomic distinctions that disadvantage some women's health care. When I host post-screening debriefings with my students, these three topics dominate discussion. What I find striking is that my classes—all of which are situated in a Latinx Studies department—rarely consider the primary purpose of No Más Bebés as advocating racial, or specifically Chicana, body rights. When race enters our discussion, it tends to be linked to socioeconomic issues, namely that only poor brown and Black demographics go to county hospitals and that institutions do not value poor, dark-skinned lives. My students observe that No Más Bebés features a woman's journey riddled by patriarchal obstacles that are worsened by socioeconomic biases, but not a journey of a specifically dark-skinned woman who may be signaling a call for continued redress for violations against bodies like her own.

When students do speak of Chicanas in the documentary, they mostly do so with the pride and respect they feel as they celebrate the Madrigal Ten (the ten Chicana plaintiffs) for bravely contesting an unjust system. My classes overwhelmingly support the Chicana heroines. Interestingly, while the students watch the plaintiffs lose their case in No Más Bebés, few consider the legal loss significant in a lasting way, even if it was an outrageous judicial blunder. Discussions in my classes express a sense of victory as students feel that the Chicanas win the trial in the court of public opinion, evidenced by consequential pressures to modify medical procedural requirements. While it pleases me to watch class after class declare the Madrigal Ten heroes and to celebrate change and victory regardless of the case ruling, I am troubled that my students leave the screening feeling little conviction to address the plaintiffs' grievances. That is to say, No Más Bebés inspires my students to feel that Chicanas can contribute to ongoing protections of female reproductive rights. Yet I wonder why students consistently broaden their discussions of these Chicana plaintiffs to national issues of general female reproductive rights. This raises the question: how do Chicanx rhetors—in this case, Chicana plaintiffs who collaborated to

direct private mourning into community testimonial—maintain control of the activism and redress they seek?

While I claim that Chicanx self-representation of fragmentation through rhetorics of woundedness can be generative, they can also be exploited by an outside gaze, even when seeking alliances with adjoining demographics. Furthermore, when the expression of woundedness is situated in institutionalized violations against the physical body instead of in the metaphorical, new vulnerabilities develop. We are no longer traveling an inner story of self, as in our discussion of Moraga's rhetorics of woundedness; we are considering public stories of body, specifically Chicanx female bodies that have too often been repurposed as bridges of access by allies or borders of denial by antagonists. I specifically worry that when narratives isolate a woman's journey from conditions of race, culture, and class, the narrative's destination can often be relocated to benefit exterior forces more extensively than those wounded.

My concerns recall Maria Lugones's argument in "Toward a Decolonial Feminism" (2010), which raises a shocking yet thought-provoking consideration: does the idea of intersectionality negate the possibility for "brown women" to exist? Mainly associated with feminist theory but also highly useful in studies of sexual identities and racial identities, *intersectionality* functions on the visualization of an identity that lives at crossroads. If we imagine an individual as a unique location of identity, we might visualize this individual as a spatial marker who consists of a potentially limitless range of roads that converge to define the individual. Roads lead to this crossroad or intersection to usher a stream of experiences that all meet (sometimes in a crashing conflict and other times in gentle motion). Yet Lugones asks us to consider if a person's aspects are ever separable to visualize as roads that travel apart. Indeed, Lugones considers intersectionality an extension of colonial reduction systems that isolate fragments of selves.[1] These concepts build on her seminal 2008 essay, "The Coloniality of Gender," in which Lugones notes that Kimberlé Crenshaw and other feminists of color understand categories as representing a dominant group norm; thus "women" denotes white middle-class women, and "brown" denotes Chicano heterosexual men, notably excluding Black heterosexual Chicanos and Latinos. Lugones argues that focus on categories inherently "distorts what exists at the intersection," a distortion that impacts perceptions of violence against women of color.[2]

I consider perceptions of ongoing violence against Chicanas at each of my post-screening discussions of *No Más Bebés* as my students continue to relocate

Chicanas from the intersection and into the isolated pathway of "women." This isolation signals audience tendency to recognize more dominant narratives of violations against women's reproductive rights rather than entrenched biopolitical targeting of racialized female bodies. By isolating Chicana identity fragments away from the intersection, audiences might not detect the need to act in defense of Chicanas—only in defense of women's continued rights to reproductive choices. While this attention to "woman" absolutely fits the context that motivated the Madrigal Ten to testify, given the horrendous violations that the rhetors suffered in their reproductive lives, somewhere in the telling of *No Más Bebés*, the rhetorics of woundedness as distinctive to Chicanx female narratives becomes secondary and subjugated for many of my student audiences. The illegibility of Chicanx rhetorics of woundedness here highlights the existence of audiences who might be unaccustomed to detecting specific Chicana rhetorical traditions and the domination of prominent narratives that deliberately or unintentionally extend institutional silencing of grievances experienced and articulated by female Chicanx rhetors.

Since 2018, with the more prominent media coverage of Latin American immigrant detention camps and reports of abuse and neglect against youth and female bodies, my students have increasingly begun to link their considerations of nonconsensual sterilizations of Chicanas as depicted in *No Más Bebés* with a larger lack of care for immigrant bodies. Yet these links are tentative and insecure. This may be because students entering ethnic studies courses do not often possess the training to confidently diagnose common grievances between Chicana mothers under the care of medical institutions and Mexican migrants detained under law enforcement. That is to say, for many audiences, the "brown woman" is more "brown" or more "woman" in various situations—perhaps testifying to Lugones's argument that the "brown woman" cannot exist when larger dominant group norms lay claim to pieces that comprise the "brown woman" beyond the intersection. Prevailing narratives deter audiences from confidently asserting links among a range of institutional violences committed against the "brown woman" as part of a specific targeting of lives, specifically wombs, as in need of border patrolling.

At its best, intersectionality performs exactly that for which rhetorics of woundedness and fragmentation practice—articulations of distinct identity pieces that together-apart construct one's overlapping and complicated social realities. However, the idea of separate pathways before and after the crossing space interests me. While I do not criticize the acknowledgment of meeting points

at intersections, I wonder what might be lost by conceptualizing fragments of selves that sporadically pass at crossroads yet otherwise travel prolonged, disconnected pathways. Indeed, I perceive risk in these isolated identities since attention to the categories underestimates the manner that, all along, pieces of identities inform one another both in knowledge of self and in compounded engagements with external realities.

I also wonder what vulnerabilities might arise when "brown women" are conceptualized as existing only at the metaphorical intersection. While spaces of intersectionality function as locations of diagnosing various factors that inflict Chicanx identities and realities, can the conceptualization of separate pathways leading to and from the intersection be derailed and controlled by dominating biopolitical forces—thereby leading to a misdiagnosis of Chicanx female woundedness? Furthermore, when "brown women" are then redirected beyond crossroads to split their identities along various isolated identity-avenues, what are the tolls that Chicanas must deliver when navigating more socially legitimized roadways, such as the Chicano Boulevard or White Feminist Avenue? I fear that this commandeering of Chicana agendas steers praxis outward for the benefit of others rather than being maintained in lived realities and needs of Chicana communities. Rather, I am interested in frameworks that understand identity fragments as pieces that may not always travel on the same lane or at the same speed yet still constantly collaborate to advance, navigate, and collide in one's journey as, for example, "brown women."

The above concerns dominate part 2 of *The Wound and the Stitch*, wherein I examine biopolitical control of Chicanx bodies and identities—and the consequential impact on rhetorics of woundedness. Of special interest are moments when rhetorical potencies of pain and sacrifice are perceived to serve isolated identity-avenues rather than remaining centralized at the location of woundedness. Appropriation of Chicanx woundedness steers pain outward for the benefit of others rather than the inflicted. Part 2 focuses on three chief concerns: first, the compartmentalization of Chicanx experiences; second, ways that isolated identity strands impact audience (mis)perceptions of rhetorics of woundedness; finally, misdiagnosis.

Chapter 3, "Biopolitics and 'Crying Wounds' in *No Más Bebés*," addresses the first two concerns as I explore the compartmentalization of Chicana rhetorics and audience reactions to the body violations expressed in *No Más Bebés*. *No Más Bebés* provides two productive opportunities: first, it demonstrates the inflicted wound as a form of institutionalized border patrol that violates Chicana

bodies; and second, I critically engage with the possible impact of the film's emphasis on female motherly roles as a universalizing rather than a race- and body-specific discussion. I examine possible outcomes of placing fragments of identities into tidy gridwork patterns and the potential impact of categorization systems that divide and obscure an individual's (and community's) realities.

In chapter 4, "Border-Patrolling Chicana Bodies and Wound Theory as Resistance," I focus on the impacts of misdiagnosis, or that which Lugones perceives as distortions at intersections. Yet I extend this distortion to not just Chicana identity but Chicana grievances. Recalling my students' difficulties in perceiving that a grievance—many grievances, in fact—still need redress for the Chicana plaintiffs in *No Más Bebés* and for continued biopolitical violations against Chicana bodies, I note that just as a person's complexity of identity is obscured by compartmentalizing each self into isolated pathways, similarly obscured are the perpetrators. Naming the assaults as, for example, "patriarchy" or "racism" disconnects the wound from the brown woman. The "woman" travels one road obstructed episodically by patriarchal injustices, while the "brown" travels another road impeded by bigotry. These separate pathways of assault do not permit a full examination of biopolitical patterns specific to the "brown woman." When the "brown woman" is at last conceptualized at intersections, she arrives with two separate perpetrators at her heels. Yet the concept of the two perpetrators conceals racism and patriarchy as often operating in coordination— particularly as a coordination in still active systems of coloniality. This is, indeed, a dangerous condition and advances my main query in chapter 4: how do we amplify and secure the voice that speaks from the wound so that expressed grievances direct redress to the wounded rather than being rhetorically resituated to heal another?

My goal for part 2 is to understand how the historical genealogy I trace of the rhetorical expression of generative wounds also accommodates a destructive repurposing of the very same rhetorics. The value of sacrifice as a Christological and Nahua metaphysical framework does find extra- and intra-cultural manipulation to turn the generative into an inflicted wound that silences and divides Chicanx communities. Before I delve deeper in part 3 into productive manifestations of rhetorics of woundedness in visual traditions, I must discern the flipside—the dangers of such rhetorical practices due to (il)legibility of vulnerabilities—and the possible strategies to fortify Chicanx custody over our own stories and storytelling.

To be clear, while part 1 defined the generative wound as a historical rhetorical strategy of employing one's fractured selves to access an interior method of survival and empowerment, part 2 studies non-generative inflictions that create and control externalized fragmentation to serve purposes only partially relevant, sometimes minimally so, to the wounded. That is, rhetorics of woundedness are managed or eclipsed to suit dominant narratives. The cost is the misdiagnosis of grievances and perpetrators. Another purpose of part 2 is to establish that I do not advocate woundedness but rather rhetorical methods of resistance against any sense of shame and semi-ness in the already-wounded. In short, here I focus on contrasting the rhetorical tradition of the generative wound with the non-generative repurposing of that tradition.

3

Biopolitics and "Crying Wounds" in *No Más Bebés*

The strategy of historical rhetorics of woundedness necessitates that woundedness in its complexity and entirety remains active at the site of conflict to access generative confrontation of the inflictor(s). In the virgenes abrideras, only through the engaged and frequent parting of Mary's praying hands can Mary's fragmented state reveal her pain. It is essential that within Mary's body, she carry the entirety of her wounded state, the narrative of her torment. Only with her entire narrative of woundedness can Mary confront sins that separate mother from son and divine from profane. In other words, the rhetoric of the generative wound, as it relates to Catholic female devotional rhetoric, is built on the premise that the wounded must control and contain her narrative. When rhetorics of woundedness are compartmentalized rather than addressed in their entirety, inflictions particular to the injured may become decentralized or secondary. For example, prayers that prioritize the need of the devout rather than reflect on the pain of Mary to reveal her blessedness and the sacrifice of Christ to reveal salvation may be rebuked as irreverent rather than pious. In short, rhetorics of woundedness prioritize the voice from the wound. Voices exterior to wounds disrupt and undermine pain's generative potentials and the messages they may impart.

Applying this concept to contemporary Chicanx inheritors of rhetorics of woundedness, female rhetors who express grievances of "brown women" do so to articulate individualized experience but concurrently confront perpetrators of the wound. When these wounds are reduced to only injuries that "brown" or "women" experience and relocated to isolated pathways, the testimony of pain becomes constrained to serve, for example, chiefly Chicano or feminist matters. Although attention to inflictions committed against these categories is undoubtedly valuable, precise examination of wounds that impact "brown women" is necessarily neglected in the process. To be clear, I do not advocate that Chicanas be removed from discussions of specific categories of experiences but rather

argue that Chicanas must also claim a discursive space in which their primary concerns are addressed and in which rhetorical strategies can be identified, practiced, and disseminated to attend to those primary concerns.

"Rhetorics of woundedness" is based on the principle that to mobilize care toward infliction, we must first observe each wound in its specific complexity and entirety, and second identify pathways that link particular inflictions to a larger neighborhood that suffers a similar—but not necessarily the same—epidemic.[1] We must also remain mindful that while the goal is to tend to the specific and whole wound, this goal is necessarily limited based on the inherently partial legibility of pain, and that the rhetor will always reserve sections of her narrative as exclusive to self. Nonetheless, the voice from the wound and that which it makes intelligible to external audiences must remain central in generative applications of rhetorics of woundedness. In chapter 3, I analyze how the lack of centrality and lack of cultivated discursive spaces for, about, and by Chicanas redirect mobilization from addressing specific grievances that dominate Chicanas' various experiences.

Just as I argued in chapter 2 that the "I" must be maintained in its multiplicity to reject colonial purging of the "not-I," chapter 3 asserts that infliction at the root of biopolitical wounds must be inspected in its multiplicity to avoid misdiagnosis—a misdiagnosis that all too often ministers to the feminist or Chicano but not specifically to the "brown woman." Away from the intersection, woundedness cannot be absolutely generative, and associated rhetorical traditions at the foundations of rhetorics of woundedness are more readily exploited. This is especially the case when we consider generative woundedness as informed by Catholic exaltations of sacrifice.[2]

The interweaving of a strand of Marianismo in rhetorics of woundedness is often plucked from the tapestry of this complicated rhetorical tradition in such a way as to resituate the speaker as a type of essentialized Chicana who graciously assents to suffering. Such repurposing of the rhetorical tradition at the core of *The Wound and the Stitch* essentializes Latin American and Latina women as opting to carry burdens silently while concurrently defying conditions of victimization through understated perseverance. Yet when this ideal figure is prodded to speak of woundedness, her words are framed into a narrative that does not grieve on her own account but instead guides others who the narrative deems exempt from the suffering that the essentialized Chicana bears. These types of repurposing of Chicana rhetorics of woundedness isolates and misapplies this one martyr aspect of the cultural rhetoric in such a way as to

manipulate that which is considered sanctioned and even sacred testimony of sacrifice for the betterment of a larger *familia*. At the privileging of dominant narratives, we witness a violation of our rhetorical strategies and abandonment of voices that call from the wound. Instead, essentializing ideals (and often their cautionary binary counterparts) are deployed as simulacra of real Chicana lives, conditions, and wants—thereby limiting the inflicted wound to speak of only aspects of pain that may be relevant to heal another.

Sanctioned Cries of Dismembered Chicana Docu-Bodies

The positive aspect of sacrifice is often defined through negative cautionary models. A traditional representation of Chicana cultural roles as sacrificer is framed by such a cautionary model, the *child*-sacrificing mother. La Llorona, for example, is the Mexican legend of the crying woman trapped between life and the afterlife as she is condemned to forever search for her children that she murdered. The legend of La Llorona is often studied as a colonial narrative that becomes linked with the Mexican figure of the historical Doña Marina (also known as Malintzin) and her mythologized construction as the more derogatorily referenced Malinche, yet La Llorona's narrative spreads throughout Latin American traditions. While no historical evidence locates the origin of La Llorona, studies have suggested that she derives from pre-contact traditions. Dennis Tedlock, for example, references La Llorona as the Wailing Woman (Xpuch) in his translation of the *Popol Vuh*.[3] Yet despite historical obscurities, the dominant imaginings that stem from colonial-era mythmaking depict the woman as a dreadful aberration from the female identity of life-giver.

Per this prevalent narrative of a failing mother, La Llorona is cursed to mourn for not only her lost children but the lost potential of her future. Her new identity is, thus, "the crier" (*la llorona*), an existence trapped in infinite grief. In the telling of the legend, it is significant that the crying, not the infanticide, is used as chief narrative method to strike terror in listeners. We never know why La Llorona murders her children, and we are never taken to the event of infanticide. This story is untold, since La Llorona can vocalize only primal pain that no human can possibly understand or even bear to hear; she is removed from humanity and, thereby, intelligibility. It might then be argued that this vocalization is its distinct social transgression. La Llorona expresses pain where it should not exist and cautions women to maintain traditional gender roles that

80 THE INFLICTED WOUND

call for the sacrifice of self in service, not destruction, of family. Just as crucial, the legend warns women to maintain silence in pain. After all, the terror of La Llorona is rooted in her crying.

In Cherríe Moraga's 1995 essay, "Looking for the Insatiable Woman," Moraga listens to the crying and determines its true horror—a silencing of Chicana voices. Moraga notes that no one knows the impetus behind La Llorona's act of infanticide. No one knows her story. Only part of her life is told by horrified exterior forces that have no tolerance for Mexicana and Chicana narratives.[4] Moraga writes that La Llorona "is the story that has never been told truly, the story of that hungry Mexican woman who is called puta/bruja/jota/loca because she refuses to forget that her half-life is not a natural born fact."[5] La Llorona must, therefore, forever search for her lost truths, hidden by society's hijacking of her story. She searches for her voice and consequential lost potentials. Ultimately, Moraga deems La Llorona's fate to be demonstrative of the dreaded cries for representation and redress by Chicana communities.

Such silenced grief is the subject of *No Más Bebés*, which recounts the class action civil rights lawsuit filed against Los Angeles County-USC Medical Center after a group of ten Chicana plaintiffs, also known as the Madrigal Ten, alleged that they had received nonconsensual sterilization procedures between 1971 and 1974. The ten plaintiffs include Guadalupe Acosta, Estella Benavides, Rebecca Figueroa, Helena Orozco, and the six interviewed in *No Más Bebés*: Consuelo Hermosillo, Maria Hurtado, Dolores Madrigal, Maria Figueroa, Melvina Hernández, and Jovita Rivera. Consulting these six members of the Madrigal Ten, the documentary holds the medical and judicial systems accountable for creating a version of the crying, wandering woman who inadvertently signed away the lives of her future children. The filmmakers create a space where the other half of the truth can be voiced and the horrors of the past might be put to rest. *No Más Bebés* extends work presented by executive producer Virginia Espino from her 2007 dissertation "Women Sterilized as They Give Birth: Population Control, Eugenics, and Social Protest in the Twentieth-Century United States." Espino's dissertation challenges notions that eugenics during this period were limited to cases of the criminal and mentally ill whose rights were revoked to allow nonconsensual sterilization procedures. Accordingly, Espino exposes how non-disabled, non-incarcerated women also had their right to consent violated.

No Más Bebés continues Espino's efforts to humanize and make intelligible hidden narratives that reject half-truths. However, once this message is performed, pain is again covered. Crying must stop because the Madrigal Ten are

deemed survivors, heroes who, in their private family lives, are now rightfully fulfilled by grandchildren and who, in their public lives, are justly satisfied by procedural changes resulting from their honorable sacrifices. While there is undoubtedly positive social and personal validation in the portrayal of the women, I question if this portrayal reinforces a pervasive silencing of Chicana pain—even if silence is performed as a positive closure of wounds. Posed another way, are the plaintiffs' wounds opened to generate awareness for their own restitution?

While the documentary gives voice to the plaintiffs' grievance and does so to address the silencing of Chicanas by medical and legal institutes, the film concurrently prioritizes "women." This may lead some audiences, who are socially prepared by mainstream media to more readily perceive narratives of women's body rights, to overlook specific "brown women" issues that are also contained in *No Más Bebés*. That is to say, "brown women" are silenced beneath the prominence of "women" voices all too often when narratives expand the focus beyond Chicana-specific lived contexts. Espino's dissertation maintains a tighter focus on the "brown woman" and more firmly links sterilization to racial targeting. Yet the documentary indicates, at times subtly and other times openly, a broader feminist agenda as a driving motivation behind the Madrigal Ten, which, I argue, triggers mainstream codes for audiences to hone into "women's" issues that absorb Chicana-specific realities. We see this indicated in the closing credits to *No Más Bebés* as it dedicates itself "to the women of *Madrigal v. Quilligan* and their fight for reproductive justice," potentially reframing the lawsuit as redressing the wounds against women's rights rather than a personal woundedness.

My study of *No Más Bebés* contemplates how audiences—such as my students prior to their familiarization with rhetorics of woundedness, diverse Chicana-specific lived realities, and biopolitical theories on institutionalized racial violences—might overlook nonconsensual sterilizations as a phenomenon that includes yet extends beyond general women's rights to their bodies. Such audience experiences do not reflect poorly on *No Más Bebés*, which I highly esteem, but rather raises discussion on how difficult it may be for mainstream audiences to detect Chicana rhetorics and grievances. That is to say, I consider audience reception here. Still, *No Más Bebés* provides an essential vehicle through which I illustrate ways that audiences might misread rhetorics of woundedness. This misreading results from how articulations of Chicana grievances are often obscured under mainstream dominant narratives. While *No Más Bebés* clearly directs attention to the painful and immensely personal

injustices of sterilization during the 1960s and 1970s, there is no claim that injustices continue for these Chicanas or women from their specific demographic—except in the silence about this past, which the film proceeds to correct by giving them voice.

Interestingly, a brief boom of transdisciplinary scholarly attention to *Madrigal v. Quilligan* occurred in the decade preceding the documentary, such as Myla Vicenti Carpio's "The Lost Generation: American Indian Women and Sterilization Abuse" (*Social Justice*, 2004), Alexandra Minna Stern's "Sterilized in the Name of Public Health: Race, Immigration, and Reproductive Control in Modern California" (*American Journal of Public Health*, 2005), Jessica Enoch's "Survival Stories: Feminist Historiographic Approaches to Chicana Rhetorics of Sterilization Abuse" (*Rhetoric Society Quarterly*, 2005), Derek H. Suite et al.'s "Beyond Misdiagnosis, Misunderstanding and Mistrust: Relevance of the Historical Perspective in the Medical and Mental Health Treatment of People of Color" (*Journal of National Medical Association*, 2007), and Rebecca M. Kluchin's "Locating the Voices of the Sterilized" (*The Public Historian*, 2007). While representing a wide range of interests in social studies, medical humanities, rhetoric, and history, all these revisits of the *Madrigal v. Quilligan* case distinctly contrast the past and present—a critical point to make because this move means that the wound remains temporally distant at a specific historical period from which now a message can arise to benefit a more present agenda.

To reinforce this point, as each plaintiff recalls her most profound moments of pain, *No Más Bebés* consistently interjects predominately cheerful family scenes from the women's post-sterilization lives. A significant temporal distancing thus buffers the audience from the wound, allowing the plaintiffs' narratives to be extrapolated for more modern and immediate purposes. This distinction between past violations and present needs is initially established in director Tajima-Peña's choice to stage the film's opening images in the vacated rooms of County hospital where the sterilizations had occurred, vacant now as the building does not conform to new California earthquake safety laws. The setting is of the past, where long white corridors and cold examination beds evoke an eerie emptiness. Visual choices in this opening scene emphasize spaces void of life. Entering a patient room, the camera zooms toward the ceiling at the rail of a curtain divider, the curtain rings still dangling but without curtains since no patients remain to be concealed. Yet, while Tajima-Peña opens with this haunting, lingering emptiness, it is only a painful reminder rather than an active agent of the past.

Fig. 5 | Still of Maria Hurtado, *No Más Bebés*, PBS, 2015. Directed by Renee Tajima-Peña. Produced by Virginia Espino. Image courtesy of Renee Tajima-Peña and Virginia Espino. Photo: Claudio Rocha.

Remembering this past, the first heroine of the documentary, Maria Hurtado, leads the film crew through the hospital maternity ward. With her adult daughter by her side, Hurtado attempts to locate the rooms she inhabited during sterilization and, in the process, encounters an infant infirmary crib (fig. 5). Activity pauses for thirteen seconds as Hurtado stands beside the crib, her body cut by the camera frame below the chest as her voice from offscreen testifies to her tragedy. The empty crib is the primary focus here. Only Hurtado's hands are shown, resting over the transparent plastic edges surrounding the crib's head and foot. This poignant moment of reflection is thereby not expressed in Hurtado's face or body language except that her hands are still, perhaps even relaxed. Her fingers—thickly aged but healthy in fullness and elasticity—extend over the crib's plastic edge, the ring finger adorned by a chunky tri-band golden wedding ring. These are not the hands of a young mother but those of a life lived with an implied steadiness, healthiness, and family. Still, the empty crib is testament enough to Hurtado's past pain. The empty crib recalls family members who were never allowed into the life Hurtado has lived. Much can be imagined in the positioning of this scene—hands denied the touch of the baby who might have filled the crib's void. Still, Hurtado's identity is removed. Her body is fragmented into parts to represent the tragedy, but not necessarily to represent herself. Most dominant is her part as a woman, a potential mother.

Also dominant in this scene is a surprising racial negation. During Hurtado's fragmentation, in Spanish she narrates that she felt targeted for the way she looked, but she does not allude to race or gender. Instead, she speaks of temperament: "They looked at me and must have thought, 'This one has so many children. We will just sew her up, so she won't know that we did the operation.' I'm not one to show a lot of sweetness or tenderness or pain because I look tough." As the recollection concludes, the camera withdraws from the crib to show Hurtado standing with her daughter. Hurtado continues, "Inside, I feel pain remembering. But apparently, it doesn't show."[6] Her voice breaks; she begins to cry, which cues the graphics of the documentary title to fill the screen. The narrative may now begin as Hurtado's arms spread around the empty crib to expose a hidden suffering.

We might recall Laura Mulvey's film theories on the positioning of females in camera frames as objects of investigation, penetration, and consumption.[7] Mulvey argues that the camera's gaze often functions as an annihilation of female subjects to launch a primary purpose advanced by the privileged camera-controller, a surrogate of the male gaze. In this moment of *No Más Bebés*, Hurtado's exterior is breached so that the film's narrative may launch. Her strength collapses, revealing the secret behind the woman: she can still be moved to emotionally wander the County corridors of her past, searching for her lost children. Her wound opens with her cry, revealing the horror of a traumatic narrative that is film-sanctioned. Crying is permitted now. Hurtado's past is suddenly present, but it functions at this moment not to trigger audience advocacy so much as to activate audience sympathy. This penetration of Hurtado's persona functions as a humanization, not exclusively of Hurtado but of a court case that is significant for female reproductive rights.

Here, it is helpful to consider Pooja Rangan's criticism that the documentary genre's desire to persuade audiences to legitimize as human those "othered" due to political or economic conditions may, in actuality, participate in dehumanization.[8] In *No Más Bebés*, we can interpret a demonstration of this dehumanization in the opening scene when Hurtado is redefined from a complete woman who wanders halls of her past into a fragmented identity when the camera reduces her to solely hands by an empty crib. Hurtado is made nonhuman in this pivotal moment—the faceless victim of sterilization. Her voice continues, but, recalling Rangan's argument, documentary filmmakers often limit voice under the film's qualifying conditions to give voice to the silenced. The qualifying condition in this scene is to turn strength (or toughness) into weakness (or

weeping), something that is perhaps culturally denied Hurtado through the dominant Marianismo convention of understated female perseverance. We might evoke, as well, the lesson conveyed in the La Llorona narrative to maintain silence even in pain. Yet Hurtado is permitted to be a crying woman searching for lost children to advance the film's narrative. Hence, Hurtado's view of herself as a tough individual is reevaluated for the audience's benefit.

It is also important to note that the grieving mother is made central here as a point developed from Espino's dissertation. The normative mother, rather than the deviant criminal or mentally ill, is a gateway to studying eugenics. This is perhaps a tactic to raise rhetorical pathos. Nevertheless, motherhood may not always inspire compassion for all audiences, particularly within a Spanish-speaking Chicana body. Accordingly, this mother must still be humanized beside the crib, as if her sterilization is not enough reason to empathize. The camera reconstitutes Hurtado from hands to human only when she breaks down in her daughter's arms. Crying, she now meets the film's condition for becoming humanized. No longer a stable figure of strength, Hurtado is relocated to the past to be again that young mother in deepest mourning. Yet that past does not directly impact the audience—only the humanization of the woman who recalls that past. As the film progresses more plaintiffs recall their pain, and this pain is more directly displayed without fragmented visuals. A constancy, though, is the continued sharp distinction between past and present. There remains for the viewer a distinct safety in the emphasis on temporal divisions. However, there is no safety for the plaintiffs, who must continue to reenter their wounds.

Perhaps the most powerful moment of suffering in *No Más Bebés* is toward the film's end. The now elderly plaintiff Consuelo Hermosillo is asked to listen to a cassette tape of her younger self testifying during a May 1978 pretrial recording session. Now sitting in her dining room with hands tightly clasped in contemplation, Hermosillo transforms with each word of testimony as the cassette plays and she gradually reenters her wound narrative. Unlike the opening scene when Hurtado must fragment into a body part before we can witness her pain, Hermosillo slowly alters in front of the camera, tears deepening the lines on her aged face as her youthful Spanish-speaking voice reaches from the past. Yet the voice of pain, as in Hurtado's scene, continues to be disembodied and reaching from beyond our view. With Hurtado, the painful recollection occurs as the camera focuses on the crib; with Hermosillo, the pained voice is tinny and tiny in an old cassette visibly spinning its playback. In both cases, we do not see

86 THE INFLICTED WOUND

the body, the mouth speaking. We hear only disembodied pain. The pain says: "I always dream I have my baby. I dream I get to Mexico with the baby. People want to see him. But I won't show them. Because I have a surprise. A miracle. He's something that's mine that nobody else can see. That's what I dream."[9] In this dream, now shared with the world, Hermosillo wishes to guard her secret miracle, a miracle that never manifests for her but highlights her desire for control over something entirely her own. She speaks of a baby but also of a yearning for self-determination, "something that's mine" and beyond another's control. The scene is heartbreaking as it summarizes the violation of family, body, and life; additionally, it temporally collapses spaces between the young, devastated voice from a dehumanizing past and the crying older woman who is now humanized so the audience may access her secrets and pains.

Yet does this scene call audiences to protect Hermosillo's rights or the rights of others like her? And, how are others like her? Indeed, what cause or demographic does Hermosillo claim, if any? I am inclined to deem that in this profoundly private moment between Hermosillo and her disembodied pain, no one else is present. The wound is specific to this woman. Indeed, during this scene, Hermosillo is lost in an illegible pain, a pain incomprehensible beyond the particular body and emotional experience that Hermosillo still endures. Yet all the while she sits in her kitchen, the camera attempts to articulate that pain and extract it. Again this recalls Rangan, who encourages us to question messages that are sent to society's "others" when they are asked to document themselves in order to claim their human rights.[10] For the women of *No Más Bebés*, there is a message that their articulated pain is honored and has led to landmark public changes in hospital procedures, but there is also a message that their unarticulated pain will receive no more address; their specific wounds need no more redress. Their past is not society's present. Only the pain that can be obtained and repackaged into a dominant exterior narrative will be treated—not for the wounded past but for a new future demographic. No one can recover and actualize Hermosillo's dream. Thus, the film's closing images tidy the painful narratives as the camera withdraws from Hermosillo, still sitting alone in her dining room, crying beside the cassette player as the voice from the past spins into silence (fig. 6).

The film ends, however, with a sense that these women are too powerful to remain too long in their past wounds. Unlike La Llorona, the plaintiffs know when to move on. A quick transition thus occurs at the film's conclusion that finalizes the separation of the past from the present, allowing the audience to

Fig. 6 | Still of Consuelo Hermosillo, *No Más Bebés*, PBS, 2015. Directed by Renee Tajima-Peña. Produced by Virginia Espino. Image courtesy of Renee Tajima-Peña and Virginia Espino. Photo: Claudio Rocha.

feel morally soothed by happier footage of the women's current lives. We see plaintiff Dolores Madrigal with an adult son as he tenderly watches his mother, the two immensely proud and relieved to learn of hospital procedural changes that the Madrigal Ten impacted; we see Hermosillo singing to her infant granddaughter, and Hurtado dancing with her husband. Further distancing pain, the film credits roll beside images of the plaintiffs as young adults in the 1970s, happy even in their past as they hold their children, graduate from school, and exude confidence as young working women. The film's parting impression is that these women were always brilliant and capable—human. Now, they are even more so—heroes, a claim the film certainly supports with great care and esteem. And while this positive viewing of the Madrigal Ten is a productive achievement in providing role models from a largely concealed history, how does it prod audiences toward action or reflection? What purpose does the opening of these heroes' wounds serve? Again, I recall my students in the varied courses that I teach in a Latinx Studies department, as they applaud the Chicana heroines yet also are satisfied to move on from the screening without further motivation to address the wounds expressed.

Pathways to Diagnosis, Rerouted

This point brings me to the second issue I wish to explore in part 2: how isolated identity strands impact audience (mis)perceptions of rhetorics of woundedness. I am concerned about appropriating Chicana rhetorics and histories to benefit an exterior agent. The result is a misdiagnosis of inflictions that "brown women" may face, or the inadequate treatment of their wounds. Certainly, one intention of director Renee Tajima-Peña is to afford the plaintiffs the opportunity to express their distressing experiences, and the plaintiffs are unquestionably positioned as sympathetic protagonists, both through interviews with the filmmakers and from original court proceedings. However, Tajima-Peña's self-professed objective filming ideology also offers voice and agency to the attorneys, medical staff, physicians, and administrators, many of whom complicate the plaintiffs' narratives. Accordingly, Tajima-Peña cautiously balances various arguments, a goal she expressed during a red-carpet interview at the film's 2015 Los Angeles Film Festival world premiere; Tajima-Peña intended to offer fair, journalistic objectivity to allow the audience opportunity to gain an informed take-away.[11]

Although the film does not judge the medical and legal establishments involved in the *Madrigal v. Quilligan* case, the narrative is framed to bring a debate on reproductive rights to the forefront. Yet what is the function of this debate? Does *No Más Bebés* generate audience awareness of woundedness as correlating with Chicana biopolitical targeting? More specifically, does *No Más Bebés* move discussion from female bodies to Chicana bodies, or do Chicana bodies serve primarily to advance a larger narrative of female reproduction rights? This raises the question: why were these women deemed a demographic that should be offered sterilization in the first place?

Approximately one-third of the way through the documentary, the film introduces archival 1960s and 1970s news footage of general concerns about population booms. These concerns are directly followed by an NBC news report of a Black mother contesting the sterilization of her two teenage daughters in Alabama. The NBC reporter notes that the mother's illiteracy may have contributed to the undesired sterilizations. Her use of a large "X" in lieu of her consenting signature seems important to the news report. The archival report is then addressed by modern interviews conducted by the *No Más Bebés* filmmakers, first with a physician who recalls the term "Mississippi Appendectomy" as commonly applied in the southern United States as code for systematic sterilization of low-income Black women. Following this scene in *No Más Bebés* is a

modern interview with Antonia Hernandez, attorney for the plaintiffs, who notes that Los Angeles County-USC Medical Center was only one institute among many nationwide that participated in female sterilization, usually of women from low economic status. Hernandez states, "It happened to white poor people in Appalachia, it happened to poor Black people, it happened to poor Latino people; it was that sense that poor people were having too many babies."[12] While the documentary argues that perceptions on socioeconomic and potentially related English literacy issues impacted medical sterilization practices—regardless of race—*No Más Bebés* chooses to narrate reproductive rights violations through Chicana bodies whose wounds are reopened for the advantage of the audience.

Although the County medical defendants are historically and legally depicted as victorious since they defeated the Madrigal Ten in court, the *No Más Bebés* filmmakers resist a one-sided portrayal of victory. This further fortifies the notion that the Chicanas need no redress—only perhaps acknowledgment and respect, which is surely valuable but does not address particular Chicana grievances. Recalling the moment of her legal defeat forty years later, Hernández recalls that although she had wanted to cry when the losing verdict had been read, she instead needed to "project strength" in defeat. Crying is not allowed at that moment; it would be solely self-serving when more work is left to be done for a larger demographic. The film shows some of the results of such work in the aforementioned scene where plaintiff Dolores Madrigal, now an older woman, listens to her adult son read aloud the resulting changes in hospital regulatory laws since *Madrigal v. Quilligan*. Madrigal weeps with joy. Yet, while the narrative resists defeat and presents honors to the Madrigal Ten and their lawyer through the assertion of moral and long-term procedural victories, it concurrently lessens the active need for action since the Chicanas' tears shift from pain to elation, they regain their steady toughness, and they accomplish private and social fulfillment. As a result, the film raises awareness about how Chicana bodies have been historically controlled but does not issue a call to action to stop continued control.

To raise this historical awareness during promotion of *No Más Bebés*, Espino and Tajima-Peña both emphasized their past blind spots regarding female reproductive rights, which had been overshadowed by their attention to abortion rights. Espino states in an interview with *Rewire* that she initially struggled to believe that sterilizations occurred at County, even after she admits to growing up with an awareness that County was "never a place that people wanted to

go for medical care; it was a place you had to [because you were poor], otherwise you stayed away from it."[13] Espino also states that she had not heard of *Madrigal v. Quilligan* until she was in graduate school (1995–2007) nor had she considered that reproductive rights extended beyond the issue of abortion. Tajima-Peña likewise admits to this lack of past awareness in the same interview, stating that "like a lot of other middle-class women, the question for me when it came to reproductive rights had always been: Do we have access to safe and legal abortion? Reproductive justice was a new idea to me. . . . What we don't talk about enough is that women also have a constitutional protection to give birth, and that some women have that right taken from them."[14] Tajima-Peña and Espino's realization that they had previously perceived a narrow platform on which to discuss rights to body seems shared by the *No Más Bebés* audience who, as the filmmakers note, overwhelmingly respond to the documentary's new insights in reproduction rights.[15] In the end, the documentary provides reproductive rights advocates an expanded awareness to serve their platform. Yet to what extent will that expansion be directed to benefit specifically Chicana bodies?

A hopeful note can be detected in the production support obtained from organizations such as California Latinas for Reproductive Justice (CLRJ) and National Latina Institute for Reproductive Health (NLIRH), both organizations aiming to secure Latina rights to reproductive health. The partnership with CLRJ and NLIRH is significant since the film reflects through the voices of politician Gloria Molina and journalist Claudia Dreifus that Chicana rights were often represented as a secondary issue during the 1970s by the Chicano Movement or overlooked by white feminists. The film interviews sociologist Elena Gutierrez who attests that Chicanas have now redefined their own feminist movement—claiming rights for abortion but also rights for as many children as they desire, an argument that was not prevalent in historical white feminist groups. However, the film's emphasis on the need to recognize Chicana advocates seems answered and now advanced to recent issues, again positioning the needs of Chicana bodies in the past. This sense of moving on to new problems also relates to the film's other partnerships with organizations that promote social change through political awareness and cultivation of voice, such as Chicken & Egg Pictures, which supports women nonfiction filmmakers whose artful and innovative storytelling catalyzes social change, and Voto Latino, a media organization that spotlights Latino leadership. Again, the fact that these organizations are present as support for the documentary indicates a shift in representation both in media and in leadership. Accordingly, the film's primary

audiences are female reproductive rights activists and Latinx legal and political organizations who raise awareness of *Madrigal v. Quilligan* to honor the plaintiffs' past and invite the continuation of the spirit of this now-humanized case to address current needs. Yet, what are these current needs regarding Chicana populations?

To recap the story with which I launched part 2, in my university classes I have screened *No Más Bebés* sixteen times for a total of 773 students. My students overwhelmingly perceive three primary purposes: first, to advocate for female body rights; second, to advocate for multilingual and multi-reading-level accessibility on medical forms; and third, to advocate for attention to socioeconomic inequities in health care. Though my classes are situated in a Latinx Studies department, rarely do students observe the documentary's advocacy for racial issues. My students perceive race as a contextual condition connected to language and reading complications, as well as socioeconomic medical inequities. They make a tighter connection between language/reading and socioeconomic inequities and the nonconsensual aspect of the case. My students seem to understand that sterilization procedures, as related in *No Más Bebés*, occurred partially due to patients' struggles with language skills and/or incomprehension of medical terms and processes.

One scene from the documentary that fortifies this notion is when various plaintiffs express that they misunderstood "sterilization" as a "cleaning" and "tubal ligations" as a "tying of tubes" that could then be "untied" when pregnancy might later be desired. Within this narrative, language (beyond yet also including Spanish-English translation issues) and education contribute to miscommunications that involve violations of reproductive rights. While these compiling factors indeed are present in the *Madrigal v. Quilligan* case, race is observed chiefly by my students as factoring into socioeconomic inequities that created frameworks where a lack of bridges between the medical and the Chicana understanding of tubal ligation led to tragic, unwanted sterilization. This focus on communication disconnections is concerning in its evasion of race and biopolitics as well as its possible implication that the burden to address miscommunications might be partially shared with the patient, whose language and education skills might also be examined as part of the problem. Indeed, in nearly every one of my post-screening talks with my students, at least one student inevitably comments that *it's important to read everything before you sign it*. Such a sentiment strikingly echoes the film's footage of the 1970s NBC news report that indicated a Black mother's illiteracy as contributing to the problem. This is a

form of victim-blaming rather than an examination of institutionalized targeting of demographics or racial inequities in educational, medical, and judicial systems.

No Más Bebés does express various opinions from plaintiffs and witnesses that sterilization procedures would be less likely to be offered and practiced on a white middle-class female patient. However, by emphasizing language and education as contributors to both the problem and the solution—that the Chicana plaintiffs and my students later applaud in victory—the documentary centers woundedness as based on a patient's non-normative communicative skills (as contrasted with normative communicative skills acquired in educational experiences of middle-class, English-fluent speakers). The documentary's attention in this regard responds to findings in the court case. The Madrigal Ten lose their case because the presiding judge, Jesse Curtis, Jr., deems the plaintiffs' language needs and "subcultural" perspectives as demanding accommodation beyond the reach that medical professionals can reasonably be expected to serve. In other words, while the judge did see a bias, he believed it was directed against Chicanas due not to race or illegalities but due to epistemological hierarchies that the law system cannot address. Yet, in decolonial understanding, these epistemological hierarchies create notions that since one is less knowing, one is less human. In this case, the "less knowing" is understood within frameworks of language and cultural perspectives. A consequence in *No Más Bebés* is that language and knowing as it relates, first, to socioeconomics and, second, to race become the crucial issues. The resultant miscommunications aggravate gendered biases against a woman's rights to body.

It is interesting to recall that in the opening scene of *No Más Bebés*, Maria Hurtado does not state that her gender, race, or economic status influenced doctors to sterilize her. Of note is that she also does not point to language as an issue—even though she is the only featured plaintiff in the documentary whose interview is entirely in Spanish. Hurtado instead expresses that her "tough" appearance led to the assumption that she would feel no hurt or sadness, implying a lack of ramifications should a perpetrator target her. While *No Más Bebés* emphasizes that other factors, particularly language and socioeconomic biases, may have guided systematic sterilizations, Hurtado's comments reveal an aspect that marks Chicana biopolitics within a distinct grouping that necessitates its own attention. There is a narrative type of the essentialized Chicana as a willing sacrifice, a tough woman who can carry burdens silently and who will defy conditions of victimization through understated perseverance. There are fundamental

Marian principles in this willing sacrifice, recalling such Christian traditions as the acquiescent Virgin Mary, who immediately and graciously assents at the Annunciation to all the sacrifice she is to carry, witness, and suffer as Christ's bearer. Indeed, this sort of tough perseverance with grace and silence under extreme duress is the root of Marianismo as a female cultural ideal in Latin American and Latinx gender role traditions, providing an iconic female counterpart to male machismo.

This speaks to the historical genealogy of strategic rhetorical responses to woundedness that I trace. Yet, the Marian rhetorical traditions that concern my studies are those that position Mary as concurrently a testifier against sin—the *virgen abridera* that reveals wounds to suit her *own* agenda. Traces of this positioning can be perceived in Hurtado's statement as both a source of identity and a source of misperception as to what that identity is truly denoting. Hurtado's defiant tone, set jaw, and occasional apathetic shrugs when she relates her memories throughout the documentary hint at a strategy of the wound as transformed into a generative source of counter-strength that she claims as toughness. Yet it is also this same "toughness" that Hurtado believes initially misled physicians to target her as a person who could emotionally cope with sterilization and the later misperceptions that she was unaffected by such violations.

No Más Bebés addresses this misperception and pierces Hurtado's emotions to display the human beneath the tough mask. Significantly, this mask is traditionally constructed by a segment of Chicana culture to sacrifice one's inner needs so one might willfully give of self, body, and opportunity to secure one's agenda, which is often focused on obtaining immediate benefit for *la familia* (usually children). Interestingly, in the narrative framework of *No Más Bebés*, it is society that seizes the role of *la familia*. The Chicanas' pains are opened as heroic sacrifices for progress and opportunity to benefit an extended *familia* of future feminists. While much scholarship has been focused on representation in popular culture of a colonial trope casting the brown woman as a self-sacrificing love interest for male protagonists so that, in the end, the white lover might unite with a white female protagonist, here we might note a variation on this formula.[16] The Chicana's sacrifice more directly empowers the white female protagonist. In return, sacrifice is reframed, denying Chicana victimhood or woundedness in order to spotlight heroism.

Interestingly, this reframing of sacrifice recalls colonial myths of modernity where the pursuit of human progress allows for no victims—just a sense of rightful advancement. Enrique Dussel's argument about the myth of modernity

again joins our conversation here as Dussel criticizes notions of victimization as part of civilizing journeys, as "redemptive sacrifices" contribute to the progress of collective modernity.[17] Building from this point, we might interpret Hurtado as still very much in pain as she emotionally wanders hospital hallways in search of lost children, but her woundedness is silenced until the film needs her to cry—to open her arms around the empty crib and thereby expose the hidden narratives in her heart. This opening occurs to provide progress for exterior needs. When the film has made sufficient use of her pain, she may fold her arms again to brace herself in the guise of toughness, practicing a Christological form of redemptive sacrifice rather than claiming victimhood.

This control of Hurtado's wound speaks to the motivations behind Cherríe Moraga's desire to represent Chicana bodies and narratives by making prominent pain—not toughness. Insistence on victimhood counters myths of modernity that build on colonizing narrative fictions that sacrifices made by brown bodies advance civilization. Moraga's strategy is to maintain one's wounded state to deny colonial fictions. We might recall from part 1 Moraga's insistence that the aggrieved maintain the wound as a private illegibility but also that one processes a public legibility of the wound via the audience-self. In such a process, sacrifice and pain serve one's own generative purposes and fuel one's own empowering accusations. In this way, one might control one's woundedness to benefit one's definition of *la familia*—rather than permit a redefinition of who may benefit from Chicana sacrifices. Again, this is one contribution of *The Wound and the Stitch*: to make apparent that Chicana strategies to generate from the wound are part of a rhetorical confrontation that aims to make evident inflictions in order to actualize one's testimony and therefore to redress an immediate wrong against self and one's self-determined family. Only by knowing this rhetorical history can we fortify ownership of our rhetoric and cultivate discursive spaces for, about, and by Chicanas to address specific grievances that are central to various Chicana experiences.

4

Border-Patrolling Chicana Bodies and Wound Theory as Resistance

I wanted a second chance at life, and I wanted a second chance at being a mother. I trusted. . . . I trusted the surgeon to respect and to acknowledge that I still had a future and that I wanted one. I feel like I have been robbed of the fullness that could have been given to me had this not happened to me. Did this happen to me because I was African American? Did it happen to me because I was a woman? Did it happen to me because I was an inmate? Or did it happen to me because I was all three?
—Kelli Dillon, *Belly of the Beast*

In 2021, director Erika Cohn released *Belly of the Beast*, another documentary that centralizes nonconsensual sterilization of marginalized bodies in California. Specifically, the film discusses violations against body through accounts provided by Kelli Dillon, an African American female prison inmate who was sterilized without informed consent in 2001. The above quote is from Dillon's 2014 testimony to the California State Assembly Health Committee in support of a bill prohibiting inmate sterilization procedures as a form of birth control except in specified emergencies. Senate Bill 1135 would be later signed into law in July 2014 by then–California Governor Jerry Brown, making California the first state to provide both notifications of nonconsensual sterilization and reparations (with Assembly Bill 1764) to survivors who were sterilized while incarcerated in California women's prisons in addition to eugenics violations that date to the early 1900s.[1] Dillon's rhetoric here thereby ushered in a turning point for Californian law regarding systematized violations committed against particular bodies.

As in Maria Hurtado's sorrowful opening of *No Más Bebés*, humanization through a penetrating camera serves here as crucial advancement of the documentary's narrative. Significantly, however, this moment arrives at the pinnacle of *Belly of the Beast* when victory and redress finally draw within reach. The context

of the humanization moment also occurs as part of the rhetorical engagement with the state health committee rather than solely for film spectators. In context, Dillon sits at a long desk with a team of lawyers and advocates in front of the committee panel. She testifies calmly and methodically: "I wanted a second chance at life, and I wanted a second chance at being a mother." She continues, "I trusted . . . ," but must then pause. At that moment, the camera, as with Hurtado, breaches her. She brings to the forefront of her testimony a wound from the past that is suddenly present. She cries. She is humanized. Yet she quickly regains control of her narrative: "I trusted the surgeon to respect and to acknowledge that I still had a future and that I wanted one."[2] In this statement, a painful past anguishes her in the present and grievously limits her future—thereby denying safe temporal distance from the original wound.

Director Cohen assists Dillon's efforts to maintain central and active her woundedness. Overlapping the visuals of the committee hearing, we hear Dillon's later interview with filmmakers in the production of *Belly of the Beast*. This layering permits us to tap into Dillon's perspectives as a testifier before the committee and as her own responsive audience when reviewing testimony footage. We are given access to Dillon's reflections on her own rhetoric. She observes, "As I'm sitting here listening to myself, I'm saying to myself like, damn, this is a sad ass story! Where the fuck is my happy ending? I deserve a fresh new start. I'm ready to fall in love. I'm ready to be loved. I'm ready to have a home. I'm ready to see the world. I'm a good person that a lot of fucked up shit has happened to. I'm ready! I am so, so ready."[3] While this scene launches a victorious wrap-up of the documentary as the bill is approved by the committee and the narrative proceeds to offer audiences emotionally soothing images of Dillon in happier moments, *Belly of the Beast* resists putting Dillon's past to rest.

Instead, it puts into action Dillon's motivation as an audience of her own rhetoric. Dillon is ready for a happy ending. *Belly of the Beast* accordingly closes by advancing further redress through a reparations bill that the film's featured team of advocates and lawyers immediately put forward after successfully supporting the initial bill. This reparation bill (AB 1764) has been enacted, effective July 16, 2021, provides $4.5 million to be split evenly among all eligible individuals, and accepted applications until December 2023 from Californian women inmates who were sterilized without consent.[4] The loss and violations experienced by the impacted women most definitely do not obtain adequate compensation from this reparations bill. How does one put a price on such damages? Yet the wounds do maintain centrality for direct redress.[5] That is to say, the

wound that Dillon exposes and allows access to for the *Belly of the Beast* audience—while enormously costly to her—maintains discourse on the specific violated body, cultivating a rhetorical environment in which the primary concerns of the wounded are addressed even if complete compensation might never be actualized; further, it flattens temporal distancing from violation to clarify ripples of pain as extending across time to disadvantage the wounded, now and always.

Dillon's voice has not, then, been rhetorically resituated to stand in for a larger family of grievances.[6] Many lives can benefit and surely have already benefitted from Dillon's testimony, and many other wound narratives may correspond with Dillon's, but her own needs and the needs of those who she identifies as assaulted for similar purposes remain motivation for Dillon's narrative. It is also important to note the specific demographics that she identifies as targets of assault in seeking redress. In Dillon's testimony to the health committee, she highlights race as her first emphasis yet concludes by considering possible overlapping identity factors. "Did this happen to me because I was African American? Did it happen to me because I was a woman? Did it happen to me because I was an inmate? Or did it happen to me because I was all three?"[7] Opting to ground narratives of nonconsensual sterilization in specific violated bodies, *Belly of the Beast* acknowledges and supports what we might view as a form of rhetorical sovereignty, engaging inherent embodied and civic power to govern the self through articulation within one's elected modes, styles, and languages and to advance claims within public discourses.[8]

In the empowerment of rhetorical sovereignty, a narrative grounded in specific violated flesh most generatively confronts systematic agents of violence. This point brings our discussion to the third and final issue that I explore in part 2, which centers on the heightened vulnerability that may result from a lack of focus on the entire wounded state of women of color. Just as a person's complexity of identity is obscured by compartmentalizing each self into isolated pathways beyond the intersection, similarly obscured are perpetrators who become, for example, an archetypal "patriarchy" or "racism." When the woman of color is at last conceptualized at intersections, she accordingly arrives with two separate perpetrators at her heels. However, the concept of two distinct perpetrators who approach from differing avenues and perhaps differing motivations limits the full examination of biopolitical patterns specific to each wounded body and the institutions in which systematized coordination between, for example, patriarchy and racism collaborate. These notions return my thoughts

98 THE INFLICTED WOUND

to rhetorics of woundedness as initially employed by the Madrigal Ten during their historical testimony.

Rhetorical Sovereignty or Heroic Narratives—At What Cost?

Considering a possible method to maintain control of one's sacrifices, I turn to the rhetoric of the Madrigal Ten employed at the site of the original wound to perhaps glean insight into the infliction and inflictor. My purpose is to reach a more body-specific diagnosis of Chicana grievances. I accordingly endeavor to recover the Chicana plaintiffs' rhetoric from their 1970s pretrial and court testimony recordings and transcripts. In the 1970s testimony and pretrial interviews with the plaintiffs, there is a notably heightened rhetorical emphasis on accusation and specificity versus that we see in *No Más Bebés*. Understandably, temporal distance blunts the plaintiffs' recollection of their interactions with County employees when recounted decades later. Still, the particulars and vehemence that we see in the Madrigal Ten's original 1970s rhetoric concerning earlier descriptions of blatant lies and coercive measures that County physicians and medical staff allegedly stated directly to the plaintiffs are comparably subdued in *No Más Bebés*.

For example, Jovita Rivera, who is featured for a few seconds in *No Más Bebés* with a short comment on her impressions of the *Madrigal v. Quilligan* presiding judge, Jesse Curtis, Jr., testified in the 1970s as follows: "While I was in advanced labor and under anesthesia with complications in my expected childbirth and in great pain, the doctor told me that I had too many children, that I was poor, and a burden to the government and I should sign a paper not to have more children. . . . The doctors told me that my tubes could be untied."[9] Helena Orozco, not featured in *No Más Bebés*, testified that a "doctor said that if I did not consent to the tubal ligation that the doctor repairing my hernia would use an inferior type of stitching material which would break the next time I became pregnant, but that if I consented to the tubal ligation that the stitches would hold as proper string would be used."[10]

In her original testimony Hurtado, arguably the most prominent plaintiff in *No Más Bebés*, also offered a more definitive version of her interactions with doctors. Rather than assuming that her toughness led doctors to speculate that no questions would ever be asked about a nondisclosed procedure, Hurtado narrated direct interaction with the medical staff: "I was told by members of the

Medical Center's Staff, through a Spanish-speaking nurse as interpreter, that the State of California did not permit a woman to undergo more than three caesarean section operations and that since this was to be my third caesarean section, the doctor would have to do something."[11] All three testimonies indicate overt identity assaults ("I was poor and a burden to the government"), bodily threats ("the doctor repairing my hernia would use an inferior type of stitching material"), and coercive manipulation of truths ("since this was to be my third caesarean section, the doctor would have to do something"). I highlight these three statements because they indicate extreme violations against women's reproductive rights, and they are also symptomatic of biopolitical conditions based on perceptions of the women's intersecting racial, cultural, gendered, and economic demographics—which might indicate why the Madrigal Ten are relegated into specific disempowered states of exceptions, per biopolitical theory.

States of exceptions allude to a system of biopolitical control that relies on crisis to justify a move outside regular applications of law and common ethics. As Giorgio Agamben argues, states of exception are created when expectations of legal norms are suspended, yet the law is still maintained, thereby creating an exceptional "zone" in which application of the law is extended to unusual extremes.[12] In other words, the norm is no longer sufficient to protect and serve the law of the land, so in the maintenance of lawfulness, there must be a space of exception where assaults to identity and body as well as coercive manipulation of events are excused for the *greater good* of those in the normative state. Those in the zone of exception are those who are *let to die* or *let to be unconceived*, as in the case of the Chicanas' sterilization.

Contemporary with the *Madrigal v. Quilligan* case, Michel Foucault's central thesis in "Society Must be Defended" is that modern societies have created hierarchical forms of racism that determine which living beings might be deprived of resources to best serve collective preservation of the state; the state regularizes life to strengthen itself by segregating bodies that are determined advantageous for specific tasks. This occurs systematically over extended temporal periods. Here, Foucault defines biopolitics as dealing with population as a "political problem."[13] While Foucault does not offer examples of how populations are managed, he links the concept with inherent racism and ultimately defines racism as "the break between what must live and what must die."[14] Foucault's lack of specificity regarding race as related to body color rather than as a series of socioeconomic conditions opens him to criticism, notably from Alexander G. Weheliye.[15] However, Foucault's general theory lends itself to my discussion of

how perpetrators can be obscured when we consider discourse around the *Madrigal v. Quilligan* case. I assert that medical policies of exception based on racist border patrolling of Chicana wombs fundamentally impacted Chicana sterilization rates. Also informing my discussion is Judith Butler's examination of necropower, a form of biopolitical government processes that places designated demographics onto pathways toward death. Butler exposes discourses that imagine specific demographics as *unreal* lives as opposed to *real* lives. Butler suggests that when *unreal* lives are violated, violence goes unmarked, and the fact that there was once a life also goes unmarked and unnoticed.[16]

This returns me to *No Más Bebés* and the film's at-times constricted address as to why this specific Chicana demographic was historically considered so *unreal* or so lacking in humanity that sterilization became legitimate for both the medical institute and the court system. Why was (and is) it so difficult to see the *real* lives and the potential within these lives? Indeed, why is Hurtado "humanized" in the opening scene before we enter the narrative? Does the audience require proof of a brown woman's humanity to consider her a *real* life? My purpose in examining *Madrigal v. Quilligan* is to better understand a history of eugenics in California and the ongoing biopolitical structures that institutionalize racism. By separating that history from the present, we hinder the precise diagnosis of biopolitical control of Chicana bodies, a specific form of racial purging that border-patrols the wombs of this demographic to prevent future brown children. Such an argument recalls Abraham Acosta's studies of biopolitics as applied to brown bodies who *nunca llegarán*, "never will arrive."[17] While Acosta studies the physical border and immigration, I suggest that many United States institutions view the Chicana body as a symbolic borderland that must also be patrolled to prohibit those who must never arrive.

Again I am reminded of my observations in the classroom, and I think about the slow emergence of biopolitical musings by my students since 2018. While they do not define the events in the *Madrigal v. Quilligan* case as an example of biopolitics without my later prodding, they have begun to link their considerations of nonconsensual sterilizations with media coverage of Latin American immigrant detention camps and reports of abuse and neglect against youth and female bodies. Yet the students are not yet confident enough to fully associate narratives of border patrolling as a matter of monitoring illegal bodies moving into the United States with medical practices that trespass on legal bodies. Prevailing narratives on Chicanas deter audiences from asserting links among a

range of institutional violences committed against the "brown woman" as part of a specific targeting of lives, specifically wombs, as in need of border patrolling.

There have certainly been many scholarly examinations of events involving the border-patrolling of Chicana bodies. Sterilization through exposure to harmful chemicals and nonconsensual medical procedures are present in Californian historical and contemporary relations with Chicanas and migrant Mexican women. Indeed, California's general history of sterilizations is not hidden, as in 1909 the state openly adopted laws authorizing sterilization of those deemed "feebleminded." More scholarship is needed on possible correlations between social perceptions of "feeblemindedness" and an English-dominant legal system that might view the unintelligibility or illegibility of Spanish-speakers, non-fluent English speakers, or semilingual communicators as potentially legitimizing decisions to sterilize bodies. However, it is striking that the medical records of twentieth-century California's court-sanctioned nonconsensual sterilizations disproportionately feature Californians with Spanish surnames.[18] Indeed, associations between unintelligibility and the legitimization of nonconsensual sterilization procedures resonate in Curtis's ruling against the Madrigal Ten. The judge perceived the *Madrigal* plaintiffs' particular needs for clearly translated medical terminologies as a mark of "atypical" accommodations; Curtis deemed these "subcultural" nuances of understanding as beyond what medical professionals could reasonably be expected to oblige. Curtis's verdict asserted that regulations and services cannot anticipate the experiences of those outside the sociolinguistic norm.[19]

Perceptions of intelligibility and legibility in Californian nonconsensual sterilization cases are further complicated by racialized body and border patrolling. Adaljiza Sosa Riddell ties *Madrigal v. Quilligan* to a history of work-related health risks directed specifically at Chicanas, such as exposure of female farm workers to chemicals that contribute to infertility, congenital disabilities, stillbirths, and cancers. Sosa Riddell cautions that this history remains active in present-day realities as Chicanas continue to be a high-risk demographic for reproductive victimization as well as increased health dangers due to occupational segregation and exclusion from access to information, services, and decision-making in health-related policymaking.[20] While *No Más Bebés* also points at socioeconomics as a source of reproductive rights violation, Sosa Riddell links the socioeconomic context with racial constructs that, reminiscent of Foucault's biopolitics argument, segregate bodies that are determined as better

suited for specific worksite tasks. For Chicana bodies, all too often, as Sosa Riddell demonstrates, these tasks are associated with sterilization risks.

When these risks are coupled with reproductive violations from the medical community, a biopolitical condition must be examined for its correlation between race and economics—and in collaboration with protected laws that aid in body patrolling illegible individuals, deemed "feebleminded" due to sociolinguistic barriers. We see blatant markings of these biopolitical motivations in ongoing border and immigration discourses and policies. We might recall recent reports of border patrolling of immigrant female bodies in detention centers, such as in the Irwin County Detention Center, Georgia, which was under investigation for allegations of nonconsensual sterilizations from 2017 to 2020 when the whistle-blower nurse Dawn Wooten stepped forward to testify on medical abuse.[21] After an eighteen-month bipartisan investigation by the United States Senate's Permanent Subcommittee on Investigations, the congressional examination determined in 2022 that immigrant women held by United States Immigration and Customs Enforcement officials at the Georgia detention center likely underwent "unnecessary" invasive gynecological procedures, including full hysterectomies—in addition to prevalent general medical neglect and careless coronavirus safety measures.[22]

Such complicated connections among biopolitical conditions, race, language, gender, and economics that legitimize womb-patrolling are not presented in *No Más Bebés*. These realities are underplayed as the documentary distinguishes between the plaintiffs and less economically stable Chicana mothers. To counter prevalent stereotypes that Chicanas are economically disadvantaged and overburdened with too many children who they cannot afford, the documentary offers plentiful evidence of the plaintiffs as capable mothers in financially responsible households that desired and planned for a larger family. The documentary defies misperceptions of dependency and need. We see footage ranging from the 1970s to the 2010s of the plaintiffs enjoying dinner, music, and dancing in roomy green yards and bustling kitchens where all family members appear healthy, happy, and loving—beautiful lives that, while having experienced their own clear and real challenges, are seemingly limited only by exterior forces of population control. While the documentary's emphasis on the issue of population closely approaches discussions of biopolitics, *No Más Bebés* aims to present the plaintiffs as fully capable of making their own reproductive choices. This is undeniably a positive message that I applaud, yet I also perceive continued privileging of a heroic tale over an opportunity to also engage an epidemic biopolitical

system that denies a broader range of Chicanas the right to not only decide their reproductive choices but live in general wellness.

This dominant narrative in *No Más Bebés* and in the aforementioned surge of scholarship about *Madrigal v. Quilligan* also notably excludes particular voices or narrative threads. For example, Maria Figueroa's testimony is excluded from the recent scholarly reengagement with the case. In a 1975 *Los Angeles Times* article by Robert Rawitch, the only publication that I have located that preserves Figueroa's story, Figueroa claims that in June 1971, while she was in the throes of labor, and after initially refusing repeated solicitations for sterilization, she finally agreed to the procedure. However, she gave the doctors and medical staff one verbal stipulation. Rawitch quotes Figueroa as acknowledging to County personnel that she would consent to sterilization only "provided the baby [she was about to deliver] was a boy"; although she gave birth to a girl and signed no consent forms, the tubal ligation was still performed.[23] Figueroa has since faded from mention and can be located solely in archives. While Figueroa's availability for interview in later publications covering *Madrigal v. Quilligan* is not disclosed, I wonder if her testimony that sterilization would be acceptable had a son first been born does not fit recent mainstream narratives.

Also in predominant narratives constructed around *Madrigal v. Quilligan*, there is an assumed motivation placed on the plaintiffs—a desire to give voice to female issues. This framing of motivation and initiative often neglects historical contexts that the lawsuit participated in a broader effort organized by Ralph Nader's Health Research Group (HRG). In all scholarship that I have encountered on *Madrigal v. Quilligan*, this link to HRG is mentioned in the main narrative of only Rebecca M. Kluchin's "Locating the Voices of the Sterilized" and contemporary newspaper reports.[24] Indeed, a year prior to the 1974 *Madrigal* filing, Dr. Bernard Rosenfeld, who first approached Charles Nabarrette and Antonia Hernandez, later the attorneys for the plaintiffs in *Madrigal v. Quilligan*, had authored a 1973 report on sterilization abuses in hospitals as part of HRG efforts.[25] Rosenfeld had also assisted in the 1973–1974 *Relf v. Weinberge* Alabama lawsuit, filed on behalf of Mary Alice and Minnie Lee Relf after their nonconsensual sterilization.[26] In spring 1974, County-USC and Quilligan were already reacting to new federal regulations resulting from *Relf v. Weinberge* that proposed pathways to requiring "informed consent" such as consideration of language and educational needs, as well as the age of consent and a seventy-two-hour waiting period.[27]

While *No Más Bebés* features Rosenfeld prominently as a brave and essential whistle-blower, the larger context of his actions as part of Nader's HRG is not detailed. In her dissertation, however, *No Más Bebés* executive producer Virginia Espino references Rosenfeld's role in the Public Citizen Organization;[28] the HRG is a division of the organization. Jessica Enoch's 2007 study of *Madrigal v. Quilligan* also lists Rosenfeld's HRG report, published by Nader's Public Citizen Organization, in her bibliography, but the essay does not contextualize his role as whistle-blower in the County case or his direct contact with the *Madrigal* lawyers in the development of the case, the locating of plaintiffs, and the accessing of medical documents.[29] Additionally, Enoch and *No Más Bebés* briefly allude to the Alabama case but do not connect the case with Rosenfeld's efforts or recognize that policy changes initiated by *Relf v. Weinberge* were reinforced by the *Madrigal* plaintiffs rather than introduced.

I call attention to the omission of Maria Figueroa and HRG not to underplay the plaintiffs' brave action of asserting their voices or their specific agency and motivation but to emphasize the temporal distancing of the original testimonies that reframe those same actions to perhaps rhetorically suit a modern audience's sensibilities and needs. Studying the Madrigal rhetorics within the historical specificity of the 1970s and the power dynamics that shifted over the decades that led into the 2010s at the production and consumption of *No Más Bebés* would necessarily reframe performances of Chicana rhetoric. This prompts me to wonder if framing the plaintiffs now as heroes rather than defeated litigants also gives license to rhetorically resituate their pain. Does the celebration of the Madrigal Ten outside their original rhetorical situation heal their wounds? Or does celebration, while positive and rewarding, prematurely bandage the still-bleeding, still-speaking, still-relevant wounds so audiences might withdraw from the documentary soothed and ready to perhaps take action—not on these seemingly past injustices but on current ones elsewhere?

An Epilogue: Healed or Bleeding? A Concluding
Consideration of Wound Theory

A principal motivation behind my examination of rhetorics of woundedness is my belief that it is crucial not only to observe inflictions that impact Chicana wellness but also to observe rhetorical potentials once the wounded realize a cultural strategy that can address pain for generative advantage. I recognize that

by focusing on woundedness, we risk sending a message that a segment of Chicanas has and continues to find value in their wounds, as if we are willing participants in our own suffering. As previously discussed, this false reality may embolden perpetrators to purposely target those who can *take it* out of a misinterpreted performance of *toughness*, which is partly informed by Christological cultures of sacrifice and the idealization of Marianismo. My argument throughout, though, has been that when a demographic is consistently targeted by overlapping assailant forces working in coordination to deprive self-determination and wellness, rhetorical mechanisms must be identified and implemented to navigate wounded states. The mechanisms that I study are derived from reaching into the wound and examining the entirety of an infliction, the specificity of the assailant's aim, and the ramifications on those directly wounded. This is not a quick fix, although all too often quick fixes ease the consciences of audiences who investigate such wounds, thus urging a dominant tendency to prematurely bandage the wound with declarations about healed heroes.

This tendency may partially explain the way *No Más Bebés* ends, with a sense of the plaintiffs' wellness, although no narrative of personal healing had been offered. There are moments in the documentary when the plaintiffs' pains are soothed by consideration of their granddaughters' greater potential to now enjoy safer and fuller lives. There is also comfort that the Madrigal Ten have served a more general, abstracted sense of future women. This is surely a tending to the wounds but concurrently frames the Madrigal Ten as past sacrifices within a larger narrative of modernity and progress. When tied to narratives of linear modernity, there also exists a risk that some audiences might understand Chicana wounds as productive for the larger society. In such extreme perceptions, personal healing is never allowed for Chicanas since society might benefit from their pain—hence my attention to biopolitical structures that identify and position particular bodies to suffer for the advancement of a privileged demographic. This raises the question: how does one responsibly heal or leave open the wound? I argue that such a question is vital to consider, yet can be answered only by each wounded individual. If healing must be denied, then that choice might be made only by the wounded, who elect to generate their own insight from the infliction.

Returning to the current chapter's opening consideration of *Belly of the Beast*, director Erika Cohn is mindful of this individual choice to make available open wounds as she provides audiences with the opportunity to hear the thought process voiced by Kelli Dillon in contemplating testifying in support of the

anti-sterilization bill. Sitting in her kitchen after a phone conversation with attorney and advocate Cynthia Chandler, who has requested Dillon's testimony, Dillon is initially hesitant to expose her woundedness. She states, "I have an obligation to back Cynthia because if it were not for her, I would not have found out everything that had happened to me. But, I couldn't go through like another interview, testimony, hearing, or anything because once I'm done, then I'm. . . . You know. I leave, and I go home; and everybody goes home. But I'm left now with having regurgitated all those emotions and feelings, and now they're here, and they're here and here. And then no one's there to help me process it."[30] Ultimately, Dillon realizes that to manage her wounds responsibly, she must locate a generative redirection of her pain. That redirection is to contest violence committed at her specific site of intertwined, multiply marginalized identities.

To further explore such generative management of woundedness, I turn to the work of Christina Sharpe, whose trauma theory advocates maintaining the wound or the wake. Sharpe insists that trauma must remain active in the present—rather than as part of a past that is too often repurposed from safe temporal distances to serve the nation's needs; this, Sharpe argues, denies designated bodies equal human status and protection.[31] Specifically, Sharpe conceptualizes her experiences as a Black woman who is still metaphorically living in the wake of the slave ship. She imagines the ship's hold that continues to move her and her family toward a biopolitical system that determines a living death based on race. The constant funeral wakes that dominate her family's days and nights actualize the metaphor into her present reality. Sharpe argues that instead of memorializing slavery as a past event within a framework of understanding that is limited by incomplete archives and thereby "reinscribe[s] our own annihilation," that scholars address disconnects between what is said to be history and what is lived as a still-unfolding experience from slavery.[32] To be *awake* to the reality of this still-active cut from humanity and self-determination is to "rupture the structural silences produced and facilitated by, and that produce and facilitate, Black social and physical death."[33] Mindfulness of this rupture highlights discrepancies between that which we believe and that which we live, thereby fostering new understandings of that which the world truly is and might be.

This concept of maintaining focus on still-active harms—that which we live, rather than the soothing sense of heroism that audiences perhaps crave—recalls Maylei Blackwell's theories on the generative elements of studying Chicana voices of trauma. Although Blackwell writes of histories of the Chicana political movement rather than biopolitics, she offers a productive framework of allowing

trauma to speak from a placement of primary oppression rather than as supporting the healing of others. Specifically, Blackwell criticizes ways that Chicana grievances are positioned as add-on issues that are historically accumulated and utilized to advance redress for those oppressions prioritized by male Chicanos and white, middle-class feminists—both umbrella demographics in major historical movements that have appropriated Chicana oppressions to help represent their own purposes.[34] I similarly advocate that Chicanas employ their wounds as testimony to move toward their own immediate redress. Additionally, mindfulness of the wound necessitates that injustices are not placed neatly into the past or compartmentalized into separate avenues. To present a voice of pain from the past continues the disembodiment of Chicanas in the present as merely symbolic examples of violence committed against female bodies rather than specific individuals who experience still-open woundedness. Maintaining the wound foregrounds the injustice in the lives harmed. As a result, these lives are less apt to be abstracted into a slice.

For my project, Cathy Caruth perhaps best explains the impact of woundedness as a generative theory of engagement. In her trauma theory, she contests Freud's view of woundedness as limited to an infliction that leads to inadvertent and undesired emotional recall of injury. Specifically, she challenges Freud's study of trauma as represented in the figure of the knight Tancred from Torquato Tasso's sixteenth-century epic poem, *Jerusalem Liberated*. In the poem, Tancred cannot escape the memory of his accidental killing of his own beloved. While Freud observes a traumatized mind that cannot separate his past from the present, thereby reinforcing the persistent infliction, Caruth argues that the past *is* the present. The past, as in Sharpe's analogy of the wake of a ship, continues to agitate the wound in its present state. In this way, the past produces directly and repeatedly, in tandem with the present, a potential to reveal a greater understanding of self. In Tancred's trauma of reliving the death of his beloved, Caruth sees a "voice that cries out from the wound, a voice that witnesses a truth that Tancred himself cannot fully know."[35] She continues to speak of "the crying wound" in trauma theory as a wound that "addresses us in the attempt to tell us of a reality or truth that is not otherwise available. This truth, in its delayed appearance and its belated address, cannot be linked only to what is known, but also to what remains unknown in our very actions and our language."[36]

We may recall plaintiff Hermosillo in her kitchen, listening to the crying wound of her younger self (fig. 6). In the voice that cries from her wound, we hear

of the dreams of a family that Hermosillo was prevented from ever knowing, yet the generative potential of that scene as a moment of healing and of insight for Hermosillo is not articulated. Instead, the camera withdraws, leaving Hermosillo alone in her kitchen to become lost in the past rather than apply that past to present revelations. Hermosillo is portrayed as crying over recalling pain but not as engaging with that voice of the wound to access new insight for her own benefit. Caruth's emphasis on the "delayed appearance" and "belated address" of this generative wound is particularly important. The significance of the wound is not in the past and cannot be reviewed from a safe distance if we wish to learn from trauma. The impact of the wound is delayed because it is difficult to access insight when one is in pain. Time must be taken to revisit, reconsider, and eventually learn from what the "crying wound" can tell us. Caruth writes that "The story of trauma, then, as the narrative of a belated experience, far from telling of an escape from reality—the escape from a death, or from its referential force—rather attests to its endless impact on a life."[37]

Inspired by Cherríe Moraga's "theories in the flesh," Bernadette Calafell argues that embodied knowledge, including woundedness, provides an opportunity for women of color to speak as authorities of their own experiences and from this authority negotiate historical and systemic violence.[38] Jinah Kim also views authority and negotiation in woundedness, writing that "engaging with mourning and loss means negotiating memory. It is through the terrain of both personal and cultural memory that survivors and others negotiate their traumatic past."[39] Following such notions of productive negotiations, we might observe the way that trauma from nonconsensual sterilization might impact understanding of transnational racial policies and state-sanctioned violations against brown and Black bodies, particularly females of color. This focus on females, however, is not restricted to reproductive health and rights. Indeed, biopolitics cannot be solely a feminist issue, as biopolitics is a systematized form of governance wherein colonial systems build hierarchies of being based on interweaving identity factors. In other words, a Chicana is both "brown" and "woman." She can also be "Black" and "transgender." She can be a multitude of aspects. What she cannot be is just one of her various selves, an isolated fragment from her expansive lived experience, dehumanized into slices of a person to serve as a bridge more easily for exterior agents. As her own sum, however, the voice from the wound can join a network of other voices that call from the wound.

Interestingly, there is much rising emphasis on Global South initiatives that illuminate biopolitical forces that impede wellness and obstruct reproductive

futures for women of color. Yet these reproductive futures are not restricted to issues of motherhood. They also include urgent attention to HIV/AIDS care, accessible sexual health services, expanded public medical care, education strategies to support living wages, affordable housing, and clean living environments.[40] By maintaining focus on voices from the wound as speaking of dehumanization in addition to heroic sacrifice, rhetorics of woundedness confronts as central and as present in the *now* urgent need in the specific bodies, identities, and conditions that are located in the speaking body—rather than in a faraway future *familia* of another's fashioning.

Ultimately, the historical genealogy that I trace as the rhetoric of generative wounds necessitates that Chicanxs, if they elect their own confrontations with trauma, employ inflicted pain to productive advantage and active agency of the injured party. This entails *not* dwelling in the wound as initially inflicted in the past but discovering rhetorical strategies in the present wounded state that may prompt audiences—most crucially the audience of self—to adapt what they know for the generative empowerment of the rhetor's future. When empowerment is appropriated, and the rhetor is relegated to the margins or the past, we enter a potentially harmful manipulation. That is to say, rhetoric of the generative wound must maintain the wounded as central and as present. In part 3, we will fully explore this strategy in Chicanx visual rhetorics as informed by the historical lineages advanced by virgenes abrideras.

In the virgenes abrideras, it is essential to note that the figure of Mary is not only central as a stand-alone figure but is also necessarily present, since the sculptures are interactive in nature. If we recall, the San Juan Chapultepec virgen abridera invites audiences through the sculpture's opening chest to rhetorically engage with woundedness. These audiences must interrupt Mary's prayers and her tranquility by dividing Mary's hands. Such intrusive fragmentation of her body activates tragedy—opening a narrative of sacrifice. While this may parallel the reactivated wounds in *No Más Bebés*, the two differ rhetorically in that the wounds of Mary remain the possession of Mary and are actively present for viewers to contemplate. In other words, the wound remains actualized within the audiences' own time and space, and the audiences are exposed as ongoing participants of human sin who reinitiate Mary's suffering constantly, daily, through their own sin. This audience is not soothed but rather troubled. Yet, while the viewers are located as sinners, they are also part of a progression toward salvation since they continue to meditate on Mary's constant wound. This rhetorical situation positions the audience within a more extensive dialogue

that may consider how current sins—not only past sins—must be amended to address the wound that still cries in Mary.

The Wound and the Stitch now proceeds to consider the regaining of voice through the crying wound. We will study how artists have reversed this wandering search for lost potential into productive remembering of the past as impacting and revealing the present—a particularly medieval inheritance of collapsed temporal spaces. The following discussion illustrates the historical genealogy of a form of rhetorics that I have now defined and complicated. I hope to examine distinctive Iberian, Ibero-American, and Mesoamerican rhetorical practices that position feelings of woundedness and shame to confront and transform self—from an externally perceived wandering abomination into a Chicanx that determines and narrates one's own path.

Part 3

The Generative Wound

In a short quiz for a recent art history class that I taught in the College of the Arts rather than in Latinx Studies, I featured an image of Andrea di Bartolo Cini's late-medieval *St. Lucy* (fig. 7). After having read portions of Jacobus de Voragine's thirteenth-century *Golden Legend*, my students identified Lucy (a ca. third-century martyr-saint) although her most prominent Christian iconography, a pair of eyes she carries, was absent in the featured depiction. Interestingly, Lucy's association with eyes does not enter her primary iconography until the post-medieval period, although her relationship with eyes derives from her name's etymological Latin root *lux*, light. Yet, in medieval iconography, while this association is surely acknowledged and applied as a testament to her spiritual light or clear-sighted faith, she remains more tightly bound to woundedness. Accordingly, in the icon my class studied, Lucy carries a small flaming oil lamp that serves as a marker of spiritual light but primarily as a marker of martyrdom.

The Golden Legend relates that an imperial Roman governor ordered Lucy's execution via public dousing with burning oil. Yet, since Lucy's association with light immunizes her from burns, this punishment does not kill her. Astonished by Lucy's display of faith before a witnessing public, her executioners apply a second instrument of execution—a dagger that fatally punctures her throat.

112 THE GENERATIVE WOUND

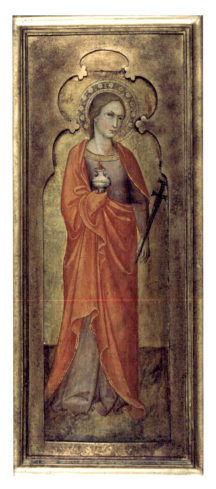

Fig. 7 | Andrea di Bartolo Cini, *St. Lucy*, altar fragment, fourteenth century. Tempera, gilding on panel, 25 × 8.1 inches. Ashmolean Museum of Art and Archaeology, Oxford, England. Photo © Ashmolean Museum.

Hence a typical medieval icon of Lucy features her haloed, wearing a red martyr cloak, and holding her instruments of sacrifice. It was through noticing the flaming lamp that my students identified Lucy, yet they notably made little to no mention of the black dagger at her side. Moreover, students tended to associate the oil lamp with Lucy's clear vision and flame of faith but marginally referenced its role as the instrument of the saint's first wound. They seemed uncertain how to address the medieval *topos* of *ostentatio vulneris* or the indication of the suffering process as an affirmative display of character.[1]

In rhetorical application of *ostentatio vulneris*, the martyr's humanity and mortality are essential links to viewing audiences. Though humanity is a common

ground shared with viewers, a saint's woundedness functions as evidence supporting claims of elevated spiritual credentials—to sacrifice one's link to the world is to prioritize one's spiritual value. In debriefing the Lucy quiz, I observed that students realized *ostentatio vulneris* as a concept applied to visual rhetorics of Christ and his wounds—and, by extension, Mary's sacrifice. As Caroline Walker Bynum has notably expressed, pain is an experience all humans can share.[2] Pain serves as an access point through which Christian iconography addresses the divine. Through Christ's bodily suffering, the human body becomes a potential gateway for salvation. Christ's wounds, the Crucifixion scene, and the stand-alone cross establish empowerment through sacrifice.

While my students appeared to accept Christ's sacrifice as the foundation for medieval Christian iconography, they seemed less comfortable expressing body harm as generative force in the visualization of sainthood. They opted for a "modern," as in post-medieval, visual study of Lucy's oil lamp to denote the saint's light and vision, leaving aside the lamp's double meaning as source of woundedness. More significantly, their lapse of substantial analysis of the dagger—the actual killing object—might testify to mainstream aversion that I have observed in studies of woundedness. I wonder if this aversion would be as prominent with my Latinx Studies students. I am inclined to feel that the wider range of student demographics in this art history class speaks to an existence in mainstream United States audiences of a deep-rooted repugnance regarding confrontations with mortality as a potential source for invention and positive transformation.

Tamar Tembeck probes such repugnance in her studies of autopathographical works of contemporary United States and English artists who chronicle their bodily deteriorations during illness.[3] Tembeck analyzes self-representational strategies in photography by Jo Spence, Karolyn Gehrig, and Hannah Wilke as offering first-person perspectives on their process of physical dying. However, in this dying, the artists concurrently discover new self-imaginings and resolve to make visible that which society often deems unsightly—namely, mortality. While autopathographies are traditionally expressed and studied in textual representations, during the last quarter century a surge in visual autopathography has contested the social erasure of the ill, particularly to advocate attention to specific urgent medical needs that impact stigmatized and/or marginalized demographics. Most prominent in these efforts are visual autopathographies of the AIDS crisis and female health risks of breast and ovarian cancers.

The Chicanx rhetorics of woundedness that are central to my focus frequently conjure metaphorical wounds rather than physical illness; they are more often

focused on emotional suffering than physical pain. Surely medical issues about procedural and policy biases are part of Chicanx rhetorics of woundedness, as indicated in the Madrigal Ten narrative of sterilization in part 2. As well, living and working conditions disproportionately disfavor the health of low-income Chicanx bodies. Hate crime and sexual assault are also prominently addressed in Chicanx narratives of physical woundedness. However, I focus on contemporary Chicanx writers and artists who construct metaphorical displays of woundedness to manifest emotional pain and social suffering. The rhetoric I analyze differs from recent applications of autopathographies that emphasize woundedness as deriving from physical disease and impending death. Still, I note ways that rhetors in my scholarship parallel the advocacy contained in autopathographical confrontations. Both autopathographical and rhetorics of woundedness artists repurpose pain and suffering to contest social erasure and disempowerment.

To help launch part 3's analysis of visual rhetorics of woundedness as advocacy, I note Tembeck's argument that autopathography functions beyond the medical as the genre assumes a "politicized dramaturgy of the living body."[4] This dramaturgy relates premature social deaths experienced by patients inflicted with identity wounds that the "medical gaze" is not trained to see; indeed, society at large is predisposed to fix the gaze away from wounds.[5] Autopathographies thus aim to make visible both physical and emotional inflictions to maintain the still-living self, the still-inventing self, the still-relevant self, while forcing society to witness dying flesh. The impact is not unlike rhetorics of woundedness in its insistence on asserting the fragmented self as constructive, even if society tends to gaze from displays of grievance and prioritize rhetorics of wholeness. Although exposures of these wounds persist, the prevalence of the averted gaze results in a systematic lack of societal (and, by extension, academic) training or familiarity with a dominant and enduring strain both of rhetorical history and modern urgency for attention. Since a driving ambition of *The Wound and the Stitch* is to mend disruptions in cultural rhetorical tapestries, I add a historical lineage to discussions of autopathographies as related to works by contemporary Chicanx rhetors in the assertion of generative woundedness.

Similar to rhetorical strategies of medieval devotional iconography, contemporary visuals of infliction or woundedness do not signal the end of life so much as a generative potential that the best of humanity (saints, in a Catholic context) realize and display, and that spiritual aspirants commemorate and recall. I consider strategies of generative woundedness to be inheritors of medieval *ostentatio*

vulneris motifs, which identify the positive potential of woundedness and the concept that dying begins with birth, and glory potentially begins with death. In this Catholic tradition, achieved glory relies on a well-prepared and productive death. Martyrdom is the culmination of a saint's deliberate rhetorical reorientation, with her attention pivoting inward to seek direction from the soul as the gateway to God. Such reorientation resonates with Iberian colonial-era spiritual pedagogies in Teresa de Ávila's *The Interior Castle* (1577) and Ignacio de Loyola's *Spiritual Exercises* (1595). Withdrawal of the soul allows greater access to the divine, yet the distinction of martyr saints exists in moments of commandeering one's pain for productive purposes in public testimony. While the martyr's spiritual progress remains incomprehensible beyond the emotional experience of agony and subsequent encounter with divinity, martyrs are relevant specifically because they make more legible confrontations with mortality as generative moments for others to witness. Such displays of holy woundedness and their corresponding weapons of infliction are seized and deployed by the wounded to advance one's own campaign.[6] This strategy to make public that which is an otherwise incomprehensible private pain to mobilize actions that support one's agenda is the connection I draw between medieval Iberia and contemporary Chicanx rhetorics.

As I tighten this connection, I note a split between rhetorical traditions that dominate United States practices and those that inform Chicanx rhetors. This split is partially derived from rhetorical tensions between Reformation and Counter-Reformation strategies. Rhetorics of woundedness became more clearly identifiable with visual cultures that abided by the Council of Trent's emphasis on emotive Catholic devotional engagements.[7] Outside that visual culture, woundedness became increasingly concealed, hence our example of Lucy's eyes as the emerging saint attribute that is removed from a narrated martyrdom and Tembeck's analysis of aversion to woundedness in the United States and England. It is important to recall that this Reformation divergence formed rhetorical trajectories that impacted English-United States and Mexican-United States discourses with differing features.[8] At contact and during the Counter-Reformation, Iberia still largely employed the *ostentatio vulneris* both in its medieval emphasis in martyr narratives and in its later baroque manifestation of the bloodier, fleshier exposure of suffering holy bodies. Additionally, discourses from the Catholic order of Franciscans in Iberia and the Americas on inner woundedness and humility simulated martyr models in emphasis on public legibility of personal pain; this builds on Francis's lived experience, not as a

martyr-saint but as a saint whose inheritance of woundedness derives from materialization from soul to body of Christ's stigmata.[9] I emphasize Franciscan impact since the first colonial priests to entrench their associated iconography in the Americas were Franciscans, arriving in Mexico in 1523–24, followed by Dominicans in 1526, Augustinians in 1533, and Jesuits in 1572.[10]

My focus in part 3 is the inheritance of these Iberian Catholic visual rhetorics by contemporary Chicanx rhetors who employ such historical rhetorical lineages. This discussion turns away from text and toward visuals because when we consider Chicanx historical rhetorics, we must recall that Iberians first approached Indigenous rhetors through visual and corporal gestures to overcome verbal and textual obstacles. When a people's communicative modes encounter a colonizing system that obliterates or transforms those modes, the recovery of rhetorical genealogies necessitates an interweaving of rhetorical practices. Part 3, therefore, considers a visual rhetorical lineage that enters the Americas, engages with extant Indigenous rhetorics, and informs contemporary Chicanx rhetorics of generative woundedness.

I take general notions of European Christendom and localize them in Iberian visual emphasis on body and materiality that cross to the Americas and encounter Mesoamerican rhetorical employment of woundedness. Recent interest has surged in the study of this transatlantic interchange, as seen in *Visualizing Sensuous Suffering and Affective Pain in Early Modern Europe and the Spanish Americas* (2018), edited by Heather Graham and Lauren G. Kilroy-Ewbank.[11] Graham and Kilroy-Ewbank's project aligns closely to my own, with attention to emotion studies and woundedness in early modern Ibero-American contexts. However, the collection essentially maintains its art historical discipline in lieu of interweaving rhetorical practices and trans-disciplinarian scholarship. The collection also defines its range of study in the early modern and thereby does not connect historical concepts of woundedness with contemporary strategies of employing mortality for advocacy, as studied by Tembeck.

My project bridges these gaps between art history and contemporary visual studies, between cultural and visual rhetorics, and between representation and advocacy. I am concerned that without such bridging, the visual *topos* of generative wounds in contemporary Chicanx art and discourse will continue to struggle for recognition as part of historical and cultural rhetorical tradition. I have already detailed this *topos* in its textual rhetorical expression in Cherríe Moraga's writings, as well as in the case of the Madrigal Ten, where generative elements of examining the wound have been relocated or modified to more prominently

benefit exterior forces rather than the aggrieved. I have also peppered my entire examination with examples of audience (mis)understandings, uncertainties, and awkwardness vis a vis narratives of generative woundedness, as with my observations of student reception of *No Más Bebés* and St. Lucy prior to my teaching of biopolitics and rhetorics of woundedness or *ostentation vulneris* in my classes.

Yet even with my endeavors as an educator to expand awareness of rhetorical practices, I fear that without wider dissemination of scholarship on the inheritances that inform Chicanx self-representational strategies through rhetorics of woundedness, this form of rhetoric might be vulnerable to further unreceptive audiences. Part 3 accordingly places the historical genealogy of the generative wound into conversation with contemporary Chicanx art, deploying two prevailing threads: first, reverse-colonization via reclamation of genres and imagery of Mexica (Aztecan) visual arts; and, second, fusion of imagery of the Virgin Mary into Chicanx artists' lived realities. I thus bring into my genealogy consideration of Indigenous heritages that shape Chicanx art together, in parallel, and in discord with medieval Iberian influences.

Chapter 5, "Reading Wounds (from Right to Left) to Reclaim Mexica Cosmologies," focuses on visual counterstories that dismantle colonial fictions of wholeness to address historical woundedness. This type of wound develops from geographical relocation and disrupted histories based on colonial systems. In response to displacement and narrative erasures, the art I feature in chapter 5 makes central a lack of resolution and open woundedness; strategies may be elected to piece together fragmented histories or counterimagine a past, present, and future. While my attention is drawn to a female Californian strand of this rhetoric, the generative wound is deeply rooted in broader Chicanx cultural rhetorics as a legacy of Christian iconography that advances *ostentatio vulneris* and Mesoamerican visual discourses on sacrifice and renewal. Therefore, works outside the female demographic, such as by the collaborative art group Asco (Los Angeles–based) and Enrique Chagoya (born in Mexico but a Californian resident since the 1980s), also help me bridge the modern with the medieval.

Much of chapter 5 applies museum or collection theory as I consider ways that Chicanx artists reclaim visual narratives of self and culture. The Chicanx cabinets of curiosities by Amalia Mesa-Bains and by performance artist and writer Guillermo Gómez-Peña and his *Doc/Undoc* multimedia collaborators mirror attempts to seize control of pieces of lost narratives, wherein the collected becomes collector of her own story and archetypes. I also query how rhetorics of woundedness contends with permanently erased histories—fissures in history

and land-based knowledge that cannot be stitched together. Indeed, this inability to recover cultural inheritances and knowledges that have been entirely erased by coloniality returns our discussion to strategies core to rhetorics of woundedness that advance challenges against dominant narratives of wholeness. Accordingly, chapter 5 concludes by examining the collaborative multimodal *Codex Espangliensis* to consider further challenges to normative storytelling of wholeness and authority. To challenge authority, I, as a reader, practice a right-to-left analysis of the *Codex Espangliensis* to recognize rhetorical strategies of woundedness that are obscured in European left-to-right mainstream narrative. In other words, I consider ways that rhetorics of woundedness engages audience responsibility in redressing colonial wounds while concurrently inviting readers to assert agency in electing alternative reading approaches.

The *Codex Espangliensis* returns my discussion to the virgenes abrideras in chapter 6, "The Art of the Generative Wound (from Container to Co-Redemptrix)." These mutable devotional sculptures of the Virgin Mary confront worshippers to elect an approach to interpret the contained narrative as redress to woundedness. In chapter 6, I examine traces of multimodal rhetorical inheritances of these sculptures in my studies of Chicanx artists who work in various mediums: Christina Fernandez, Amalia Mesa-Bains, and Maya Gonzalez.[12] I have chosen these artists because not only are they Chicanxs who apply generative rhetorics of woundedness, but they are Californians of a similar generation, sharing urban, cultural, and social commonalities with Cherríe Moraga and the Madrigal Ten. The historical and geographical specificity of these rhetors accordingly perform within contemporary sociocultural power dynamics. In short, this discussion explores visual depictions of Chicanx fractures in modern Californian Chicanx art—a motif repurposed from female Iberian devotional rhetorics, informed by Mesoamerican visual cultures, and now deployed to advance current campaigns. Like medieval saint art, woundedness and shame continue to confront and transform self while advocating a more receptive world.

5

Reading Wounds (from Right to Left) to Reclaim Mexica Cosmologies

The photography of Christina Fernandez complicates the process of recovering fragments to stitch together the wound of historical disruption. The gulf between past and present in her art is precarious to inhabit, since Fernandez admits dependence on imagination in light of missing histories. In her photography series *María's Great Expedition*, Fernandez offers six self-portraits that restage her great-grandmother's life as a migrant single mother in early twentieth-century California. Fernandez's body serves as a surrogate to contain María's memory, yet this endeavor is essentially confined to the imagination, fragmented into episodic and stereotyped visualizations. In one example, *1927, Going back to Morelia*, Fernandez channels María as a romanticized nomad with silent-era Hollywood cupid's bow lips and slick pixie hair as she perches on luggage, alone on chunky gravel beside train tracks. In this deserted nowhere space, there is no train station or boarding platform, leading one to imagine that María will simply grab her belongings and jump on board as soon as a train nears. Although a knitting project drapes across her lap and a letter unfolds in her left hand, these objects fail to alleviate her exaggerated impatience for action.

Rather, María stares to the distance, straining to detect motion along the track line—an effort that parallels Fernandez's straining to perceive distant family pasts that may convey potentials for her own future-forward motion. Such future-forward movement is Fernandez's attempt to capture her own self-portrait as an accurate articulation of a past she embodies. However, this form of self-articulation is compromised when her history is obscured, leaving her, like María, stranded in her journey. While depicted as an unfettered woman who keenly seizes an itinerant life, María's portrayal pivots between the artist's poignant longing to embody her remarkable ancestor and an apparent lack of perceiving the real María, concealed even from family under photographic conventions. This is a historical wound. It is a sense of phantom ancestors whose

presence is marked in one's body color and form—yet whose reality remains elusive, obscured by mythmaking and pop-culture tropes.

Before tracing the historical genealogy of the visual rhetorics of woundedness, it is important to describe my understanding of Chicanx art as frustrated by a concealed spectrum of inheritances. I accordingly define Chicanx art as constituted by the artist selecting one or multiple cultural associations within a range of heritage options, contextualized in local and temporal identification impacted by one's relationship with experiences inside the United States. Yet that selection is predominately mitigated by historical disconnection. Chicanx art often observes and comments on the act of gathering and selecting from such fragmented heritages as the artist addresses gaps in historical knowledge. Beginning with the first major national traveling exhibition of Chicanx art, CARA (*Chicano Art: Resistance and Affirmation, 1965–1985,* Wight Art Gallery, UCLA, September 1990–August 1993), artists and curators have established a visual culture that deliberately emphasizes a plethora of inherited options from which to select, thereby denying easy categorization but also the legibility of one's history. As Alicia Gaspar de Alba writes, "CARA signified the presence not of one monolithic identity that calls itself 'Chicano,' but of multifaceted, often contradictory identities signified by the acronym CARA, which means 'face' in Spanish."[1]

These multifaceted and contradictory elements denote undefined or specter-like qualities in much of Chicanx art. The face of the individual artist, but also the face of a historical narrative, is not fixed but rather always potentially in flux. We saw parallels of this notion in part 1 as Cherríe Moraga rips open her white façade to reveal fragments of brown beneath, yet not necessarily at the erasure of the "I" in privilege solely of the "not-I." Similarly, Chicanx art is ever lacking in resolution—never finished, constantly absorbing, and transforming because, as Ella Maria Diaz writes, Chicanx art "is in dialogue with the history of social reality and the history of its construction."[2] The lack of resolve in this dialogue has much to do with erasures of Chicanx histories, either diminished by dominant narratives in the United States or obliterated during earlier European contact. Accordingly, a lack of settlement and lack of wholeness resonates in Chicanx visual rhetorics. If, indeed, Chicanx art is defined as a selection among various heritages, the partialness of some of these heritages—particularly the Indigenous and feminine—confront artists with blank spaces and shattered cultural artifacts.

A response to the erasure of heritages is to construct one's imaginings of past narratives, regardless of whether historical artifacts survive. In this context, cultural and historical wounds are a license to generate legends and histories. This myth-based retelling of history can be observed as a prominent feature in Chicanx art. It may be productive here to recall part 1's discussion of Maylei Blackwell's theory of "retrofitted history" or counter-memories that function as destabilizing forces against entrenched hierarchical histories and as expansions of our understanding of events. Retrofitted histories stitch together fragments of chronicles through "shared authority" that recalls, reinterprets, and even misremembers.[3] Revisioning history to the point of deliberately misremembering is also the strategy that informs visual rhetorics applied by the 1960s Sacramento, California muralist collective the Royal Chicano Air Force (RCAF). The collective aimed to fill gaps in Chicano history through a constructed mythology of a royal air force that never existed.[4] Dislocated, disassociated, and dismissed, the RCAF had no alternative but to fabricate their own histories to establish a sense of belonging in the absence of institutional recognition. Chicanx art, as a selection among a range of heritage options, therefore not only includes a range of historical and cultural associations but retrofitted inventions that are made legitimate by their visual manifestations and collective acknowledgment of those manifestations as tangible proof of deep-rooted community. These extended selections exercise rhetorical acuity as artists opt not only among heritages, histories, and mythmaking but inherited media. Experimentation across multiple media and normative modes of production is a prominent Chicanx art trait. This propensity to switch media or create hybrid or interweaving multimedia art further alludes to a sense of fragmentation or semi-ness as artists comment on continued dislocation and obscuration of Chicanx realities and histories.

Concurrently, while one goal of rhetorics of woundedness is to seek exterior redress of infliction by confronting historical erasures, the unintelligibility and illegibility of this art that defies fixed states and single modes of invention mirror a dissolution of normative rhetorical frameworks. Such a dissipation reserves legibility first to self and secondarily to community, while legibility is denied those further from the centrality of the rhetor. This inscrutability serves as a rupture with coloniality in that one cannot collect or control that which one cannot understand.[5] Our discussion of semi-ness resonates here as rhetors maintain distance through illegibility and resist melding into a system that denies hospitality. Projects by performance artist and writer Guillermo Gómez-Peña

and his multimedia collaborators epitomize the way that the selection of media and historical-political-cultural themes collectively function to critically represent fragmented realities and tactics to decode those realities.

In Gómez-Peña's 2017 *Doc/Undoc*, produced with book- and image-maker Felicia Rice, critical commentator Jennifer A. González, filmmaker Gustavo Vazquez, and sound artist Zachary James Watkins, a small trunk opens to disclose an assortment of objects. Identified as a "cabinet of curiosity," the trunk invites tactile, audio, and visual interactions with its objects to co-construct narratives with the contained assemblage: red dice, hairbrush, Tish and Snooky Manic Panic lipstick, coyote talisman, stethoscope, oversized magnifying glass, binoculars, books of matches, Remedios Mágicos tin box reading "No lo Vuelvo a Hacer" (I will not do it again) breath mints, Mexican money bills, various objects enclosed in small silky bags of various colors, push-button audio recordings, two wrestler masks, a booklet, and other seemingly random mundane and uncanny objects. The cabinet contains a narrative that depends not on a phantom history, which can only be imagined, but on performative interaction in the *now*—on the order that audiences select to engage or dismiss each object. The audience is central in *Doc/Undoc*.

The audience's role in the artwork becomes literally the case too, as the audience opens the trunk to encounter a variety of mirrors attached to the lid's interior. The multiple mirrors reflect the identity, choices, and actions of each individual who elects to open the trunk and engage with the objects contained in it. The trunk's design means that the audience turns the stagnancy of object-ness and associated power concepts of possession into an ephemeral performance that activates the objects into a narrative of exploration.[6] As a mirrored replication of audience curiosity, the trunk subordinates notions of possession save for the experiential memory formed within the audience during moments of discovery. While the trunk becomes a stage of performance rather than only a container of objects, audiences are empowered as co-creators of art and culture in the *now* while dismissing colonial systems that assert possession of history through the collection and arrangement of objects to impact phenomenological and historical formations of identities. Again, we might recall from chapter 2 Jacqueline M. Martinez and Sara Ahmed's arguments as we consider the colonizing, patriarchal, and/or heteronormative structures that might be countered as audiences perform their own contacts, assessments, and utilization of objects based on random actions of inquisitiveness. The selection of the curiosity cabinet as a medium to address object-ness and object placement is therefore not only significant in

Doc/Undoc but serves as a gateway to my analysis of Chicanx art that reverse-colonizes through collecting fragments in order to perform race, gender, and sexuality within wound states.[7]

The Collected Re-Collecting

In *Doc/Undoc*, the cabinet functions as a criticism of European early modern and Enlightenment systems of collecting and categorization. Concurrently, it repurposes these systems to self-represent via a box that contains cultural and popular artifacts for audiences to assemble as is best suited to one's encounter. Attention to audience reception is crucial in the historical context of cabinets of curiosity since the success of the cabinets' objects in imparting value relies on audience interest, meaning-making, and appraisal. Contained objects must be readable to viewers who recognize pieces in the cabinet for immediate social value, yet also must be able to enthrall audiences with more exotic features. This exotica must, however, be legible to the degree that audiences can process it into new valuing systems suitable to immediate social contexts.[8]

Traditional curiosity cabinets use material symbols to define a replica in miniature of all that is and should be valued in creation from a European worldview; the juxtaposition of regionally prized and familiar objects with rare and exotic objects expresses not only inclusiveness of European knowledge but the collector's ability to domesticate transgressive customs.[9] By extension, the cabinet creator and his audience, who share social sensibilities, can domesticate the world.[10] Yet collecting demonstrates not just power over the world but power to shape self. Collecting objects opens the potential of ultimately collecting pieces of self.[11] Pieces selected extend the value system of personhood and thereby perpetuate one's value and worldview through the collection. Self is transferred into, and signified by, the selected object(s). The collection accordingly denies impositions of reality and even time and death since it potentially outlasts the collector and, if valued by social and cultural guardians, can remain intact indefinitely as an ongoing posthumous action of reality-making. This is how museums are formed and how names such as J. Paul Getty reach immortality. Collected objects function as a mirror of not reality but of what is desirable for the collector.[12] I am interested in how traditional curiosity cabinets, with their brutal history of collecting exotic objects to enrich, empower, and extend the collector, may be viewed not for grandeur but as evidence of a collector's power

to warp reality into maintaining, as central, a concept of European superiority. If a collection is more about the collector than the cultures pilfered, cabinets can function as accusations from the wounded treasuries and identity markers of the assaulted cultures. Such a framework undercuts the immortality of the colonizer-collector and shifts prestige to infamy.

In this framework, *Doc/Undoc* transforms power dynamics traditionally associated with early modern cabinets of curiosity and develops a Chicanx response to the collecting and stripping of history. It is important to recall that in the Americas, exotic objects were collected by Iberian conquerors based on color, "natural fidelity," and craftsmanship that would be identifiable based on European valuing systems; yet after initial assessment in Europe, these objects were most often converted to monetary worth, such as when gold artifacts were melted down for currency.[13] In other words, after initially functioning as curiosities, objects of the Americas were socially appreciated as resources rather than for their artistic or cultural value. Furthermore, collectors opted to reject objects from the Americas as pieces in which they would invest their identity and with which they would be associated in perpetuity. *Doc/Undoc* protests a melting-down of Chicanx culture into an assimilated valuing system; concurrently, it embraces Chicanx material culture artifacts as worthy carriers of identity. These notions contest the placement of normative objects as those that exclusively offer value. I examine *Doc/Undoc* in my brief definition of Chicanx art to emphasize a tendency in this visual rhetoric to reclaim fragmented narratives and their objects from disregard and to link salvaged fragments as still-inventing and still-relevant in the rhetorical construction of living inheritors who *do* predominately desire to invest their identity in this cultural past and to extend into immortality their own ambitions as part of an ongoing cultural legacy in the *now*.

Although my interest in *Doc/Undoc* is focused on its ability to illustrate key aspects of Chicanx art, the piece also takes a position in an ongoing thread of art historical inheritances and does not construct solely within Chicanx art traditions. In fact, the cabinet of curiosity as a medium to comment on established power hierarchies has a long lineage in twentieth-century art history: André Breton's cabinet of curiosity of the 1920s, Marcel Duchamp's *Box in a Valise* (1935–1941), Joseph Cornell's self-contained world-in-a-box pieces such as *The Hotel of Eden* (1945), H. C. Westermann's cabinetry art in *Memorial to the Idea of Man, if He Was an Idea* (1958), and various box art by the 1960s collective art group

Fluxus. *Doc/Undoc* participates in this art historical tradition yet distinguishes itself by fusing decolonial cultural rhetorics into previous discourses on the socioeconomic power struggles that earlier artists primarily engaged. In *Doc/Undoc*, the collected has become collector. Yet the collection is not comprised of objects pilfered from others; it is a reassembling of salvaged identities that can only be pieced together through representational fragments.

Strikingly, the various mirrors in the interior of the *Doc/Undoc* lid emphasize fragmentation. Since the mirrors vary in magnitude and angle, a figure who accesses the trunk is never wholly reflected (fig. 8). The audience sees pieces of self, sometimes augmented for a part-specific element—a head that thinks, an eye that sees. At other times, the audience is revealed from distant perspectives that situate the body within site-specific contexts. Sometimes the body is warped with a wide-angle mirror that stretches the audience's reality. Sometimes space looms over the body, making it fragile and inconsequential in its diminutive state as it is no longer the dominant and central image. In certain angles, the body is erased from the reflection. In these mirrors, we might detect a parallel with the history of collecting bodies under colonial systems where bodies are warped, decentered, marginalized, or erased altogether. We also might imagine a dehumanization process with body parts drawing attention as locations for labor purposes or sexual pleasures and/or as sites in need of restraint, such as, again, a head that thinks or an eye that sees. Yet while the *Doc/Undoc* trunk contains pieces of the audience, now collected along with a myriad of objects, of note is that the collected body has the power to close the lid and walk away.

The body can also return. And, on this occasion, the return brings a new state of perception when the audience reopens the trunk. The collected knowingly becomes collector of self, deliberately placing her identity into the trunk along with the assorted objects. In this act, the audience becomes a creator of the curiosity cabinet, contributing her own living body as a worthy carrier of the collector's identity. The mirror reflections can, accordingly, assume altered meaning under these new decolonizing conditions as the audience insists on occupying spaces in dynamic ways that sometimes stretch beyond the norm and other times validate body assets. The audience challenges invisibility by consciously opening the trunk to reveal self. Yet we might recall that the trunk also contains two Mexican wrestler masks and an assortment of make-up, opportunities to reserve legibility for self and deny full disclosure to exterior spectators

Fig. 8 | Guillermo Gómez-Peña, Felicia Rice, Gustavo Vazquez, Felicia Rice, and Zachary James Watkins, *Doc/Undoc*, opened, 2017. Photographed at University of California, Irvine, April 2, 2023. Photo: Author.

while still claiming space and belonging. This inscrutability serves as a rupture with coloniality within the context of the cabinet of curiosity, since one cannot collect or control that which one cannot understand in terms of taxonomy.

Illegibility, particularly through masking, also conceals the rhetor and denies fixed states and single modes as the rhetor performs through alteration. The result is a blurring of normative rhetorical frameworks. Of note, the *Doc/Undoc* central rectangular mirror reflects a warped reality along the edges of its frame, though the central body is sound, albeit truncated. The body is also reflected in a sepia tint that differentiates itself from the clear, round mirrors as it recalls not the dynamism of body and space in the living *now* so much as a sense of the historic through aged amber hues. The rhetor's fixed state is, in this way, further complicated as the body seems temporally resituated to open the possibility of a voice from the past. Simulated is a temporal collapse, which is essential in generative application of rhetorics of woundedness. We might recall Caruth's emphasis on the "delayed appearance" and "belated address" of generative wounds since the significance of pain cannot be reviewed from a safe distance if we wish to learn from trauma. The impact of the wound is delayed because it is difficult to access insight when one suffers. Time must be taken to revisit, reconsider, and eventually learn from that which the "crying wound" can tell us. This cry of historical woundedness in the *Doc/Undoc* central mirror speaks even as the audience member's body remains fragmented, much like the histories of colonized peoples. Still, the body persists as a carrier of history and a carrier of a present that will eventually close the trunk and enter a future, having indicated an ability to reality-make by intentionally participating in the construction of a microcosm of the world.

It follows that if, per collection theory, the collector is made immortal through the reality-making of a microcosm, then the collective of artists behind *Doc/Undoc* and its co-creating audience assert their capacity to construct from selections of fragments and imaginings a retrofitted Chicanx reality and history—but most significantly through the placement of one's own body as carrying value. As *Doc/Undoc* collaborator Jennifer A. González writes in the cabinet's booklet, the project creates a potential wherein audiences might "reach into the interior, psychic state of radical unbelonging in order to grasp the intricate, violent workings of the world that have resulted in this uneven, unequal, and unjust conjecture."[14] The purpose is to recognize that unbelonging within violent machinations is the Chicanx artist-audience challenge. Gómez-Peña further explains in the cabinet's "Artists' Book: Instructions" that an artist's task is to

complicate assumptions and challenge "simplistic definitions": "My job is also to keep the wound open; make it hurt a bit, not to heal it."[15]

The cabinet is a reminder of a past of violent collecting of peoples from which uneven, unequal, and unjust unbelonging has occurred for the reality-making of immortal mini-gods (the colonial collector and subsequent museum-makers). Yet the new collectors of *Doc/Undoc* do not seek to correct that history. *That* history must remain as testimony to the newly reframed immoral mini-gods. Instead, the collectors of *Doc/Undoc* aim to generate creative assemblages of new cultural identities from open wounds and scattered fragments of obliterated histories. Furthermore, these assemblages are never possessed by a grand creator since meaning is renewed into alternative configurations with each new audience member that asserts self into and selects objects from the container. The container is thus not a traditionally cohesive cabinet with organized drawers that represent a full vision of the world's values but a disorderly single-compartment trunk. Again, we encounter a moment where Chicanx rhetors privilege fragmentation to undermine rhetorics of wholeness.

New configurations and unresolved (sometimes messy) definitions from the wide range of heritage options remain defining traits of Chicanx art, which *Doc/Undoc* explores in theme and medium. This strategy is also applied in Amalia Mesa-Bains's installation art pieces *Curiositas: The Cabinet* (1990) and *New World Wunderkammer* (2013–14). As with *Doc/Undoc*, Mesa-Bains's cabinets of curiosity exhibit a sense of unfinished states as objects scatter about spaces in seemingly random order for audiences to appraise and construct meaning. However, one point of departure is a correlation Mesa-Bains draws between the cabinet as phenomenological and devotional. In *New World Wunderkammer*, Mesa-Bains's cabinet expands to a room-filled assortment of objects where Catholic devotional items intermingle with Mesoamerican and European artifacts. In one corner of this assortment is a private holy space or shrine. A framed picture, perhaps a deceased loved one, sits among a cluster of candles, one votive in a glass container that bears the iconic image of the Virgin of Guadalupe. In this way, a juxtaposition is drawn between collecting a microcosm of the world and a microcosm of Catholic spirituality. However, this correlation is merely offered without resolution. The assortment of objects comprises pieces of a narrative: from pre-contact Mesoamerican artifacts to modern glass art and scientific glass test tubes alongside an accordion-like codex. Yet, as in *Doc/Undoc*, the didactic goal, if one exists, remains individualized to each encounter.

This sentiment returns to my definition of Chicanx art as emphasizing a lack of resolve and finish. Yet incompletion does not equate partialness or semi-ness as a diminished state. Instead, inspiration and activism merge from this lack of closure. Again, as Gómez-Peña writes, the artist must aim to "keep the wound open; make it hurt a bit, not to heal it." The open wound reminds the artist of a vast selection of rhetorical and cultural inheritances, of archived histories and imagined pasts that substitute irretrievable erasures, and of artistic traditions in motifs and mediums. These selections can conflict or cooperate, and they can also form a sense of hybrid oneness or separate but intertangling fragments—or impossible resolutions. The act of keeping the wound open and hurting a little maintains the source of these options and facilitates conscious, deliberate election of rhetorical strategy. I am most interested in Chicanx art techniques that focus on this very same wound. Specifically, I study the ways that artists employ cultural rhetorics for the purpose of reverse-colonization via reclamation of genres and imagery of Mexica visual arts and via appropriation of Marian imagery into lived realities of Chicanx artists. Both patterns merge in their strategies of displaying inflictions of identity, culture, and gender to confront and transform one's reality.

Decolonial Counter-Reading of Woundedness

Staying with the work of Guillermo Gómez-Peña, his *Codex Espangliensis— From Columbus to the Border Patrol* (2000) applies reverse-colonization strategies to advance its narrative. I use the term *reverse-colonization* here rather than *decolonization*, which has been a prominent keyword throughout my project until now, because Gómez-Peña and his collaborator-artist Enrique Chagoya are not aiming so much to undo or to *de*-colonize but rather to perform a more aggressive assault, to reverse the colonization process against opponent forces. This narrative is expressed through a gathering and clashing of fragmented pieces of Chicanx inheritances, predominantly associated here with ancient Mexica, colonial contact, the Mexican revolution, and United States pop culture. Told in the medium of a simulated Mesoamerican codex, the accordion-styled folds of the narrative can be extracted into one single, long page. In Mesoamerican tradition, one would read this page from right to left, but one may also elect to unfold this codex from left to right, as in the European reading direction, in which case the narrative begins with a battle involving the comic book hero Superman.

Damián Baca's 2009 analysis of the *Codex Espangliensis* begins with a description of this battle on page 15/1, a numbering system that Baca assigns since the book includes no system of its own. Per Baca's numbering, page 1 is the Superman battle when read left to right, but it is page 15 when read right to left. Baca privileges the right-to-left Indigenous narrative direction by his numbering system (15 superseding 1), but his interpretations of the codex are primarily attentive to the left-to-right European narrative that he decodes for possible subversive meaning on a micro-level through audience reception analysis. I use Baca's numbering for a consistent reference system, but I offer a macro-level right-to-left reading that detects in the codex's complete envisioning rhetorics of woundedness that are otherwise obscured in left-to-right readings. I accordingly offer a literal counter-story.

Yet while nearly every page of the *Codex Espangliensis* includes story via texts by Gómez-Peña, these texts are constantly disrupted, simulating disrupted histories. The partialness of text is symptomatic of ongoing wounds of voicelessness but also a dismissal of alphabetical hierarchies, as the *Codex Espangliensis* emphasizes visuality. Accordingly, I focus on visual rhetorics that Chagoya employs. I detail the process of recognizing cultural rhetorics of woundedness through these opportunities. I hope to demonstrate how the reading directions differ in their understanding of woundedness and how unlearning European reading conventions might salvage strategies of rhetorical woundedness.

In the left-to-right reading that begins on page 15/1, the first page of the European narrative, an image of a black-and-white Superman sprawls prone on his side amid rubble (fig. 9). There seems to have been a fierce battle that has left Superman defeated; however, there is no clear indication as to why Superman has fallen. The left-to-right narrative begins at this moment, and all we can observe is that Superman's black-and-white reality is now bloodied by his loss, and he is either dead or unconscious. Indeed, death is the likeliest indication as his superhero costume is torn from his broken body—no longer Superman but perhaps his exposed everyman alter ego, Clark Kent. A large piece of the costume has been snagged on debris and waves above him as a ruined flag in tattered defeat. On this makeshift flag, the costume's distinctive "S" chest emblem is sideways and bloodied. Above the black-and-white Superman is the wording: "THREATENED? ENDANGERED? OR EXTINCT?" This design is bleak, but in the next image-cell on the same page, Superman is inexplicably back in action and in full color.[16]

READING WOUNDS (FROM RIGHT TO LEFT) TO RECLAIM MEXICA COSMOLOGIES 131

Fig. 9 | Guillermo Gómez-Peña, Enrique Chagoya, and Felicia Rice, *Codex Espangliensis*, page 15/1, Superman and Skull and Mickey Mouse on Plate, 2000. Image courtesy of Moving Parts Press.

Superman's reemergence is met by an animated, airborne human skull that collides with him, as a floating human heart presides over the scene.[17] In the left-to-right reading, the outcome of Superman's collision with the skull is unresolved concerning the skull's fate, but the remainder of the codex's narrative traces multicolored Superman as he advances from these opening battle encounters to traverse a world populated by Mesoamerican and Catholic cultural icons along with a slew of his allied United States pop icons. The first of these pop icons to join Superman's adventures is Mickey Mouse, who appears at the far-right edge, also on page 15/1 in the left-to-right narrative. With Disney references throughout, the *Codex Espangliensis* joins a prominent thread of media criticism launched in Latin American social theory, notably in 1971 when Chilean scholars Dorfman and Mattelart's *Para leer al Pato Donald* famously examined how Disney's ideologies colonized Latin America via cartoons that promoted capitalistic societies, imperialism, and infantilization of audiences to the effect that the social authority of the United States is staged as limitless and supreme.[18]

Here, Mickey Mouse is part of Chagoya's reimagining of the circa-1566 *Codex Magliabechiano* (fig. 10). As in the sixteenth-century codex, the *Codex Espangliensis* image features a group of Indigenous Mesoamericans who are gathered around three large bowls of severed human body parts as they consume (presumably) pieces of bodies from the bowl. In the historic *Magliabechiano* image, the god Mictlāntēuctli, a lord of the underworld, oversees the meal by directly facing and considering the diners;[19] in Chagoya's *Espangliensis* reimagining, the

Fig. 10 | *Codex Magliabechiano* (detail), folio 73r, ca. 1566. Manuscript paint on paper, 6.3 × 8.7 inches. Image courtesy of Ministero della Cultura / BiblioMinistero della Cultura / Biblioteca Nazionale Centrale, Firenze. Reproduction restricted.

god is relocated to the top of a nearby pyramid, where Mictlāntēuctli shakes salt on Mickey Mouse, who is bound to a dinner plate. Significantly, Chagoya previously quoted the *Magliabechiano* in his 1994 *The Governor's Nightmare* that criticized then–California Governor Pete Wilson for his support for Proposition 187, also known as the "Save Our State" initiative (SOS) that involved heightened anti-immigration measures.[20] Given that Chagoya quotes both the *Magliabechiano* and *The Governor's Nightmare* in this scene, the *Espangliensis* image is politically charged as a comment on American pop culture (signaled by Mickey Mouse), immigration politics (SOS), and colonial collections of Mesoamerican cultural narratives (since the *Magliabechiano* was a post-contact representation of pre-contact customs and religions).

After this scene, the left-to-right reading follows Superman through colonial and postcolonial confrontations with Mesoamericans and their descendants, a culture clash complicated by the presence of additional religious and pop icons. The book ends on page 1/15 with the image of the marriage of a conquistador and a woman wearing colonial-era bridal attire. The exaggerated abundance of flowers in the bride's headgear may allude to the union of Hernán Cortés and Doña Marina/Malintzin/Malinche. The couple's ceremony occurs at a graveyard

with a tomb and skeletal remains looming behind the bride. As the backdrop for the vows, a giant hellmouth emerges from a burst of flames. Enthroned in the open hellmouth is Satan, presiding over the unholy union. Flying in the foreground, as if launching from the hellmouth, is a solid blood-red Superman, no longer multicolored; a bright white skull covers his chest instead of his standard "S" logo.

Read in this left-to-right order, the codex's overall narrative trajectory moves from the defeat of black-and-white Superman, then follows multicolored Superman who travels Mesoamerica as part of colonizing forces. The consumption of Mickey Mouse early in the narrative initiates the fall of the Mexica legacy as its Chicanx descendants proceed to consume the teachings of Catholic and United States pop icons. The marriage scene is the pinnacle of the depicted loss since the bride makes a bloodline pact ordained by Satan while blood-red Superman flies victoriously. This is a story of colonization and conversion that continues into the twentieth and twenty-first centuries through mass media and pop culture assimilation.

It is nonetheless possible to detect subversion in the left-to-right reading of the *Codex*. This subversion manifests in the potential for multiple interpretations of various religious and pop culture icons in Chagoya's images. We might recall David Carrasco's decolonial theories that advocate rereading Christian symbols used in colonial and conversion visual programs to tap potentially hidden meaning-making by nondominant audiences who might, all along, have found counter-rhetorics invested in the symbols.[21] Page 3/13 of the *Codex* provides an example of rereading icons for subversive meaning, featured in Baca's analysis. Here, along a riverbank, a group of armed conquistadors gathers Indigenous peoples (fig. 11). In the foreground, both male and female natives, stripped nude, are mutilated either through a gorging of eyes or dismemberment of one or both hands. A mass of severed hands lie wasted on the bloodied ground while the river in the background streams red. At the bottom left edge of the scene, inhabiting the margin space outside the image box, Mickey Mouse gleefully watches. Part of his foot and round belly protrude into the massacre space, making him complicit in the violence rather than a mere observer. One of his yellow shoes lifts in unbridled amusement, exposing a bloodied sole. In the upper right corner, also sharing both the massacre and margin spaces, Spiderman hovers, also bloodied on his feet as well as on his closed fists. He is unmasked, revealing his secret identity as George Washington.[22]

134 THE GENERATIVE WOUND

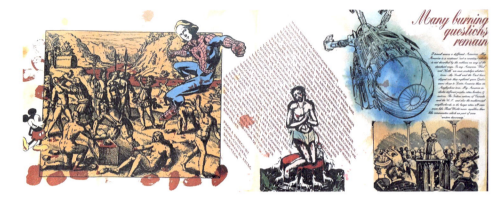

Fig. 11 | Guillermo Gómez-Peña, Enrique Chagoya, and Felicia Rice, *Codex Espangliensis*, page 3/13, Man of Sorrows and Massacre, 2000. Image courtesy of Moving Parts Press.

To the right of this mutilation scene is an image of Christ. He appears in the Man of Sorrows motif, bloodied and in misery. Here, Christ kneels in prayer on top of what appears to be a column stump, likely the flagellation column. Along the round base of the column, seven white lambs lift their heads to Christ, perhaps to receive his blood that drips over the column's edge. A white cup, symbolizing a Eucharistic chalice, catches a heavy stream of blood from the spear wound in Christ's side, here represented on the right side rather than the traditional left. The other Crucifixion wounds are detectable in nail piercings on his visible feet and his hands that are clasped in prayer over his bare chest. Crowned with spiky thorns, Christ tilts his head in desolate engagement with the audience. In the interpretation of these side-by-side images of bloodshed, we might, as directed by Carrasco's methodology, read an act of subversion as Christ bleeds along and in empathetic solidarity with Mesoamericans.[23] Such an interpretation provides an example of rereading rhetorics for potentially hidden meaning for the nondominant audiences who might, all along, have found counter-rhetorics. Yet, while I agree with methodologies that recognize possible counter-receptions in rhetorics, I suggest that counter-rhetorics are insufficient to decolonize historical narratives. After all, decoding individual pieces functions on a micro-level that continues to engage within colonial frameworks rather than dismantling the entire system.

For example, this micro-reading and decoding of the Man of Sorrows and mutilation scene in the *Codex Espangliensis* does not consider the United States

pop culture references that border the massacre nor two additional images on the right of the page: a drawing of a space satellite and an early twentieth-century type-metal print cut by José Guadalupe Posada in which a church congregation flees in terror as a pulpit priest points directly at the threatening satellite.[24] Accordingly, emphasis on the possible rhetorical relationships that a left-to-right reading exposes between the massacre scene and Catholic iconography prioritizes the colonial moment and possible audience reception in that historical moment, and it underplays the specific relationship that informs this contemporary Chicanx art regarding United States pop culture and technology, as well as the Posada print as Mexican political art—thereby limiting the immense scope of the *Codex Espangliensis* to colonial contact and a linear-time, left-to-right European narrative.

Yet the collapsing of eras and cultures is a leading feature of the *Codex Espangliensis*.[25] Taking page 3/13 of the codex in its totality, the layering of cultural annihilation across time and involving multiple power systems is immense. Does the Christ image imply empathy for the dismembered Indigenous people at the left of the page, or is he sorrowful that the contemporary world at the right of the page might no longer need his religion to access the celestial realm because it has science? To arrive at an answer, we must further consider the rhetorics of woundedness at the core of Christ's depicted suffering and then apply this analysis on a macro-level to initiate my right-to-left reading of the *Codex Espangliensis*.

According to traditions of Catholic devotional rhetorics of woundedness, Christ's suffering is a triumph for himself as Savior and for the Church that he births. The Man of Sorrows icon, stemming from twelfth-century Byzantine visual rhetorics and adopted for heavy circulation by the later Franciscan Order, aims for the audience's emotional responsiveness regarding this laborious birth.[26] The response elicited is for Christian viewers to reflect on their debt to Christ who bleeds to salvage humanity of Original Sin. Yet through Christ's loss, much is gained not only for the audience who can now secure redemption but also for Christ and the institute that immortalizes his wounds as proof of victory. Originally associated and employed for Easter celebrations, the Man of Sorrows motif signals the death of human Jesus but the rebirth of divine Christ. This rebirth is marked by Christ's physical re-manifestation during the sacrament of Eucharist where the body and blood of Christ is consumed. In Chagoya's Man of Sorrows, Christ bleeds into a chalice, the wine for the Eucharist, while the lambs tilt their heads to gaze on Christ's sacrifice and drink the blood droplets

that fall to each of their lifted muzzles. In this way, bloodshed generates empowerment of the lambs as followers of Catholicism—and empowerment of both the Church that offers the Eucharistic service and Christ who is recalled for his *ostentatio vulneris*, his victory in woundedness.

With all these levels of empowerment *from* and *for* the wounded Christ, it is difficult to see corresponding empowerment in the accompanying scene of mutilated Indigenous people. The only empowerment is for the Castilian soldiers. Indeed, the dismemberment of natives' hands methodically incapacitates the wounded. An entire community void of hands is unlikely to survive. Reinforcing this point, in the massacre image's midground, a Castilian soldier unleashes a pack of dogs that overpowers a handless native man, unable to fight off the pack as he flails backward. Meanwhile, on the further side of the riverbank, bodies fall from a steep hillside. Although the bodies are in the far distance, we can assume that they are also Indigenous people since their hands are missing, indicated by dots of blood where hands would otherwise be attempting to grab a handhold to stabilize the falling bodies from crashing to the ground below. Lack of power is emphasized in this scene where nothing can be done to help the Indigenous people's condition. Meanwhile, Christ acts through prayer and faith, clasping his still-intact hands to activate the institutionalized Mass in his own honor and victory.

While a subversive correlation can be drawn between the bloodshed in these two images, I ask that we reread this scene from a right-to-left direction, putting Christ in a position to react not to the bloodshed but rather to the chaos at the Posada church at the emergence of the floating space satellite. When following this reading direction, I observe that the assortment of images makes a more cohesive strategy of subversion by offering a different narrative altogether rather than sporadic and limited opportunities to counter-interpret within the framework of a left-to-right European narrative. When they/we step outside European frameworks, Chagoya and Gómez-Peña position wounds as generative.

The Indigenous reading direction removes the native mutilation scene as the object of Christ's response to the bloodshed. Instead, the counter-direction positions Christ as the originator of bloodshed—his own bloodshed, his Church's nourishment from that bloodshed, and the institutional power that sponsored bloody campaigns to the Americas. Placement of Christ before the mutilation scene might be viewed as functioning as an accusation against the Christian institution behind colonial forces, funded by the Catholic monarchs of Castile and Aragon and supported by Spanish Pope Alexander VI, who declared Isabel and

Ferdinand *Los Reyes Católicos* on December 19, 1496.[27] Broadening beyond colonial contexts, Christ's placement might concurrently model a notion of generative woundedness in the face of both the conquering forces from colonial Europe and modern United States culture. There is a series of monumental events that span this page, starting with the church congregation that flees at the sight of the space satellite (in horror of science or in abandonment of the church for scientific power?). In the right-to-left reading, Christ's response is not to the massacre but to the appearance of the satellite and its effect on churchgoers. Thus, does he pray that the devout stay put and continue to consume the blood he offers, or does he pray for mercy on humanity at the coming of a new threat in the form of modern science?

Although the marginalia pop icons seem primarily engaged with the mutilation scene to the left of the page, they occupy both the scene and the margin, and this makes it possible that they can observe the events to their right and perhaps are reformulating their power tactics as they study overlapping fragments of both colonial and technological invasions. Supporting this notion, a handless native in the mutilation scene points at the floating George Washington Spiderman, thereby visually and politically linking Spiderman with the hovering satellite at which the pulpit priest points. Spiderman may be the next big threat, hinted at by the blue hue of his leggings, which is similar to the satellite's color. Spiderman also mirrors Christ's engagement with the codex audience, both figures looking directly outward from the text's plane. While Spiderman emulates the looming threat of the satellite and the rhetorical engagement strategies of Christ, his confident George-Washington smirk contrasts with Christ's empathetic suffering.

Significantly, the marginalia detail of Mickey Mouse and his bloodied shoe leaves a trail of gory footprints that, in temporal collapse, move from right to left—from Christ where the bloody prints are deepest, across the edges of the massacre scene, and to the left margin where the tracks begin to fade as Mickey presumably continues onto the next page. Mickey's footprints are especially significant in that they signal, via an ancient Mesoamerican visual trope, the start of a journey and ensuing movement, as famously depicted in the early sixteenth-century *Boturini Codex* that details the migration of Mexica people from their mythical home in Aztlán to the founding of their capital in Tenochtitlán. In other words, here in the massacre scene, Mickey's first appearance in the codex (if read right to left), the tracks indicate that Mickey begins a journey in the opposite direction of European readings. The journey's momentous start at the

138 THE GENERATIVE WOUND

mutilation scene is reinforced by the decision of *Codex Espangliensis* book designer Felicia Rice to select this image for the cover. In this Indigenous direction, Mickey's last appearance is the cannibal scene where he is eaten, a fate that implies that the incapacitated natives discover empowerment after their woundedness.

Following Mickey's right-to-left trail, Superman is also resituated in a narrative that defeats him. This right-to-left Superman emerges from the wedding ceremony hellmouth as a blood-red figure, fresh from Catholic Satan's demonic realm and carrying a skull symbolizing death as he enters the world of multicolored pop culture where he dons his iconic superhero "S" emblem to conceal the havoc he brings, alongside fellow comic-book heroes, to the Mesoamerican, colonial, and modern realities. Superman's final scene is his encounter with the Posada skull on page 15/1. The skull here is not an emblem of Catholic Satan's power but an emblem of Mexico's political cartoon pioneer José Guadalupe Posada, an artist Chagoya credits for originating Mexican modernism.[28] The right-to-left reading sees Mickey Mouse ritualistically devoured before the defeat of Superman empowers the Posada skull. In Mexica tradition, eating one's enemy signified the absorption of that enemy's power, which could then be transferred to advance one's own purpose. An important note to consider is that the Mexica are devouring Mickey Mouse as prepared by their own lord of the underworld, the god Mictlāntēuctli, who now, in the right-to-left narrative, advances a different framework of the afterlife than that offered in Satan's hell.

Death, according to Mexica belief, is a natural cycle of life; sacrifice assures balance in this cycle since the spilling of blood recalls both death and birth. Chagoya's rendition of the *Magliabechiano* cannibal scene emphasizes blood on both the raw body parts that the Mexica devour and on their stained lips—signaling the nourishing transference of blood from the dead to the living. The severed body parts might also recall the dismembered hands from the page 3/13 mutilation scene. However, rather than discard body parts to waste, as the conquistadors elected, on page 15/1 the Mexica avoid non-generative killing to participate in a life-death sequence. Such a ritual is ultimately designed to place reality into cosmic balance and prevent the end of time by giving back to the earth and deities. This references the concept of nepantla, as discussed in the introduction, a time when balance is regained after the earthquakes of life. Accordingly, sacrifice is understood as a communal and personal obligation. The more powerful the member of society, the more responsible that member is for sacrifice. In this framework Mickey Mouse, a pop culture superpower, is responsible for

returning his energy to the world as the Mexica consume him to energize their role in life.

This cannibalistic act may mirror the image of Christ's sacrifice to nourish his seven lambs with blood. Indeed, the act of a transference of power is embedded in the Eucharist, wherein redemption and salvation are ingested through Christ's body. A Catholic understanding of sacrifice is thus similarly linked with victory and generative transformation. These joint concepts of generative wounds form an important rhetorical partnership for my studies. However, the codex's Indigenous reading direction allows the detection of departure from Catholic teachings on bloodletting. Again, in the European left-to-right reading, only Christ can reflect on the massacre; yet in the right-to-left reading, the Indigenous peoples may reflect on their own woundedness. They maintain control of and attention to the "crying wound." This message from the wound prompts a movement away from Christ's concepts of sacrifice, where blood-spilling by his conquistadors does not give back to the earth or the gods. Bodies and blood are slaughtered in wasteful chaos by Catholic soldiers. Accordingly, the right-to-left narrative begins to elect a Mexica framework of generative wounds, evidenced by the climactic scene of the cannibal ritual that reestablishes balance after entering nepantla.

As previously detailed, my understanding and application of nepantla are largely based on perceiving the term as a metaphysical concept of securing balance within a fluctuating liminal space. The chief emphasis of nepantla is not on sites of in-betweenness but on actions of finding balance while life forces an individual into various directions. The importance of nepantla is in the emergence of the individual from the liminal space at which moment generative transformation is optimized. Linked to the metaphysical concept of *ollin*, a Náhuatl term of movement or earthquake, nepantla permits entrance into new states of being once balance is secured in the "earthquake" or violence of lived experiences. Wounds become generative and necessary for the renewal of each and all. They are, in actuality, the purpose of life. From the right-to-left reading of the *Codex Espangliensis*, we can therefore interpret the mutilation of Indigenous peoples as a departure point from the Christian bloodletting tradition. This departure is instigated by the conquistadors' violation of the generative purpose of Christ's sacrifice and initiates a recollection of Mexica ritual to activate another form of generative bloodletting to set reality into balance after the earthquakes of colonialism and the invasion of United States popular culture.

140 THE GENERATIVE WOUND

Thus, to the left of the cannibalistic scene, the skull—a symbol of Posada's political commentaries but also a symbol of the god Mictlāntēuctli who is now satisfied from the ritualistic tribute—knocks Superman backward. The floating heart indicates a new sacrifice—Superman himself. Accordingly, the codex's final image is Superman defeated in a black-and-white realm, possibly the dark death realm of Mictlān. Superman's end space in the right-to-left narrative replaces Catholic Satan's hell realm. The tattered "S" emblem waves in defeat above Superman. Turned on its side, the "S" resembles a Mexica snake—the snake denoting in Nahua iconography the movement of blood and the renewal that blood-spilling represents. The Mexica and their descendants thus fly their victory flag above the defeated symbol of modern popular culture.

This reading of the *Codex Espangliensis* shows us essentially a reverse-colonization narrative that utilizes rhetorical tactics of generative woundedness from Catholic and, most explicitly, Mexica traditions as re-envisioned by Chagoya. It is important that the codex's European reading obscures the potential of wounds as a gateway to both death and positive transformation for the wounded. The left-to-right narrative can offer only Christ's empathy for the natives, thereby voiding Indigenous potential as agents who may elect from their various inherited strategies for survival tactics. The *Codex Espangliensis* illustrates my argument that mainstream aversion to woundedness marginalizes a particular form of rhetoric that is dominant in Chicanx visual and textual arts—and that is supported in distinct ways by both Christian and Nahua historical rhetorics. However, the *Codex Espangliensis* does not directly demonstrate the female or Iberian historical lineage that I have determined to highlight. Instead, the codex prioritizes the reclamation of Mexica cultural rhetorics through bloodletting and cannibalism, which most clearly links with Christological concepts of woundedness. Yet even with the privileging of a male-driven idea of woundedness in the context of battle, bloodshed, and Christ, the codex offers one significant scene that highlights the female rhetorical culture that concerns my studies. My analysis of this scene launches the remainder of part 3's focus on Chicanx art about the female body.

Digesting and Repurposing: Confrontations from the Wound

In the *Codex Espangliensis*, if we follow Mickey Mouse's footprints from right to left across the Indigenous massacre and into page 4/12, we encounter an image

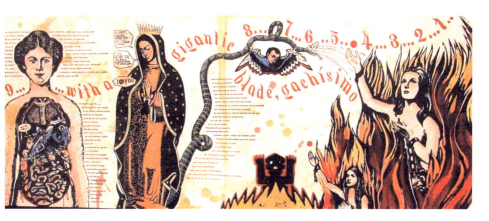

Fig. 12 | Guillermo Gómez-Peña, Enrique Chagoya, and Felicia Rice, *Codex Espangliensis*, page 4/12, Anima Sole and the Bisected Woman, 2000. Image permission granted by Moving Parts Press.

of two dark-haired women rising from flames (fig. 12). They resemble the *anima sole* or the "lonely soul" in Purgatory, an image associated with Carmelite nuns' spiritual exercises that elicit the Virgin Mary for intercession. The Carmelites were prominent in early modern Spain's devotional and colonial rhetorics, bolstered by figures such as Teresa de Ávila and Juan de la Cruz. The *Codex Espangliensis* observes this prominence by including the *anima sole* scene that depicts two women in serene gestures of rejoicing, reaching their right arms to the sky and placing their left hands over their chest. This movement breaks the chains on their shackled hands and frees the women from restriction, a contrast to the previous page's piles of dismembered hands. Wearing remnants of confinement around their wrists, the women display these broken chains much like a martyr-saint's attribute that functions both as a celebration of newfound liberation and caution against past infliction.[29] The larger of the two women lifts her palm to receive further relief from a serpent's spitting mouth. It is possible that the entire inferno is being extinguished by the snake's spray, directed by an angel who holds the snake like a water hose above his body. Helping to support the snake's weight are the angel's feathered wings, tri-colored green, white, and red like the Mexican flag. The angel can be identified as the cherub that traditionally supports not a snake but the crescent moon on which the Virgin of Guadalupe stands in clasped prayer. Indeed, as the page moves left, the Virgin stands in her iconic pose.

The Virgin here recalls the Virgin of Guadalupe, but her image alters slightly in the color and design of her robes and in the crown on her head.[30] She steps

on the end of the snake, its tail spiking upward at the left of her image, echoing the sliver of moon on which Guadalupe traditionally stands. The image also mirrors the late-medieval Immaculate Conception devotional art motif that the Virgin of Guadalupe iconography references.[31] The Immaculate Conception alludes to the Catholic proposition that Mary was exempt from original sin since she was conceived through God's design instead of human processes. Dominant artistic motifs emphasize Mary as isolated from Christ, standing with hands pressed in prayer over her chest, and designation of her exclusion from original sin often manifests in the figure of God hovering above Mary to extend a rod that marks her purity, a serpent crushed beneath her feet, or a serpent crushed beneath a slivered moon upon which Mary stands.

The crescent moon, stars, and snake or dragon are all attributes of the apocalyptic woman as described in the biblical book of Revelation. This iconography is absorbed into the Immaculate Conception motif to further empower Mary as a figure in direct confrontation with Satan—not only through her son but through her potential. In Revelation, John of Patmos describes this figure as "clothed with the sun, and the moon under her feet, and on her head a crown of twelve stars." She gives birth to a son whom Satan, in the form of a dragon, attempts to devour. However, the woman saves the child, assigns him to the custody of angels, and flees alone to the desert, where she induces Satan to trail her. In the desert, Satan opens his mouth to flood the woman with water, but she sprouts eagle wings to free herself from danger. Archangel Michael and his army of angels arrive to battle Satan, signaling the dawn of Judgment Day.

With these visual clues, one might interpret the *Codex Espangliensis* as positioning Mary and the Catholic Church quenching the fire of a colonial purgatory or hell-space from which the Chicanas reemerge healed from past wounds. In Immaculate Conception motifs, Mary often steps over the defeated snake; yet here, rather than discard the snake as a non-generative force, Mary's angel repurposes Satan's evil manifestation. Although the snake extinguishes the flames, Mary's control over the serpent permits the Chicanas to rise from the fire with their dismembered hands regained and their chains broken.

There might be a more ominous interpretation—that Mary's control of the snake's water aligns her with the dissemination of venomous powers. Additionally, in Mesoamerican contexts, the snake's cultural purpose expands. As noted in our previous discussion of the flag that waves above the defeated Superman, snakes in Nahua iconography signal the movement of blood toward death and renewal. The angel might be working in unison with the rhetorical powers of

the Nahua understanding of rebirth to free the women from the conflagrations of colonial hell. Just as possible, Mary and her angel may have conquered the Mesoamerican serpent to perform their will. These ambiguities recall a defining element of Chicanx art as confronting a lack of resolve among various conflicting fragments of cultural inheritances. Whatever may be the snake's identity, the women rise, and Mary turns her attention left to engage with another female body.

The leftmost image on page 4/12 features a woman whose chest and abdominal cavities have been newly bisected, blood still dripping along the wound's edges. Her opened body reveals organs and the comic book hero, Wonder Woman, who has been hiding in the woman's intestines. Wonder Woman emerges with a high-tech super-gun that she loads with a "KACHIK" and aims at the Virgin Mary. In comic-book word bubbles, the Virgin reacts to Wonder Woman's gun: "Oh, dear, is that a neural impacter? Do they still make those? I'd advise you to try the plasm disrupter. It's smaller." She ends with "I ♥ you" as Wonder Woman answers with "Go to Hell!" Interestingly, Baca's interpretation of this exchange is one of alliance that destabilizes Mary's status as protectress and spiritual mother.[32]

But Mary and Wonder Woman's dialogue does not indicate alliance when I read from right to left. Rather, the female bodies released from colonial hell and into the influence of Mary are now being claimed by a new force, the United States pop culture that battles Catholicism over Chicanx bodies and souls. To support my interpretation, I turn to the original context of the word bubbles, which are lifted from a May 1985 issue of *Superman* that features a battle between two opponents: Wonder Woman and the supervillain Mongul, a deposed ruler of his own alien race. In the original battle, Wonder Woman is repeatedly belittled by Mongul's misogynistic comments.[33] In the codex, Mary delivers Mongul's lines, word-by-word, except in her ending: "I ♥ you." Mongul's original line is, "I'd advise you to try the plasm disrupter. It's smaller. More of a female's weapon." That is to say, Chagoya swaps the condescending "More of a female's weapon" with "I ♥ you." Regardless of Mary's less overt hostility to Wonder Woman, Wonder Woman responds identically to Mongul and Mary, indicating equivalence between Mongul's misogynistic and condescending rhetorics and Mary's assertion of love: "Go to Hell!" In the codex, this reaction presumably begins a battle between Mary and Wonder Woman over the bisected Chicana.

While the bisected Chicana seems a mere container for Wonder Woman's surprise attack on the Church and not an active agent in the contest over her

body, I invite a closer reading of a narrative of repurposed woundedness. The opened body cavity reveals Wonder Woman rising from the woman's intestines; Wonder Woman was previously ingested. This raises the question: as in the codex's concluding cannibal scene, might the bisected Chicana have devoured her enemy, Wonder Woman, to empower herself against another force? Might the bisected Chicana be repurposing Wonder Woman's anti-misogynist response to Mongul in the comic book to now break her own ties from the Church—a Church often viewed as proclaiming love as a form of control over Chicana thoughts and bodies? If so, we might observe in the codex a tighter framing of the Church's rhetorical teachings, with Christ and Mary functioning dually as models for the wounded to find survival strategies.

I have previously noted that Christ's placement in the right-to-left narrative on page 3/13 before the mutilation models a notion of generative wounds in the face of colonial and pop-culture conquering forces. This placement of Christ's rhetoric of wounds as a model for—rather than a reaction to—the dismembered natives opens an opportunity for Indigenous agency. While I argue that the natives in the codex ultimately reject Christian strategies in favor of Nahua tactics, wounds remain a medium for advancement. Similarly, on 4/12, Mary models for the bisected Chicana a repurposing of opponents and inflictions for one's empowerment. Mary has repurposed the snake, be it Satan as a serpent, the apocalyptic woman's flood-spitting dragon, or the Mesoamerican snake of rebirth. This repurposing frees souls from colonial hellfire. The Chicana, in turn, has ingested Wonder Woman's subversion for her own self-empowerment and repurposing, possibly against Church misogyny.

The repurposing of woundedness, as well as Maylei Blackwell's methodologies on retrofitting, have returned throughout my study because the rhetorical tradition that I trace is fundamentally a retrofitted memory of trauma that rhetorically redirects assault into persistent perseverance. In part 1, I detailed Cherríe Moraga's repurposing of her wounds and those of Coyolxauhqui to demonstrate how one might use committed violence to transform victimization into accusations and protests. Such a strategy follows not only a Nahua worldview of sacrifice but Christian meditation traditions in which Christ's wounds and Mary's sorrows make human sin ever-present, a tactic that informs the historical rhetoric that I trace from the virgenes abrideras into a type of Chicanx rhetorical strategy. In this strategy, woundedness in its complexity and entirety must remain active for the generative confrontation of the inflictor(s). In part 2,

I studied (through *No Más Bebés*) the dangers of the wound being diagnosed for one aspect rather than in its totality at the crossroads of identities.

Here, in the *Codex Espangliensis*, this repurposing of the wound again appears as a prominent facet of my argument. The bisected Chicana uses her latest enemy, U.S. pop culture, to defeat a previous dominator, the Church. Yet as the narrative continues, we already know that the wound committed by pop culture will be answered, as well, by a final digestion scene of Mickey Mouse to ultimately defeat the most powerful and last pop icon, Superman. On the way to that defeat, colonial forces have been overcome as the Chicana is rebirthed by the Church. However, the Church loses its control of Chicanas who consume Wonder Woman's anti-misogynist response and aim it at the patriarchal institute.

To be clear, I am arguing that this strategy of absorbing one's assault to subdue the assaulter is a tactic advanced by Marian and Christological art, as well as Mesoamerican, and one that I observe as repurposed into new manifestations by Chicanx art—most prominently in Chicana art, a sampling of which now follows. This Chicana art applies visual rhetorics of woundedness as inherited by Marian rather than Christological imagery to confront and transform the artist's reality through generative woundedness. Chapter 6 examines a historical genealogy of the rhetoric of the female body as a painfully abstracted conduit into insight.

6

The Art of the Generative Wound
(from Container to Co-Redemptrix)

While Californian Chicanx artist Yolanda M. López does not focus on wound-edness, her provocative 1979 *Virgin of Guadalupe* series alludes to Chicanx female bodies as containers of Catholic ideologies. But these containers transform ideologies into empowerment for mundane modern lives. Absorption and employment of specifically the Virgin Mary's power icons pay homage to the Church while concurrently separating one's future from doctrinal restraints. This is best illustrated in López's self-portrait, the third in the series; she depicts herself as if in a marathon race, running with white sneakers and a victorious grin toward the audience. Behind her is a radiating portal, resembling the shimmering full-body halo that traditionally sparks from Mary as the Immaculate Conception, a motif emulated in the Virgin of Guadalupe imagery. As the artist runs from this brilliance, she either originates or flees from Mary. Either way, the artist embraces release, recalling the unshackled *anima sole* emerging from radiant flames in the *Codex Espangliensis*. In this eager advancement, López tramples Mary's attendant angel. Stepping on the angel implies triumph, like crossing a finish line. Although the artist continues in full stride, she carries what might be her victory regalia: Mary's star cloak that billows behind her; and in her right hand, a small serpent with its transcultural potentials: Satan as a serpent, the Apocalyptic Woman's flood-spitting dragon, or the Mesoamerican snake of rebirth. Again, we witness Chicanx art with a lack of resolve. Is the artist celebrating or censoring the Virgin?

Despite the crushed angel, the artist wears a pink gown that resembles the Virgin of Guadalupe's robe. In this way, she identifies her embodiedness with Mary. Yet it is also noteworthy that the robe prominently retains its delicately detailed gold-thread pattern of the *nagvioli*, the small Indigenous American flower that serves as Mexica symbol of sun deities.[1] This raises the question: is the artist running back to the Mesoamerican culture that the snake and *nagvioli* represent? Or does she run to a future where she has consumed both Mexica

and Catholic icons for her own ambition? In whichever case, López recognizes enormous cultural power in Mary and absorbs and repurposes the Virgin's attributes to endow everyday Chicanx lives. Significantly, López grounds this power into the *now* and the physical realm of the audience toward whom the artist gleefully runs. Surrounding the shimmering halo/flaming portal in the background is pale blue nothingness. In consideration of historical woundedness, we might analyze the artist within this blue-nothing context as emerging from a past whose cultural memory has been erased and dominated by the Virgin of Guadalupe and the Church she represents. Still, the artist emerges from this historical wound with a generative purpose despite a lack of resolution.

The 1970s collective art group Asco similarly emphasizes emergence from historical wounds, but with less glee and heightened confrontation. Deriving their name from a Spanish word for *repugnance*, a term colloquially associated with a physicality triggered by disgust, most commonly nausea, Asco emphasizes the Chicano body in revulsion against lived realities in urban Los Angeles. These bodies are historically marginalized into wound spaces of unbelonging and thus politically deprived. This dispossession parallels Asco's experience in art worlds, as the collective's art has largely fallen into cracks of visual and cultural scholarship. This is perhaps due to its rejection of categories; the group refused to identify with the 1970s Chicano art movement's emphasis on precolonial Mexica historical reclamation projects and modernist Mexican nationalism programs, and its multimedia art habitually crossed from visual art to theater performance to political protest, denying consistent legibility.[2] Yet this sort of rhetorical positionality situates Asco squarely in rhetorics of generative woundedness. Although rarely exhibiting body wounds, metaphorical woundedness is central in Asco's art—particularly in the collective's murals, which are not comprised of paint so much as the artists' own bodies as sometimes containers of the toxicity of politics, the inner city environment, and implosive cultural traditions. Sometimes the bodies are trapped, and other times in stalled motion. Yet while always focused on grievances of the *now*, the juxtaposition of stagnation and movement signals an existence in which one can be *seen* yet still not *exist*—a phantom experience in the bare-life reality of historically unrooted voices.[3]

Asco's 1972 performative mural/protest art *Walking Mural* comments on a cultural voice that is disempowered in its lack of grounding within mundane reality of the *now*. Specifically, Asco criticizes codifications and stagnations of Catholicism and its saints who brandish only past wounds rather than connect woundedness with current afflictions. *Walking Mural* featured Asco protesting

the then-present wound of the Vietnam-American War. The performance included a parade to army recruitment offices on Christmas Day with Patssi Valdez dressed as a black-adorned Santa María, echoing elements of the Virgin of Guadalupe yet in shadow hues. The repurposing of Marian imagery into black mourning reconnects Mary's woundedness to the Chicano communities that were suffering disproportionate war casualties. The articulation signals community mourning over Chicano militaristic sacrifices and concurrently an otherwise absent institutional Church mourning of this traditionally Catholic demographic. Mary's grief, modernized in the living and walking body of a Chicanx protest artist, simultaneously demands remembrance of self-generative rhetorics of woundedness while confronting blood-spilling that does not generatively address grievances and a Church that has abandoned the faithful's sacrifices.

Christina Fernandez's photography similarly collapses the gulf between self and history to protest abandonment and consequential voicelessness. Fernandez does not reference the Virgin Mary but instead absorbs family iconography to fill the void, the space between past and present—a gulf where she proceeds to seek the location of both woundedness and reassurance. In the aforementioned *María's Great Expedition* (1995–96), the artist offers her body as a surrogate container of her great-grandmother María's memories of migration from Mexico to California as a single mother. Yet to occupy her inheritance, Fernandez must rely on imagined, episodic, and often stereotyped portrayals of her great-grandmother whose reality is overlapped by Hollywood conventions. Frustrated by temporal gulfs and cultural erasures that reduce the abundance of her grandmother's genuine legacy, Fernandez portrays a poignant, discontented longing to know her past. In many ways, such a longing echoes Patssi Valdez as a surrogate for Santa María; both artists attempt to embody and make relevant an inheritance that otherwise fails to resonate in their current needs to be grounded and seen.

Yet while Valdez and Asco apply embodiment to criticize ways that the past fails to support modern needs, Fernandez persists in experiencing and *being* her past. Fernandez refuses to run toward the future without carrying her past with her, no matter the partialness or semi-ness of her historical knowledge. Indeed, Fernandez's photography insists on temporal collapses that are essential in generative application of rhetorics of woundedness, as I previously illustrated in my examination of *No Más Bebés*, Cathy Caruth's trauma theories, and *Doc/Undoc*'s mirrors. Visibility of a struggle to own and perform through present bodies an obscured past defines Fernandez's work as a reclamation project that confronts historical woundedness.[4]

Fig. 13 | Christina Fernandez, *Untitled Multiple Exposure #4 (Bravo)*, 1999. Gelatin silver print, 20 × 24 inches. Image courtesy of the artist.

Contemporary Chicanx Visual Rhetorics of Woundedness in Phantom Space

Developing this concept, Fernandez's *Untitled Multiple Exposures* series (1999) features overlapping portraits that combine historical images of Mexican Indigenous women with self-portraits by Fernandez.[5] As exemplified in *Untitled Multiple Exposure #4 (Bravo)*, this double-exposure makes detectable a dark wound space wherein the figures cannot entirely absorb the past into oneness with the present (fig. 13). Always together-apart or fragmented in cultural identity due to disruptions in historical inheritances, the Chicana and her ancestors in Fernandez's art cling to whatever they can share despite histories

dismembered by colonization, obscured by myths of modernity, and reimagined by popular culture. Of note, Fernandez's *Untitled Multiple Exposures* series combines not only historical images of women with Fernandez's modern self-portraits but extends rhetorical inheritances through the lens of photographers. Specifically, Fernandez merges her photography with modernist artists Manuel Álvarez Bravo, Gabriel Figueroa, Nacho López, and Tina Modotti, who originally captured the images of the Indigenous Mexican figures. Thus, Fernandez both claims her heritage in the still-active, still-relevant, and still-inventing living body of the artist and reopens the eyes of deceased photographers by sharing their perception of an urgency to preserve histories by spotlighting the body.

In *Untitled Multiple Exposure #4 (Bravo)* Fernandez merges her vision and body with the work of Manuel Álvarez Bravo (1902–2002), a pioneer of Mexican artistic photography.[6] Working in the aftermath of the Mexican Revolution, Álvarez Bravo focused on preserving cultural heritage through representation of Indigenous roots in rural populations. Bravo's rejection of the picturesque or stereotyping of Mexican identity during rapid modernization mirrors Fernandez's examinations of Hollywood conventions and gaps in historical representation of early twentieth-century Mexican American and present Chicana realities. By now placing herself in the viewing plane at the end of what would have been Álvarez Bravo's camera lens, the artist metaphorically insists that her photographer-predecessor similarly strip her of stereotyping—to see her and to validate her existence as also rooted in Mexican indigeneity. This action is performed all the while complicating the historical contexts around Álvarez Bravo's photography, a context previously discussed in chapter 2 as a post-Mexican Revolution government-sponsored visual rhetoric that celebrated indigeneity as starting point for modern Mexicans. We might recall that this celebration concurrently marginalized Indigenous populations and physically relocated them to reservations in order to advance Mexico's new face of mixed-heritage people as rightful inheritors of the land and power of Mexico while Indigenous peoples were temporally placed in an infantilized condition, belonging in a premodern past.

Rather than explore indigeneity within temporal linearity, Fernandez opts for temporal collapse. She simultaneously struggles with the impossibility of a full collapse where she can claim and be one with the past that she repeatedly desires throughout her art. Here in *Untitled Multiple Exposure #4 (Bravo)*, Fernandez hugs herself as if alone in her dark wound space, and she is absorbed in her forward-facing vision, seemingly unaware that at her back she does carry

a phantom past into a living future, no matter the partialness and haziness. As Fernandez braces herself against the struggles ahead with a stance of strength and purpose, she is concurrently braced and bolstered in the arms of an ancestor who seems to fortify Fernandez's resolution even if the artist is seemingly unaware of the embrace.

Fernandez literally emphasizes the embrace of fragmentation as an empowering act that both accuses forces of ongoing obliteration of cultural heritages, yet treasures the pieces that remain within one's reach. Again, fragmentation does not signify shame of a nonunified and incomplete culture but rather shames the systems that inflicted and still inflict historical and cultural violence. Accordingly, in Fernandez's art the embrace of a fragmented past manifests visually as both a safeguard and comfort even in the face of confrontation and loneliness. In *Untitled Multiple Exposure #6 (Lopez)* the artist positions herself as the embracer, holding and supporting the past in her arms in the figure of a woman whose image was encapsulated by Nacho López (fig. 14).[7] A photojournalist who studied under Álvarez Bravo, López (1923–1986) presented images of working class and Indigenous people in urban settings. López's photography ruptures narratives of a unified, wealthy, and modernized 1950s Mexico City. López thus functions as the middle figure in the photographic rhetorical genealogy that Fernandez draws from Álvarez Bravo to López to herself—all photographers who aim to salvage pieces of a fading ghostly past. Yet Fernandez is the only woman in the lineage, and her female perspective offers a different gaze on the women of the past that she now encounters.

In *Untitled Multiple Exposure #6 (Lopez)*, Fernandez provides respite for the female ancestor, fueling the past with energies from an empowered female future. The result is that the female ancestor is now the solidified figure supported by Fernandez, now the hazy phantom. The artist's eyes are tired and downcast, seemingly contemplative of her own murky state: while perhaps more privileged in her society as a woman of color, she is still unclear and vague due to her historical and cultural relocations and losses. The together-apart state, while comforting in its sense of belonging, continues to emphasize the impossibility of securely grasping a past when present Chicanas possess institutionally limited understandings of our own histories, obscured under colonial disruptions. Accordingly, the image series remains *Untitled* as even the most basic life details of the Indigenous Mexican ancestors, such as their names, remain elusive. The impact is not only a lack of full awareness of the past even when one's cultural phantoms are ever-present (*Untitled Multiple*

Fig. 14 | Christina Fernandez, *Untitled Multiple Exposure #6 (López)*, 1999. Gelatin silver print, 20 × 24 inches. Image courtesy of the artist.

Exposure #4) but a haziness that pervades Chicanas' own understanding of self (*Untitled Multiple Exposure #6*).

Maya Gonzalez's *The Love that Stains* (2000, acrylic on masonite) presents a similar together-apart state yet more directly emphasizes woundedness. Furthermore, it is precisely through a generative woundedness that the artist attempts to finally solidify the future with the past within the same space. Here the figure at the front of the picture plane, a dark-skinned woman with dark almond eyes and jet-black hair piled high on her head, crowned with white roses, exposes her bleeding heart (fig. 15). The woman wears a deep blue dress

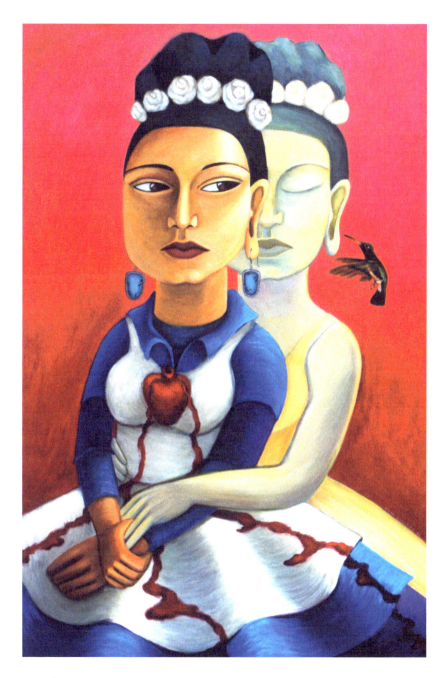

Fig. 15 | Maya Gonzalez, *The Love that Stains*, 2000. Acrylic on Masonite, 36 × 48 inches. Image courtesy of the artist. "The Love that Stains" © 2000 Maya Gonzalez.

with a white apron that contrasts with the red of her bleeding heart, no longer contained in her body but vulnerably exposed against her white-aproned bosom. Blood flows from the heart and down the apron into two streams that continue to fork down to the woman's blue gown and beyond the painting's viewing plane. Though the woman is wounded, she is soothed by the embrace of a ghostly twin who, from behind, wraps her arms around the dark-skinned twin. The ghostly twin's skin is an ethereal jade that glows softly along her arms and neck. Her eyes shut, she is possibly dead and unaffected by the sounds of a hovering hummingbird that speaks into her left ear.

We might interpret the hummingbird as representing Xochiquetzal, the Mexica goddess of love, flowers, vegetation, and fire who protects artists.[8] Frances Toor, in her canonical 1947 *A Treasury of Mexican Folkways*, details an Indigenous belief that by wearing remains of a hummingbird, one will be sought after and loved.[9] These associations with hummingbirds resonate in Laura E. Pérez's analysis of the bird as linked to matters of the heart—but more specifically the bleeding heart. Pérez writes of the hummingbird as embodying and transmitting *yolteotl*, a Nahua word that refers to "a deified heart."[10] In this interpretation, the dark-skinned twin sacrifices her own material heart as an offering to the hummingbird to access the ethereal twin. Such an offering functions from the belief that, as previously discussed, bloodletting possesses generative potential to set one's reality back into balance or to achieve nepantla after life's turmoil. Whether the hummingbird alludes to the Mexica goddess or the personification of the spiritual heart, it is evident that the dark-skinned twin expectantly attends to the hummingbird, waiting for the bird's presence to impact the ethereal twin. The wounded heart continues to bleed during this wait, a "love that stains" the dark-skinned twin with visible anticipation to engage with the ethereal twin, be she ancestor or other-self. The wounded heart is the dark-skinned twin's strategy to recover the ethereal other through various complicated and interactive meanings that hearts hold in Catholic, Mesoamerican, and Chicanx rhetoric.[11]

To further complicate the rhetorical inheritances, Gonzalez also echoes Fernandez's attempt to delineate an artistic rhetorical lineage to help to light her way. Gonzalez's works are informed by imagery from Frida Kahlo's 1939 *The Two Fridas*, again bringing Mexican visual culture into the mix.[12] *The Two Fridas* is a doubled self-portrait of the artist. Despite superficial distinctions, the twinned Kahlos share a circulatory system, making the two a single being through the movement of one blood.[13] Still, their interaction is less emotionally

THE ART OF THE GENERATIVE WOUND (FROM CONTAINER TO CO-REDEMPTRIX) 155

intimate than the Gonzalez twins. The Kahlos share a bench but sit at a distance and hold hands rather than embrace. Their attention is also directed at the audience rather than each other. The stormy gray sky engages the two Kahlos with their environment and society, while the Gonzalez twins are enclosed in a crimson wound realm that benefits from a heightened sense of withdrawal, peace, and union, removed from phenomenological experiences. Accordingly, *The Love that Stains* positions the dark-skinned twin as recovering her ethereal twin by exposing a bleeding heart. In this exposure, the past lineage or bloodline is ever-pumping. The Gonzalez twins' journey is to regain each other and close the gulfs between the two by clinging, if not to one's obliterated historical data, then to one's own heart that undeniably bleeds from a real—not imagined—past.

In contrast, the twin Kahlos, who not only reveal their hearts but their veins, snip their own bloodline with a scissor. This cut threatens to widen the gulf between the twins and their present world. The Kahlos' journey is, furthermore, a removal of self from the future, signaled by the end of the bloodline. The only blood Frida will share is with herself, perhaps a comment on the artist's much-studied family turmoil and painful divorce from Diego Rivera at the time of the painting's creation.[14] In short, Kahlo's wounds testify externally to her emotional suffering and isolation, while Gonzalez's wounds address an internal fissure in cultural identity. This is not unlike Cherríe Moraga's own contact with her inner Beloved in "The Dying Road to a Nation," in which the wound of historical detachment fosters the realization of a together-apart state with one's imagined historical inheritance. In both textual and visual employment of rhetorics of woundedness, delving into wound experiences reorients one's attention inward where one might seek directions from an imagined self as an ancestor. In this endeavor to twin the present with the past, one might claim fragments of one's history and delink them from imposed narratives—much as in Christina Fernandez's art.

Amalia Mesa-Bains's *The Twins* further demonstrates elements that define my analysis of visual rhetorical traditions of generative woundedness: the Chicanx female body as a container of past others, an emphasis on together-apart as both a bisecting wound and opportunity to recollect identity fragments, the absorption and repurposing of exterior strategies to advance one's message, and advocacy for redress (fig. 16). Mesa-Bains presents two women who expose their body cavities: one revealing organs and a fetus and the other containing the image of the Virgin of Guadalupe. Mirroring the physical bisection, the women

Fig. 16 | Amalia Mesa-Bains, *The Twins: Guadalupe*, 1997. Giclée print, 22 × 16 inches. Courtesy of the collection of Richard Bains.

metaphorically split as two parts of the virgin-whore dichotomy. Twins, they are fragmented into binary spaces as they must choose existence as either the corporal and sexualized body or the spiritual container of the virgin mother. Of note, neither woman exposes her lungs or heart; they have no voice and are not allowed to feel, a sense heightened by their plastic mannequin exteriors. The anatomical woman has a dark nothing-space where her heart and left lung might be found. Also absent, therefore, is the bloodline that potentially unites both the Gonzalez and Kahlo twins. The Mesa-Bains twins cannot be linked except in the touching of the back of their hands, where they seem fused as if the mannequin mold that might have formed the figures was flawed.

It is highly significant that the women are not as separated as designed. This is a small detail, but one that hints at solidarity amid differing experiences of object-ness. Indeed, we might detect a joint confrontation of the virgin-whore dichotomy. The women refuse to hide the internalization of imposed gender roles under a façade of sameness but rather externalize their ingested social codes to confront the dichotomies enforced on their identities. In this way, woundedness is exposed as an accusation and stimulus, similar to that presented by the Kahlo twins. As in *The Two Fridas*, Mesa-Bains situates her twins

against a cloudy sky that maintains attention outward to lived reality in the *now* as opposed to the intimate wound space where the Gonzalez twins seek each other. Also, as with the bisected woman in the *Codex Espangliensis*, the opened body cavity both models itself after and targets devotional rhetorics of the Virgin Mary for ongoing misogyny that offers the female body as mere container. Yet it is exactly in her role as container in the genre of virgenes abrideras that Mary transforms her own state of object-ness in Iberian and Ibero-American art. Indeed, the Mesa-Bains and Kahlo twins perform the same strategy. In the virgenes abrideras, Mary is a container designed specifically to be bisected. Yet in her most diminished state as a nonhuman object, to be touched and opened by any who encounter her, the virgen abridera most clearly exhibits the generative wound as a strategy that rhetorically confronts audiences with that which is already uncomfortably known yet must now be addressed, and again and again in perpetuity. That is to say, the object insists on redress for its objectification; the wounded demands attention to her woundedness. Once again, we encounter (non)humanness as rhetorical action.

Medieval Iberian Inheritances of Rhetorics of Woundedness

While I have peppered *The Wound and the Stitch* with references to the virgenes abrideras as providing historical rhetorical models for generative woundedness, I now directly link discussion of Chicanx art to a lineage of female cultural rhetorics that resonate in the sculptures. Recall from the introduction that when the San Juan Chapultepec virgen abridera is activated through the audience's opening of Mary's closed arms, the figure simulates a crucifix (fig. 2). This insinuation of a crucified Mary appears in sixteenth-century Iberian virgenes abrideras and accompanies a shift in the carved narratives that are enclosed in Mary's interior. The first 250 years of Iberian virgenes abrideras, the earliest being the circa 1270 Allariz sculpture, featured a version of Mary whose entire body cavity would open to reveal the Joys of Mary: the Annunciation, Nativity, Adoration of the Magi, Resurrection of Christ, Ascension of Christ, Descent of the Holy Spirit, and Coronation of the Virgin.[15] However, by circa 1520 the sculpture's body cavity begins to open to reveal the Passion of Christ narrative, the earliest existing example of which is the virgen abridera of Pie de Concha.

During the next generation of virgenes abrideras, the sculptures' opening mechanisms became limited to the chest cavity, as exemplified in the circa

1576–1625 virgen abridera housed in the Museo Arqueológico Nacional in Madrid, which is strikingly similar in its Immaculate Conception design to the San Juan Chapultepec sculpture (fig. 17). Largely sponsored by female patrons for female-specific locations and audiences, these sorrowful and restricted-access sculptures of Mary were the form that crossed to the Americas. In the San Juan Chapultepec virgen abridera and its sister in Gama de la Paz, Mexico, as well as a sixteenth- or seventeenth-century Buenos Aires virgen abridera, the interiors feature either the Passion of Christ or the Sorrows of Mary rather than the Joys of Mary. I posit that the shifts from joys to sorrows and from full-body access to narrowed admittance emphasize a rhetorics of woundedness that specifically empowers Mary as she assumes crucified position, again as seen in the Madrid virgen abridera (fig. 18).

Although damaged and containing only two of its original four bas-relief narratives, the Madrid virgen abridera provides an example of the shift from the Joys of Mary to the Passion of Christ program with its preserved carvings of the Prayer of Jesus on the Mount of Olives and the Holy Burial. The sculpture's two lost narrative scenes were likely the Crucifixion and another episode of the Passion, although the Museo Arqueológico Nacional catalog notes that after the loss of the two central bas-relief narratives an image of the Virgin Mary had been pasted into one of the empty cavities.[16] This image was also ultimately lost, but nonetheless, the concept of an image of the Virgin Mary as filling the vacant role that Christ's Passion played in the Madrid virgen abridera might signal a larger sentiment of greater equivalence between the wounds and sacrifices of Christ and Mary. Indeed, in the original and still-intact design of the seventeenth-century San Juan Chapultepec virgen abridera, the interior carved narratives of Mary's Sorrows stand in for Christ's Passion scenes. This raises the question, are the Mexican *virgenes abrideras* placing more rhetorical weight on Mary's role as co-redemptrix?

As co-redemptrix, Mary's role is equated with Jesus's role in securing human redemption from original sin. The chest openings in Latin American virgenes abrideras indicate support for Mary's designation as co-redemptrix, not only in positioning her arms as cruciform but through the opening of her breasts as a gateway to interior narratives of redemption. Such iconography creates rhetorical modification, prompting audiences to adapt what they know of redemption as gained not only through Christ but Mary. I propose that this destabilization is premised on Mary's emotions of loss yet acquiescence—forming retrofitted memory of an otherwise dominant masculine narrative of Christ as the sole

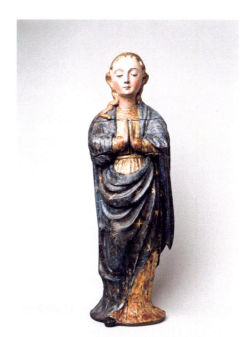

Fig. 17 | Virgen abridera, ca. 1576–1625. Wood, pigment, gold, polychromed, 6.3 × 3.9 × 19.8 inches. Museo Arqueológica Nacional, Madrid, Spain, Inv. 1969/44/1. Photo: Juan Carlos Quindós de la Fuente.

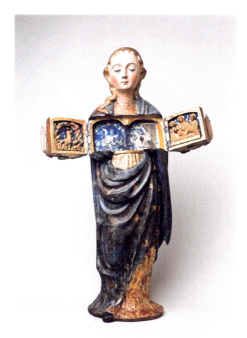

Fig. 18 | Virgen abridera, opened to show the Passion of Christ, ca. 1576–1625. Wood, pigment, gold, polychromed, 6.3 × 3.9 × 19.8 inches. Museo Arqueológica Nacional, Madrid, Spain, Inv. 1969/44/1. Photo: Juan Carlos Quindós de la Fuente.

redeemer through the action of body sacrifice. While Christ's narrative most definitely emphasizes emotion, Mary's emotional simulation of the crucifix that is performed exclusively through sentiment provides an alternative way of understanding redemption. Specifically, this retrofitting of Christian history permits Mary's emotions to be a historical authority and to centralize her in sacrifice and redemption narratives.

In visual iconography, Mary's status as co-redemptrix predates this specific shift in Iberian *virgenes abrideras*. Medieval thought often linked Mary's milk and Christ's blood, merging the sacrifice of bodily fluids into one unifying effort to intercede on behalf of humans. Early medieval medical theories additionally considered blood and milk to be interchangeable and believed that blood channeled from the womb to the breast via a lacteal duct, the *vasa menstrualis*. Bartolomaeus Anglicus's thirteenth-century *De Proprietatibus Rerum* details this "holough veyne," citing Greek (Hippocrates), Roman (Galen), Byzantine (Constantine), and Iberian (Isidore of Seville) authorities.[17] Connection between these fluids was enhanced by vision narratives, such as those related by thirteenth-century Saint Mechtild of Magdeburg, who envisioned Christ's revelation that "the blood of grace is like the milk that I drank from my Virgin Mother."[18] Christ's spilled blood thus extends Mary's spilled milk, exalting Mary as Co-Redemptrix. Associations between the impacts of both forms of sacrifices—blood and milk—were widespread throughout medieval Europe. However, while the sacrifices were paired across Europe, the designation of Mary as Co-Redemptrix remained controversial. Iberia was more receptive to the Co-Redemptrix designation and, in support, developed visual and textual rhetorics.

My insistence that rhetorics of woundedness be considered within Iberian frameworks is based on this support as well as contextual interreligious dialogues in late-medieval and early modern Iberia and the effect of such dialogue on art of the Mesoamerican region. Due to incompatibility with Jewish and Islamic doctrines on divine incarnation, pre-fifteenth-century multifaith Iberian Christian textual and visual rhetorics tended to less frequently disseminate the Passion of Christ.[19] Avoidance of Christ's suffering responds to conversion-based and trans-faith rhetorical tactics. Fourteenth-century Franciscan theologian Francesc Eiximenis, a prominent figure in Aragon under King Martin and Queen Maria de Luna's patronage, is a prime example of this rhetorical strategy. In his *Llibre del Crestià*, he remarkably does not urge readers

to meditate on Christ or his Passion. Instead he provides references, should readers be interested in independently pursuing meditations on the Passion.[20] Furthermore, Eiximenis's presentation of Christ is almost exclusively as a divine and all-powerful figure, not the human son of God; concurrently, Mary is elevated more closely as Christ's equal yet still functions as compassionate intercessor, a mother who opens redemption for humanity. In this way, Christ's suffering was often moderated via Mary's human experience of sacrifice and emotional woundedness—developing through Mary's generative wounds a model for redemption through female bodies. Thus, when we consider generative wounds in Chicanx visual and textual rhetorics, it is useful to examine Marian devotional culture in addition to a Christological one in the formation of specific Iberian and Ibero-American rhetorics that interchange within multifaith contexts—which in the colonial period expanded from Jewish and Islamic converts to include Mesoamericans.

I focus my attention here on these distinctive multifaith encounters and a corresponding emphasis on breasts and femaleness as location of sacrifice. This discussion is surely impacted by Franciscan thoughts on humility and shame as innate to femaleness, the prominence of the cults of Mary and Saint Anne, and the dominance of Isabelline ideological shifts and rise of female patronage in the late medieval and early modern periods.[21] I am particularly interested in drawing a rhetorical lineage through visual cultures sponsored by the Poor Clares of the Franciscan Order, evidenced in the San Juan Chapultepec virgen abridera, first documented in the Franciscan convent of Santa Catarina de Sena in Oaxaca. This virgen abridera encapsulates an emphasis on female breasts as a gateway to both sacrifice and generation, thereby functioning as one reference point in tracing the historical genealogy of rhetorics of woundedness adapted in the Americas.

Significantly, while virgenes abrideras, as a genre designed to fragment the Virgin Mary's body parts, can be located throughout medieval Europe, non-Iberian sculptures differ substantially. Virgenes abrideras north of Spain contain the Trinity (fig. 19). Mary is the symbolic vessel of Christianity as she holds the Trinity in her body; she is an abstracted structure that encloses Christ's teachings. In Iberian tradition, however, Mary contains as central her own lived narrative that, through the centuries, transitions from joys of motherhood to Christ's sacrifice—and then her own sacrifice and sorrows as she assumes the crucified position. I am interested in how this Iberian tradition resonated with female

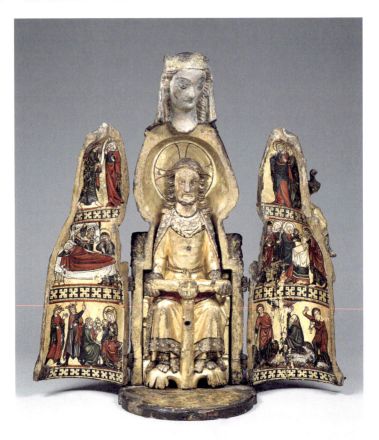

Fig. 19 | Shrine of the Virgin, opened to show the Trinity, ca. 1300. German, made in Rhine Valley. Oak, linen covering, polychromy, gilding, gesso, 14.5 × 13.6 × 5.1 inches. Gift of J. Pierpont Morgan, 1917. Image copyright © The Metropolitan Museum of Art. Image source: Art Resource, New York.

patronage of such sculptures and the development of rhetorics of woundedness as practiced in transatlantic colonial interchange and contemporary Chicanx textual and visual rhetorics.

Through story, Iberian sculptures impart teachings but also provide dynamic interactions to extract from viewers knowledge that they also contain and bring into the encounter. Only by approaching the objects as embodying text can viewers identify and exercise Mary's narrative. Accordingly, the vírgenes abrideras

function as both destinations and points of embarkation since they locate viewers as also narrative vessels. This activates awareness of one's location in the realm of devotional knowledge, knowledge one carries just as Mary bears in her carved interior. As a rhetor, the devout locates herself as a person of Catholic faith before opening the sculptures, and rhetorically as she converses with the sculpture's exposed narratives. Elina Gertsman explores this interactivity as part of Western Europe's medieval visual culture, in which viewers enter situations where they are "essentially constituted and reformed by the interaction with the object."[22] There is a process of fragmentation and reconstruction. This parallels with the invention of rhetors who are splintered from a wider context to locate and reform in *topoi* encounters. Gertsman studies virgenes abrideras as objects that provoke memory via visuals that anchor the "mind's eye" into contemplation before the eye wanders to the next visual anchor.[23] While virgenes abrideras clearly stimulate memory as viewers recall narratives, the pieces also offer an active epistemology that adjusts present self and space, particularly in Iberian sculptures that concern the rhetorical inheritances that I address.

While Gertsman likens Mary's body to a Eucharistic monstrance and thus acknowledges a prominent application of Marian visual rhetorics that associate Mary with a container,[24] the religious instability in the Iberian Peninsula historically avoided understanding Mary as a mere container, giving rise to more dynamic and active rhetorics surrounding the Virgin. Gertsman writes of Western European tradition deep in a conceptualized space of Christendom but does not focus on the realities of the Iberian borderland spaces where Catholic and Islamic faiths contested for nearly eight hundred years. In such disputed regions, Mary's body was not just a container, like a monstrance. After all, the monstrance is not the site of Christ's transfiguration but that of adoration for an already-extant transubstantiation of bread into the body of Christ after the Eucharistic ritual. To regard Mary as a vessel of completed action suppresses Mary's agency, thereby restricting her ability to intercede. In borderland cultures such as pre-Isabelline Iberia, limiting Mary's dynamism would be particularly problematic. This mindset would logically follow Iberian colonizers into Mexico as a new contested space.

Erin Kathleen Rowe discusses late-medieval and early modern Iberian perceptions of saints whose "job was to protect and serve the nation."[25] The apostle Santiago, for example, had an obligation to "protect and intercede for Castilians, while Castilians, in return, had to venerate and honor his relics."[26] Rowe credits exposure to borderland territories of Byzantium during the First Crusade as

a stimulus for Castilian reliance on warrior saints, in contrast with dominant Latin faith culture.[27] Santiago became linked with militaristically reclaiming a golden age prior to the Islamic invasion in 711 CE. The success of the iconography of Santiago as *matamoros* or Muslim-slayer would be later applied to Santiago as *mataindios* or Indigenous-slayer, particularly in Iberian campaigns in Peru.[28] Between the Muslim invasion and the 1492 reconquest, Iberian Catholic faith in Mary as intercessor and Co-Redemptrix also grew. An Iberian tendency toward more active engagement with Mary fortifies traditions of the 431 Council of Ephesus that declared Jesus's incarnation dependent on Mary's role, since only a conceiving human mother could validate Jesus's humanity. It follows that in Iberian theological discourses and art, Mary is more readily conceptualized as a site of transformation, not solely a container for that which God conceived outside her body.

Perhaps to further advance Mary's status as a site of transformation, the doctrine of Mary's own Immaculate Conception was heavily supported by Iberian royal campaigns, especially in Aragon, which most closely aligned with Franciscan theological advancement of the doctrine. In 1333, Alfonso IV established the royal confraternity of the Immaculate Conception in Zaragoza, and in 1414 the Confraternity of the Immaculate Conception of Barcelona began to petition Holy Roman Emperor Sigismond to join Aragon in defense of the doctrine, thus launching Spain's international campaign for the Immaculate Conception. In 1469, when Ferdinand II of Aragon married Isabel of Castile, Castile promoted the Immaculate Conception. Isabel retained her favorite poet and preacher, Ambrosio de Montesino, a Franciscan Immaculist who wrote the *Brevario de la Inmaculada Concepción de la Virgen Nuestra Señora* in 1508 at Toledo. Isabel also requested a copy of the 1497 *Vita Christi* by Sor Isabel de Villena that related Mary's Immaculate Conception, funded celebrations of the Immaculate Conception at the monastery in Guadalupe, founded the Franciscan Order of the Conception in Toledo (run by former lady-in-waiting Beatriz da Silva), and sponsored chaplaincies in honor of the Immaculate Conception in Toledo, Guadalupe, and Seville. In 1508 Isabel's daughter Queen Juana established a convent of the Virgin of the Immaculate Conception in Palma de Mallorca.[29] The end result of rampant Iberian Franciscan and political support for this doctrine was that in colonial-era art programs we see a rise in Mary's status as exempt from original sin, implying equivalent purity with Jesus. Fifteenth and sixteenth-century Immaculate Conception motifs further accentuated Mary's redemptrix role.

This prominence of Mary as human redemptrix clearly raises the viability of her access as intercessor and correlates with the concurrent proliferation of Iberian reports on visions, mostly featuring Mary who tended to be reported as appearing in the flesh in rural locations, manifesting in images held in urban spaces, and prompting rediscovery of her image in art pieces that often had backstories of having been lost during the Muslim invasion.[30] This proliferation of saintly activity speaks to how Mary's role in Iberia was not that of a passive container. This may explain the contrast between southern and northern virgenes abrideras and later rhetorical traditions of modeling female Catholic meditation on a more active Marian agency, one where, for example, Carmelite nuns prayed directly to Mary to release the *anima sole* from hellfire. Mary's body in borderland art emphasizes potentialities at active juncture points to function as a simulation of elected pathways during life's turmoil. This point draws our discussion back to the rhetorical strategy of the Iberian and Ibero-American virgenes abrideras in their confrontation with audiences.

In many ways, we might approach this strategy as linked to medieval concepts of pilgrimage. Pilgrimage is not limited to access to holy spaces. Indeed, pilgrimage was a way of life. V. A. Kolve applies the pilgrim's road as a metaphor for the liminal spaces that open when humans encounter options for pathways between fixed providential points.[31] Here, moral choices are tied to location. Pilgrims navigate journeys of trial, guided by internalized faith-texts from which they select the most apt *exempla* to externalize as they progress through physical life. In this way, pilgrims parallel rhetors, recalculating in middling experiences as they recall past knowledge to modify the present self while aware of future goals. A temporal collapse is essential in this process to more closely understand one's episodic experience of life as fashioned by the all-seeing God, who observes existence in instantaneous and simultaneous motion. This middling space is a moment of quiet, meditation, and selection amid the chaos of multiple pathways along the metaphoric "pilgrim road" of life. When these principles translate into the Americas, the "pilgrim road" might be understood within the Nahua metaphysical framework of nepantla, a space in which to find equilibrium and clarity amid the earthquakes of life. A prevalent navigation tool in Catholic Iberian borderland practices was reflection on Mary's life. To emulate her virtues would lead one to the correct path along the pilgrimage to salvation, and along this path, if challenges manifest, Mary's intercession could be best sought if one were living by her model. Given this context, the

purpose of Iberian *virgenes abrideras* can be seen as making accessible Mary's human experiences through bas-relief fragments of her life—accessed through a deliberate choice for a "pilgrim" to touch and fracture Mary's body as a gateway to salvation. Meditating on Mary's now-externalized image-narratives, the pilgrim's own interior knowledge of text-narratives is activated, thereby positioning the pilgrim to act upon that activation.

As previously noted, early *virgenes abrideras* such as the circa 1270 Allariz sculpture, commissioned by Queen Violante of Castile for a Franciscan convent of Poor Clares, featured Mary with the Christ Child in her arms. To activate the sculpture, Mary's body is bisected to externalize bas-relief images of the Joys of Mary, providing *exempla* on pure life and accompanying happiness. Also previously stated, post-Reconquista and post-contact *virgenes abrideras* exhibit many narrative shifts. First, *virgenes abrideras* begin to feature Mary without the Christ Child, allowing her to be the primary and single focal point of the sculptures' exterior design. Specifically, she begins to be portrayed as a stand-alone Immaculate Conception. Most significant to our study, when these later sculptures are bisected, they externalize the Sorrows of Mary, complicating the *topoi* from which audiences might select rhetorical reactions and introducing new rhetorics of woundedness that inform my project.

The 1520 *virgen abridera* at the Toledo Convent of the Concepción de las Madres Agustinas, also known as the Convent of las Gaitanas, an order of barefoot nuns, illustrates this new rhetorical situation.[32] Although the Toledo sculpture functions as a bas-relief panel cabinet, rather than a sculpture in the round, it serves as a transitional piece from older Joys of Mary *virgenes abrideras* to Ibero-American pieces that focus on Mary's Immaculate Conception, Co-Redemptrix role, woundedness, and female body.[33] The Toledo piece has three states (fig. 20). Closed, it is undecorated, but opened, its outer wings feature traditional Joys of Mary narratives that celebrate events of motherhood. Between the winged narratives, Mary stands as the Immaculate Conception *Tota Pulchra* on a crescent moon. Beneath the moon is the defeated dragon. The sculpture's last state is revealed when viewers part Mary's praying hands to reveal in her chest cavity an internalized narrative of sorrows. The breast as a gateway to inner pain emphasizes Mary's female body, much as in the *virgen abridera* of San Juan Chapultepec, as well as the sculptures from Gama de la Paz, Mexico and Buenos Aires, Argentina. Opening the chest cabinet also relocates Mary's praying hands to the cruciform position.

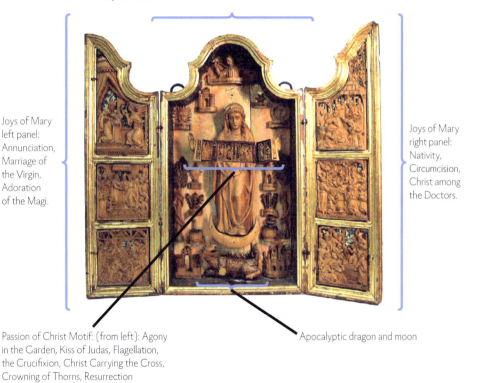

Tota Pulchra, featuring Mary standing on a crescent moon, while attributes encircle her: closed gate of Paradise, star of the sea, personified sun and moon, spotless mirror, Tower of David, palm, cypress, lily, rose, sealed fountain, well of life-giving, enclosed garden, City of God.

Joys of Mary left panel: Annunciation, Marriage of the Virgin, Adoration of the Magi.

Joys of Mary right panel: Nativity, Circumcision, Christ among the Doctors.

Passion of Christ Motif: (from left): Agony in the Garden, Kiss of Judas, Flagellation, the Crucifixion, Christ Carrying the Cross, Crowning of Thorns, Resurrection

Apocalyptic dragon and moon

Fig. 20 | Virgen abridera, 1520. Convent of the Concepción de las Madres Agustinas, Toledo, Spain. Polychromed wood, 23 × 27 × 6 inches. Annotations by author. Photo: Antonio Pareja.

As I previously argued, the destabilization of Christ as sole redeemer and sole possessor of woundedness is premised on Mary's emotions of loss yet acquiescence—forming a retrofitted memory of a dominant masculine Catholic narrative. Mary's emotional simulation of the crucifix provides an alternative understanding of redemption as also accessed through emotional sacrifice. Related to this point, Ibero-American art of woundedness accentuates differences in visualities of pain as a physical infliction and suffering as its emotional counterpart.[34] Given this context, it is significant that the San Juan Chapultepec sculpture blurs such difference. Christ's physical pain and Mary's emotional suffering are two sides of a cohesive story of sacrifice.

The crossing into the Americas of the virgenes abrideras, as seen in the San Juan Chapultepec sculpture, retains a stand-alone focus on Mary as Immaculate Conception, breast triptychs, and sorrow narratives. The San Juan Chapultepec piece additionally strays from conventional renditions of the Passion of Christ, which the Toledo inner triptych features in a more standardized rendering. As noted in fig. 20, the Toledo virgen abridera features in its Passion of Christ narrative (left to right): Agony in the Garden, Kiss of Judas, the Flagellation, the Crucifixion, Christ Carrying the Cross, the Crowning of Thorns, and the Resurrection. If we recall from figure 2, the San Juan Chapultepec virgen abridera features (left to right): Agony in the Garden, Christ's Encounter with Mary on the Way to Calvary, the Crucifixion surrounded by Mary and John, and the Descent from the Cross in the narrative of a pietà with Mary holding the body of Christ. The Passion of Christ motif thereby merges into a Sorrows of Mary narrative with Mary's final encounter with Christ, Mary's experiences of the Crucifixion, and most significantly Mary's grief. The pietà centralizes Mary as a mother in mourning. Mary's iconographic role accordingly transforms in this brief history of the virgenes abrideras from the mother-container of God's son in northern European sculptures to abstracted container of joyful motherhood in Iberian sculptures that then darken into Christ's sacrifice, and finally to the container and narrator of Mary's own woundedness.

While Mary's emotions still respond to the dominant presence of Christ, it is *her* positionality that she relates and her own woundedness that she unfolds. She gains possession of her body cavity to assert a narrative about herself rather than function as a mere container of another's narrative. Like the contemporary cabinets of curiosity by Mesa-Bains and Gómez-Peña I analyzed earlier, Mary contains fragments of her own experiences that do not narrate the identity of the collector (or Creator) so much as display inflictions against her own humanity.

THE ART OF THE GENERATIVE WOUND (FROM CONTAINER TO CO-REDEMPTRIX) 169

In her salvaged narrative, she confronts and transforms her reality. I suggest that Iberian sixteenth- and seventeenth-century virgenes abrideras encapsulate a rhetorical strategy of selecting and presenting episodes of one's own lived trauma to repurpose grievances into a generative assertion of the reality that one aims to conceive. This assertion is actualized by prodding audiences into liminal reflection spaces to reroute the metaphorical pilgrim into a desired direction. I conclude that virgenes abrideras functioned as a vital import of the Iberian historical rhetorics of woundedness that then shifted to meet new rhetorical conditions in the Americas.

An Epilogue: Engaging Audience Responsibility from the Wound

Unlike their northern counterparts, Iberian virgenes abrideras do not codify Mary's role as a container of God's creation and Christ's actions. Instead, the Iberian sculptures offer a more dynamic Mary who temporally collapses past knowledge into present choices. This rhetorical strategy extracts textual memories from viewers, who then activate present pathways. Mary's externalized wounds become sites of contemplation that obligate audiences to manifest rhetorical responses. In the San Juan Chapultepec virgen abridera, viewers rhetorically traverse from Christ's meditation in the garden as he prepares for sacrifice into Mary's human and female experiences of Christ's choices and her own sacrifices as the mother who, all along, knew that this pain would arrive. Even with foreknowledge of the loss of her son, Mary acquiesced to sacrifice, much like her devotees who know that with the opening of the virgen abridera they will enter a wound. This woundedness is reactivated each time an audience interrupts Mary's prayer to divide her hands and bisect her chest cavity. Audiences are located in their own time and space as ongoing participants of a Catholic perception of human sin. Identified as sinners in need of redemption, the audience obligates Mary to a life of martyrdom in which the birthing of her son and the milk that nourished his life all aimed at sustaining him for sacrifice. Mary confronts viewers with the wounds they brought and continue to bring to her reality both in the past and present. To highlight this point in the San Juan Chapultepec virgen abridera, Mary clings to her son's etherealized body in the pietà scene. Past pain continues to wound the present. Yet meditation on this accusation places the audience not only in the role of sinner but on progression toward salvation.

I return here to Cathy Caruth's understanding of trauma theory and conceptualization of "the crying wound." This crying wound is the "belated address" of trauma as generative pain that is revisited and maintained in the present—rather than at a safe distance—so that sacrifices of the past might inform decisions of the present. Virgenes abrideras place audiences in daily engagement with (and as activators of) pain and suffering to make relevant to today's actions sacrifices of the past. Mary's woundedness engages audience responsibility to choose a "pilgrim" path to redemption. Advancement on this path relies on constant traversing across borders of internalized and externalized epistemologies, embodied texts, and performative rituals. This coexistence of faith and phenomenology in Iberia provides shifting rhetorical maneuvers that link body with spiritual empowerment. It is an extension of *ostentatio vulneris* or the indication of the suffering process as an affirmative display of devotional attributes.

The presence of this visual rhetorical practice that is transported across the Atlantic into Mexican virgenes abrideras manifests and adjusts for new borderland nun cultures. The American transformations indicate a value of Mary's dynamic engagement in empowering new female devotional audiences. As with the Allariz and Toledo virgenes abrideras, the San Juan Chapultepec sculpture would have engaged convent nuns, specifically Franciscan nuns of Santa Catarina de Sena. This engagement happened through rhetorical strategies that presented the female body as a conduit of holy teachings. Yet the greater emphasis of the San Juan Chapultepec virgen abridera on narrating Mary's experiences and emotions would have heightened a sense of agency and self-determination for Mexican Franciscan nuns as reflection of their own sacrifices as cloistered women. Alongside Nahua concepts of sacrifice and balance, Mary's narrative of the generative wound as contained and employed for her own purposes as Co-Redemptrix becomes a prominent thread in the fabric from which Chicanx rhetorics of woundedness arise.

In the Chicanx art that I have presented, as well as in Cherríe Moraga's texts, there are clear commonalities with the rhetorics that I have discussed in the iconography of the virgenes abrideras: the female body fragmented, temporal collapses that link past wounds to present actions, hidden narratives of violence that externalize as confrontations, and repurposed ownership of those wound narratives. However, while the seventeenth-century Mexican nuns introduced to the virgenes abrideras were presumably receptive audiences of Mary's confrontations and accordingly were prompted toward acts of redemption, Chicanx art of the twentieth and twenty-first centuries in the United States often meets

THE ART OF THE GENERATIVE WOUND (FROM CONTAINER TO CO-REDEMPTRIX) 171

unreceptive audiences who are made uncomfortable by the reminders of colonial, conversion, and pop-culture invasions of body and soul.

Rhetorics of generative wounds are predominately marginalized in mainstream United States social discourses, a *dis-ease with disease*, as Tembeck's discussion of autopathography terms it.[35] Yet Tembeck views disrupted comfort as necessary to provoke audiences to emotionally transition from passive reception to engaged responsibility.[36] Tembeck suggests that images of the ill or wounded have potential to transform disinterested viewers into witnesses. Even if the audience is an unwilling or hostile witness, the act of confrontation with the wound prompts audience action—either to tend to the wound or to let the injury continue. This has all along been the strategy of rhetorics of woundedness in Catholic devotional art. It is also a strategy in Mesoamerican cultures where the act of sacrifice opens a space of nepantla. In this space, amid earthquakes, balance is secured for a brief moment where crossroads might be assessed and actions chosen in response to and in preparation for the next life disruption.

Like modern autopathographies, the Chicanx cultural rhetorics that I examine make visible both physical and emotional inflictions to maintain the still-living self as part of a still-dislocated history, the still-inventing self as part of a still-relevant heritage. The impact is an insistence on asserting self as constructive in a society that is often untrained to esteem such value, particularly when delivered in rhetorics of fragmented heritages, mixed media, dislocations, and bisected bodies. Indeed, it is risky to elect a narrative of fragmentation in lieu of wholeness. To disrupt colonial fictions that the self is whole and unified is to own one's incompleteness. Declarations of incompleteness or semi-ness may be often misinterpreted as self-contempt or disclosures of inability or defect. There might also be a misperception of clumsiness or that which Moraga describes as *"baby that I am,"* a possible result of elected in-betweenness during the unlearning of normative or straight performance of self.

Yet if rhetorics of woundedness are cultivated as a strand of Chicanx cultural rhetorics, then I am concerned about conditions where the nonreceptive audience cannot understand strategies elected by Chicanx rhetors. This is especially troubling when a young adult negotiates the two worlds of academic and cultural rhetorics. I wonder, when a student crafts her narrative persona as marginalized, fragmented, and semilingual, is her tactic recognized as cultural rhetoric? I am inclined to testify that those of us who perform our disparate parts are often not recognized for our rhetorical inheritances. I speak from experience as

a Californian educator and Chicana who identifies as a fragmented rhetor and who performs, centralizes, and shares my elected cultural rhetoric with my students. The reality of my classroom is that I teach writing and rhetoric in an ethnic studies department that serves predominately Chicanx students. Many who enroll in my courses crave validation as students whose immediate rhetorical culture remains outside principal learning opportunities. I fear that my students fail to be recognized when they craft rhetorical voices to reflect experiences of fragmentation, split loyalties, and prominent ruptures associated with "impostor syndrome" (particularly as expressed by my first-generation students).

This is particularly prevalent when a student employs rhetorics of woundedness that involves representation of the self as incomplete. A common response from well-meaning audiences, one I received throughout my education, is to act on a perceived need to fix Chicanx rhetors, which may result in inadvertently accusing such rhetors of irresponsibly maintaining wounds.[37] Such actions may prevent ownership of this rhetorical culture and further alienate rhetors from expressing self. Indeed, one of my students recently related a poignant moment of liberation from pressures to "fix" herself. Finally owning her fragmentation and purging shame linked to her sense of semi-ness, she testified, "I had thought we had to be whole in order to be sane."

Yet what is so insane, what is so shameful about fragmentation and semi-ness? Is the shame indeed that which is possessed by the Chicanx rhetor who elects a vocabulary of semi-ness, partialness, and woundedness? Or is the shame a reminder to the audience that the rhetor has lost pieces of the cultural and historical self? Is the shame, in actuality, more about the impact of wound disclosures? Are audiences dis-eased when confronted with the semilingual, semi-American/semi-Other, semi-understood reality of many Chicanx narrators? It is my hope that my study of the cultural rhetorics of woundedness raises awareness not only of the historical lineage that remains active in the art and text of Chicanx rhetorics but also that informs self-representation strategies of Chicanx students. I thereby conclude my project with a final examination of rhetorics of woundedness by considering feelings of academic woundedness in Chicanx university composition students and the way these emotions might be harnessed to generatively stimulate more inclusive classroom environments.

Conclusion | The Linguistic Wound and Stitch Pedagogy

In 1803 Marcelo de la Cruz, a Mixtec Indigenous man from Nochistlán, defied the bishop of Oaxaca, Mexico, by disregarding the condemnation of the dilapidated parish church of San Juan Chapultepec. In an act of rebellious devotion, Marcelo advanced, and eventually prevailed, in his mission to secure in San Juan Chapultepec a sanctuary for the virgen abridera bequeathed to him by his aunt, Maria Manuel Aguilar. This virgen abridera represents a rhetorical inheritance from Iberian traditions that were translated to suit the needs of new audiences in Mesoamerica and that were later reimagined in late twentieth-century United States rhetorics to recentralize woundedness to express, not devotional sacrifices, but disproportionate losses as Chicanas are systematically targeted to surrender self, body, and opportunity. In many ways, my research echoes Marcelo's act of employing inherited objects of fragmentation and woundedness to call attention to a dejected space, abandoned by its own organization, and I echo contemporary Chicana rhetors who advocate attention to continuous and structured abandonment of Chicanx wellness and potential. In my final thoughts, the condemned space is the rhetorical home of Chicanx students, neglected by educational institutions that marginalize Chicanx sense of belonging and thereby their cultivation of academic wellness and potential.

After more than twenty years of teaching college composition in Southern California, sixteen of which have been as an instructor of Latinx rhetoric and composition in a Chicano and Latino Studies department, I have worked with students who elect to centralize Latinx rhetorical cultures and strategies as the gateway to self-advocacy. Many of these students crave validation as writers whose immediate rhetorical lineage remains outside normative writing opportunities. Accordingly, my efforts to recover fragments of rhetorical genealogies aim to raise greater attention to my students' varied journeys and to emphasize forms of rhetorics that meaningfully validate their own self-representational strategies as modern cultural writers.

To my Chicanx students, I propose conscious conversations between present learners and textual spaces constructed from a historical southwestern European trajectory that engages with a northwestern Mesoamerican trajectory to enter southwestern Indigenous and United States cultural discourses. Chicanx rhetorics in my projects function as spaces informed by Iberian and Mesoamerican rhetorics that impact Southwestern United States communicative modes as expressed today in one's community but also shaped by the individual who navigates an assortment of life experiences and rhetorical spaces.[1] I share with students my belief that by knowing our rhetorical inheritances and the modes through which to participate in those inheritances, we gather tools for rhetorical sovereignty and prepare to centralize our discursive spaces and needs through our own communicative strategies.[2]

To reach this goal, however, we must surpass two primary hurdles: a disjunction between the scholarship of historical-cultural rhetorics and writing pedagogy and the still-extant prioritization of a line of rhetorical history that privileges a northwestern European trajectory. I address these pedagogical challenges as they relate to the inclusion of students who participate in rhetorics of woundedness. I also emphasize not only how teaching may change to accommodate a more expansive range of rhetorical inheritances that includes (but is not limited to) rhetorics of woundedness, but how students who articulate woundedness, semi-ness, or fragmentation may generatively challenge teachers who normalize rhetorics of wholeness and the enforcement of language competencies and "correctness" in writing and genre conventions. My goal is to investigate ways that prescribed classroom performances of wholeness may be destabilized in lieu of inflicting shame on student rhetors.

From Rhetorics of Woundedness to Stitch Pedagogies

Again, I am reminded of my student who testified that she "thought we had to be whole in order to be sane." In the supposed "safe" space of classrooms, this student was led to feel insane for her assertion of fragmentation in her rhetorical self-representations. The student was enrolled in one of my recent upper-division Chicana literature classes. I designed an opening thematic exploration of rhetorics of woundedness, which I introduced through Cherríe Moraga's "La Güera," similar to how *The Wound and the Stitch* begins. I later tasked students to analyze the articulation of fragmentation in Ana Castillo's *Watercolor*

Women / Opaque Men. Throughout Castillo's novel, the narrator ("I") engages with a concealed self, *Ella* ("not-I")—a relationship with fragmented self that students readily pursued. The above student testimony blossomed from analysis of the "I" and "*Ella*" dynamic as the student recognized parallels to her own reality. This recognition that fragmentation does not indicate insanity, I feel, is a primary move in contesting myths of wholeness, especially regarding self-perceptions in youth populations.

I also note that while the thematic focus in this class continued to shift beyond rhetorics of woundedness as our semester progressed, many students elected to interweave a sustained analytical thread on semi-ness and fragmentation into ongoing literary encounters. For example, in Carla Trujillo's *What Night Brings* (2003), student essays predominately examined a series of tug-of-war experiences among fragmented identities, loyalties, and engagements that the protagonist encounters around a variety of issues such as sexuality (lesbian desire vs. transgender desires), domestic violence (parental love vs. contesting abusive family hierarchies), spirituality (faith vs. spiritual abandonment). In response to Sara Borjas's poetry in *Heart Like a Window, Mouth Like a Cliff* (2019), students noted methodical isolation of body parts to convey emotions of woundedness and survival, systematic dismantling and revisioning of identity, and the celebration of fragmentation as Borjas purges shame associated with semi-ness. The most popular poem students selected to analyze was "Pocha Café," which evokes semi-ness as a testimony to both personal and community survivance. What I learned from my students' capacity to acutely identify and articulate rhetorics of woundedness throughout our course was that many of my Chicanx students gripped tightly to our opening studies of generative woundedness precisely because such scholarship validated their sense of self. A class I designed as a survey of Chicana literature became a focused study of narrative strategies to contest rhetorics of wholeness—specifically because students elected the lens of fragmentation to tap into self-legitimizing explorations.

I see similar efforts to claim validation in my composition courses, where students not only detect rhetorics of woundedness in Chicanx writing but tap into their own articulation, development, and empowerment of this same rhetoric. With the demographic of students I teach in my Californian ethnic studies department, issues of semilingualism and insecurities fostered by writing hierarchies are particularly present. From anonymous, voluntary surveys that I have distributed on the first day of my classes since 2007, I have calculated that only 42 percent of my surveyed students consider English their primary language

when communicating with family and friends. However, 100 percent claim English as their primary academic language. I note this informal data because it suggests a potential sense of linguistic fragmentation as a routine aspect of student navigation through various communication spaces. This semi-ness is not so much an issue of fluency with the English language as an issue of pressures to compromise one's self-representational tactics. Such tensions arise in education but more severely in composition courses due to yet another myth or fiction that concerns our current discussion—the myths of Standard English.

For many of my students, there is no smooth cohesiveness in writing and rhetorical experiences. As language codifies their academic identities into fully and wholly converting to Standard English, some of my students express that they often feel compelled as they progress in their academics to leave behind loved ones as they continuously practice in school spaces the abandonment of language and modes of rhetoric that are associated with home communicative structures. This point returns us to my argument that performances of many Chicanx rhetorical traditions, such as rhetorics of woundedness, tend to be misunderstood as academic assessors, scholars, and even students themselves view shame in performances of semi-ness. Consequently, home rhetorics and those loved ones associated with such rhetorics might be conceptualized as an externally manifested "not-I."

I often hear of such experiences from students during discussions of a poem that I have frequently assigned to my lower-division classes. "Elena" (1984) by Pat Mora opens, "My Spanish isn't enough." The narration continues for three stanzas in the first-person voice of a Mexican American immigrant mother. In the first stanza, the mother remembers when her language was enough, a past when she and her children could share their lives: "Listening to my little ones, / Understanding every word they'd say, / Their jokes, their songs, their plots."[3] The second stanza is grounded in the present, during which, now speaking English in the United States, the children sit around the kitchen table, laughing exclusively with each other, as the mother can only "stand by the stove and feel dumb, alone."[4] In the third stanza, the mother devises a strategy to learn English so that in the future she can reenter her children's circle. However, she is discouraged by her husband's frown, her children's laughter, and the grocer's and mail carrier's mocking. Yet Elena persists: "Sometimes I take / My English book and lock myself in the bathroom, / Say the thick words softly, / For if I stop trying, I will be deaf / When my children need my help."[5] For my students, this poem stimulates much reflection about language as unifier and divider.

I again shared this poem during two recent composition class sections, total-ing forty students, of whom twenty-four self-identified as Latino, six as Anglo-American, five as international, four as Asian American, and one as European American. Students in both sections observed that Elena had been misdiag-nosed as "stupid," "irrelevant," and "an outsider" due to her lack of English-language skills. One student commented that "she isn't learning, so she has to lose her kids." This raises the question, is relevancy in the United States based on active linear progress toward wholeness of one's English-language identity? When I posed this question, both class sections overwhelmingly agreed this to be the case. Additionally, some students offered that the more complete they become in specifically academic English, the further they seem to move from their families and parts of themselves. I note this lived and fictional parallel because it suggests why my students so quickly identified Elena's predicament as a language problem that worsens as her children proceed to adopt English.

In Elena's case, her children become a nonreceptive audience to her frag-mented self-representation. The result is that she loses her potential to be the mother-protectress, recalling our discussion of Moraga's concern over her desta-bilization of mother-protectress roles. Realizing their own subversion of family roles, some of my students voiced guilt over past routine mockery that they directed at family and friends for employing nonstandard English. Semi-ness in language is a shame many of my students have once experienced and are now beginning to inflict. A few of my students have been distressed to observe in Elena their own alienated mother and in Elena's children their own counter-parts who laughed at, rather than alongside, someone due to language inequi-ties. One of my students has commented that because of this language impasse, Elena becomes simply the cook and cleaner, a stereotype instead of a mother. The student continued that this sort of flattening of relationships happened with himself and his grandparents. He did not elaborate, but the class agreed that as the children learn, a wedge is formed. Further, Elena is now forced to fit a socially constructed stereotype of the Chicana, often portrayed in popular culture as verbally ineffective and thus deemed valuable only in performing menial tasks in domestic spaces. Even in these spaces, she is mocked, as Elena experiences at home, simply waiting for the mail. She is far removed from trans-lingual fluidity of navigating urban and personal language spaces. Rather, her tongue is metaphorically severed, and her identity is sacrificed as a stereotype, a shame, someone to ridicule or scorn—even by her children. This is an example of linguistic violence.

Yet my students also detect hope in the poem. Finding herself designated as deficient, Elena uses shame to generate a plan to learn "enough" English. She does not aim to master the language or assimilate by becoming English-speaking; she has already assimilated economically and geographically. She desires only enough English to protect her children. In this way, Elena marks a distinction between language and culture, sidestepping the lure of multilingualism or translingualism as a gateway for multiculturalism. For Elena, language is a tool, not equated with culture. As one of my students succinctly stated, "She just wants to be a mom again." Elena cannot understand her kids and thereby no longer knows them until she can speak some of their new language. Hence, Elena learns in isolation, hiding her studies in the seclusion of her bathroom so that she might gain some English tools.

My students interpret the study space of the bathroom as symbolizing Elena's shame but also a cleansing of shame. Elena makes such a choice—the only seemingly available one, given the legal, socioeconomic, and gendered realities that she juggles—to develop semilingual ability so her English might someday be "enough." She does not seek mastery. Translingual navigation is not her goal, and neither is wholeness. She wants only "enough." In this choice, she is reduced to the bathroom space, a shameful placement by society and her own family, yet a space she must seize to transform and regain agency. Here, she can cleanse herself from imposed shame so she might learn enough of a language to access the space she desires—a seat at her children's conversation table. I see Elena as developing a positive semilingual existence that is of necessity yet also offers the potential to free her of shame.

However, I acknowledge that the term *semilingual* has, itself, been a source of derision and stigma. Traditionally semilingualism has been associated with negativity, particularly as the term impacts students. It is not my intent to dismiss derogatory associations tied to semilingualism. I am sensitive to the damages that the term has inflicted and continues to inflict when applied to academic assessment. After all, to be marked as *semi* implies a lack of full formation. The term *semilingual* designates a language user as deficient in the user's languages. We can see in Alastair Pennycook and Emi Otsuji's *Metrolingualism: Language in the City* (2015) a prominent current framing of semilingual as a derogatory designation. The authors contextualize the term within a range of linguistic vocabularies that describe daily experiences of navigating urban language spaces. To avoid binary systems, Pennycook and Otsuji reject *monolingualism* and *multilingualism*

in favor of *translingualism*, a term the authors feel transcends language limits by including multimodal interactions that function beyond the alphabetic.

Yet avoidance of linguistic identities as semi- returns our discussion to a privileging of wholeness. While I appreciate Pennycook and Otsuji's expansion toward multimodal engagements and rejection of binaries, the authors advance narratives of wholeness by suggesting that semilingualism signals "that a person's linguistic competence might be made up of two half competencies."[6] The sense of being half-competent can surely be derogatory. I do not contest that.[7] However, this halfwayness may also be a tactic elected by rhetors who find value in fragmenting one's self-representational strategies to advance identity construction, linguistic and cultural resistance, and epistemological confrontations. Indeed, I am reminded of Scott Richard Lyons's call for pedagogy that makes visible and fosters rhetorical sovereignty in the context of Native American student rights to articulate in elected modes, styles, and languages and to employ self-fashioned voice to express desire and agenda in public discourse.[8] I add that students must also practice identification of what exactly might inform the construction of their voice and why articulation of partialness might be their elected form of self-representation and, indeed, endorsed in prominent threads of Chicanx historical rhetorics.

Interestingly, in my classroom surveys I have noticed that many students seek to maintain their primary languages in personal interactions while acquiring "just enough" English-language writing skills to flourish in their current ambitions. When I interrogate the notion of "just enough," I find that students identify alphabetic writing as essential to complete their university degree and prosper in their careers, while other forms of communication, be it language, dialect, or nonalphabetic, continue to flourish in personal practices without limit. I suggest that many students resist total academic assimilation by holding tightly and proudly to a linguistic semi-ness that compartmentalizes the "just enough" required writing skills from the free-forming multimodal and language expressions outside classrooms. There are strategic advantages in this choice to maintain the language that they know best—even if this choice exposes them to accusations of a semilingual existence.

As Asao Inoue argues, assessment is a tool through which society "produces social arrangements."[9] I believe that some of my students consciously choose to wear their semilingualism to encourage assessors to recognize linguistic wounds inflicted through enforcement of language competencies and "correctness" in

writing and genre conventions. Some of my students also consciously claim the label of semilingual to emphasize who they are, where they come from, where they are going, and how labels of shame attempt to stop them. By wearing these labels, they confront social arrangements and Standard English assessors. Thus, my students continue to overwhelmingly switch to personal languages outside the classroom, which are often their maintained primary languages and widely multimodal—distinct from the alphabetical academic language. I find that while it is vital to reflect on violence that a term like semilingual can inflict, particularly in classrooms, I also see the potential for action and transformation by confrontation and appropriation of the term.[10]

In the seminal 1999 "Textual Identities: The Importance of Being Non-Native," Claire Kramsch and Wan Shun Eva Lam speak of language learners who consciously explore tensions that might occur when they refuse to abide by any single "correct" norm of language usage. In allowing these tensions, writers construct new "textual homes" for their alternative "textual identities."[11] I find this argument instrumental as the authors address these language users' avoidance of "correctness" to partially exile themselves into an in-between space, yet one that they deliberately build and inhabit to mark their distinction and emphasize critical acuteness from their chosen vantage points. Kramsch and Lam reverse the hierarchy that places native English writers at the top of critical writing, arguing instead that the rhetorical homes of non-native-English writers afford a critical insider outsider stance. This aligns with Edward Said's discussion of the advantage and potential power of exile perspective. I appreciate this reversal and wonder how the concepts of "textual homes" and "textual identities" might be constructed in classroom dynamics for students who find a personal and academic strategic advantage in maintaining a semilingual positionality.

As an insider-outsider, a language user employs that which Victor Villanueva describes as a "relativistic perception of language."[12] Villanueva defines this perception as belonging to code-switchers who know, as they daily navigate various locations and peoples, that language is never fixed. While such a perspective is punished by designers of standardized tests who often assume a fixed meaning of language and prioritize the alphabetical, the "relativistic perception" allows rhetorical power, as the insider-outsider knows how to employ codes more astutely to fit a particular location and audience. I appreciate that such positionality might serve as a reminder that the semilingual, not as the master of one language but rather as an explorer traversing languages, can refashion her

language to advance her immediate goals while challenging perceptions that language is stagnant and knowledge of language can ever be absolute.

Yet I caution against normalizing linguistic nomad space—a sense of perpetual in-betweenness that denies existence outside the liminal zones. Again, I invoke notions of nepantla as an act of emergence from the liminal space rather than the inhabitation of that liminal space. Finding stability allows one to emerge from the earthquakes of life, the uprootedness of no-space, to generatively transform and reemerge in the lived space. While I argue that semilingualism debunks myths of wholeness as the "correct" representation of linguistic identity, I hesitate to place my students in the eternal state of the exile, outsider, or even borderland dweller. Instead, I aim to locate a rhetorical landscape upon which contemporary Chicanx rhetors can build their textual homes, a place where semi-ness, partialness, fragmentation, and woundedness can be expressed without shame.

I define *textual homes* as written spaces where students occupy text with stories of their lives, cultures, values, and hopes. To feel like home for one's identity and voice, such written spaces must be articulated in rhetorics and languages that cultivate student feelings of belonging.[13] Belonging is fortified by agency and choice as students elect rhetorical inheritances from one or multiple of their intersecting identities. That is, I define *elected rhetorical inheritance* as a claim to voice that derives from and fortifies one's assertion of self, contextualized in local and temporal associations. By no means is the elected rhetorical inheritance a "birthright." Rather, it is a dynamic sense of voice, impacted by one's living relationship with communication experiences and mitigated by historical (dis)connection. To foster connections, particularly as a decolonizing measure to reclaim lost historical fragments and clarify all our options in constructing a textual home base, we must stitch fissures among scholarship of historical rhetorics, contemporary cultural rhetorics, and writing studies. I maintain that all three aspects must be interwoven to identify the complicated tapestry of Chicanx rhetorics and inform our students who practice rhetorics of woundedness that they are not outsiders but do, indeed, belong.

Linking Rhetorical Histories with Cultural Composition

The disjunction between the scholarship of historical-cultural rhetorics and writing pedagogy has served as a detriment to our Chicanx students. In this reflection,

I investigate this disjunction by coupling two frameworks—historical rhetorics and composition as rhetorical sovereignty—that I have not seen sufficiently jointly explored. Classroom demands spur this investigation. Like many composition instructors, I locate my teaching strategies within students' needs and interests. I am encouraged in recent experiences to witness a heightened presence of Chicanx students in my Southern California classrooms. Because of this presence, I find myself increasingly striving to cultivate teaching strategies that respond to Chicanx students and a demonstrated want for validation as both members of the undergraduate community yet also as members of a rhetorical lineage isolated from central narratives. Unfortunately, the impact of Iberian and Indigenous rhetorical traditions in the United States and even in California, with its larger Chicanx student population, is predominately neglected outside Spanish language and ethnic studies scholarship and thus struggles for general application in composition.

Additionally, a sampling of Chicanx rhetorical studies courses offered by ethnic studies departments in the California State University and University of California systems emphasize public discourse and sociopolitical movements that stem from the 1960s Chicano Movement and post-1970s Chicana feminist rhetorics. This aligns with ethnic studies departments that serve missions to increase knowledge of contemporary realities and current multicultural interchanges and impacts. Such a focus necessarily prioritizes twentieth and twenty-first-century rhetorics, and while studies in Chicanx contemporary public discourses are enormously instructive and empowering to our students and their communities, they do not directly address an expansive rhetorical lineage to challenge northwestern European domination of historical rhetorics. Concurrently, Chicanx rhetoric courses tend to privilege public speech and performance over composition. Surely, we have room for rhetoric courses that cultivate both civic performative discourse and textual self-expression.

I propose attention to a European trajectory that enters an Iberian and Southwestern American cultural discourse within which contact with Mesoamerican rhetorical cultures can be examined. It is vital for Chicanx students to experience a moment similar to that narrated by Cherríe Moraga in the 2000 foreword to the second edition of *Loving in the War Years*—an epiphany that reveals her cultural inheritance through the figure of Coyolxauhqui. As detailed in part 1, Moraga recalls this moment: "Without knowing, I looked for Coyolxauhqui in these dark wartime writings of twenty years ago, the dim reflection of my own pale moonface lighting my way. *I am not the first*, I kept telling myself, *I*

am not the only one to walk this road."[14] Here, Moraga teaches the importance of locating predecessors in our quests to articulate self. We might detect similar locating of meaningful predecessors in our studies of artworks by Christina Fernandez, Maya Gonzalez, and Amalia Mesa-Bains. For Moraga, desire for rhetorical companionship, in essence, are the "war years" during which unreceptive audiences deny the validity of her rhetorical woundedness—torn among her various disparate identities and loyalties.

As an educator, I wonder how Moraga's need for rhetorical forebears to establish her own sense of validity is a common experience for our students. It is of note that Moraga was, in those twenty "war years," an established and renowned writer even when her discourse was/is isolated and/or dismissed. Yet how do our less-established students feel when they seem to walk their road alone with no rhetorical ancestor lighting their way? I suspect that for many Chicanx students, the metaphorical "war years" are the college years. Without historical teachings that one's modes of self-expression and, thereby, identity construction are not isolated but instead participate in a long rhetorical tradition, one may indeed feel like the first and only one to walk this road. It scares me that many of our students daily navigate the university with a sense of fragmentation and split purpose that seem unique to themselves. The relief that Moraga experiences by locating a fragmented hero—a symbol of ever-present violence committed against Chicanx bodies that strive for voice—is a hero too often denied to students due to diminished representation of historical-cultural rhetorics of generative woundedness. This situation is especially unjust due to this cultural rhetoric's vast proliferation in Chicanx discourse and advocacy writing and arts, as illustrated throughout *The Wound and the Stitch*. By emphasizing historical rhetorics of Ibero-American discursive traditions, I heighten recognition of Chicanx rhetorical forebears. Through an increased account of rhetorical legacies, Latinx students gain exposure to increased opportunities for validation, where they might learn that they do not walk alone but inherit a multitude of rhetorical traditions that continue to impact their self-representational strategies as modern writers.

Unfortunately, scholarship on this Ibero-American trajectory needs more cultivation in rhetorical studies and in building connections with contemporary composition practices. When this trajectory is studied, it is often isolated from living inheritors. I have accordingly located few resources that impart historical rhetorics that might connect to my Latinx students. One resource is Damián Baca and Victor Villanueva's *Rhetorics of the Americas 3114 BCE to 2012 CE* (2010),

which presents varied essays that introduce Indigenous and Ibero-American historical rhetorics; yet while this edited collection offers a valuable telling of, per Baca, "the other face" of America's rhetorical traditions, it does not fully explore impacts of these legacies on college composition writers. More recently, Baca's *Rhetorics Elsewhere and Otherwise: Contested Modernities, Decolonial Visions* (2019), coedited with Romeo García, acknowledges ruptures in writing and rhetoric studies and stresses that decolonial scholarship must tend to that rupture.[15] Yet while *Rhetorics Elsewhere and Otherwise* emphasizes the need to relink writing and cultural rhetorics, it steps away from the historical roots offered in *Rhetorics of the Americas* to focus on mostly contemporary practices. Again, we see a disconnect between studies on writing and historical rhetorics.

For example, in one of *Rhetorics Elsewhere*'s essays, "*La Cultura Nos Cura*: Reclaiming Decolonial Epistemologies Through Medicinal History and Quilting as Method," authors Iris D. Ruiz and Sonia C. Arellano explore therapeutic storytelling through quilting as a cultural rhetoric of healing. The essay expands rhetoric into textile expression and chooses quilting to access Indigenous narrative arts. Yet, while tactile rhetoric enters as a historical medium, scholarship on a specific discursive tradition—for example, *how* a specific tactile rhetorical practice from a particular population produced healing textiles—remains elusive. The history, production, and social context of this tactile rhetoric is applied generally across time and space, stemming from unidentified Indigenous practice. This is not to say that Ruiz and Arellano are wrong that such a rhetorical tradition exists and has potential value in composition. I merely argue that attention to contemporary cultural composition is the primary goal of the essay rather than distinguishing a historical rhetorical lineage. With this primary goal, the authors' expansion of composition's borders to consider tactile rhetorics is an intriguing contribution that I applaud within an edited collection that brings us much closer to stitching the rupture between cultural rhetorics and composition. Yet I argue that historical rhetorics will tighten that stitching; all three elements—historical rhetorics, contemporary cultural rhetorics, and composition—are required to satisfy Latinx students' needs for validation.

In critical composition pedagogy, Juan Guerra makes further strides in linking Ibero-American rhetorical practices with writing theories. Guerra's "Putting Literacy in Its Place: Nomadic Consciousness and the Practice of Transcultural Repositioning" (2004) references conceptions of in-betweenness or nomadic consciousnesses that empower Chicanx writers. Guerra writes that "transcultural repositioning is a rhetorical ability that members of our [Chicanx] community

often enact intuitively," and these members are advantageously positioned between cultures in such a way as to "develop a rhetorical practice that mainstream dwellers who rarely venture outside the matrices of their own safe houses are not likely to cultivate."[16] Guerra applies this "nomadic consciousness" to composition pedagogy and asks educators to foster spaces of in-betweenness where students might compose reflections on their travels between sociolinguistic identities. In these student reflections, Guerra believes writers might engage critically with their immediate world. However, he does not link this pedagogy with the engagement of historical rhetorical traditions, though he may be recalling Gloria Anzaldúa's borderland-dweller or drawing on nepantlisma as students inhabit in-between spaces for rhetorical exercise. Guerra additionally does not explain why Chicanx writers might possess this "intuitive" transcultural repositioning ability based on historical and temporal specificity.

Again, my own application of nepantla does not practice in-betweenness as a space to inhabit. It is additionally crucial to note that nomadic navigations of the borderland state situate Chicanx writers as constantly practicing skills of rhetorical adaptions that, although enabling varied critical insights, can perpetuate ever-bending performativity to suit immediate audiences. I do not advocate an academic experience that continues to ask some students more than others to twist themselves into rhetorical knots. I seek an academy that makes more accessible opportunities for students to elect rhetorical vehicles that suit their dynamic identities in their varied fragmented yet together-apart states. While my pedagogy appreciates audience, context, and rhetor positionings as core to writing strategies, I aim to make normative not nomadic rhetoric so much as stillness, to first unearth rhetoric that provides companionship for students' self-articulation. My primary attention is to equip learners with skills to discover historical rhetorics that offer blueprints for building their own rhetorical homes on landscapes of belonging.

In my research, I explore Chicanx historical rhetorics and link that history with critical pedagogy to offer rhetorical landscapes upon which modern Chicanx writers might construct their own home bases. If we aim to guide students toward strategies of empowerment through writing, we must contextualize their options in their rhetorical inheritances. Accordingly, rhetorics of seminess, fragmentation, and generative wounds are not shameful in their lack of cohesive wholeness but are discursive home bases that must be recognized for their cultural values. I argue that historical-cultural rhetorics must be actively endorsed in composition classrooms. We must endeavor to bridge scholarly

conversations in Latinx historical rhetorics and student composition so students might regularly access their own discursive lineages and select among their inherited rhetorical strategies. This scholarship would best be introduced to incoming university writers in lower-division composition courses to provide rhetorical forebears and resist the perception of university life as "war years." As well, upper-division courses on emerging issues in rhetoric and composition might direct graduating majors to extend research to further bridge disjunctions between cultural rhetorical scholarship and pedagogy.

Delinking Chicanx Cultural Rhetorics from Dominant Narratives

While bridging cultural historical rhetorics to modern writers is essential, concurrent delinking is vital. I speak of delinking writing studies from a thread of rhetorical history that privileges a northwestern European trajectory. My concern is the continued academic neglect of rhetorical traditions that entered the western Americas and still inform Chicanx rhetors in United States composition classrooms. The issue's timeliness is pressing as increasingly hostile popular media conversations pressure Chicanx students to believe that their cultural inheritances stem exclusively south of the United States-Mexico border rather than also being historically rooted in Amerindian and Ibero-American contexts across Southwestern regions. I have observed that composition pedagogy often promotes a similar historical trajectory that tells of a rhetorical framework that travels from Aristotle's Greece into northwestern Europe and ultimately into the northeastern United States. That is, a norm in the field of composition is to link rhetorical strategy to an ancient Greek origin, positioning other rhetorical trajectories as derivative and infantilized. Even in sessions of rhetorical society workshops that advocate decolonial theory and rhetorical sovereignty in which I have participated, I have witnessed my colleagues in Latinx rhetoric insist that Greece must always remain part of the discussions about rhetoric since, after all, *rhetoric* is etymologically a Greek word. Indeed, the privileging of this Greek-to-northwestern-Europe-to-northeastern-US trajectory is deeply rooted in the writing and communication fields.

Yet such a trajectory infantilizes the Global South in both its history and rhetorical practices. As Enrique Dussel notably argues, "This idea of a 'necessary' movement of history from East to West, one can readily appreciate, must first have had to eliminate Latin America and Africa from the movement of World

History, situating them like Asia in a state of 'immaturity' or 'childhood.'"[17] It follows that Europe's maturation or entry into the "modern" cannot occur until Europe masters the child or savage, asserting hierarchies. This myth of modernity and its associated arsenal of colonial tools, such as fictions of wholeness and assertions that a discipline (rhetoric) cannot begin without centralizing Greece and then Rome, conquers through language and communication. When such centralization of this trajectory is denied, accusations of illegibility and illegitimacy abound. In the context of university writing spaces, these accusations facilitate textual borders between composition and those students who do not share northwestern European rhetorical inheritances. The consequence may be reinforced by perceptions that Chicanx rhetors are foreign in composition classrooms.

Delinking raises the potential to create polycentric classroom experiences where notions of foreignness are supplanted by practices of expanded rhetorical traditions that impact diverse modern writing strategies based on students' desires. Informing my ideas are Walter Mignolo's "Delinking" (2007) and "Epistemic Disobedience and the Decolonial Option" (2011), Victor Villanueva and Damián Baca's *Rhetorics of the Americas* (2010), Iris Ruiz and Raúl Sánchez's *Decolonizing Rhetoric and Composition Studies* (2016), Baca and Romeo García's *Rhetorics Elsewhere and Otherwise* (2019), and García and José M. Cortez's "The Trace of a Mark That Scatters: The Anthropoi and the Rhetoric of Decoloniality" (2020).

Like many of these decolonial writing and rhetoric scholars, I practice delinking to fortify belonging that supports convergences of Latinx rhetorical histories and practices but also pays attention to specific spaces in time and place, encounters, and individuals within Southwestern United States communicative frameworks as expressed today and shaped by individuals who navigate various life experiences and rhetorical spaces. Yet the specificity of my teaching in Latinx Studies should not limit this pedagogy to Latinx students but serve as a consideration for how we might expand historical rhetorics in more diverse writing inheritances. Indeed, my classes attract students majoring in other ethnic studies departments and the general student body who seek to satisfy writing requirements in a way that represents knowledge production within an ethnic studies field of interdisciplinary inquiry and social action. By contextualizing writing strategies within various rhetorical inheritances, we may guide students to enter historical rhetorical lineages in order to actively lead in the formation of academic voices that do not conflict with cultural rhetorical identities.

As we expand inclusivity of these rhetorical identities, I wonder how we might support rhetorical genealogies that are not mapped into a single privileged narrative. This expansion puts into action Walter Mignolo's vision of a pluriversality that links histories and narratives of decolonization with new common foundations for meaning-making and therefore self-representation.[18] Mignolo further explains pluriversality as renouncing the "conviction that the world must be conceived as a unified totality . . . in order for it to make sense. . . . [V]iewing the world as an interconnected diversity instead, sets us free to inhabit the pluriverse rather than the universe."[19] I also reference Ellen Cushman and colleagues in conceiving decolonizing rhetorics as offering "options, rather than alternatives . . . in an effort to *pluriversalize* rhetorics without universalizing or authenticating another alternative approach to rhetoric."[20] In the context of composition, I apply the pluriverse to accommodate multitudes of rhetorical homes built on Chicanx cultural discursive lineages, where embodied learners might express self with no fear of transgressing rhetorical borders.

I am reminded that Peter Elbow's seminal "Inviting the Mother Tongue" was written over twenty years ago. The call has long been raised to cultivate a home for each writing student. We might recall Elbow's argument that "people can't learn to write well unless they write a great deal and with some pleasure, and they can't do that unless they feel writing to be as comfortable as an old shoe— something they can slip into naturally and without pinching." Elbow continues: "Our home language is not just inside us; we are also inside it."[21] However, when that home is not recognized in academic neighborhoods—not taught as a core language home base for modern writers—students might perceive a pressure to dismantle their cultural rhetorical home to construct a new academic-sanctioned textual space. Kay Halasek observes in *Pedagogy of Possibility* (1999) that such dismantling "remains one of education's most ironic demands[:] that a student who gains admission to the academy must lose, deny, or neglect her home knowledge in order to acquire the power to defend and argue for the validity of that same alternative world view."[22] Halasek and Elbow reflect primarily on institutional indoctrination through suppression of home rhetorics in exchange for academic convention, a process poignantly narrated by Ngũgĩ wa Thiong'o in his postcolonial cultural theory. Ngũgĩ recalls his experiences as an African student who was taught that his family's language identity was associated with "negative qualities of backwardness, underdevelopment, humiliation and punishment." He continues: "We who went through that school system were meant

to graduate with a hatred of the people and the culture and the values of the language of our daily humiliation and punishment."[23] Though Ngũgĩ reflects on African experiences, similar narratives abound in reports of Latinx students feeling pressured to conform to academic communicative convention, swapping a sense of belonging in one's cultural textual home for an academic rhetorical landscape that situates the Latinx rhetor and writer as an uprooted foreigner.

As an example, I pull from my experiences as a first-generation Chicana and Apache-Mescalero student who experienced meandering academic journeys full of unbelonging.[24] My educational journey consisted of one BA (anthropology), three MAs (English with an emphasis on narrative theory, Art History with an emphasis on medieval Iberia, English with an emphasis on Chicana rhetoric), and one PhD (English with emphasis on Chicanx multimodal rhetoric and critical composition). I earned my last three degrees while teaching at a community college, then a private Catholic university, and finally two public state universities. While in my forties, I finally completed my dissertation, and twenty years after beginning my teaching career I secured a tenure-track position. My excessive degrees and years of teaching before "arriving" confirm prolonged isolation in academic life where my only role models, as excellent as they were as mentors, expressed experiences unfamiliar to mine. They articulated an academic rhetoric I might mimic to achieve the success they modeled. Still, the validation I would then receive was based on performativity in a rhetorical vehicle that did not derive from my cultural home. My experiences speak to a need for validation I could not locate from the educators who populated my journey. In my five degree programs, I studied with only one Latino and zero Latina instructors.

Throughout my education, I accordingly opted to perform silently in classrooms rather than practice vocabularies and rhetoric that felt clumsy in my mouth. This silence was fortified by an absence of literature that might have helped me better understand myself through rhetorics that might have flowed more smoothly into my mind and from my mouth. Only when I entered my PhD program did I receive guidance to situate my home rhetoric into academic settings. My faculty advisor handed me Cherríe Moraga's *Loving in the War Years*; I soon realized that it took me decades to feel that rhetoric was not just an area of study but an action and art that I embodied. That realization validated me as a speaker. It mobilized my voice. In many ways, my experiences testify to a still-extant predominance of education narratives where Latinx students struggle

with the erasure of home identities after lengthy attempts to navigate nomadic borderlands between personal and academic linguistic and rhetorical spaces.

A quick sampling of contemporary Latinx fiction and nonfiction reveals a prevailing theme of intracultural conflicts in modern schooled writers who may prevail in mainstream United States rhetorical spaces yet are confronted by unreceptive cultural-home audiences. In Julia Alvarez's novels, such as *How the García Girls Lost Their Accents* (1992) and *¡Yo!* (1997), the main protagonist, Yolanda, experiences a constant tug-of-war between moments of alienation and reconciliation with her family—all regarding her career as a mainstream writer who makes public her private truths. Ana Castillo also reveals family battles over her identity as a writer in both her fictionalized memoir, *Watercolor Women / Opaque Men* (2006) and her nonfiction memoir *Black Dove* (2016); Castillo regards the metaphorical borderland that she must cross between her writer-home and culture-home as far from utopian and indeed an additional burden she must carry to liberate her voice.[25] Milcha Sanchez-Scott addresses the struggles to maintain one's culture-home while chasing competitive ambitions. Her plays, *Dog Lady* (1984) and *The Cuban Swimmer* (1984), metaphorically illustrate these issues by framing the protagonists' identities as racers. One a runner and the other a swimmer, they must choose different pathways toward victory: either leave your culture-home behind by transforming into an animal or, more specifically, a dog-lady (bitch); or tow your family along your racecourse at the risk of drowning, as in *The Cuban Swimmer*. The culture-home here hinders the young protagonists' aspirations to compete in United States society. Although their dilemma is fictionalized through athletic competitions, the theme of assimilated or academic writers resonates in Sanchez-Scott's plays. They speak to student experiences of facing additional costs when entering competitive spaces, most prominently in classrooms.

The struggle to liberate the writer from the cultural and academic tug-of-war is perhaps most memorably conveyed by Richard Rodriguez's election of assimilation in his memoir *Hunger of Memory* (1982). Even in his early years, he recalls the realization that once institutionally indoctrinated in the classroom, he is compelled to inhabit a new textual home. He explains: "Here is a child who cannot forget that his academic success distances him from a life he loved, even from his own memory of himself. . . . Gradually, necessarily, the balance is lost. The boy needs to spend more and more time studying, each night enclosing himself in the silence permitted and required by intense concentration. He takes his

first step toward academic success, away from his family. . . . He cannot afford to admire his parents."[26]

Leslie Ann Locke, Lolita A. Tabron, and Terah T. Venzant Chambers examine family and cultural losses a student may feel compelled to accrue to chase academic ambitions. In the authors' 2017 "If You Show Who You Are, Then They Are Going to Try to Fix You': The Capitals and Costs of Schooling for High-Achieving Latina Students," they argue that students from traditionally marginalized groups enter academic spaces with cultural capital that is undervalued.[27] The result is often cultural identity suppression to avoid assessment of academic ability and/or scrutinization as a "real" student; this suppression necessarily distances the student from her family, culture, and rhetorical traditions.[28] The authors conclude that for Latina students it is difficult to bring an authentic sense of self to academic settings since achievement alienates expression of cultural self.[29] I believe this is especially true when a student employs rhetorics of woundedness that involve self-representation as fragmented and incomplete—states of identity that provoke mainstream responses to "fix" the student. Interestingly, this is a point that Locke, Tabron, and Chambers emphasize, inspired by their interview with a Chicana student, Lillie, who observes that if a student conceals her Latinx heritage, then she is less likely to be confronted with corrective measures.[30]

Such an observation recalls my previous discussion of Trinh T. Minh-ha's notion of the "not-I" as an othering of one's cultural self. The "not-I" conceals non-normative selves to pursue social and academic benefits offered to the externally sanctioned "I," which is instructed by coloniality institutes. Karen Barad explains that Trinh's "not-I" theory confronts notions established by a "colonizing logic" that perceives the "I" as maintaining and stabilizing itself through eliminating or dominating that which it deems to be "the other," the "not-I."[31] Accordingly, the "not-I" is rejected from active identity and consequently may be diminished as a motivator for the external performance of self. A similar process stifles cultural expression and participation in historical rhetorics in modern Latinx writers.

In "'The Politics of Location': Text as Opposition" (2002), Renee Moreno proposes a critical composition pedagogy to beckon the previously suppressed "not-I" or cultural identity. Moreno conceptualizes writing as a space of resistance where students occupy text with counterstory. Such personal narrative in composition aims to prevent that which Ngũgĩ famously observes as "colonization of the

mind." Moreno raises concerns about colonization via education: "What happens to you as a result of becoming educated? What parts of an identity remain intact? What parts transform? How do you see yourself?"[32] Moreno's questions motivate my interest in critical pedagogies that assist students in resisting academic conformity. However, I wonder if the answer to these questions is more efficiently located not solely in resistance but in the facilitation of an academy that makes more accessible cultural rhetorical landscapes on which homes may be built from historical belonging.

I am reminded of Lisa Delpit's "The Silenced Dialogue: Power and Pedagogy in Educating Other People's Children" (1988), which memorably asserts that students are lifted when they access the "culture of power" via academic conventions. Delpit suggests that by denying conventional skills in favor of process-oriented teaching, instructors withhold academic tools of success from students who reside outside power cultures. While I align with Moreno's argument that every student should have a textual home to safely express the cultural self, and I support process-oriented teachings that make mindful one's election of inherited rhetorics, I also align with Delpit's argument that students must acquire tools of the power culture to advance in academia. However, I offer that this is not necessarily an either-or situation; I suggest that every culture is, indeed, a culture of power if only we delink pedagogy from a privileged narrative and if only we learn to recognize varied cultural rhetorical inheritances and their potential impact on contemporary rhetorical practices in composition.

Regarding rhetorics of woundedness, I emphasize generative power embedded in historical rhetorics precisely to underscore the rhetor's ability to seize control of an otherwise inflicted assault. Rhetorics of woundedness repurposes upsets as concurrently testament of survival and accusation of assault—thereby centralizing the rhetor's lived experience, fortitude, and demands. Rhetorics of woundedness is only one thread of Chicanx rhetoric and only one specific genealogy within a vast tapestry of Latinx historical rhetorics. It is the thread that I hang onto when someone insists that my wounds might be healed and obscured into a distant memory. It is a thread that I live and protect. It is one of many prominent Ibero-American rhetorical traditions that support a rhetorical "culture of power," but it is also unfortunately directly dismantled by the more institutionally prominent rhetorics of wholeness. For this reason, I again emphasize the importance of teaching the history of rhetoric as a linked component to

composition, so students in diverse environments might recognize multitudes of rhetorical traditions available to help us build our own textual homes that have, all along, belonged in United States composition classes. It is my hope that through development of scholarship that links historical-cultural rhetorics with writing pedagogy we might curtail student misperceptions that they walk alone and are in need of "fixing."

Notes

Introduction

1. Vázquez Martínez, "Historia y devoción de un santuario," 258–59, 266. In discussing historical views of San Juan Chapultepec as a space of syncretized Indigenous Catholicism that included perceived practices of idolatry, Vazquez Martinez describes negotiations between Marcelo de la Cruz and local church leaders as follows: "Es posible que al conocer los casos de idolatría en San Juan Chapultepec y los alrededores de la Villa del Marquesado, asi corno la necedad de los indios de adoctrinarse, los franciscanos dispusieran tener una junta con Marcelo de la Cruz el 16 de junio de ese mismo año en el convento" (266).

2. Sánchez Reyes and González Hernando, "De la virgen abridera," 22–23; Vázquez Martínez, "Historia y devoción de un santuario," 266.

3. Vázquez Martínez, "Historia y devoción de un santuario," 266, 273.

4. See Katz, "Marian Motion." Gertsman studies virgenes abrideras as part of the interactivity of Christendom's medieval visual cultural; see *Worlds Within*. González Hernando has published location-specific scholarship on Iberian sculptures; see *El arte bajomedieval y su proyección*.

5. Katz, "Behind Closed Doors."

6. See Katz, "Non-Gendered Appeal," for a counterargument asserting that Shrine Madonnas are not cultivated exclusively by female patrons for female devotions.

7. For various discussions of the terms *Latinx* and *Chicanx*, see Milian, "Extremely Latin, XOXO." Although interpretation, reception, and utilization of the "x" in *Chicanx* and *Latinx* varies in scholarly and popular thought, I view the "x" as minimizing binary thinking about gender identities, making more prominent a move toward expansive inclusivity, and marking both the unresolved inheritance of colonized identities and the potentials that arise from such lack of resolve. In short, the "x" aligns with my concept of woundedness, a mark that obliterates specificity yet concurrently places no limits on generative potential.

8. See Muñoz, "Feeling Brown, Feeling Down."

9. My concept of rhetoric as part of decolonization processes aligns with arguments advanced by García and Cortez, "Trace of a Mark That Scatters."

10. For trauma theory, see Caruth, *Unclaimed Experience*.

11. Shaping my ideas on decolonization and delinking are works by Mignolo, including *Darker Side of the Renaissance*; "Delinking"; "Epistemic Disobedience." See also Baca and Villanueva, *Rhetorics of the Americas*; Ruiz and Sánchez, *Decolonizing Rhetoric and Composition Studies*; García and Baca, *Rhetorics Elsewhere and Otherwise*; García and Cortez, "Trace of a Mark That Scatters."

12. See Pérez Huber and Solórzano, "Racial Microaggressions"; Pérez Huber and Solórzano, "Visualizing Everyday Racism." See also Pérez Huber, "Racial Microaffirmations."

13. See Muñoz, *Disidentifications*.

14. I use the term *colonization* as do Ruiz and Sánchez in *Decolonizing Rhetoric and Composition Studies*. Ruiz and Sánchez define it "to include not only the taking of land but also the taking of culture and the defining of knowledge (of which language is a crucial part)" (xiii).

196　NOTES TO PAGES 11–16

15. Petra Pakkanen criticizes syncretism as a categorizing system but suggests ideas of syncretism as heuristic tools for locating otherwise "hidden antecedents of historical facts and to interpret them" ("Is It Possible," 125–26; Pakkanen cites Leopold and Jensen, *Syncretism in Religion*). For political impacts linked to syncretism in Latin America see also Benavides, "Syncretism and Legitimacy."

16. Troncoso Pérez, "Crónica del *Nepantla*," 143–44.

17. Pérez, "Spirit Glyphs," 200.

18. Ibid., 220n7.

19. Anzaldúa, *Light in the Dark*, 253, 258.

20. Anzaldúa, *Interviews / Entrevistas*, 176.

21. Anzaldúa, "Now Let Us Shift," 541.

22. Blackwell, "Lídres Campesina," 13.

23. See D. Baca, "*Rhetoric Interrupted.*" Baca views nepantlisma as a space in which one might adapt the colonizer's rhetoric to interrupt colonizing macro-narratives.

24. Guerra, "Putting Literacy in Its Place."

25. Troncoso Pérez details the original text of the exchange in "Crónica del *Nepantla*," especially 144–46. For an English translation, see Durán, *History of the Indies*.

26. For a similar observation on prevalent applications of *nepantla* by contemporary Chicanx scholars, see de Antuna, "What We Talk About," 159–62.

27. For canonical writings in decolonial theory, history, and methodology, see Moraña, Dussel, and Jáuregui, *Coloniality at Large*. For application of decolonial pedagogy in rhetoric and composition, see Ruiz and Sánchez, *Decolonizing Rhetoric and Composition Studies*.

28. Turner, "Variations on a Theme of Liminality."

29. Maffie, *Aztec Philosophy*. Maffie places *nepantla* into conversation with a cluster of Náhuatl words that share possible etymological roots:

Weaving cluster: *tlaxinepanoa*, "to weave something"; *tlaxinepanoliztli*, "the act of weaving"; *xinepanoa*, "to weave something, like mats, fences, or something similar"; *qualli tlaxinepanoani*, "the accomplished weaver"; *tlaxinepanolli*, "something woven" (359–60).

Joining cluster: *nenepanoa*, "to join or mix one thing with another"; *cennepanoa*, "to mix some things with others"; *nepan uiuixoa*, "to shake or swing two things together"; *tlanelpanuiuixoliztli*, "the act of shaking and mixing something together"; *ixnepoa*, "to line or cover something, to fold a blanket, to join one with another" (356–57).

Social interconnectivity cluster: *nenepantlazotlalo*, "to love each other"; *nenepantlazotlaliztli*, "the love they have for each other"; *nenepantlazotlaltia*, "to create bonds of friendship between people"; *manepanoa*, "to get married, or to join hands"; *nepanoa*, "to have intercourse with a woman or to push into a group of people"; *nenepanoliztli*, "copulation or carnal intercourse"; *motlatolnepanoa*, "to agree on what is said"; *tlatolnepaniuiliztli*, "agreement or conformity of reasons and opinions"; *nepanotl titotla paloa*, "to greet with one another"; *nenepantlapaloliztli*, "reciprocal greeting"; *nepan tzatzilia*, "to shout to one another or for those who are working to hurry one another"; *tictonepantlatlaxilia*, "to blame each other for something"; *tenepantla moctecani*, "to stir up trouble among others"; *tenepantla moquetzani*, "the one who puts himself between those who are quarreling in order to calm them"; *nepantla quiza titlantli*, "the messenger between two people" (356–57).

30. See Maffie, *Aztec Philosophy*, notably 355, 360, 363, and the chapter "Teotle as Nepantla."

31. See the foreword of Ruiz and Sánchez, *Decolonizing Rhetoric and Composition Studies*, where Victor Villanueva differentiates *decolonial* from *postcolonial*.

32. Further discussions of coloniality can be located in Grosfoguel, "Epistemic Decolonial Turn," 219–20.

33. For arguments that decolonization impacts violations that manifest in metaphorical and physical forms, see Ndlovu-Gatsheni, *Epistemic Freedom in Africa*, which explores how Africa and the Global South "became victims of genocides, epistemicides, linguicide and cultural imperialism, but also the trajectories of struggles for epistemic freedom that were provoked and ensued" (2). For counter-arguments that insist that decolonization focus on solely the physical, see Tuck and Yang, "Decolonization Is Not a Metaphor."

34. Kim, *Postcolonial Grief*, 68.

35. For further discussion of rhetorical inheritances, see my examination of archival methodologies in Ramirez, "Archival Quest."

36. See my examination of the myth of wholeness as impacting writing pedagogies in Ramirez, "Unmaking Colonial Fictions."

37. Moraga, "Entering the Lives of Others," 19. See also Calafell, *Latina/o Communication Studies*, 8, 93.

38. On critical race theories and methodologies, see writings by Pérez Huber and Solórzano. Also valuable for the development of my scholarly frameworks is T. Torres, "Latina Testimonio."

39. See Lechuga, "Anticolonial Future."

40. Mignolo, "Foreword," x.

41. See also Sánchez, "Writing," 88, 85, 80.

42. Rappaport and Cummins, *Beyond the Lettered City*, 255.

43. See Anzaldúa, "Acts of Healing."

44. See Ramirez, "Unmaking Colonial Fictions."

45. See Yarbro-Bejarano, *Wounded Heart*, 4. Yarbro-Bejarano perceives that nearly every poem in the first edition of Moraga's *Loving in the War Years* centers on the female body, which Moraga systematically tears into semihuman pieces. See also S. Smith's reference to Moraga's "self-censoring body" as a form of detachment between the socially-constructed body and the identity formed in relation to body (*Subjectivity, Identity, and the Body*, 139–40).

46. Anzaldúa, *Borderlands / La Frontera*, 6.

47. Moraga, *Loving in the War Years*, 2nd ed., iii.

48. See Foucault, "'Society Must Be Defended,'" 66.

49. Caruth, *Unclaimed Experience*, 4.

50. For the artists' biographies and works, see their websites: Amalia Mesa-Bains at the MacArthur Fellows Program (https://www.macfound.org/fellows/474); Maya Gonzalez at her artist website (http://www.mayagonzalez.com); Christina Fernandez at her gallery (https://galleryluisotti.com/artists/christina-fernandez).

51. Powell, "2012 CCCC Chair's Address," 388.

Part 1

1. Miller, *Art of Mesoamerica*, 225.

2. Moraga, *Loving in the War Years*, iii.

3. See Klein's studies on depictions of females in Mexica visual culture, especially Klein's scholarship on the Coyolxauhqui Stone in context with the Coatlicue sculpture, "Devil and the Skirt" ("New Interpretation of the Aztec Statue"). For a general study of female representation in Mexica art, see Klein and Quilter, *Gender in Pre-Hispanic America*.

4. For interpretations of Mexica male-female iconography and gender ideologies, see Sigal, "Imagining Cihuacoatl"; see also Brumfiel, "Figurines and Aztec State." For ancient

Mesoamerican gender iconography and ideologies, see McCafferty and McCafferty, "Conquered Women of Cacaxtla"; Berlo, "Icons and Ideologies at Teotihuacan"; Paulinyi, "'Great Goddess' of Teotihuacan."

5. See the artist's gallery at https://www.santabarraza.com/.

6. Mignolo, "Epistemic Disobedience," 48.

7. See Butler, *Precarious Life*; for considerations on woundedness as a gateway to self-knowledge and civic affect relationships, see also Calafell, *Latina/o Communication Studies*.

Chapter 1

1. Blackwell, ¡*Chicana Power!*, 11–12, 29.

2. Ibid., 2.

3. Ibid., 40.

4. Miller, *Art of Mesoamerica*, 225. See also Umberger, "Art and Imperial Strategy in Tenochtitlan," 14.

5. Anzaldúa, *Light in the Dark*, 251.

6. Ibid.

7. Ibid., 253.

8. Anzaldúa, *Borderlands / La Frontera*, 42. See also an examination of Anzaldúa's shadow-beasts in Calafell, *Monstrosity, Performance, and Race*, 64–66.

9. Moraga, "La Güera," 25. For racial performativity, see also Muñoz, "Feeling Brown, Feeling Down."

10. Moraga, "La Güera," 27.

11. Moraga and Anzaldúa, *This Bridge Called My Back*, xliii–xliv.

12. Moraga, *Loving in the War Years*, 1st ed., 132.

13. Moraga, "La Güera," 29.

14. Moraga, "Entering the Lives of Others," 19.

15. Lugones, *Peregrinajes/Pilgrimages*.

16. Yarbro-Bejarano, *Wounded Heart*, 5.

17. Davies, "Race, Gender, and Disability," 37.

18. Moraga, *Hungry Woman*, 62.

19. Pérez, *Chicana Art*, 203.

20. Moraga, *Loving in the War Years*, 1st ed., 141.

21. L. Torres, "Building a Translengua," 281.

22. S. Smith, *Subjectivity, Identity, and the Body*, 140.

23. Moraga, *Loving in the War Years*, 1st ed., 113.

24. Said, "Reflections on Exile," 434–35.

25. Ibid., 435.

26. Maffie, *Aztec Philosophy*, 361.

27. Boone, *Cycles of Time and Meaning*, 60.

28. Ibid., 258n32; Boone cites Klein, "None of the Above," 183–253.

29. Nancy, "Corpus," 28.

30. Ndlovu-Gatsheni, *Epistemic Freedom in Africa*, 25–26.

31. For an exploration of Central and South American use of the term *susto* as related to PTSD, see Kenny, "Trauma, Time, Illness, and Culture."

32. Moraga, *Loving in the War Years*, 2nd ed., 197.

33. Ibid., 197–98.

34. Ibid., 198.

NOTES TO PAGES 44–55 199

35. Bonfiglio, "Inventing the Native Speaker," 49.

36. Moraga, *Loving in the War Years*, 2nd ed., iii.

37. Ibid., 45–46.

38. For an examination of constructed notions of indigeneity to negotiate Chicanx identity in the United States see Saldaña-Portillo, *Indian Given*. Also consider Alberto, "Nations, Nationalisms, and *Indígenas*."

39. Moraga, *Loving in the War Years*, 2nd ed., 205.

40. Ibid., 202.

41. Ibid.

42. Ibid.

43. Ibid., 203.

44. Ibid., 205.

45. For discussions on performativity of race, see Muñoz, "Feeling Brown, Feeling Down."

Chapter 2

1. Merleau-Ponty, *Phenomenology of Perception*, lxxx.

2. Ibid., lxxiv.

3. Ibid., lxxxi.

4. J. Martinez, *Phenomenology of Chicana Experience and Identity*, 37.

5. Ibid., 38.

6. Ahmed, "Orientations," 550.

7. Ibid, 552.

8. Ibid, 566.

9. S. Smith, *Subjectivity, Identity, and the Body*, 18.

10. Ibid.

11. Ibid.

12. Kim, *Postcolonial Grief*, 86. Kim writes in the context of transpacific decolonial studies and trauma theory.

13. Yarbro-Bejarano, "De-Constructing the Lesbian Body," 154.

14. Ibid., 143.

15. See the author's studies of Yarbro-Bejarano and Chicana lesbian rhetorical studies as impacting Carmen Machado's rhetorics of woundedness in Ramirez, "Self-Loving in the Epidemic Years," 2–3.

16. Barad, "Diffracting Diffraction," 169.

17. See the application of "monster" in decolonial studies in Calafell, *Monstrosity, Performance, and Race*, 56.

18. See Foucault, "'Society Must be Defended,'" 66.

19. See Weheliye, *Habeas Viscus*.

20. See Weheliye, "Black Life / Schwarz-Sein."

21. Ramirez, "Unmaking Colonial Fictions," 170.

22. See Wynter and McKittrick, "Unparalleled Catastrophe for Our Species?"

23. See also Quijano's argument of dualism as a Eurocentric tool of colonization in "Coloniality of Power."

24. For studies of racial categorization in *casta* paintings, see Katzew and Deans-Smith, *Race and Classification*.

25. Katzew, *Casta Painting*, 180.

26. Bleichmar, *Visible Empire*, 169.

NOTES TO PAGES 55–66

27. Olson, "Casta Paintings and the Rhetorical Body," 322.

28. Katzew, *Casta Painting*, 7.

29. Ibid., 40.

30. Ibid., 43.

31. Ibid., 51.

32. Martínez, *Genealogical Fictions*, 56.

33. Ibid., 159.

34. A. Smith, "Against the Law," 63.

35. Quijano, "Coloniality of Power," 552–53.

36. Dussel, "Eurocentrism and Modernity," 69, 74–75.

37. See Soto, *Reading Chican@ Like a Queer*, 68; Lugo-Lugo, "'So You Are a Mestiza,'" 618; Soto Vega and Chávez, "Latinx Rhetoric and Intersectionality," 320–21.

38. Cortez, "History," 53.

39. Acosta, *Thresholds of Illiteracy*, 42.

40. See Miner, *Creating Aztlán*.

41. See Ríos, "Mestizaje," 110. For discussion on "Half-breed Theory," see Miner, "'When They Awaken.'"

42. See Craven, "Multiple Identities of Modernisms from Mexico"; Knight, "Racism, Revolution, and Indigenismo"; Barnitz, *Twentieth-Century Art of Latin America*.

43. For discussion on the use of Aztlán in Chicanx discourses of utopian imaginings, see Delgado, "Chicano Movement Rhetoric."

44. For a study of the Mexican female body as site of a genetic form of settler colonialism wherein "whiteness of property" was achieved through nineteenth-century intermarriages in the United States West and Southwest, see Cedillo, "Unruly Borders, Bodies, and Blood."

45. Minh-ha, "Not You / Like You," 416.

46. D'Alleva, *Methods and Theories of Art History*, 76.

47. Ramirez, "Unmaking Colonial Fictions," 177.

48. Earle, *Body of the Conquistador*, 3.

49. Ibid., 22.

50. Ibid., 89.

51. Ibid., 82–83.

52. Ramirez, "Unmaking Colonial Fictions," 177.

53. See Barad, "Diffracting Diffraction," 176.

54. Moraga, "Welder," lines 27–29.

55. Ibid., lines 44–45; 42.

56. Barad, "Diffracting Diffraction," 175.

57. See Barad, "Transmaterialities," 406.

58. Barad, "Diffracting Diffraction," 168.

59. Moraga, *Native Country of the Heart*, 55–56.

60. For discussion on theories of trauma as a community bond, in connection with theories advanced by Calafell and Boym, see Baugh-Harris, "Remembering Julia de Burgos."

61. Butler, *Precarious Life*, 19.

62. Yarbro-Bejarano, *Wounded Heart*, 50.

63. For an examination of Moraga's vision of a *queer* Aztlán, see Minich, *Accessible Citizenships*, especially 39–73. See also López, "Performing Aztlán."

64. Moraga, *Loving in the War Years*, 2nd ed., 147.

65. Ibid., iii.

66. Moraga, *Native Country*, 3.

67. Ibid., 98.

68. Ibid., 223. As we have seen, Moraga sometimes employs italics as she does here.

Part 2

1. Lugones, "Toward a Decolonial Feminism." Lugones's view of intersectionality as an extension of colonial categorization is controversial in the context of the widespread embrace of discourses of intersections, developed particularly by feminists of color. Accordingly, I include Lugones's more expansive detailing of her argument:

> Intersectionality has become pivotal in U.S. women of color feminisms. As said above, one cannot see, locate, or address women of color (U.S. Latinas, Asians, Chicanas, African Americans, Native American women) in the U.S. legal system and in much of institutionalized U.S. life. As one considers the dominant categories, among them "woman," "black," "poor," they are not articulated in a way that includes people who are women, black, and poor. The intersection of "woman" and "black" reveals the absence of black women rather their presence. That is because the modern categorial logic constructs categories as homogeneous, atomic, separable, and constituted in dichotomous terms. That construction proceeds from the pervasive presence of hierarchical dichotomies in the logic of modernity and modern institutions. The relation between categorial purity and hierarchical dichotomies works as follows. Each homogeneous, separable, atomic category is characterized in terms of the superior member of the dichotomy. Thus "women" stands for white women. "Black" stands for black men. When one is trying to understand women at the intersection of race, class, and gender, non-white black, mestiza, Indigenous, and Asian women are impossible beings. They are impossible since they are neither European bourgeois women, nor Indigenous males. (757n9)

See also Eguchi, Calafell, and Abdi, *De-Whitening Intersectionality*.

2. Lugones, "Coloniality of Gender," 4.

Chapter 3

1. See Mohanty, *Feminism Without Borders*, which calls for the practice of "common differences" that conceptualizes collaborations and alliances based on observations of common concerns while deemphasizing commonalities in identity categories (225–26).

2. Scholarship on Marianismo abounds in Latin American and Latinx studies. A general starting point is Vazquez and Vazquez, *The Maria Paradox*.

3. See Tedlock, *Popol Vuh*: "The temptress Xtah and Xpuch are now Lust Woman and Wailing Woman, and they stand revealed as the predecessors of a dangerous phantom known all the way from Guatemala to northern New Mexico by her Spanish name, La Llorona, and Tecum, Keeper of the Mat in the ninth generation of Quiché lords, becomes Black Butterfly" (15).

4. Moraga, *Loving in the War Years*, 2nd ed., 145.

5. Ibid., 147.

6. Tajima-Pena, *No Más Bebés*, 1:07 to 1:44.

7. See especially Mulvey, "Visual Pleasure and Narrative Cinema," and Mulvey's discussion with Beugnet in "Film, Corporeality, Transgressive Cinema."

8. Rangan, *Immediations*, 9.

202 NOTES TO PAGES 86–104

9. Tajima-Pena, *No Más Bebés*, 35:54 to 36:33.
10. Rangan, *Immediations*, 16.
11. Espino and Tajima-Peña, "2015 Los Angeles Film Festival."
12. Tajima-Pena, *No Más Bebés*, 28:53 to 29:06.
13. Espino and Tajima-Peña, "Conversation."
14. Ibid.
15. Espino and Tajima-Peña, "Post-Screening Discussion."
16. See Calafell, "Pro(re-)claiming Loss," 49.
17. Dussel, "Eurocentrism and Modernity," 75.

Chapter 4

1. Disability Rights Education and Defense Fund, "California Passes Landmark Law to Provide Reparations."
2. Cohn, *Belly of the Beast*, 1:08:36 to 1:08:59.
3. Ibid., 1:09:17 to 1:09:51.
4. California Legislative Information, "Health and Safety Code-HSC Division 20."
5. See "California Launches Program to Compensate Survivors."
6. Jindia, "Belly of the Beast."
7. Cohn, *Belly of the Beast*, 1:09:07 to 1:09:17.
8. See Lyons's foundational "Rhetorical Sovereignty," 449. Lyons writes in the context of composition pedagogy that fosters recognition of Native American student rights to articulate in elected modes, styles, and languages and to employ self-fashioned voice to express desire and agenda in public discourse.
9. Enoch, "Survival Stories," 10.
10. Ibid., 11.
11. Ibid.
12. Agamben, "Introduction to *Homo Sacer*," 31.
13. Foucault, "'Society Must Be Defended,'" 66.
14. Ibid., 74.
15. See Weheliye, *Habeas Viscus*.
16. Butler, *Precarious Life*, 35. See also an analysis of Butler's necropolitics discussion by McKinnon, "Necropolitics as Foreign Affairs Rhetoric."
17. Acosta, "Hinging on Exclusion and Exception."
18. See Manian, "Coerced Sterilization"; see also Stern, "Sterilized in the Name of Public Health."
19. Enoch, "Survival Stories," 16.
20. Sosa Riddell, "Bioethics of Reproductive Technologies," 190.
21. Manian, "Immigration Detention and Coerced Sterilization"; Associated Press, "More Migrant Women Say."
22. Montoya-Galvez, "Investigation Finds Women Detained by Ice."
23. Rawitch, "Latin Women File Suit on Sterilization."
24. See Kluchin, "Locating the Voices of the Sterilized," 135.
25. Kistler, "Women 'Pushed' into Sterilization, Doctor Charges," A3.
26. Kistler, "Many US Rules on Sterilization," A3.
27. Ibid., A3, A26.
28. Espino, "Women Sterilized as They Give Birth," 209.

29. Enoch, "Survival Stories." The report is by Rosenfeld, Wolfe, and McGarrah, *Health Research Group Study*.

30. Cohn, *Belly of the Beast*, 1:02:18 to 1:02:48.

31. Sharpe, *In the Wake*, 14.

32. Ibid., 13, 20.

33. Ibid., 22.

34. Blackwell, *¡Chicana Power!*, 11–12.

35. Caruth, *Unclaimed Experience*, 3.

36. Ibid., 4.

37. Ibid., 7.

38. See Calafell, *Latina/o Communication Studies*, 8, 93; Baugh-Harris, "Remembering Julia de Burgos," 187.

39. Kim, *Postcolonial Grief*, 9.

40. See Jolly, "On Forbidden Wombs."

Part 3

1. A standard in studies of medieval iconography of individual saints is Réau, *Iconographie de l'art Chrétien*. For studies in medieval visual culture of woundedness, see Perkins, *Suffering Self*; Decker and Kirkland-Ives, *Death, Torture, and the Broken Body*; Merback, *Thief, the Cross and the Wheel*. For non-visual contexts of medieval perceptions of woundedness, see McNamer, *Affective Meditation and Invention*; Cohen, *Modulated Scream*.

2. Bynum, *Fragmentation and Redemption*, 92.

3. See Tembeck, "Exposed Wounds"; "Selfies of Ill Health." Audience reception of disability visualities also enters our discussion. See Millett-Gallant and Howie, *Disability and Art History*.

4. Tembeck, "Selfies of Ill Health," 3.

5. See Tembeck, "Selfies of Ill Health," 1; "Exposed Wounds," 95.

6. Bynum, *Christian Materiality*, 64.

7. For economic and social changes that impacted Catholic cultural engagement tactics of the period, see Bireley, *Refashioning of Catholicism*. For codified tactics advocated at the Council of Trent, see O'Malley, *Trent*.

8. Poole views a distinctly Castilian Catholicism entering Mesoamerica as "untouched by the religious upheavals following the revolt of Martin Luther in 1517 [and] molded during the seven-century struggle to drive the Moors (Arab and Berber Muslims from North Africa) from Iberian soil. . . . In the course of this struggle Catholicism and Spanish identity became fused both in reality and in myth" (*Our Lady of Guadalupe*, 19).

9. For historical contexts of Franciscan impact on Iberia, see Webster, *Els Menorets*; also, Seubert, "Transubstantiation of St. Francis of Assisi." Robinson provides scholarship on emotive art on the eve of the colonial era in *Imagining the Passion*. To localize historical analysis of emotive art into Franciscan discourses, see Derbes, *Picturing the Passion*; Kennedy, "In Search of Authenticity."

10. Pierce, "From New Spain to New Mexico," 60.

11. Graham and Kilroy-Ewbank, *Visualizing Sensuous Suffering and Affective Pain*. Graham and Kilroy-Ewbank provide a wealth of resources on the representation of pain in early modern European art. Most applicable to my project are Broomhall, *Early Modern Emotions* and Dijkhuizen, Frans, and Enenkel, *Sense of Suffering*. For representations of pain and suffering,

204 NOTES TO PAGES 118–132

see Di Bella and Elkins, *Representations of Pain in Art*; Reinhardt, Edwards, and Duganne, *Beautiful Suffering*; Morris, *Culture of Pain*; Gouk and Hills, *Representing Emotions*; Grønstad and Gustafsson, *Ethics and Images of Pain*; Coakley and Kaufman Shelemay, *Pain and Its Transformations*; Cohen, "Animated Pain of the Body." I add to this list Elkins's foundational emotion-reception theory, *Pictures and Tears*.

12. For the artists' biographies and works, see their websites: Amalia Mesa-Bains at the MacArthur Fellows Program (https://www.macfound.org/fellows/474); Maya Gonzalez at her artist website (http://www.mayagonzalez.com); Christina Fernandez at her gallery (https://galleryluisotti.com/artists/christina-fernandez).

Chapter 5

1. Gaspar De Alba, "From CARA to CACA," 212, emphasis original. For discussions on resistance against defining Chicanx art, see Baugh and Sorell, *Born of Resistance*, especially the introduction (3–36). For an entire section on differing views on defining Chicanx art, see also J. González et al., *Chicano and Chicana Art*, 13–75.

2. Diaz, *Flying Under the Radar*, 50. See also Gaspar de Alba, *Chicano Art*.

3. Blackwell, ¡*Chicana Power!*, 2.

4. Diaz, *Flying Under the Radar*, 26.

5. See also García and Cortez, "Trace of a Mark That Scatters," 105, reading the inscrutability of the "x" in *Latinx* as a rupture in coloniality systems.

6. For extended conversations on objectness, see Weschler, *Seeing is Forgetting*.

7. For further discussion on performativity of race, see Muñoz, "Feeling Brown, Feeling Down."

8. See Meadow, "Merchants and Marvels."

9. Shelton, "Cabinets of Transgression," 179–80.

10. Ibid., 203.

11. Baudrillard, "System of Collecting," 12.

12. Ibid., 11.

13. Shelton, "Cabinets of Transgression," 203–4.

14. Gómez-Peña, Rice, Vazquez, González, Watkins, *Doc/Undoc*, 19.

15. Ibid., 28.

16. D. Baca, "Chicano Codex," 568, 570. Baca describes this scene as "a multicolored Superman battles his black-and-white inverted twin."

17. In Chagoya, "Oral History," the artist identifies the floating heart as Aztecan and credits José Guadalupe Posada for the skull.

18. Dorfman and Mattelart, *How to Read Donald Duck*. See McClennen, "Beyond *Death and the Maiden*." In 2018 the J. Paul Getty's *Pacific Standard Time: LA/LA* sponsored the exhibit "How to Read El Pato Pascual," which examined the impact of Disney pop culture on Latin American visual arts. The exhibition was a collaborative project featuring 150 works of art by forty-eight Latinx artists at the MAK Center for Art and Architecture at the Schindler House and the Luckman Fine Arts Complex at CSU Los Angeles. See Lerner and Ortiz-Torres, *How to Read El Pato Pascual*.

19. See Boone, *Codex Magliabechiano and the Lost Prototype*, 81.

20. See Cordova, "Enrique Chagoya III." SOS required law enforcement and government employees to investigate and report people suspected of lacking immigration documents. Additionally, it mandated residents prove immigration status before receiving state benefits.

It is implied in *The Governor's Nightmare* that the human body parts centrally located in serving pots amid the diners are Pete Wilson's.

21. See D. Baca, "Chicano Codex," 576; Baca references Carrasco's 1989 *The Imagination of Matter*. See also Peterson, *Paradise Garden Murals of Malinalco*, in which Peterson aligns with Carrasco's multiple interpretations. Peterson posits a form of "visual bilingualism" as she examines Malinalco murals from potentially differing perspectives of Christian friars and Indigenous audiences.

22. Collaborator J. González identifies the face as Washington at *Doc/Undoc.com*.

23. D. Baca, "Chicano Codex," 576.

24. J. González identifies the Posada cut at *Doc/Undoc.com*.

25. See Austin and Montiel, "*Codex Espangliensis*."

26. See Barcham, "Franciscans and the Man of Sorrows."

27. For more discussion on the power of the designation "Catholic Monarchs" all the way to 1936, when General Francisco Franco claimed the emblems associated with the title, see Edwards, *Spain of the Catholic Monarchs*, iix.

28. Chagoya describes this scene: "Right on the facing page, we see Superman being killed by a skeleton of Posada. This is out of a Posada print. And in front of it a bleeding heart, an Aztec bleeding heart" ("Oral History").

29. It might be recalled that St. Peter's revered chains are the prized relics around which the Roman basilica San Pietro in Vincoli was constructed. Chains and manacles are also attributes that identify the sixth-century Frankish saint Leonard of Noblac.

30. For studies on the Virgin of Guadalupe iconography, see Peterson, *Visualizing Guadalupe*; J. Rodriguez, *Our Lady of Guadalupe*; Rodriguez and Fortier, *Cultural Memory*. See also Pierce, "From New Spain to New Mexico."

31. See also Stratton, *Immaculate Conception in Spanish Art*.

32. D. Baca, "Chicano Codex," 577. Baca additionally identifies Mary as Wonder Woman's twin to build on his theory that twinning is central to the *Codex Espangliensis*.

33. Moore and Gibbons, "For the Man Who Has Everything," 18. The comic book was later animated in an episode of the television series *Justice League Unlimited*, directed by Dan Riba.

Chapter 6

1. For Mesoamerican perceptions of the *nagvioli*, see J. Rodriguez, *Our Lady of Guadalupe*, 29.

2. Diaz notes that Asco was absent from art history until the twenty-first century due to enduring institutional beliefs that avant-garde art is meant to "change the art world and not social reality" (*Flying Under the Radar*, 42). Recent work on Asco can be found in Gonzalez, Fox, and Noriega, *Phantom Sightings*; Alvarado, *Abject Performance*; McMahon, *Domestic Negotiations*.

3. Gonzalez, Fox, and Noriega, *Phantom Sightings*, 21.

4. Ontiveros, "Christina Fernandez," 152.

5. See Epstein and Szupinska, *Christina Fernandez*.

6. See Hopkinson and Álvarez Bravo, *Manuel Álvarez Bravo*; Álvarez Bravo, et al., *Manuel Álvarez Bravo*; Álvarez Bravo, *Manuel Álvarez Bravo: Photographs*.

7. See Mraz, *Nacho López*.

8. Keller, Erickson, and Villeneuve, *Chicano Art for Our Millennium*, 36.

9. Toor, *Treasury of Mexican Folkways*, 142.

206 NOTES TO PAGES 154–166

10. Pérez, *Chicana Art*, 292; see also Pérez, "Spirit Glyphs," 197 (citing Miguel León-Portilla).

11. See Kilroy-Ewbank, *Holy Organ or Unholy Idol?*; "Love Hurts."

12. For further comparisons of the Kahlo and Gonzalez pieces, see Pérez, *Chicana Art*, 292.

13. Lindauer, *Devouring Frida*, 148.

14. For examinations of emotional and physical suffering expressed in Kahlo's art, see Herrera, *Frida Kahlo*; Herrera, *Frida*.

15. For song lyrics of "Los Set Goytx" or "The Seven Joys," see Candelaria, *Rosary Cantoral*, 75–78. Candelaria notes that the Seven Joys of Mary were especially celebrated in northeastern Spain, particularly in Catalonia and Aragón. Candelaria focuses on a ballad from the *Llibre Vermell* (Red Book), a collection of music compiled for pilgrims to the famous Black Madonna at the Benedictine monastery of Montserrat in Catalonia during the late fourteenth century, which presents a good example of a rosary-like prayer that combines seven recitations of the "Ave Maria" with meditations on the Joys.

16. Museo Arqueológico Nacional, Complete Sheet of Inventory 1969/44/1.

17. Price, "Bitter Milk," 146.

18. Miesel, "Mothering God," 31.

19. See further examination of this historical context in Robinson, *Imagining the Passion*.

20. See Eiximenis, *Vida de Cristo* (taken from the *Llibre del Crestià* or Book for Christians) as recorded in Santoral, BNE MS 12688, fol. 386r.

21. See Villaseñor Black, "St. Anne Imagery and Maternal Archetypes." See also Ramirez, "Spain's Toledo *Virgen Abridera*."

22. Gertsman, *Worlds Within*, 10.

23. Ibid., 158.

24. Ibid., 50.

25. Rowe, *Saint and Nation*, 135. Rowe uses *nation* as derived from the Latin *natio*, a term grouping those "from the same region who shared customs, history, and possibly language," 3.

26. Ibid., 25.

27. Ibid., 26–27.

28. See Silverblatt, "Political Memories and Colonizing Symbols." Silverblatt details Indigenous strategies to repurpose Santiago as a mountain god. She argues that "Christian ideology was turned to the service of Indigenous resistance" and "Iberian Catholicism's foremost warrior saint, Santiago, could also be drafted to serve in the defense of native religion" (186). While adopting Santiago is a Hispanicizing of native faith, Silverblatt views this act as resistance-in-acquiescence, leading to faith-hybridization that resuscitated Indigenous gods (191).

29. See Ramirez, "Spain's Toledo *Virgen Abridera*," especially pp. 47–48. See also Webster, *Els Menorets*; Stratton, *Immaculate Conception in Spanish Art*; Liss, "Isabel, Myth and History."

30. Christian, *Apparitions*, 8.

31. Kolve, "Man in the Middle," 34. Kolve quotes Augustine: "Man is always in the middle between heaven and hell. . . . This is his place" (*De ordine terum*, book 2).

32. The focus of my MA thesis was the Toledo Convent of the Concepción de las Madres Agustinas virgen abridera; specifically, I examined female patronage and the Immaculate Conception motif represented in the object. See Ramirez, "Spain's Toledo *Virgen Abridera*."

33. Doña Guiomar de Meneses founded the Convent of las Gaitanas in 1459, as well as San Pedro Mártir and the Hospital de la Misericordia, thereby associating the Toledo virgen abridera with a prominent female benefactor of Toledo. The sculpture has remained for five centuries in its convent, moved for study once in 2000. See Ramirez, "Spain's Toledo *Virgen Abridera*," 11, 15.

34. Graham and Kilroy-Ewbank, *Visualizing Sensuous Suffering*, 12.

35. See Tembeck, "Performative Autopathographies," 17. Tembeck adapts the term "dis-ease" from Jo Spence.

36. Tembeck references Sliwinski, "Painful Labour." Sliwinski studies reception theory based on the potential of photography to open spectators' notions of responsibility from a set of moral duties and toward a questioning of personal ethical relationships between visual object and self.

37. See Locke, Tabron, and Venzant Chambers, "'If You Show Who You Are,'" 13–16.

Conclusion

1. For a spectrum of discussions on cultural rhetorics, see Cedillo et al., "Listening to Stories."

2. See Lyons, "Rhetorical Sovereignty," 449–50.

3. Mora, "Elena," ll. 3–5.

4. Ibid., ll. 9–11.

5. Ibid., ll. 18–22.

6. Pennycook and Otsuji, *Metrolingualism*, 16.

7. For a discussion on *semilingual* in educational contexts, see Valadez, MacSwan, and Martínez, "Toward a New View."

8. Lyons, "Rhetorical Sovereignty," 447.

9. Inoue, "Technology of Writing Assessment," 97.

10. See Muñoz, *Disidentifications*; see also Calafell, *Monstrosity, Performance, and Race*.

11. Kramsch and Lam, "Textual Identities," 62.

12. Villanueva, *Bootstraps*, 23. In *Fourth Generation Evaluation*, Guba and Lincoln describe relativistic ontology as asserting Truth as fluid and multiple, built on socially governed realities. Guba and Lincoln, like Villanueva, favor pedagogy that nurtures relativistic perspectives.

13. For related studies on linguistic justice in the classroom, see Ayash, *Toward Translingual Realities in Composition*; Baca, Hinojosa, and Murphy, *Bordered Writers*; Horner, Lu, Royster, and Trimbur, "Opinion"; D. Martinez, "Imagining a Language of Solidarity."

14. Moraga, *Loving in the War Years*, 2nd ed., iii.

15. García and Baca, *Rhetorics Elsewhere and Otherwise*, 4.

16. Guerra, "Putting Literacy in Its Place," 34.

17. Dussel, "Eurocentrism and Modernity," 69 (in response to Georg Wilhelm Friedrich Hegel).

18. Mignolo, "Delinking," 497.

19. Mignolo, "Foreword," x.

20. Cushman et al., "Decolonizing Projects," 2.

21. Elbow, "Inviting the Mother Tongue," 362.

22. Halasek, *Pedagogy of Possibility*, 36–37.

23. Ngũgĩ wa Thiong'o, *Decolonising the Mind*, 28.

24. Ramirez, "Archival Quest," 96.

25. Soto, *Reading Chican@ Like a Queer*, 64.

26. R. Rodriguez, *Hunger of Memory*, 51.

27. Locke, Tabron, and Venzant Chambers, "'If You Show Who You Are,'" 14.

28. Ibid., 26, 30.

29. Ibid., 27.

NOTES TO PAGES 191–192

30. In her interview with Locke, Tabron, and Venzant Chambers, Lillie (age: 20 years; racial self-identification: Latina/Mexican) contextualizes her observations by recalling a biracial friend who is repeatedly placed in ESL classes. Although her friend is "half-Black and half-White," per Lillie's description, Lillie indicates her belief that her friend's biracial features are misidentified as Latinx. For Lillie, this perceived Latinx heritage is the root of her friend's continued placement in ESL and reveals language biases against those who appear to be Latinx. Accordingly, Lillie concludes that students who can conceal their Latinx identity may be advantaged if they do so. Lillie states: "People swear to God that she is Mexican and they try to put her in ESL, and it's like if you show who you are then they are going to try and fix you. So if you pretend to not be that person, then they are not going to try and fix you anymore" (26).

31. Barad, "Diffracting Diffraction," 169.

32. Moreno, "'Politics of Location,'" 225.

Bibliography

Acosta, Abraham. "Hinging on Exclusion and Exception: Bare Life, the US/Mexico Border, and *Los que nunca llegarán.*" *Social Text* 30, no. 4 (2012): 103–23.

———. *Thresholds of Illiteracy: Theory, Latin America, and the Crisis of Resistance.* New York: Fordham University Press, 2014.

Agamben, Giorgio. "Introduction to *Homo Sacer: Sovereign Power and Bare Life.*" In *Biopolitics: A Reader*, edited by Timothy Campbell and Adam Sitze, 134–44. Translated by David Macey. Durham: Duke University Press, 2013.

Ahmed, Sara. "Orientations: Toward a Queer Phenomenology." *GLQ: A Journal of Lesbian and Gay Studies* 12, no. 4 (2006): 543–74.

Alberto, Lourdes. "Nations, Nationalisms, and *Indígenas*: The 'Indian' in the Chicano Revolutionary Imaginary." *Critical Ethnic Studies* 2, no. 1 (2016): 107–27.

Alvarado, Leticia. *Abject Performances: Aesthetic Strategies in Latino Cultural Production.* Durham: Duke University Press, 2018.

Alvarez, Julia. *How the García Girls Lost Their Accents.* New York: Plume, 1992.

———. *¡Yo!* New York: Plume, 1997.

Álvarez Bravo, Manuel. *Manuel Álvarez Bravo: Photographs from the J. Paul Getty Museum.* Los Angeles: The J. Paul Getty Museum, 2001.

Álvarez Bravo, Manuel, Laura González Flores, Gerardo Mosquera, Muriel Rausch, and Mónica Fuentes Santos. *Manuel Álvarez Bravo.* Alcobendas: TF Editores, 2012.

Antuna, Marcos de. "What We Talk About When We Talk About Nepantla: Gloria Anzaldúa and the Queer Fruit of Aztec Philosophy." *Journal of Latinos and Education* 17, no. 2 (2018): 159–63.

Anzaldúa, Gloria E. "Acts of Healing." In *This Bridge Called My Back: Writings by Radical Women of Color*, edited by Cherríe Moraga and Gloria Anzaldúa, xxvii–xxviii. Albany: State University of New York Press, 2015.

———. *Borderlands / La Frontera: The New Mestiza.* San Francisco: Aunt Lute Books, 2012.

———. *Interviews / Entrevistas.* Edited by AnaLouise Keating. New York: Routledge, 2000.

———. *Light in the Dark / Luz en lo Oscuro: Rewriting Identity, Spirituality, Reality.* Edited by AnaLouise Keating. Durham: Duke University Press, 2015.

———. "Now Let Us Shift . . . the Path of Conocimiento . . . Inner Work, Public Acts." In *This Bridge We Call Home: Radical Visions for Transformation*, edited by Gloria Anzaldúa and AnaLouise Keating, 540–77. London: Routledge, 2002.

Associated Press. "More Migrant Women Say They Didn't OK Surgery." *Los Angeles Times*, September 18, 2020. https://www.latimes.com/world-nation/story/2020-09-18/ap-exclusive-more-migrant-women-say-they-didnt-ok-surgery.

Austin, Kat, and Carlos Urani Montiel. "*Codex Espangliensis*: Neo-Baroque Art of Resistance." Translated by Victoria J. Furio. *Latin American Perspectives* 39, no. 3 (May 2012): 88–105.

Ayash, Nancy Bou. *Toward Translingual Realities in Composition: (Re)Working Local Language Representations and Practices.* Denver: University Press of Colorado, 2019.

Baca, Damián. "The Chicano Codex: Writing Against Historical and Pedagogical Colonization." *College English* 71, no. 6 (2009): 564–83.

———. "*Rhetoric Interrupted*: La Malinche and Nepantlisma." In *Rhetoric of the Americas: 3114 BCE to 2012 CE*, edited by Damián Baca and Victor Villanueva, 143–51. New York: Palgrave Macmillan, 2010.

Baca, Damián, and Víctor Villanueva, eds. *Rhetorics of the Americas: 3114 BCE to 2012 CE*. New York: Palgrave, 2010.

Baca, Isabel, Yndalecio Isaac Hinojosa, and Susan Wolff Murphy, eds. *Bordered Writers: Latinx Identities and Literacy Practices at Hispanic-Serving Institutions*. Albany: State University of New York Press, 2019.

Barad, Karen. "Diffracting Diffraction: Cutting Together-Apart." *Parallax* 20, no. 4 (2014): 168–87.

———. "Transmaterialities: Trans*/Matter/Realities and Queer Political Imaginings." *GLQ: A Journal of Lesbian and Gay Studies* 21, nos. 2–3 (2015): 387–422.

Barcham, William. "Franciscans and the Man of Sorrows in Fifteenth-Century Padua." In *Beyond the Text: Franciscan Art and the Construction of Religion*, edited by Xavier Seubert, 62–83. Saint Bonaventure: Franciscan Institute Publications, 2013.

Barnitz, Jacqueline. *Twentieth-Century Art of Latin America*. Austin: University of Texas Press, 2001.

Baudrillard, Jean. "The System of Collecting." In *The Cultures of Collection*, edited by John Elsner and Roger Cardinal, 7–24. Translated by Roger Cardinal. London: Reaktion Books, 1994.

Baugh, Scott L., and Víctor A. Sorell, eds. *Born of Resistance: Cara a Cara Encounters with Chicana/o Visual Culture*. Tucson: University of Arizona Press, 2015.

Baugh-Harris, Sara. "Remembering Julia de Burgos: Faithful Witnessing as Decolonial Feminist Performance." In *De-Whitening Intersectionality: Race Intercultural Communication, and Politics*, edited by Shinsuke Eguchi, Shadee Abdi, and Bernadette Marie Calafell, 183–202. Lanham: Lexington Books, 2020.

Benavides, Gustavo. "Syncretism and Legitimacy in Latin American Religion." In *Syncretism in Religion: A Reader*, edited by Anita M. Leopold and Jeppe S. Jensen, 194–216. London: Routledge, 2014.

Berlo, Janet C. "Icons and Ideologies at Teotihuacan: The Great Goddess Reconsidered." In *Art, Ideology, and the City of Teotihuacan*, edited by Janet C. Berlo, 129–68. Washington, DC: Dumbarton Oaks, 1992.

Bireley, Robert. *The Refashioning of Catholicism, 1450–1700: A Reassessment of the Counter Reformation*. Washington, DC: Catholic University of America Press, 1999.

Blackwell, Maylei. ¡*Chicana Power! Contested Histories of Feminism in the Chicano Movement*. Austin: University of Texas Press, 2011.

———. "Lídres Campesinas: Nepantla Strategies and Grassroots Organizing at the Intersection of Gender and Globalization." *Aztlán: A Journal of Chicano Studies* 35, no. 1 (2010): 13–47.

Bleichmar, Daniela. *Visible Empire: Botanical Expeditions and Visual Culture in the Hispanic Enlightenment*. Chicago: University of Chicago Press, 2012.

Bonfiglio, Thomas Paul. "Inventing the Native Speaker." *Critical Multilingualism Studies* 1, no. 2 (2013): 29–58.

Boone, Elizabeth Hill. *The Codex Magliabechiano and the Lost Prototype of the Magliabechiano Group*. Berkeley: University of California Press, 1983.

———. *Cycles of Time and Meaning in the Mexican Books of Fate*. Austin: University of Texas Press, 2007.

Borjas, Sara. *Heart Like a Window, Mouth Like a Cliff*. Blacksburg: Noemi Press, 2019.

Broomhall, Susan, ed. *Early Modern Emotions: An Introduction*. London: Routledge, 2017.

Brumfiel, Elizabeth. "Figurines and Aztec State: Testing Effectiveness of Ideological Domination." In *Gender and Archaeology*, edited by Rita P. Wright, 143–66. Philadelphia: University of Pennsylvania Press, 1996.

Butler, Judith. *Precarious Life: The Powers of Mourning and Violence*. London: Verso, 2004.

Bynum, Caroline Walker. *Christian Materiality: An Essay on Religion in Late Medieval Europe*. New York: Zone Books, 2015.

———. *Fragmentation and Redemption: Essays on Gender and the Human Body in Medieval Religion*. New York: Zone Books, 1992.

Calafell, Bernadette Marie. *Latina/o Communication Studies: Theorizing Performance*. New York: Peter Lang, 2007.

———. *Monstrosity, Performance, and Race*. New York: Peter Lang, 2015.

———. "Pro(re-)claiming Loss: A Performance Pilgrimage in Search of Malintzin Tenépal." *Text and Performance Quarterly* 25, no. 1 (2005): 43–56.

"California Launches Program to Compensate Survivors of State-Sponsored Sterilization." CA.gov. Updated December 31, 2021. https://www.gov.ca.gov/2021/12/31/california-launches-program-to-compensate-survivors-of-state-sponsored-sterilization.

California Legislative Information. "Health and Safety Code-HSC Division 20. Chapter 1.6. Forced or Involuntary Sterilization Compensation Program." CA.gov. Updated July 16, 2021. https://leginfo.legislature.ca.gov/faces/codes_displaytext.xhtml?division=20.&chapter=1.6.&lawCode=HSC.

Candelaria, Lorenzo. *The Rosary Cantoral: Ritual and Social Design in a Chantbook from Early Renaissance Toledo*. Rochester: University of Rochester Press, 2008.

Carpio, Myla Vicenti. "The Lost Generation: American Indian Women and Sterilization Abuse." *Social Justice* 31, no. 4 (2004): 40–53.

Carrasco, Davíd. *The Imagination of Matter: Religion and Ecology in Mesoamerican Traditions*. Oxford: BAR International Series, 1989.

Caruth, Cathy. *Unclaimed Experience: Trauma, Narrative, and History*. Baltimore: Johns Hopkins University Press, 1996.

Castillo, Ana. *Black Dove: Mamá, Mi'jo, and Me*. New York: Feminist Press, 2016.

———. *Watercolor Women Opaque Men: A Novel in Verse*. Willimantic: Curbstone Press, 2005.

Cedillo, Christina. "Unruly Borders, Bodies, and Blood: Mexican 'Mongrels' and the Eugenics of Empire." *Journal for the History of Rhetoric* 24, no. 1 (2021): 7–23.

Cedillo, Christina V., Victor del Hierro, Candace Epps-Robertson, Lisa King, Jessie Male, Staci Perryman-Clark, Andrea Riley-Mukavetz, and Amy Vidali. "Listening to Stories: Practicing Cultural Rhetorics Pedagogy; A Virtual Roundtable." *Constellations: A Cultural Rhetorics Publishing Space* (May 2018): 1–10.

———. "Unruly Borders, Bodies, and Blood: Mexican 'Mongrels' and the Eugenics of Empire." *Journal for the History of Rhetoric* 24, no. 1 (2021): 7–23.

Chagoya, Enrique. "Oral History Interview with Enrique Chagoya." Interview by Paul Karlstrom and Kara Maria. Smithsonian Archives of American Art. July 25–August 6, 2001. Accessed January 13, 2020. https://www.aaa.si.edu/collections/interviews/oral-history-interview-enrique-chagoya-12495.

Christian, William. *Apparitions in Late Medieval and Renaissance Spain*. Princeton: Princeton University Press, 1981.

Coakley, Sarah, and Kay Kaufman Shelemay, eds. *Pain and Its Transformations: The Interface of Biology and Culture*. Cambridge, MA: Harvard University Press, 2007.

BIBLIOGRAPHY

Cohen, Esther. "The Animated Pain of the Body." *Art History Review* 105, no. 1 (2000): 36–68.

———. *The Modulated Scream: Pain in Late Medieval Culture*. Chicago: University of Chicago Press, 2010.

Cohn, Erika, dir. *Belly of the Beast*. San Francisco, CA: Women Make Movies, 2021. Streaming video file, 81 min. https://www.kanopy.com/en/csulb/video/11120413.

Cordova, Ruben. "Enrique Chagoya III: Yet More Heroes and Villains." *Glasstire: Texas Visual Art*. October 15, 2019. Accessed May 20, 2020. https://glasstire.com/2019/10/15/enrique-chagoya-iii-yet-more-heroes-and-villains.

Cortez, José. "History." In *Decolonizing Rhetoric and Composition Studies: New Latinx Keywords for Theory and Pedagogy*, edited by Iris D. Ruiz and Raúl Sánchez, 49–62. Merced: Palgrave Macmillan, 2016.

Craven, David. "The Multiple Identities of Modernisms from Mexico in the Early Twentieth Century." In *Mexico Modern: Masters of the 20th Century*, edited by David Craven and Luis-Martín Lozano, 24–43. Santa Fe: Museum of New Mexico Press, 2006.

Cushman, Ellen, Rachel Jackson, Annie Laurie Nichols, Courtney Rivard, Amanda Moulder, Chelsea Murdock, David M. Grant, and Heather Brook Adams. "Decolonizing Projects: Creating Pluriversal Possibilities in Rhetoric." *Rhetoric Review* 38, no. 1 (2019): 1–22.

D'Alleva, Anne. *Methods and Theories of Art History*. London: Laurence King Publishing, 2012.

Davies, Telory W. "Race, Gender, and Disability: Cherríe Moraga's Bodiless Head." *Journal of Dramatic Theory and Criticism* 21, no. 1 (2006): 29–44.

Decker, John R., and Mitzi Kirkland-Ives, eds. *Death, Torture, and the Broken Body in European Art, 1300–1650*. London: Ashgate, 2015.

Delgado, Fernando Pedro. "Chicano Movement Rhetoric: An Ideographic Interpretation." *Communication Quarterly* 43, no. 4 (1995): 446–55.

Delpit, Lisa. "The Silenced Dialogue: Power and Pedagogy in Educating Other People's Children." *Harvard Educational Review* 53, no. 3 (1988): 280–98.

Derbes, Anne. *Picturing the Passion in Late Medieval Italy: Narrative Painting, Franciscan Ideologies, and the Levant*. New York: Cambridge University Press, 1996.

Diaz, Ella Maria. *Flying Under the Radar with the Royal Chicano Air Force: Mapping a Chicano/a Art History*. Austin: University of Texas Press, 2017.

Di Bella, Maria Pia, and James Elkins, eds. *Representations of Pain in Art and Visual Culture*. London: Routledge, 2012.

Dijkhuizen, Jan Frans van, and Karl A. E. Enenkel, eds. *The Sense of Suffering: Construction of Physical Pain in Early Modern Culture*. Leiden: Brill, 2008.

Disability Rights Education and Defense Fund. "California Passes Landmark Law to Provide Reparations to Survivors of State-Sponsored Forced Sterilization." DREDF.org. July 13, 2021. Accessed March 29, 2023. https://dredf.org/2021/07/13/california-passes-landmark-law-to-provide-reparations-to-survivors-of-state-sponsored-forced-sterilization.

Dorfman, Ariel, and Armand Mattelart. *How to Read Donald Duck: Imperialist Ideology in the Disney Comic*. London: Pluto Press, 2019.

Durán, Diego. *History of the Indies of New Spain*. Translated by Doris Heyden. Norman: Oklahoma University Press, 1994.

Dussel, Enrique. "Eurocentrism and Modernity (Introduction to the Frankfurt Lectures)." *boundary 2* 20, no. 3 (1993): 65–76.

Earle, Rebecca. *The Body of the Conquistador: Food, Race, and the Colonial Experience in Spanish America, 1492–1700*. Cambridge, UK: Cambridge University Press, 2012.

Edwards, John. *The Spain of the Catholic Monarchs: 1474–1520*. Oxford: Blackwell Publishers, 2000.

Eguchi, Shinsuke, Bernadette Marie Calafell, and Shadee Abdi, eds. *De-Whitening Intersectionality: Race, Intercultural Communication, and Politics*. Lanham: Lexington Books, 2020.

Eiximenis, Francesc. *Vida de Cristo*. Edited by Fulton J. Sheen. Translated by Juan Godó. Barcelona: Herder Editorial, 1985.

Elbow, Peter. "Inviting the Mother Tongue: Beyond 'Mistakes,' 'Bad English,' and 'Wrong Language.'" *JAC* 19, no. 3 (1999): 359–88.

Elkins, James. *Pictures and Tears: A History of People Who Have Cried in Front of Paintings*. New York: Routledge, 2001.

Enoch, Jessica. "Survival Stories: Feminist Historiographic Approaches to Chicana Rhetorics of Sterilization Abuse." *Rhetoric Society Quarterly* 35, no. 3 (Summer 2005): 5–30.

Espino, Virginia R. "Women Sterilized as They Give Birth: Population Control, Eugenics, and Social Protest in the Twentieth-Century United States." PhD diss., Arizona State University, 2007.

Espino, Virginia, and Renee Tajima-Peña. "A Conversation With 'No Más Bebés' Filmmakers Virginia Espino and Renee Tajima-Peña." Interview by Tina Vasquez. *Rewire*, February 1, 2016. https://rewire.news/article/2016/02/01/conversation-mas-bebes-filmmakers-virginia-espino-renee-tajima-pena.

———. "A Post-Screening Discussion of 'No Más Bebés' with Renee Tajima-Peña and Virginia Espino." UCLA Chicano Studies Research Center. YouTube, May 24, 2016. 39:35 duration. https://www.youtube.com/watch?v=We5zFzhSUwo&app=desktop.

———. "2015 Los Angeles Film Festival—Carpet Chat with Virginia Espino and Renee Tajima-Peña." Interview by Debbie Lynn Elias. YouTube, June 12, 2015. Accessed November 28, 2019. https://youtu.be/zF4nhj1CA_A.

Foucault, Michel. "'Society Must Be Defended': Lecture at the Collège De France, March 17, 1976." Translated by David Macey. In *Biopolitics: A Reader*, edited by Timothy Campbell and Adam Sitze, 61–81. Durham: Duke University Press, 2013.

García, Romeo, and Damián Baca, eds. *Rhetorics Elsewhere and Otherwise: Contested Modernities, Decolonial Visions*. Urbana: Conference on College Composition and Communication of the National Council of Teachers of English, 2019.

García, Romeo, and José M. Cortez. "The Trace of a Mark That Scatters: The Anthropoi and the Rhetoric of Decoloniality." *Rhetoric Society Quarterly* 50, no. 2 (2020): 93–108.

Gaspar De Alba, Alicia. *Chicano Art Inside/Outside the Master's House*. Austin: University of Texas Press, 1998.

———. "From CARA to CACA: The Multiple Anatomies of Chicano/a Art at the Turn of the New Century." *Aztlán: A Journal of Chicano Studies* 26, no. 1 (2001): 205–31.

Gertsman, Elina. *Worlds Within: Opening the Medieval Shrine Madonna*. University Park: Pennsylvania State University Press, 2015.

Gómez-Peña, Guillermo, Enrique Chagoya, Felicia Rice, and Jennifer González. *Codex Espangliensis—from Columbus to the Border Patrol*. San Francisco: City Lights Books, 2000.

Gómez-Peña, Guillermo, Felicia Rice, Gustavo Vazquez, Jennifer González, and Zachary James Watkins. *Doc/Undoc: Documentado/Undocumented Ars Shamánica Performática*. San Francisco: City Lights Books, 2017.

González Hernando, Irene. *El arte bajomedieval y su proyección: Temas, funciones y contexto de las Vírgenes Abrideras tríptico*. Madrid: Editorial Académica Española, 2011.

González, Jennifer A. "*Codex Espangliensis* Commentary." *Doc/Undoc.com*. Accessed December 7, 2019. https://docundoc.com/2014/01/06/codex-espangliensis.

González, Jennifer A., C. Ondine Chagoya, Chon Noriega, and Terezita Romo, eds. *Chicano and Chicana Art: A Critical Anthology*. Durham: Duke University Press, 2019.

Gonzalez, Rita, Howard N. Fox, and Chon A. Noriega, eds. *Phantom Sightings: Art After the Chicano Movement*. Los Angeles: University of California Press, 2008.

Gouk, Penelope, and Helen Hills, eds. *Representing Emotions: New Connections in the Histories of Art, Music, and Medicine*. Burlington: Ashgate, 2005.

Graham, Heather, and Lauren G. Kilroy-Ewbank, eds. *Visualizing Sensuous Suffering and Affective Pain in Early Modern Europe and the Spanish Americas*. Leiden: Brill, 2018.

Grønstad, Asbjørn, and Henrik Gustafsson. *Ethics and Images of Pain*. New York: Routledge, 2012.

Grosfoguel, Ramón. "The Epistemic Decolonial Turn: Beyond Political-Economy Paradigms." *Cultural Studies* 21, nos. 2–3 (2007): 211–23.

Guba, Egon, and Yvonne S. Lincoln. *Fourth Generation Evaluation*. Newbury Park: Sage Publications, 1989.

Guerra, Juan. "Putting Literacy in Its Place: Nomadic Consciousness and the Practice of Transcultural Repositioning." In *Rebellious Reading: The Dynamics of Chicana/o Cultural Literacy*, edited by Carl Gutierrez Jones, 19–37. Santa Barbara: Center for Chicana/o Studies, University of California–Santa Barbara, 2004.

Halasek, Kay. *A Pedagogy of Possibility: Bakhtinian Perspectives on Composition Studies*. Carbondale: Southern Illinois University Press, 1999.

Herrera, Hayden. *Frida: A Biography of Frida Kahlo*. New York: Harper & Row, 1983.

———. *Frida Kahlo: The Paintings*. New York: HarperCollins Publishers, 1991.

Hopkinson, Amanda, and Manuel Álvarez Bravo. *Manuel Álvarez Bravo*. London: Phaidon, 2002.

Horner, Bruce, Min-Zhan Lu, Jacqueline Jones Royster, and John Trimbur. "Opinion: Language Difference in Writing; Toward a Translingual Approach." *College English* 73, no. 3 (2011): 303–21.

Ignatius of Loyola. *The Spiritual Exercises of Saint Ignatius*. Translated by Pierre Wolff. Liguori: Ligouri Publications, 1997.

Inoue, Asao B. "The Technology of Writing Assessment and Racial Validity." In *Handbook of Research on Assessment Technologies, Methods, and Applications in Higher Education*, edited by Christopher Schreiner, 97–120. Hershey: IGI Global, 2009.

Jindia, Shilpa. "Belly of the Beast: California's Dark History of Forced Sterilizations." *The Guardian*, June 30, 2020. https://www.theguardian.com/us-news/2020/jun/30/california-prisons-forced-sterilizations-belly-beast.

Jolly, Jallicia. "On Forbidden Wombs and Transnational Reproductive Justice." *Meridians: Feminism, Race, Transnationalism* 15, no. 1 (2016): 166–88.

Katz, Melissa. "Behind Closed Doors: Distributed Bodies, Hidden Interiors, and Corporeal Erasure in *Vierge Ouvrante* Sculpture." *RES: Anthropology and Aesthetic* 55/56 (2009): 194–221.

———. "Marian Motion: Opening the Body of the Vierge Ouvrante." In *Meaning in Motion: The Semantics of Movement in Medieval Art*, edited by Nino Zchomelidse and Giovanni Freni, 63–91. Princeton: Princeton University Press, 2011.

———. "The Non-Gendered Appeal of *Vierge Ouvrante* Sculpture: Audience, Patronage, and Purpose in Medieval Iberia." In *Reassessing the Roles of Women as "Makers" of Medieval Art and Architecture*, edited by Therese Martin, 37–91. Leiden: Brill, 2012.

Katzew, Ilona. *Casta Painting: Images of Race in Eighteenth-Century Mexico*. New Haven: Yale University Press, 2004.

Katzew, Ilona, and Susan Deans-Smith, eds. *Race and Classification: The Case of Mexican American*. Stanford: Stanford University Press, 2009.

Keller, Gary D., Mary Erickson, and Pat Villeneuve, eds. *Chicano Art for Our Millennium: Collected Works from the Arizona State University Community*. Tempe: Bilingual Press/Editorial Bilingüe, 2004.

Kennedy, Trinita. "In Search of Authenticity: The Art of the Dominican and Franciscan Orders in the Age of Observant Reform." In *Sanctity Pictured: The Art of the Dominican and Franciscan Orders in Renaissance Italy*, edited by Trinita Kennedy, 76–90. Nashville: First Center for the Visual Arts, 2014.

Kenny, Michael G. "Trauma, Time, Illness, and Culture: An Anthropological Approach to Traumatic Memory." In *Tense Past: Cultural Essays in Trauma and Memory*, edited by Paul Antze and Michael Lambek, 151–71. New York: Routledge, 1996.

Kilroy-Ewbank, Lauren Grace. "Holy Organ or Unholy Idol? Forming a History of the Sacred Heart in New Spain." *Colonial Latin American Review* 23, no. 3 (2014): 320–59.

———. *Holy Organ or Unholy Idol? The Sacred Heart in the Art, Religion, and Politics of New Spain*. Leiden: Brill, 2018.

———. "Love Hurts: Depictions of Christ Wounded in Love in Colonial Mexican Convents." In *Visualizing Sensuous Suffering and Affective Pain in Early Modern Europe and the Spanish Americas*, edited by Heather Graham and Lauren G. Kilroy-Ewbank, 313–57. Leiden: Brill, 2018.

Kim, Jinah. *Postcolonial Grief: The Afterlives of the Pacific Wars in the Americas*. Durham: Duke University Press, 2019.

Kistler, Robert. "Many US Rules on Sterilization Abuses Ignored Here." *Los Angeles Times*, December 3, 1974, A3, 24–26.

———. "Women 'Pushed' into Sterilization, Doctor Charges: Thousands Victimized at Some Inner-City Teaching Hospitals, Report Claims." *Los Angeles Times*, December 2, 1974, A1, 3, 26–28.

Klein, Cecelia F. "The Devil and the Skirt: An Iconographic Inquiry into the Pre-Hispanic Nature of the Tzitzimime." *Ancient Mesoamerica* 11, no. 1 (2000): 1–26.

———. "A New Interpretation of the Aztec Statue Called Coatlicue, 'Snakes-Her-Skirt.'" *Ethnohistory* 55, no. 2 (2008): 229–50.

———. "None of the Above: Gender Ambiguity in Nahua Ideology." In *Gender in Pre-Hispanic America*, edited by Cecelia F. Klein and Jeffrey Quilter, 183–253. Washington, DC: Dumbarton Oaks Research Library and Collection, 2001.

Klein, Cecelia F., and Jeffrey Quilter. *Gender in Pre-Hispanic America*. Washington, DC: Dumbarton Oaks Research Library and Collection, 2001.

Kluchin, Rebecca M. "Locating the Voices of the Sterilized." *The Public Historian* 29, no. 3 (Summer 2007): 131–44.

Knight, Alan. "Racism, Revolution, and Indigenismo: Mexico, 1910–1940." In *The Idea of Race in Latin America, 1870–1940*, edited by Richard Graham, 71–113. Austin: University of Texas Press, 1990.

Kolve, V. A. "Man in the Middle: Art and Religion in Chaucer's Friar's Tale." In *Studies in the Age of Chaucer*, edited by Thomas J. Heffernan, 5–46. Norman: New Chaucer Society, 1990.

Kramsch, Claire, and Wan Shun Eva Lam. "Textual Identities: The Importance of Being Non-Native." In *Non-Native Educators in English Language Teaching*, edited by George Braine, 57–75. New Jersey: Lawrence Erlbaum Associates, 1999.

Lechuga, Michael. "An Anticolonial Future: Reassembling the Way We Do Rhetoric." *Communication and Critical/Cultural Studies* 17, no. 4 (2020): 378–85.

Leopold, Anita M., and Jeppe S. Jensen. *Syncretism in Religion: A Reader*. London: Routledge, 2014.

Lerner, Jesse, and Rubén Ortiz-Torres, eds. *How to Read El Pato Pascual: Disney's Latin America and Latin America's Disney*. Los Angeles: Black Dog Publishing Limited, 2017.

Lindauer, Margaret. *Devouring Frida: The Art History and Popular Celebrity of Frida Kahlo*. Hanover: University Press of New England, 1999.

Liss, Peggy K. "Isabel, Myth and History." In *Isabel la Católica, Queen of Castile: Critical Essays*, edited by David A. Boruchoff, 57–78. New York: Palgrave Macmillan, 2003.

Locke, Leslie Ann, Lolita A. Tabron, and Terah T. Venzant Chambers. "'If You Show Who You Are, Then They Are Going to Try to Fix You': The Capitals and Costs of Schooling for High-Achieving Latina Students." *Educational Studies* 53, no. 1 (2017): 13–36.

López, Tiffany Ana. "Performing Aztlán: The Female Body as Cultural Critique in the *Teatro* of Cherríe Moraga." In *Performing America: Cultural Nationalism in American Theater*, edited by Jeffrey D. Mason and J. Ellen Gainor, 160–77. Ann Arbor: University of Michigan Press, 1999.

Lugo-Lugo, Carmen R. "'So You Are a Mestiza': Exploring the Consequences of Ethnic and Racial Clumping in the US Academy." *Ethnic and Racial Studies* 31, no. 3 (March 2008): 611–28.

Lugones, María. "The Coloniality of Gender." *Worlds and Knowledges Otherwise* 2 (Spring 2008): 1–17.

———. *Peregrinajes/Pilgrimages: Theorizing Coalitions Against Multiple Oppressions*. Lanham: Rowman and Littlefield, 2003.

———. "Toward a Decolonial Feminism." *Hypatia* 25, no. 4 (Fall 2010): 742–59.

Lyons, Scott Richard. "Rhetorical Sovereignty: What Do American Indians Want from Writing?" *College Composition and Communication* 51, no. 3 (2000): 447–68.

Maffie, James. *Aztec Philosophy: Understanding a World in Motion*. Boulder: University Press of Colorado, 2014.

Manian, Maya. "Coerced Sterilization of Mexican-American Women: The Story of Madrigal v. Quilligan." In *Reproductive Rights and Justice Stories*, edited by Melissa Murray, Katherine Shaw, and Reva B. Siegel, 97–116. St. Paul: Foundation Press, 2019.

———. "Immigration Detention and Coerced Sterilization: History Tragically Repeats Itself." American Civil Liberties Union. September 29, 2020. https://www.aclu.org/news/immigrants-rights/immigration-detention-and-coerced-sterilization-history-tragically-repeats-itself.

Martinez, Danny C. "Imagining a Language of Solidarity for Black and Latinx Youth in English Language Arts Classrooms." *English Education* 49, no. 2 (2017): 179–96.

Martinez, Jacqueline M. *Phenomenology of Chicana Experience and Identity: Communication and Transformation in Praxis*. Lanham: Rowman and Littlefield, 2000.

Martínez, María Elena. *Genealogical Fictions: Limpieza de Sangre, Religion, and Gender in Colonial Mexico*. Stanford: Stanford University Press, 2008.

McCafferty, Sharisse D., and Geoffrey G. McCafferty. "The Conquered Women of Cacaxtla: Gender Identity or Gender Ideology?" *Ancient Mesoamerica* 5 (1994): 159–72.

McClennen, Sophia A. "Beyond *Death and the Maiden*: Ariel Dorfman's Media Criticism and Journalism." *Latin American Research Review* 45, no. 1 (2010): 173–88.

McKinnon, Sara L. "Necropolitics as Foreign Affairs Rhetoric in Contemporary US-Mexico Relations." In *Precarious Rhetorics*, edited by Wendy S. Hesford, Adela C. Licona, and Christa Teston, 62–81. Columbus: The Ohio State University Press, 2018.

McMahon, Marci R. *Domestic Negotiations: Gender, Nation, and Self-Fashioning in US Mexicana and Chicana Literature and Art*. New Brunswick: Rutgers University Press, 2013.

McNamer, Sarah. *Affective Meditation and the Invention of Medieval Compassion*. Philadelphia: University of Pennsylvania Press, 2011.

Meadow, Mark A. "Merchants and Marvels: Hans Jacob Fugger and the Origins of the Wunderkammer." In *Merchants and Marvels: Commerce and the Representation of Nature*, edited by Paula Findlen and Pamela Smith, 182–200. New York: Routledge Press, 2002.

Merback, Mitchell B. *The Thief, the Cross, and the Wheel: Pain and the Spectacle of Punishment in Medieval and Renaissance Europe*. Chicago: University of Chicago Press, 1998.

Merleau-Ponty, Maurice. *Phenomenology of Perception*. Translated by Donald A. Landes. London: Routledge, 2012.

Miesel, Sandra. "Mothering God." *Crisis Magazine*, December 1, 2021, 28–33. https://www.crisismagazine.com/vault/mothering-god-2.

Mignolo, Walter. *The Darker Side of the Renaissance: Literacy, Territoriality, and Colonization*. Ann Arbor: University of Michigan Press, 1995.

———. "Delinking." *Cultural Studies* 21, nos. 2–3 (2007): 449–514.

———. "Epistemic Disobedience and the Decolonial Option: A Manifesto." *Transmodernity: Journal of Peripheral Cultural Production of the Luso-Hispanic World* 1, no. 2 (2011): 44–66.

———. "Foreword: On Pluriversality and Multipolarity." In *Constructing the Pluriverse: The Geopolitics of Knowledge*, edited by Bernd Reiter, ix–xvi. Durham: Duke University Press, 2018.

Milian, Claudia. "Extremely Latin, XOXO: Notes on LatinX." *Cultural Dynamics* 29, no. 3 (2017): 121–40.

Miller, Mary Ellen. *The Art of Mesoamerica: From Olmec to Aztec*. London: Thames and Hudson, 2006.

Millett-Gallant, Ann, and Elizabeth Howie. *Disability and Art History*. New York: Routledge, 2017.

Miner, Dylan A. T. *Creating Aztlán: Chicano Art, Indigenous Sovereignty, and Lowriding Across Turtle Island*. Tucson: University of Arizona Press, 2014.

———. "'When They Awaken': Indigeneity, Miscegenation, and Anticolonial Visuality." In *Rhetorics of the Americas: 3114 BCE to 2012 CE*, edited by Damián Baca and Víctor Villanueva, 169–95. New York: Palgrave, 2010.

Minh-ha, Trinh T. "Not You/Like You: Postcolonial Women and the Interlocking Questions of Identity and Difference." In *Dangerous Liaisons: Gender, Nation, and Postcolonial Perspectives*, edited by Anne McClintock, Aamir Mufti, and Ella Shohat, 415–19. Minneapolis: University of Minnesota Press, 1997.

Minich, Julie Avril. *Accessible Citizenships: Disability, Nation, and the Cultural Politics of Greater Mexico*. Philadelphia: Temple University Press, 2014.

Mohanty, Chandra Talpade. *Feminism Without Borders: Decolonizing Theory, Practicing Solidarity*. Durham: Duke University Press, 2003.

Montoya-Galvez. "Investigation Finds Women Detained by ICE Underwent 'Unnecessary Gynecological Procedures' at Georgia Facility." CBSNews.com. November 15, 2022. https://www.cbsnews.com/news/women-detained-ice-unnecessary-gynecological-procedures-georgia-facility-investigation.

Moore, Alan (author), and Dave Gibbons (illustrator). "For the Man Who Has Everything." *Superman* 4, no. 11 (special annual edition). DC Comics: May 1985.

Mora, Pat. "Elena." In *Latino Boom: An Anthology of US Latino Literature*, edited by John S. Christie and José B. Gonzalez, 369. New York: Pearson-Longman, 2006.

Moraga, Cherríe L. "Entering the Lives of Others: Theory in the Flesh." In *This Bridge Called My Back: Writings by Radical Women of Color*, edited by Cherríe Moraga and Gloria Anzaldúa, 19. Albany: State University of New York Press, 2015.

———. "La Güera." In *This Bridge Called My Back: Writings by Radical Women of Color*, edited by Cherríe Moraga and Gloria Anzaldúa, 22–29. Albany: State University of New York Press, 2015.

———. The Helena María Viramontes Lecture in Latina/o Literature Series, April 18, 2019, California State University, Long Beach, CA.

———. *The Hungry Woman: Mexican Medea*. Albuquerque: West End Press, 2013.

———. *The Last Generation*. Boston: South End Press, 1993.

———. *Loving in the War Years: Lo que nunca pasó por sus labios*. 1st ed. Cambridge, MA: South End Press, 1983.

———. *Loving in the War Years: Lo que nunca pasó por sus labios*. 2nd ed. Cambridge, MA: South End Press, 2000.

———. *Native Country of the Heart: A Memoir*. New York: Farrar, Straus, and Giroux, 2019.

———. "The Welder." In *This Bridge Called My Back: Writings by Radical Women of Color*, edited by Cherríe Moraga and Gloria Anzaldúa, 219–20. Albany: State University of New York Press, 2015.

Moraga, Cherríe, and Gloria Anzaldúa, eds. *This Bridge Called My Back: Writings by Radical Women of Color*. Albany: State University of New York Press, 2015.

Moraña, Mabel, Enrique Dussel, and Carlos A. Jáuregui, eds. *Coloniality at Large: Latin America and the Decolonial Debate*. Durham: Duke University Press, 2009.

Moreno, Renee. "'The Politics of Location': Text as Opposition." *College Composition and Communication* 54, no. 2 (December 2002): 222–42.

Morris, David B. *The Culture of Pain*. Berkeley: University of California Press, 1991.

Mraz, John. *Nacho López, Mexican Photographer*. Minneapolis: University of Minnesota Press, 2003.

Mulvey, Laura. "Visual Pleasure and Narrative Cinema." In *The Routledge Reader in Gender and Performance*, edited by Lizbeth Goodman, 296–301. London: Routledge, 1999.

Mulvey, Laura, and Martine Beugnet. "Film, Corporeality, Transgressive Cinema: A Feminist Perspective." In *Feminisms: Diversity, Difference, and Multiplicity in Contemporary Film Cultures*, edited by Laura Mulvey and Anna Backman Rogers, 187–202. Amsterdam: Amsterdam University Press, 2015.

Muñoz, José Esteban. *Disidentifications: Queers of Color and the Performance of Politics*. Minneapolis: University of Minnesota Press, 1999.

———. "Feeling Brown, Feeling Down: Latina Affect, the Performativity of Race, and the Depressive Position." *Signs: The Journal of Women in Culture and Society* 31, no. 3 (2006): 675–88.

Museo Arqueológico Nacional. Complete Sheet of Inventory 1969/44/1 (Virgen Abridera). Accessed May 30, 2023. https://ceres.mcu.es/pages/Main#subir.

Nancy, Jean-Luc. "Corpus." In *Thinking Bodies*, edited by Juliet Flower MacCannell and Laura Zakarin, 17–31. Translated by Claudette Sartiliot. Stanford: Stanford University Press, 1994.

Ndlovu-Gatsheni, Sabelo J. *Epistemic Freedom in Africa: Deprovincialization and Decolonization*. London: Routledge, 2018.

Ngũgĩ wa Thiong'o. *Decolonising the Mind: The Politics of Language in African Literature*. London: James Currey Heinemann, 1986.

Noriega, Chon A. *From the West: Chicano Narrative Photography*. San Francisco: The Mexican Museum / Singer Printing, 1995.

Olson, Christa. "Casta Paintings and the Rhetorical Body." *Rhetoric Society Quarterly* 39, no. 4 (October 2009): 307–30.

O'Malley, John W. *Trent: What Happened at the Council.* Cambridge, MA: Belknap Press of Harvard University Press, 2013.

Ontiveros, Mario. "Christina Fernandez." In *Phantom Sightings: Art After the Chicano Movement*, edited by Rita Gonzalez, Howard N. Fox, and Chon A. Noriega, 152–55. Los Angeles: University of California Press, 2008.

Pakkanen, Petra. "Is It Possible to Believe in a Syncretistic God?" *Opuscula* 4 (2011): 125–41.

Paulinyi, Zoltán. "The 'Great Goddess' of Teotihuacan: Fiction or Reality?" *Ancient Mesoamerica* 17 (2006): 1–15.

Pennycook, Alastair, and Emi Otsuji. *Metrolingualism: Language in the City.* London: Routledge, 2015.

Pérez, Laura E. *Chicana Art: The Politics of Spiritual and Aesthetic Altarities.* Durham: Duke University Press, 2007.

———. "Spirit Glyphs: Reimagining Art and Artist in the Work of Chicana Tlamatinime." In *Rhetoric of the Americas*, edited by Damián Baca and Victor Villanueva, 197–226. New York: Palgrave Macmillan, 2010.

Pérez Huber, Lindsay. "Racial Microaffirmations as a Response to Microaggressions." *Center for Critical Race Studies at UCLA Research Briefs*, no. 15 (June 2018). https://issuu.com /almaiflores/docs/lph_racial_microaffirmations.

Pérez Huber, Lindsay, and Daniel G. Solórzano. "Racial Microaggressions: What They Are, What They Are Not, and Why They Matter." *Latino Policy and Issue Brief*, no. 30 (November 2015). https://files.eric.ed.gov/fulltext/ED580213.pdf.

———. "Visualizing Everyday Racism: Critical Race Theory, Visual Microaggressions, and the Historical Image of Mexican Banditry." *Qualitative Inquiry* 21, no. 3 (2015): 223–38.

Perkins, Judith. *The Suffering Self: Pain and Narrative Representation in the Early Christian Era.* London: Routledge, 1995.

Peterson, Jeanette Favrot. *The Paradise Garden Murals of Malinalco: Utopia and Empire in Sixteenth-Century Mexico.* Austin: University of Texas Press, 1993.

———. *Visualizing Guadalupe: From Black Madonna to Queen of the Americas.* Austin: University of Texas Press, 2014.

Pierce, Donna. "From New Spain to New Mexico: Art and Culture on the Northern Frontier." In *Converging Cultures: Art and Identity in Spanish America*, edited by Diana Fane, 59–68. New York: The Brooklyn Museum, 1996.

Poole, Stafford. *Our Lady of Guadalupe: The Origins and Sources of a Mexican National Symbol, 1531–1791.* Tucson: University of Arizona Press, 1995.

Powell, Malea. "2012 CCCC Chair's Address: Stories Take Place; A Performance in One Act." *College Composition and Communication* 64, no. 2 (2012): 383–406.

Price, Merrall Llewelyn. "Bitter Milk: The *Vasa Menstrualis* and the Cannibal(ized) Virgin." *College Literature* 28, no. 1 (2001): 144–54.

Quijano, Anibal. "Coloniality of Power, Eurocentrism, and Latin America." *Nepantla: Views from South* 1, no. 3 (2000): 533–80.

Ramirez, Loretta. "Archival Quest: Research Writing Pedagogies to Recover Historical Rhetorics that Centralize Latinx Voice and Inquiry." *Composition Studies* 51, no. 1 (2023): 91–110.

———. "Self-Loving in the Epidemic Years: Carmen Machado's Rhetoric of Woundedness." In "Chicana Lesbians: Re-Engaging the Iconic Text, *The Girls Our Mothers Warned Us About*," edited by Stacy Macias and Liliana González, special issue, *Journal of Lesbian Studies* 26 (2023): 1–15.

———. "Spain's Toledo *Virgen Abridera*: Revelations of Castile's Shift in Marian Iconography from Medieval to Isabelline." MA thesis, California State University, Long Beach, 2016.

———. "Unmaking Colonial Fictions: Cherríe Moraga's Rhetorics of Fragmentation and Semi-ness." *Rhetoric Review* 41, no. 3 (2022): 168–83.

Rangan, Pooja. *Immediations: The Humanitarian Impulse in Documentary.* Durham: Duke University Press, 2017.

Rappaport, Joanne, and Tom Cummins. *Beyond the Lettered City: Indigenous Literacies in the Andes.* Durham: Duke University Press, 2012.

Rawitch, Robert. "Latin Women File Suit on Sterilization: 11 Claim They Were Coerced or Deceived into Having Operations." *Los Angeles Times*, June 19, 1975, OC1, 3.

Réau, Louis. *Iconographie de l'art Chrétien.* Paris: Presses Universitaires De France, 1955.

Reinhardt, Mark, Holly Edwards, and Erina Duganne. *Beautiful Suffering: Photography and the Traffic in Pain.* Williamstown: Williams College Museum of Art, 2007.

Riba, Dan, dir. *Justice League Unlimited.* Season 1, episode 2, "For the Man Who Has Everything." August 7, 2004, on Cartoon Network. Warner Bros. Animation, 2004, 21 minutes.

Ríos, Gabriela Raquel. "Mestizaje." In *Decolonizing Rhetoric and Composition Studies: New Latinx Keywords for Theory and Pedagogy,* edited by Iris D. Ruiz and Raúl Sánchez, 109–24. Merced: Palgrave Macmillan, 2016.

Robinson, Cynthia. *Imagining the Passion in a Multiconfessional Castile: The Virgin, Christ, Devotions, and Images in the Fourteenth and Fifteenth Centuries.* University Park: Pennsylvania State University Press, 2013.

Rodriguez, Jeanette. *Our Lady of Guadalupe: Faith and Empowerment Among Mexican-American Women.* Austin: University of Texas Press, 1994.

Rodriguez, Jeanette, and Ted Fortier. *Cultural Memory: Resistance, Faith, and Identity.* Austin: University of Texas Press, 2007.

Rodriguez, Richard. *Hunger of Memory: The Education of Richard Rodriguez; An Autobiography.* New York: Bantam Books, 1982.

Rosenfeld, Bernard, Sidney M. Wolfe, and Robert McGarrah. *A Health Research Group Study on Surgical Sterilization: Present Abuses and Proposed Regulations.* Washington, DC: Health Research Group, 1973.

Rowe, Erin Kathleen. *Saint and Nation: Santiago, Teresa of Avila, and Plural Identities in Early Modern Spain.* University Park: Pennsylvania State University Press, 2011.

Ruiz, Iris D., and Sonia C. Arellano. "*La Cultura Nos Cura*: Reclaiming Decolonial Epistemologies Through Medicinal History and Quilting as Method." In *Rhetorics Elsewhere and Otherwise: Contested Modernities, Decolonial Visions,* edited by Romeo García and Damián Baca, 141–68. Urbana: Conference on College Composition and Communication of the National Council of Teachers of English, 2019.

Ruiz, Iris D., and Raúl Sánchez, eds. *Decolonizing Rhetoric and Composition Studies: New Latinx Keywords for Theory and Pedagogy.* Merced: Palgrave Macmillan, 2016.

Said, Edward. "Reflections on Exile." In *One World, Many Cultures,* edited by Stuart Hirschberg and Terry Hirschberg, 430–36. Boston: Allyn and Bacon, 1998.

Saldaña-Portillo, María Josefina. *Indian Given: Racial Geographies Across Mexico and the United States.* Durham: Duke University Press, 2016.

Sánchez, Raúl. "Writing." In *Decolonizing Rhetoric and Composition Studies: New Latinx Keywords for Theory and Pedagogy,* edited by Iris D. Ruiz and Raúl Sánchez, 77–89. Merced: Palgrave Macmillan, 2016.

Sánchez Reyes, Gabriela, and Irene González Hernando. "De la virgen abridera de Felipe II a las abrideras de Indias: El descubrimiento de dos esculturas en México." *Boletín de Monumentos Históricos* 3, no. 34 (2015): 6–28.

Sanchez-Scott, Milcha. *Dog Lady and the Cuban Swimmer: Two One-Act Plays*. New York: Dramatists Play Service, Inc., 1988.

Seubert, Xavier. "The Transubstantiation of St. Francis of Assisi: Searching for a Paradigm." In *Beyond the Text: Franciscan Art and the Construction of Religion*, edited by Xavier Seubert, 210–26. Saint Bonaventure: Franciscan Institute Publications, 2013.

Sharpe, Christina. *In the Wake: On Blackness and Being*. Durham: Duke University Press, 2016.

Shelton, Anthony Alan. "Cabinets of Transgression: Renaissance Collections and the New World." In *The Cultures of Collecting*, edited by John Elsner and Roger Cardinal, 177–291. Cambridge, MA: Harvard University Press, 1994.

Sigal, Peter. "Imagining Cihuacoatl: Masculine Rituals, Nahua Goddesses and the Texts of the Tlacuilos." *Gender and History* 22, no. 3 (2010): 538–63.

Silverblatt, Irene. "Political Memories and Colonizing Symbols: Santiago and the Mountain Gods of Peru." In *Rethinking History and Myth: Indigenous South American Perspectives on the Past*, edited by Jonathan David Hill, 174–94. Urbana: University of Illinois Press, 1988.

Sliwinski, Sharon. "A Painful Labour: Responsibility and Photography." *Visual Studies* 19, no. 2 (2002): 150–61.

Smith, Andrea. "Against the Law: Indigenous Feminism and the Nation-State." *Affinities Journal* 5 (2011): 56–69.

Smith, Sidonie. *Subjectivity, Identity, and the Body: Women's Autobiographical Practices in the Twentieth Century*. Bloomington: Indiana University Press, 1993.

Sosa Riddell, Adaljiza. "The Bioethics of Reproductive Technologies: Impacts and Implications for Latinas." In *Chicana Critical Issues: Mujeres Activas en Letras y Cambio Social*, edited by Norma Alarcón, 183–96. Berkeley: Third Woman Press, 1993.

Soto, Sandra K. *Reading Chican@ Like a Queer*. Austin: University of Texas Press, 2010.

Soto Vega, Karrieann, and Karma R. Chávez. "Latinx Rhetoric and Intersectionality in Racial Rhetorical Criticism." *Communication and Critical/Cultural Studies* 15, no. 4 (2018): 319–25.

Stern, Alexandra Minna. "Sterilized in the Name of Public Health: Race, Immigration, and Reproductive Control in Modern California." *American Journal of Public Health* 95, no. 7 (July 2005): 1128–38.

Stratton, Suzanne L. *The Immaculate Conception in Spanish Art*. New York: University of Cambridge Press, 1994.

Suite, Derek H., Robert La Bril, Annelle Primm, and Phyllis Harrison-Ross. "Beyond Misdiagnosis, Misunderstanding and Mistrust: Relevance of the Historical Perspective in the Medical and Mental Health Treatment of People of Color." *Journal of National Medical Association* 99, no. 8 (August 2007): 879–85.

Szupinska, Joanna. *Christina Fernandez: Multiple Exposures*. Edited by Rebecca Epstein. Riverside: University of California, Riverside Arts, 2022.

Tajima-Pena, Renee, dir. *No Más Bebés*. Produced by Virginia Espino. Los Angeles: Moon Canyon Films, 2015. DVD, 79 minutes.

Tedlock, Dennis, trans. *Popl Vuh: The Mayan Book of the Dawn of Life*. Rev. ed. New York: Simon and Schuster, 1996.

Tembeck, Tamar. "Exposed Wounds: The Photographic Autopathographies of Hannah Wilke and Jo Spence." *RACAR/Canadian Art Review* 33, nos. 1–2 (2008): 87–101.

———. "Performative Autopathographies: Self-Representations of Physical Illness in Contemporary Art." PhD diss., McGill University, Montreal, 2009.

————. "Selfies of Ill Health: Online Autopathographic Photography and the Dramaturgy of the Everyday." *Social Media and Society* (January–March 2016): 1–11.

Teresa of Avila. *The Interior Castle*. Translated by Mirabai Starr. New York: Riverhead Books, 2003.

Toor, Frances. *A Treasury of Mexican Folkways: The Customs, Myths, Folklore, Traditions, Beliefs, Fiestas, Dances, and Songs of the Mexican People*. New York: Crown Publishers, 1947.

Torres, Lourdes. "Building a Translengua in Latina Lesbian Organizing." *Journal of Lesbian Studies* 21, no. 3 (2017): 272–88.

Torres, Theresa L. "A Latina *Testimonio*: Challenges as an Academic, Issues of Difference, and a Call for Solidarity with White Female Academics." In *Unlikely Allies in the Academy: Women of Color and White Women in Conversation*, edited by Karen L. Dace, 65–75. New York: Routledge, 2012.

Troncoso Pérez, Ramon. "Crónica del *Nepantla*: Estudio, edición y anotación de los *Fragmentos sobre la historia general de Anáhuac*, de Cristóbal del Castillo." PhD diss., Universitat Autònoma de Barcelona, 2012.

Trujillo, Carla. *What Night Brings*. Willimantic: Curbstone Press, 2003.

Tuck, Eve, and K. Wayne Yang. "Decolonization Is Not a Metaphor." *Decolonization: Indigeneity, Education and Society* 1, no. 1 (2012): 1–40.

Turner, Victor. "Variations on a Theme of Liminality." In *Secular Ritual*, edited by Sally F. Moore and Barbara G. Myerhoff, 36–52. Amsterdam: Van Gorcum, 1977.

Umberger, Emily. "Art and Imperial Strategy in Tenochtitlan." In *Aztec Imperial Strategies*, edited by Frances F. Berdan, Richard E. Blanton, Elizabeth Hill Boone, Mary G. Hodge, Michael E. Smith, and Emily Umberger, 85–106. Washington, DC: Dumbarton Oaks, 1996.

Valadez, Concepción M., Jeff MacSwan, and Corinne Martínez. "Toward a New View of Low-Achieving Bilinguals: A Study of Linguistic Competence in Designated 'Semilinguals.'" *Bilingual Review/Revista Bilingüe* 25, no. 3 (2000): 238–48.

Vazquez, Gil, and Carmen Inoa Vazquez. *The Maria Paradox: How Latinas Can Merge Old World Traditions with New World Self-Esteem*. New York: Putnam, 1996.

Vázquez Martínez, Ana Laura. "Historia y devoción de un santuario en las inmediaciones de la ciudad de Oaxaca: La virgen de San Juanito." In *Religiosidades y feligresías: Un recorrido por las configuraciones devocionales en México*, edited by María Teresa Jarquín Ortega and Gerardo González Reyes, 251–76. Cerro del Murcielago: El Colegio Mexiquense, 2022.

Villanueva, Victor. *Bootstraps: From an American Academic of Color*. Urbana: National Council of Teachers of English, 1993.

Villaseñor Black, Charlene. "St. Anne Imagery and Maternal Archetypes in Spain and Mexico." In *Colonial Saints: Discovering the Holy in the Americas, 1500–1800*, edited by Allan Greer and Jodi Bilinkoff, 3–23. New York: Routledge, 2003.

Voragine, Jacobus de. *The Golden Legend: Readings on the Saints*. Translated by William Granger Ryan. Princeton: Princeton University Press, 2012.

Webster, Jill. *Els Menorets: The Franciscans in the Realms of Aragon from St. Francis to the Black Death*. Toronto: Pontifical Institute of Mediaeval Studies, 1993.

Weheliye, Alexander G. "Black Life/Schwarz-Sein: Inhabitations of the Flesh." In *Beyond the Doctrine of Man: Decolonial Visions of the Human*, edited by Joseph Drexler-Dreis and Kristien Justaert, 237–62. New York: Fordham University Press, 2019.

————. *Habeas Viscus: Racializing Assemblages, Biopolitics, and Black Feminist Theories of the Human*. Durham: Duke University Press, 2014.

Weschler, Lawrence. *Seeing is Forgetting the Name of the Thing One Sees: Over Thirty Years of Conversations with Robert Irwin*. Berkeley: University of California Press; Los Angeles: Getty Foundation, 2008.

Wynter, Sylvia, and Katherine McKittrick. "Unparalleled Catastrophe for Our Species? Or, To Give Humanness a Different Future: Conversations." In *Sylvia Wynter on Being Human as Praxis*, edited by Katherine McKittrick, 7–89. Durham: Duke University Press, 2015.

Yarbro-Bejarano, Yvonne. "De-Constructing the Lesbian Body: Cherríe Moraga's *Loving in the War Years*." In *Chicana Lesbians: The Girls Our Mothers Warned Us About*, edited by Carla Trujillo, 143–55. Berkeley: Third Woman Press, 1991.

———. *The Wounded Heart: Writing on Cherríe Moraga*. Austin: University of Texas Press, 2001.

Index

academic convention(s), 188–89, 192, 130, 26, 174, 180
 See also pedagogy(ies)
African American(s), 57, 95, 97
 See also Blacks
Afro-Latinidad, 57
agency, 55, 67, 118 181, 178
 as devotion, 163, 165, 170
 education, 181
 indigenous agency, 144
 No Más Bebés, 88, 104
 repurposed woundedness, 35, 109
Ahmed, Sara, 49, 59
Anima Sole (The Lonely Soul in Purgatory), 141, 146, 165
Anzaldúa, Gloria E., 29, 37, 43, 51, 59
 borderland theory, 12, 22, 40
 mestiza consciousness, 20, 40
 nepantla, 12
 woundedness, 22, 36
Apocalyptic Woman, 142, 144, 146
appropriation(s), 24, 38, 109, 129, 146
 Chicana narratives, 73, 88, 107
Asco, 24, 117, 146, 148, 205n2
assimilation, 49, 62, 124, 133
 colonization, 52–53, 56, 59, 61
 in education, 49 178–79, 190
audience reception, 20, 81, 123, 130, 135
 See also non-receptive audience(s)
autoethnographic writing/essay, 30, 39, 50
autopathography, 24, 113–14, 171
Aztlán, 11, 59–60, 65, 137

Baca, Damián, 130, 143, 183–84, 187, 196n23
Barad, Karan, 51, 62, 191
Belly of the Beast, 95–97, 105
belonging(s), 8, 17, 121, 127, 150–51
 academic, 173, 180–81, 185, 187, 189, 192
 See also unbelonging
binaries, 29, 34, 51, 79, 156, 178–79
 as colonial constructs, 20, 53, 60–62
 racialization of, 46, 53, 58, 60
 See also dualities; hybridity

biopolitics, 30, 69, 91–92, 99–102, 117
 (non)humanness, 22, 52
 patterns of, 59, 74, 97
 reproductive rights, 23, 72–74, 78, 88, 102, 108
 structures/systems of, 8, 22–23, 100, 105–6, 108
 theory, 19, 81, 99
 See also states of exception
bisected bodies, 143, 171
 Chicana bodies in art, 143–45, 155, 157
 virgen(es) abridera(s), 166, 169
Blacks, 52, 70–71, 88–89, 91, 106, 108
 See also African American(s)
Blackwell, Maylei, 12, 34–35, 106–7, 121, 144
 See also retrofitted memory
blood, 21, 130, 133–38, 143, 148, 154–56
 Catholic concepts, 61, 135, 139, 160
 Nahua concepts, 29, 138, 140, 142, 154
 racialized concepts, 56
borderland(s), 22, 36
 academic, 181, 185, 190
 Chicana bodies, 40, 100
 Iberian Christian-Iberian Islam border, 163, 165, 170
 nepantla discussions, 12–13, 15–16, 40
 See also in-betweenness; *nepantla*
border patrol
 Chicana wombs, 23, 72–74, 100–102
Boturini Codex, 137
Bravo, Manuel Álvarez, 149–51
breast(s), 113
 Coyolxauhqui, 28–29
 Virgin Mary, 158, 160–61, 166, 168
 See also chest(s)
Butler, Judith, 63–64, 100
Bynum, Caroline Walker, 113

cabinet(s) of curiosity(ies)
 Amalia Mesa-Bains, 24, 117, 128, 168
 as colonizing worldmaking, 18, 122–24, 128
 audience reception/co-creation, 125, 127
 Doc/Undoc, 24, 117, 122–24, 127–28, 168
 virgen(es) abridera(s) as cabinets, 1, 166, 168

226 INDEX

cabinet(s) of curiosity(ies) *(continued)*
 See also collection theory; *Doc/Undoc*;
 museum(s): studies
Calafell, Bernadette Marie, 52, 63, 108
California, 12, 33, 119, 121, 132, 148
 Chicana/o/x students, 8, 18–19, 25–26, 172–73,
 175, 182
 non-consensual sterilization, 69, 80, 82, 90,
 95–96, 99–101
 text and visual rhetorics, 5, 18, 24–25, 117–18,
 146
cannibalism
 transference of power, 138–40, 144
Carrasco, Davíd, 133–34, 205n21
Caruth, Cathy, 23–24, 40, 107–8, 127, 148, 170
 See also crying wound; trauma theory
casta painting(s), 53–57, 59–60
 See also *mestiza/o/os*: colonial constructs
Castillo, Ana, 29, 36, 174–75, 190
Catholicism, 136, 143, 147, 195
 Iberian Catholicism, 163–64, 203n8
 syncretized Indigenous Catholicism, 1, 195n1,
 206n28
Chagoya, Enrique, 24, 117, 129–136, 138, 140–41, 143
chest(s), 83, 134, 141–43
 Superman, 130, 133
 virgen(es) abridera(s), 1, 109, 157–58, 166, 169
 See also breast(s)
Chicana body
 biopolitics, 74, 100
 body rights, 70, 88–89
 border-patrolled, 23, 100–2
 color identity, 39
 narrative control, 51, 85, 88–90, 94
 sites of woundedness, 38, 51, 89, 100–2
Chicano Movement, 39, 58–59, 90, 182
Chicanx art, 11, 24–25, 118, 120–21, 129, 143
 Chicana art(ist), 28, 145
 Chicano art, 120, 147
 Codex Espangliensis, 118, 135, 140, 143, 145
 Doc/Undoc, 123–24, 127–129
 inheriting Iberian visual rhetorics, 24–25, 116–
 17, 145, 170
 inheriting Mesoamerican visual rhetorics,
 24–25, 117, 145
 visual rhetorical genealogies, 4, 24, 116, 151
 visual rhetorical inheritance(s), 25, 118, 150,
 154, 163
 visual rhetorical lineage(s), 116, 154, 161
 visual rhetorics of woundedness, 24–25, 116–18,
 127–29, 143–45, 157, 170

Yolanda Lopez's art, 146
 See also Asco; Fernandez, Christina; Gonzalez,
 Maya; Mesa-Bains, Amalia; visual rhetorics
Chicanx rhetoric, 19–21, 23, 29, 58, 67–68, 113–16
 Chicana rhetoric, 72–73, 78, 81–82, 88, 104, 189
 pedagogy, 26, 172, 174, 176, 181–83, 192
 rhetorical genealogy(ies), xv, 5, 14, 17, 19–20,
 173, 188
 rhetorical home(lessness), 39, 173, 180, 185, 188
 rhetorical inheritance(s), 16–17, 20, 41, 171, 173
 rhetorical lineages, 9–11, 13, 173, 182, 184, 187
 See also (il)legibility; pedagogy(ies); rhetoric;
 self-representation; rhetoric(s) of
 fragment(ation); rhetoric(s) of
 woundedness
Christ, 93, 142, 160–61, 163
 Codex Espangliensis depiction of, 134–37, 139–
 140, 144
 redeemer, 113, 158, 160
 virgen(es) abridera(s) depiction of, 1, 77, 157–58,
 161, 166–69
 wounds, 5, 17, 61, 113, 116
 See also Jesus
Christ as the Man of Sorrows, 134–35
Christendom, 4–5, 116, 163, 195n4
Christological, 74, 94, 105, 140, 145, 161
Christ's Passion
 See Passion of Christ
civility, 55–56
civilization, 57, 94
Coatlicue, 35, 65–66
Codex Espangliensis—From Columbus to the Bor-
 der Patrol, 25, 118, 129–46, 157, 205n32
Codex Magliabechiano, 131–32, 138
collection theory, 24, 117, 127
 See also cabinet(s) of curiosity(ies);
 museum(s), studies
colonial fiction(s), 34, 45, 51–52, 60, 94
 fictions of wholeness, 22, 24, 36, 41, 117, 171
coloniality, 16, 19–25, 67, 71, 74, 121
 academic, 187, 191
 biopolitical, 23
 historical (mis)representation, 20, 24–25, 118,
 127
 identity impact, 30, 41–42, 48, 50–51, 61–62, 64
colonization, 4, 61, 133, 191, 195n14, 197n33
 colonialism, 16, 52, 132
 colonial wound(edness), 16, 19, 30–31, 53, 61, 118
 disrupted histories, xv, 10, 12–13, 16, 150
 settler colonialism, 20
colonizing logics, 18, 51, 53, 60, 191

composition, 18, 25–26, 44, 70, 172–73, 175–77
 pedagogy, 12, 181–93
 See also pedagogy(ies)
container(s), 25, 118
 cabinet(s) of curiosity(ies), 122, 128
 concepts of Chicana body(ies), 143, 146–48,
 155–57
 concepts of Indigenous body(ies), 57
 virgen(es) abridera(s), 157, 163–65, 168–69
convent, 1, 5, 164, 166, 170
convent nun(s)
 See nun(s)
Convent of Santa Catarina de Sena in Oaxaca, 1,
 4, 161, 170
co-redemptrix
 See Virgin Mary; redeemer
correctness, 22, 26, 30, 174, 179–181
 See also linguistics; pedagogy(ies);
 semilingualism
Cortés, Hernán, 1, 132
Counter-Reformation
 art iconography, 115
counterstory, 117, 130, 191
Coyolxauhqui, 12, 27–30, 35–36, 44, 65–66, 182
 rhetorical *topoi* shared with *virgen(es)*
 abridera(s), 28–29, 46, 144
Coyolxauhqui Stone, 27–29, 35, 66
criollos, 55, 57
critical race theory, 23
 See also pedagogy(ies)
crucifixion/crucified, 113, 134, 157–58, 161, 168
cruciform
 Virgin Mary depictions of, 158, 166
cry or crying, xii, xiv, 45, 96, 110, 127
 La Llorona, 79–80
 No Más Bebés, 73, 80, 84–86, 89, 94, 107–8
crying wound(s), 23, 107–8, 110, 127, 139, 170
 See also Caruth, Cathy; wound theory;
 trauma theory
cultural rhetorics, 19–20, 26
 Chicana/o/x art, 125, 129–130, 157, 171
 Chicana/o/x writing, 21, 29–30, 62, 67, 78
 historical, xiv, xv, 114, 116–117
 Mexica cultural rhetorics, 140
 pedagogy, 18, 171–72, 174, 181, 183–88, 192–93
 See also pedagogy(ies); rhetoric; visual
 rhetorics

death, 7, 9, 107–8, 123, 130
 autopathographies, 114
 biopolitics, 100, 106

Cherríe Moraga's writings, 42, 47, 51, 66
Christ, 15, 135
Coyolxauhqui, 28
Mexica/Nahua belief system, 138, 142
Mictlān, 140
decolonization, xv, 10, 45, 129, 188
 colonial ruptures, xv, 10, 45
 decolonial feminism, 5, 10, 38, 71
 decolonial imaginaries, 51
 decolonial methodologies, 23, 50
 decolonial rhetoric, 13, 22, 30
 decolonial theory, 22, 48, 53, 133, 186
 decolonial understandings, 41, 92
dehumanization, 53, 84, 86, 109, 125
 See also humanization; (non)human(ness)
de la Cruz, Marcelo, 1–2, 5, 173, 195n1
delinking
 decolonial methodology, 7, 21, 48, 50–51, 155
 pedagogy, 186–87, 192
 rhetorical practices, 13, 19, 30, 37, 42
 See also unlearning
de Sahagún, Bernardino, 60
de Voragine, Jacobus, 111
Dillon, Kelli, 95–97, 105–6
discursive space(s), 10, 78, 94, 174
dislocation(s), 8, 49, 57, 121, 171
documentary, 95–96
 film criticism, 84
 No Más Bebés, 23, 69–70, 80–84, 88–95, 102,
 104–5
Doc/Undoc, 24, 117, 122–28, 148
 See also cabinet(s) of curiosity(ies)
dominant narrative(s), 75, 120
 Chicanas dominant narratives of, 34–35, 72,
 79, 81, 103
 coloniality, 25, 118
 pedagogy, 12, 186–93
 See also fictions of wholeness; myth of
 modernity
Doña Marina
 See Malinche
dualities, 28
 colonial constructs, 53, 57 , 59
 See also binaries; hybridity
Dussel, Enrique, 22, 53, 57, 93–94, 186
 See also infantilization; infant societies; myth
 of modernity

earthquake(s), 14–15, 30, 40–41, 66, 138–139, 165,
 171, 181
 See also *nepantla; ollin*

228 INDEX

El Movimiento Estudiantil Chicano de Aztlán
(MEChA), 39, 59
epistemologies, 23, 47, 92, 163, 170, 179
decolonization, 10, 16, 22, 38, 62
delinking, 7, 13, 19, 42
See also pedagogy(ies)
erasure(s), 14, 62, 190
colonial/coloniality, 24, 117, 120–21, 129, 148
social erasure of ill/wounded, 113–14
ethnic studies, 18, 26, 70, 72, 172
composition and rhetoric courses, 175, 182, 187
eugenics, 80, 85, 95, 100
Eurocentrism, 49, 50, 53, 57, 61
exile, 34, 40–41, 64–65, 180–81
See also in-betweenness; insider-outside;
semi-ness

faith, 17, 136, 165, 170, 175
conversion contexts, 12, 56, 160–61, 163–64
sacrificial contexts, 36, 111–12, 148
familia/family, 7, 86, 97, 102, 106, 188
academic settings, xiii, 9, 191
casta family structures, 53
Cherríe Moraga writings, 34, 63–67, 190–91
Chicana sacrifice, 79–83, 93–94, 108–9
Christina Fernandez photographs, 119, 148
Frida Kahlo's art, 155
generational language divisions, 175–78, 188
Latinx depiction of, 175, 190–191
feminism
Chicana feminist(s), 18, 182
feminist movement, 34, 37, 90
feminists of color, 71, 201n1
white feminist(s), 73, 90
Fernandez, Christina, 25, 118, 148, 154–55, 183
Maria's Great Expedition series, 119, 148
Untitled Multiple Exposures series, 149–52
fiction(s) of wholeness, 30, 53, 61, 187
unlearning of, 22, 24, 36, 117
Figueroa, Maria, 80, 103–4
See also Madigal Ten
first-generation student(s), xi–xii, 7–8, 172, 189
See also pedagogy(ies)
Foucault, Michel, 99, 101
fragment(ation), xv, 5, 16–17, 19–22
See also fiction(s) of wholeness; (il)legibility;
linguistics: fragmentation; (non)
human(ness); rhetoric(s) of
fragment(ation); rhetoric(s) of
wound(edness); self-representation: frag-
mentation; semilingualism; semi-ness;
wound(edness)

Francesc Eiximenis, 160–61
Franciscan (Order), 1, 11, 60, 116, 135 160–61
Immaculate Conception support, 164
rhetoric of woundedness, 115–16
virgen(es) abridera(s), 1, 4–5, 161, 166, 170
See also Poor Clare(s)
Friar Diego Durán, 11–13

Gaspar De Alba, Alicia, 29, 120
generative wound(edness), 74–75, 109, 145, 171
Chicanx rhetoric, 9–10, 16–19, 21–26
Cherríe Moraga writings, 29–34, 40, 42,
44–48, 62, 64
Chicanx visual rhetoric, 114, 116–18, 140, 144,
147, 155
Christian belief, 5, 21, 77–78, 114, 137, 139
Mexica/Aztec belief, 10, 139
pedagogy, 175, 183, 185
trauma theory, 108, 127
virgen(es) abridera(s), 157, 161, 170
See also trauma theory; wound(edness);
wound theory
Gómez-Peña, Guillermo
*Codex Espangliensis—Columbus to the Border
Patrol*, 129–30, 136
Doc/Undoc, 117, 121–22, 127, 129, 168
Gonzalez, Maya, 25, 118, 183
The Love That Stains, 152–57
grief, 50, 79–80, 148, 168
grievance(s)
Chicana grievances, 74–75, 77–78, 89, 94, 98,
107
generative articulations of, 74, 97, 147–48, 169
Madrigal Ten, 70, 81
silencing of 6, 23, 72, 114

Health Research Group (HRG), 103–4
herida abierta, 22
See also Anzaldúa, Gloria E., borderland
theory
Hermosillo, Consuelo, 80, 85–87, 107–8
See also Madigal Ten
Hernandez, Antonia, 89, 103
heteronormativity, 27, 34, 40, 49, 52, 122
internalizations, 41, 43, 48, 64
historical genealogy
rhetorics of woundedness, xiv–xv, 5, 10–11, 17,
74, 93
methodology, 18–21, 34
visual genealogy, 109—110, 117, 120, 145, 161
homeless(ness), 39–41, 44–45, 47
Huitzilopochtli, 27, 35, 65–66

human(ness)
 See (non)human(ness)
humanization
 in documentary, 84–86, 95–96
 See also (non)human(ness)
Hurtado, Maria, 80, 83–85, 87, 92–96, 98, 100
 See also Madigal Ten
hybridity, 20, 121, 129
 mestiza/o, 56–59
 See also binaries; dualities

Iberia
 female patronage, 4–5, 158, 160–61
 virgen(es) abridera(s), 3–5, 161–62
 See also medieval
Iberian Peninsula, 55–56, 163
iconography
 Catholic/Christian, 111, 113, 135, 164
 Chicana/o/x contemporary art, 28, 114, 117, 148
 Franciscan Order, 116
 Mesoamerica/Nahua, 28–29, 35, 140, 142, 197n4
 virgen(es) abridera(s), 158, 170
 See also Virgin Mary
(il)legibility
 deliberate illegibility, 5–6, 8–9, 120–21, 125, 127, 147
 linguistic, 101–2
 non-receptive audiences, 23, 74, 72, 187
 woundedness, 86, 78, 94, 115
 See also intelligibility
immaculate conception
 See Virgin Mary
in-betweenness
 academic, 171, 184–85
 linguistic, 180–81
 nepantla, 11–13, 15, 40–41, 139
 See also borderland(s); liminality; *nepantla*
inclusivity/inclusiveness, 123, 172, 188, 195n7
indigeneity, 20
 Cherríe Moraga's writings, 45–46, 50, 61–62
 colonial(ity) views of, 53, 57–58, 60–61
 post-Mexican Revolution representation of, 150
 See also Indigenous
Indigenous(ness), 1, 117, 120, 182
 Cherríe Moraga's writings, 21, 45
 Chicana/o movement representation of, 59
 Christianity, 1, 3–4, 11–12
 Codex Espangliensis, 130–31, 133, 135–136, 138–140, 144
 Mesoamerican beliefs, 14, 19, 154

mestiza/o colonial representation, 53, 55–58
 post-Mexican Revolution representation of, 58, 149–51
 rhetoric, 10–11, 20, 24, 116, 174, 184
 See also indigeneity
infantilization, 131, 150, 186
 See also myth of modernity
infant societies, 53, 57
 See also myth of modernity
insider-outsider, 40, 65, 180
 See also exile; in-betweenness; semi-ness
institutional indoctrination, 3, 188
institutional violences, 72, 101
intelligibility, 6, 78–80, 101
 See also (il)legibility
internalization, 41, 51, 156
intersectionality, 10, 13, 73–74, 78, 97
 fragmentations, 16, 34
 Maria Lugones, 71–72, 74, 201n1
invisibility, 8, 62, 125
Irwin County Detention Center, Georgia, 102
Isabelline, 161, 163
Isabel of Castile, 136
 Immaculate Conception support, 164

Jesus, 135, 158, 164
 See also Christ; Christ as the Man of Sorrows
Joys of Mary. *See* Virgin Mary

Kahlo, Frida
 The Two Fridas, 154–57
Kim, Jinah, 16, 51, 108
knowing-unknown, 49, 50
 See also Martinez, Jacqueline M

La Llorona, 79–80, 85–86, 201n3
Latina(s), 39, 78, 90, 189, 191
Latino(s), 71, 89–90, 177, 189
Latinx, 9–10, 26, 57–58, 70, 91, 93
 education, 173, 183–84, 186–87, 189–192
legibility
 See (il)legibility; intelligibility
legitimacy
 linguistic, 44
 rhetorical racialization of, 56
lesbian
 fragmentation, 51, 62
 intersectionality, 22, 34, 40, 43, 49, 175
liminality, 13–14, 139, 165, 169, 181
 See also borderland(s); in-betweenness; *nepantla*

230 INDEX

linearity, 21, 57, 150
 See also myth of modernity
linear progress(ion), 53, 57, 177
 See also myth of modernity
linguistics, 6–8, 10, 17–18, 48, 50, 57
 education, 25, 177–179, 181, 190
 fragmentation, 22, 39, 46, 176
 relativistic perception of language, 180, 207n12
 See also correctness; pedagogy(ies);
 semilingualism
López, Nacho, 150–51
Lopéz, Yolanda M., 146–47
Los Angeles County-USC Medical Center, 23,
 69, 80, 89, 98, 103–4
 No Más Bebés filming of, 82, 84
Lugones, María, 38, 71–72, 74, 201n1

Madrigal, Dolores, 80, 87, 89
 See also Madigal Ten
Madrigal Ten, 23, 25, 101, 114, 116, 118
 No Más Bebés, 70–72, 80–81, 87, 89, 92, 98–99,
 104–5
 See also *Madrigal v. Quilligan*
Madrigal v. Quilligan, 23, 69, 82, 98–101, 103–4
 No Más Bebés, 23, 69, 81, 88–91, 100, 103
 See also Madrigal Ten, *No Más Bebés*
Malinche, 79, 132
Malintzin
 See Malinche
Marianismo, 78, 85, 93, 105
Martinez, Jacqueline M., 49, 122
Martínez, María Elena, 55–56, 58
martyr, 78
 saints, 111–12, 115–16, 141
martyrdom, 111, 115, 169
medieval
 European belief
 collapsed time, 110
 iconography, 112–15
 Immaculate Conception, 142
 medical theory, 60, 160
 pilgrimage, 165
 purity systems, 56, 58
 saints, 111–12, 118
 visual culture, 163
 Iberia, 19, 24, 113–15, 117, 189
 female patronage, 4–5, 158, 160–61
 views on saints, 163
 virgen(es) abridera(s), 3–5, 161–62
 Mesoamerica, 28, 66
 See also Iberia

Merleau-Ponty, Maurice, 48
 See also phenomenology
Mesa-Bains, Amalia, 24–25, 118, 183
 New World Wunderkammer, 117, 128, 168
 The Twins: Guadalupe, 155–57
Mesoamerica
 Chicanx art impact, 146, 154, 160–161
 Chicanx rhetoric impact, 26, 174
 Codex Espangliensis, 131–34, 138, 143–44
 colonial audiences, 4, 173
 colonization of, 128
 philosophy, 5, 11, 21, 30, 142, 171
 reading traditions, 25, 129
 rhetorical historical genealogy, 14, 21, 29, 34,
 116, 182
 visual cultures, 25, 28, 117–118, 137
 See also iconography; Chicanx art; medieval;
 Mexica/Aztec; Nahua; *nepantla*;
 Indigenous
mestiza/o/os, 12, 53, 40
 casta paintings, 53–56, 59
 colonial racial hierarchies, 56–57
 erasure of indigeneity, 57
 hybridity, 20, 56, 59
 popularity in Chicana/o rhetoric, 58–59
 post-Revolution Mexico nation-building,
 58–59
 scholarly critique of, 53, 57–58, 59
mestiza consciousness, 20, 40
 See also Anzaldúa, Gloria E
mestizaje, 20, 53, 56–59
 See also *mestiza/o/os*
methodology, 10, 13, 23, 34, 50, 134, 144
 woundedness as methodology, 16–21
 See also delinking: decolonial methodology;
 decolonialism: methodology;
 pedagogy(ies): decolonial methodology;
 wound(edness): decolonial method
Mexica/Aztec
 Aztlán, 7, 59, 137
 cosmologies, 10–11, 14–15, 30, 40, 140
 deities, 27–28, 35, 66, 146, 154
 generative wound(edness), 11, 14–15, 138–40
 iconography, 24, 28–29, 117, 129, 137
 See also cosmologies; cultural rhetorics; death;
 generative wound(edness); Indigenous;
 Mesoamerica; Mictlān; Nahua; *nepantla*;
 sacrifice(s)
Mexico, 11–12, 27–28, 66–67, 86, 116–117, 138
 indigeneity, 148, 150–51
 mestizaje, 54–55, 58

Mexican *virgenes abrideras*, 1–4, 158, 163, 166, 173

Mickey Mouse, 131–33, 137–38, 140, 145

microaggression(s), xi, 8

Mictlán, 140
See also death: Mexica/Nahua belief system

Mictlāntēuctli, 131–32, 138, 140

Mignolo, Walter
colonial wound, 30
delinking, 42, 50, 187
pluriversality, 19, 188

Minh-ha, Trinh T., 22, 59, 60, 191
See also "not-I"

Mongul, 143–144

monstrance, 163

monstrosity, 36, 52, 61

Mora, Pat, 176
"Elena," 176–78

Moraga, Cherríe, 21–22, 25–53, 59–67, 94, 108, 170–71, 182–83
ESSAYS
"The Dying Road to a Nation," 30, 40–41, 43–47, 66, 155
"La Güera," 21, 30, 37–39, 46, 59, 61, 174
"Looking for the Insatiable Woman," 45, 65, 80
"A Long Line of Vendidas," 37, 39, 43, 45
"Queer Aztlán: The Re-Formation of the Chicano Tribe," 65
NON-FICTION BOOKS
Loving in the War Years, 30, 37–39, 44, 65, 182, 189
Native Country of the Heart, 30, 33, 45, 63, 65–67
PLAYS
Heroes and Saints, 38
The Hungry Woman, 38, 64
POEMS
"The Welder," 61–62

motherhood, 23, 44, 85, 109
Virgin Mary, 15, 46, 161, 166, 168
See also Moraga, Cherríe, mother(hood)-daugher(hood); tongue, mother tongue

mourning, 7, 9, 31, 67
community-building, 63–64, 71, 148
No Más Bebés, 85
Virgin Mary, 15, 148, 168
woundedness, 108

multimodal(ity), 19–20, 25, 118, 179–80, 189

Mulvey, Laura, 84
See also documentary

museum(s), 18
studies, 24, 117, 123, 128
See also cabinet(s) of curiosity(ies); collection theory

myth of modernity, 22, 53, 57, 93–94, 150, 187
See also linearity; linear progress(ion)

Nader, Ralph, 103–4

Nahua, 11, 140, 144
iconography, 29, 140, 142
metaphysics, 5, 11–14, 17, 74, 143–44, 165, 170
Náhuatl, 11–14, 40, 139, 154, 196n29
See also iconography: of Mesoamerica; Mexica/Aztec; *nepantla*

nepantla, 10–17, 19
as balance in earthquake (*ollin*), 14–15, 30, 40–41, 138–139, 165, 171, 181
Mesoamerican concepts of, 5, 13–15, 40, 154, 165, 196n29
nepantlisma, 185, 196n23
pedagogy, 181, 185
See also borderland(s), in-betweenness; liminality

No Más Bebés, 23, 69–74, 80–95, 98–105, 109, 148
See also *Madrigal v. Quilligan*

nonconsensual sterilization, 69, 72, 80–81, 95, 97, 100–103, 108

(non)human(ness), 22, 30, 52–53, 61, 92, 157
See also biopolitics; dehumanization; humanization; states of exception

(non)humanness as rhetorical action, 53, 157

nonreceptive audience(s), 6, 9, 23
in academics, xiii, xiv, 171, 177
See also unreceptive audience(s)

normativity
See heteronormativity

"not-I," 22, 59–62, 78, 120, 175–76, 191
See also oppressor-within; other-within

nun(s), 1, 141, 165–66, 170
See also convent

ollin, 14, 17, 40, 139

oppression, 44, 107

oppressor, 21, 37

oppressor-within, 39
See also "not-I"; other-within

original sin, 17, 135, 142, 158, 164

Orozco, Helena, 80, 98
See also Madigal Ten

ostentatio vulneris, 112–15, 117, 136, 170
See also sacrifice(s)

232 INDEX

other-within, 61
 See also "not-I"; oppressor-within

Passion of Christ, 160–61
 virgen(es) abridera(s), 1, 157–59, 168
patriarch(y), 65–66, 74, 97
pedagogy(ies), 25–26
 academic convention, 180, 188–89, 192
 belonging, 173, 180–81, 185, 187, 189, 192
 critical composition, 19, 26, 191
 critical race theory, 17
 cultural rhetorics and writing, 18, 174, 181,
 184–86, 193
 rhetorical inheritances, 26, 174, 181, 185, 187, 192
 rhetorical sovereignty, 179
 textual identities, 180
 textual spaces, 26, 174, 188
 validation, 172–73, 175, 182–84, 189
 See also composition; cultural rhetorics; epis-
 temologies; ethnic studies; first-generation
 student(s)
performance, 6, 34, 46, 52, 105
 in academics, 26 174, 176, 182
 in art, 117, 121–22, 147–48
 performance of self, 60, 171, 191
 rhetoric, 9, 18, 42, 104
performativity, 6, 37–38, 47, 185, 189
phenomenology, 48–49, 170
pilgrim, 165–66, 169–70
pluriversality, 19, 188
 See also Mignolo, Walter
Poor Clare(s), 4–5, 161, 166
 See also Franciscan (Order)
Posada, José Guadalupe, 135–36, 138, 140
postcolonial, 11, 13, 15–16, 132, 188
Public Citizen Organization, 104
purity
 racialized construct, 55–56, 58–59, 201n1
 Virgin Mary, 142, 164

queer phenomenology, 49–50
 See also Ahmed, Sara
Quijano, Anibal, 22, 53, 57

racism, 23, 52, 74, 97, 99–100
Rangan, Pooja, 84, 86
 See also documentary
redemption, 46, 170
 Christ, 135, 139
 Virgin Mary, 46, 158, 160–61, 168–70
 See also co-redemptrix: Virgin Mary; Virgin
 Mary: redemptrix

redress, 16, 25, 80, 107
 decolonization, 16, 118
 No Más Bebés, 69–71, 74, 86, 89
 woundedness as advocacy, 6, 64, 94–97, 121,
 155, 157
re-member, 36, 43–44
reorientation, 9, 115
 See also Ahmed, Sara; phenomenology
reproductive rights, 23, 70, 72, 84, 88–91, 99, 101
retrofitted memory, 35–36, 144, 158, 168
 See also Blackwell, Maylei
reverse-colonization
 Codex Espangliensis, 24, 117, 129, 140
rhetoric
 multimodal, 19–20, 25, 118, 179–80, 189
 rhetorical history(ies), xv, 94, 114, 174, 186
 rhetorical reorientation, 6–7, 9, 115
 rhetorical tapestry(ies), xv, 9–10, 20, 78, 181, 192
 See also California: textual and visual rhetorics;
 Chicanx art; Chicanx rhetoric; cultural
 rhetorics; decolonization: decolonial rheto-
 ric; delinking: rhetorical practices; ethnic
 studies: composition and rhetoric courses;
 Franciscan (Order): rhetoric of wounded-
 ness; historical genealogy: rhetorics of
 woundedness; Indigenous: rhetoric; Meso-
 america: Chicanx rhetoric impact;
 Mesoamerica: rhetorical historical geneal-
 ogy; pedagogy(ies); performance; semi-ness:
 rhetorics; standard English; rhetorical sov-
 ereignty; rhetoric(s) of fragment(ation);
 rhetoric(s) of wholeness; rhetorics of
 wound(edness); visual rhetorics
rhetorical inheritances
 See Chicanx rhetoric; pedagogy(ies): rhetori-
 cal inheritances
rhetorical sovereignty, 68, 97–98, 174, 179, 182, 186,
 202n8
rhetoric(s) of fragment(ation), 5, 20–21, 41
 See also rhetoric(s) of woundedness
rhetoric(s) of wholeness, 20, 41, 114, 128
 in education, 26, 174–75, 192
rhetoric(s) of woundedness, xv, 5–7, 9–10, 21
 audience reception of, 23, 72–75, 81, 88, 113–14,
 117, 146, 169, 171
 contemporary Chicanx rhetorics, 11, 22
 Cherríe Moraga, 29, 36–39, 49–53, 59, 62–64
 contemporary Chicanx visual rhetorics, 25,
 145, 148–149, 155
 generative strategy, 77–78, 104, 109, 117–118,
 127, 170–71
 historical Iberian, 115, 158, 160–62, 166, 169

INDEX 233

historical Mesoamerican, 11, 14–15
pedagogy, xv, 26, 172, 174–76, 181, 191–92
reading of, 130, 135
rhetorical genealogy, xv, 14, 34, 121
trauma theory, 24, 77
Rivera, Jovita, 80, 98
See also Madigal Ten
Royal Chicano Air Force (RCAF), 121

sacrifice(s), 7, 29, 74, 81, 148, 177
Cherríe Moraga's writings, 21, 35–36, 65, 94
Chicana/o/x rhetorics of woundedness,
79–80, 92–94, 105, 154, 173
Christian beliefs, 17, 46, 93, 135, 138–139,
160–161
Mexica/Aztec beliefs, 21, 29–30, 35, 138, 140,
170–71
myth of modernity, 93–94, 105
repurposed sacrifices, 73, 79, 94, 98, 109
saints, 112–13, 117
virgen(es) abridera(s), 14–15, 77–78, 109, 144,
161, 168–171
See also wound(edness)
saint(s), 111–16, 118, 141, 147, 160–61, 163–64
See also generative wound(edness): martyr;
martyrdom; ostentatio vulneris; sacrifice(s);
wound(edness)
St. Francis, 115
See also Franciscan (Order)
St. Lucy, 111–13, 115, 117
St. Mechtild of Magdeburg, 160
San Juan Chapultepec, 1, 173, 195n1
San Juan Chapultepec *virgen abridera*, 1–5, 109,
157–158, 161, 166, 168–170
See also virgen(es) abridera(s)
self-representation, 5, 9, 19–20, 55, 58, 113
fragmentation, 5, 71, 177, 179, 191
pedagogy, 173–74, 176–77, 179, 183, 188, 191
woundedness, 5, 10, 68, 71, 117, 172, 191
See also rhetoric; rhetoric(s) of
fragment(ation); rhetoric(s) of wounded-
ness; semilingualism
semilingualism, xiii, 175
as derogatory, 178–79
as rhetorical strategy, 179
See also correctness; fiction(s) of wholeness;
(il)legibility; intelligibility; linguistics; rhet-
oric; rhetoric(s) of fragment(ation);
rhetoric(s) of woundedness
semi-ness
as derogatory, 8, 17, 171
as generative woundedness, 9, 21, 26, 51, 174–75

identity, 8–9, 48
linguistic, xiii, 176–77, 179
rhetoric, 30, 65, 121, 129, 148
shame, xiii–xiv, 44, 51, 75, 172, 181, 185
See also fiction(s) of wholeness;
fragment(ation); (il)legibility;
(non)human(ness); semilingualism
serpent(s), 29, 141–44, 146
See also snake(s)
sexuality, 10, 38, 49–50, 123, 175
shame, 1, 22, 37, 41, 75, 161
academic, 26, 174–178, 180–81
creative energy of, 38, 51, 62, 110, 118, 151
semi-ness, xii–xiv, 43–44, 46, 51, 172
Sharpe, Christina, 52, 106–7
Shrine Madonna
See virgen(es) abridera(s)
snake(s)
iconography, 29, 140–44, 146
See also serpents
Spiderman, 133, 137
Sorrows of Mary
See Virgin Mary
standard English, 176–77, 180
See also correctness; linguistics; pedagogy(ies);
rhetoric; rhetoric(s) of fragment(ation);
semilingualism
states of exception, 99
See also biopolitics
sterilization
Belly of the Beast, 95, 97, 106
Irwin County Detention Center, 102
Madrigal v. Quilligan, 23, 80–85, 88–93,
99–103, 108, 114
Relf v Weinberge, 88, 103
See also California: non-consensual
sterilization
stitch(es), 14, 62, 98–99
historical methodology, 16, 18–20, 25, 34
pedagogy, 26, 181, 184
Superman, 129–33, 138, 140, 142–43, 145

Tembeck, Tamar, 113–16, 171
See also autopathography
temporal collapse, 137
Christina Fernandez's photography, 148,
150
medieval concepts of, 165, 169
rhetorics of woundedness, 127, 170
temporal distance
narrative, 82, 96–98, 104
woundedness, 82, 96–7, 106

234 INDEX

temporal gulfs
Christina Fernandez's photograph, 148
Tenochtitlán, 1, 11, 27, 137
textual homes, 180–81, 193
See also pedagogy(ies)
theory(ies) in the flesh, 38, 108
thinking body, 42 45
together-apart, 72, 149, 151–52, 155, 185
Cherríe Moraga's writings, 62, 64, 67
See also Barad, Karen
tongue, xiii, 29, 38–39, 45, 52, 177
forked tongue, 22, 43
mother tongue, 39, 43–45, 188
transdisciplinary scholarship, 18, 116
transubstantiation, 163
trauma theory(ies), 23–24, 40, 64, 106–7, 148, 170
belated address, 107–8, 127
See also Caruth, Cathy; wound theory

unbelonging, 127–28, 147, 189
uncivilized, 52, 56, 59
unintelligibility, 5–6, 9, 101, 121
See also (il)legibility
unreceptive audience(s), 117, 171, 183
in academics, 8, 190
See also nonreceptive audience(s)

Valdez, Patssi, 148
vierge ouvrante
See virgen(es) abridera(s)
Villanueva, Victor, 180, 183, 187
Violante of Castile, 5, 166
virgen(es) abridera(s), 4–5, 21, 25, 118
audience interactivity, 109, 162, 165–66
Mexican audiences, 170
comparisons to Coyolxauhqui Stone, 28–29
generative wounds, 14–15, 77, 93, 144, 157, 168–70
iconographical shifts, 157–160, 166–68
Iberian vs. northern Europe, 161–65, 169
San Juan Chapultepec virgen abridera, 1–5, 109, 157,161, 168–170, 173
See also bisected bodies; breast(s); cabinet(s) of curiosity(ies); chest(s); Christ, virgen(es) abridera(s) depiction of; container(s); cruciform, Virgin Mary in virgen(es) abridera(s) depictions of; Franciscan (Order); generative wound(edness); iconography; immaculate conception; medieval; Passion of Christ, virgen(es) abridera(s); sacrifice(s)

Virgin Mary, 1–5, 24–25, 29–30, 109–10, 117–18, 157–70
Amalia Mesa-Bains art, 157
Asco performance art, 148
Codex Espangliensis, 141–44, 157
co-redemptrix, 25, 118, 158, 160–66, 170
iconography, 28, 142, 160
Immaculate Conception
doctrine of, 164
iconography, 4, 142, 146
virgen(es) abridera(s), 1, 158, 166, 168
intercession/intercessor, 141, 161, 164–65
Joys of Mary, 46, 157–58, 161, 166, 206n15
Sorrows of Mary, 158, 166, 168
Yolanda Lopez's art, 146–147
See also breast(s); cruciform; motherhood; mourning; purity; redemption; virgen(es) abridera(s)
Virgin of Guadalupe, 128, 148, 155
Codex Espangliensis depiction of, 141–142
Yolanda M. López depiction of, 146–47
visual rhetorics, 5, 11, 18–19
Chicana/o/x visual rhetorics, 58, 109, 120–21, 124, 150, 155
Christian Iberia, 4, 113, 116, 160
Codex Espangliensis, 130, 135, 145
virgen(es) abridera(s), 4, 162–63, 170
woundedness, 24, 29, 114, 116, 120, 149
See also Chicanx art; cultural rhetorics; rhetoric

Weheliye, Alexander G., 22, 52, 99
whiteness, 21, 37–39, 46, 56–57, 59, 62
Wilson, Pete, 132
Wonder Woman, 143–45
wound(edness)
academic woundedness, xi , 172
decolonial method, 16–19
inflicted woundedness, 22–24, 45, 69, 73–74, 79
linguistic woundedness, 17, 25, 173, 179
open wounds, 16, 22, 105, 107, 117, 128–29
rhetorical woundedness, 27, 130, 183
See also agency: repurposed wounds; Chicana body: sites of woundedness; Chicanx art: visual rhetorics of woundedness; Christ: wounds; colonization: colonial wound(edness); crying wound(s); fragment(ation); Franciscan (Order): rhetoric of woundedness; generative wound(edness); historical genealogy:

rhetorics of woundedness; (il)legibility: woundedness; methodology: woundedness as methodology; mourning: woundedness; redress: woundedness as advocacy for; rhetorics of woundedness; sacrifice(s): Chicana/o/x rhetorics of woundedness; self-representation: woundedness; semi-ness: as generative woundedness; temporal collapse: rhetorics of woundedness; temporal distance: woundedness; visual rhetorics: woundedness; wound theory

wound theory, 23, 74
 See also trauma theory
Wynter, Sylvia, 2, 53

Yarbro-Bejarano, Yvonne, 51, 197n45

Xochiquetzal, 154

THE RSA SERIES IN TRANSDISCIPLINARY RHETORIC

Other titles in this series:

Nathan Stormer, *Sign of Pathology: U.S. Medical Rhetoric on Abortion, 1800s–1960s*

Mark Longaker, *Rhetorical Style and Bourgeois Virtue: Capitalism and Civil Society in the British Enlightenment*

Robin E. Jensen, *Infertility: A Rhetorical History*

Steven Mailloux, *Rhetoric's Pragmatism: Essays in Rhetorical Hermeneutics*

M. Elizabeth Weiser, *Museum Rhetoric: Building Civic Identity in National Spaces*

Chris Mays, Nathaniel A. Rivers and Kellie Sharp-Hoskins, eds., *Kenneth Burke + The Posthuman*

Amy Koerber, *From Hysteria to Hormones: A Rhetorical History*

Elizabeth C. Britt, *Reimagining Advocacy: Rhetorical Education in the Legal Clinic*

Ian E. J. Hill, *Advocating Weapons, War, and Terrorism: Technological and Rhetorical Paradox*

Kelly Pender, *Being at Genetic Risk: Toward a Rhetoric of Care*

James L. Cherney, *Ableist Rhetoric: How We Know, Value, and See Disability*

Susan Wells, *Robert Burton's Rhetoric: An Anatomy of Early Modern Knowledge*

Ralph Cintron, *Democracy as Fetish*

Maggie M. Werner, *Stripped: Reading the Erotic Body*

Timothy Johnson, *Rhetoric, Inc: Ford's Filmmaking and the Rise of Corporatism*

James Wynn and G. Mitchell Reyes, eds., *Arguing with Numbers: The Intersections of Rhetoric and Mathematics*

Ashely Rose Mehlenbacher, *On Expertise: Cultivating Character, Goodwill, and Practical Wisdom*

Stuart J. Murray, *The Living from the Dead: Disaffirming Biopolitics*

G. Mitchell Reyes, *The Evolution of Mathematics: A Rhetorical Approach*

Jenell Johnson, *Every Living Thing: The Politics of Life in Common*

Kellie Sharp-Hoskins, *Rhetoric in Debt*

Jennifer Clary-Lemon, *Nestwork: New Material Rhetorics for Precarious Species*

Nicholas S. Paliewicz, *Extraction Politics: Rio Tinto and the Corporate Persona*

Paul Lynch, *Persuasions of God: Inventing the Rhetoric of René Girard*